THE GREAT IRISH FAMINE

Visual and Material Culture

The Great Irish Famine

Visual and Material Culture

Marguérite Corporaal, Oona Frawley
and Emily Mark-FitzGerald

LIVERPOOL UNIVERSITY PRESS

First published 2018 by
Liverpool University Press
4 Cambridge Street
Liverpool
L69 7ZU

British Library Cataloguing-in-Publication data
A British Library CIP record is available

ISBN 978 1 78694 159 6 cased
ISBN 978 1 78694 160 2 limp

Typeset by Carnegie Book Production, Lancaster
Printed and bound by CPI Group (UK) Ltd, Croydon CR0 4YY

Contents

Figures

Contributors

Marguérite Corporaal is Associate Professor of British Literature at Radboud University Nijmegen, and was the principal investigator and coordinator of the ERC-funded research project *Relocated Remembrance: The Great Famine in Irish (Diaspora) Fiction, 1847–1921*. Furthermore, she was the director of the *International Network of Irish Famine Studies*, funded by NWO (2014–17). Among her international publications are *Relocated Memories of the Great Famine in Irish and Diaspora Fiction, 1847–1870* (Syracuse University Press, 2017), *Travelling Irishness in the Long Nineteenth Century* (co-edited, Palgrave, 2017) and *Irish Studies and the Dynamics of Memory* (Peter Lang, 2017).

Fintan Cullen is Professor Emeritus of the History of Art at the University of Nottingham. Over the past few decades, he has published widely on the representation of Ireland; his most recent book being *Ireland on Show: Art, Union and Nation* (Ashgate, 2012). He is presently writing a study of the representation of migration and the Irish in the long nineteenth century to be published by Peter Lang in their Reimagining Ireland series.

Bryce Evans is Associate Professor in History at Liverpool Hope University. His previous books include political biographies of two of the leading figures of the Irish twentieth century, *Seán Lemass: Democratic Dictator* (The Collins Press, 2011) and *Frank Aiken: Nationalist and Internationalist* (Irish Academic Press, 2014), and an economic history of Ireland during the Second World War subtitled *Farewell to Plato's Cave* (Manchester University Press, 2014). He has received substantial research funding from the Wellcome Trust, the AHRC, the Royal Historical Society, the Economic History Society and the Winston Churchill Memorial Trust

(among others), and keeps a research blog at www.drbryceevans.wordpress. com. His essay in this collection received the 2016 Irish Famine Summer School Best Paper award from the Irish Heritage Trust.

Melissa Fegan is Associate Professor in the Department of English at the University of Chester, where she teaches nineteenth-century literature and culture. Her publications on literary representations of the Irish Famine include *Literature and the Irish Famine 1845–1919* (Oxford University Press, 2002), and book chapters and journal articles on the Irish writers William Carleton, James Clarence Mangan and Aubrey de Vere, the Young Irelanders, and Famine motifs in twentieth- and twenty-first-century fiction.

Oona Frawley is Lecturer in the Department of English at Maynooth University. Her research interests lie in Irish Studies, particularly of the late nineteenth through to the twenty-first centuries; in ecocriticism; and in memory and trauma studies. She is particularly interested in comparative and transhistorical perspectives on literature and culture. She is the author of *Irish Pastoral* (Irish Academic Press, 2005) and the editor of the four-volume *Memory Ireland* project, as well as editor of *A New and Complex Sensation: Essays on Joyce's Dubliners* (The Lilliput Press, 2004), *New Dubliners* (New Island Books, 2005) and *Selected Essays of Nuala Ní Dhomhnaill* (New Island Books, 2005). A Hennessy Award nominee, her first novel, *Flight*, was published in 2014 by Tramp Press and was nominated for an Irish Book Award in the 'newcomer' category.

Lisa Godson is Director of the MA Design History and Material Culture at the National College of Art and Design and is Visiting Research Fellow at the School of Histories and Humanities at Trinity College Dublin. A scholar of material culture, Irish history, religion and architecture, publications include the co-edited *Making 1916: Material and Visual Culture of the Easter Rising* (Liverpool University Press, 2015); *Modern Religious Architecture in Germany, Ireland and Beyond: Influence, Process and Afterlife since 1945* (Bloomsbury, 2019); *Uniform: Clothing and Discipline in the Modern World* (Bloomsbury 2019) and her forthcoming monograph *How the Crowd Felt: Ceremonial Culture in the Irish Free State*.

Peter Gray is Professor of Irish History and Director of the Institute of Irish Studies at Queen's University Belfast. His publications include *The Irish Famine* (Thames and Hudson, 1995), *Famine, Land and Politics: British Government and Irish Society 1843–50* (Irish Academic Press, 1999) and *The Making of the Irish Poor Law, 1815–43* (Manchester University Press, 2009). He is a Member of the Royal Irish Academy.

Jason King is Academic Coordinator of the Irish Heritage Trust and the National Famine Museum in Strokestown Park. His recent publications include *Irish Famine Migration Narratives: Eyewitness Testimonies* (Routledge, 2018), *Children and the Great Hunger in Ireland* (with Christine Kinealy and Gerard Moran, Cork and Quinnipiac University Press, 2018), *Performance and Interculturalism Now: New Directions?* (with Charlotte McIvor, Palgrave, 2018) and *Women and the Great Hunger* (with Christine Kinealy and Ciarán Reilly, Cork and Quinnipiac University Press, 2017). He also curates several exhibits and a digital archive on the Great Hunger and Irish Famine migration.

Emily Mark-FitzGerald is Associate Professor in the School of Art History and Cultural Policy at University College Dublin. A scholar of the visual culture of Irish poverty, famine, migration, museum studies and cultural policy, her recent publications include *Commemorating the Irish Famine: Memory and the Monument* (Liverpool University Press, 2013) and the *Irish Museums Survey 2016*, funded by the Irish Research Council. She represents Art History on the Historical Studies Committee of the Royal Irish Academy and has been one of the Directors of the Irish Museums Association since 2009.

Andrew G. Newby is Kone Foundation Senior Research Fellow at Tampere Institute for Advanced Social Research, and Docent in European Area and Cultural Studies at the University of Helsinki. He has curated the museum exhibition *Nälkä! The Great Finnish Famine, a 150th Anniversary Exhibition* (2017–), and his publications include *Ireland, Radicalism and the Scottish Highlands* (Edinburgh University Press, 2007) and *Éire na Rúise: An Fhionlainn agus Éire ar thóir na saoirse* (Coiscéim, 2016).

Niamh O'Sullivan is Professor Emerita of Visual Culture (National College of Art and Design) and is Curator of Ireland's Great Hunger Museum at Quinnipiac University. Formerly Head of Education at the National Gallery of Ireland, she curated the first retrospective exhibitions of Aloysius O'Kelly (Dublin City Gallery, The Hugh Lane, 1999–2000) and Daniel Macdonald (Ireland's Great Hunger Museum, 2016). She is editor of the *Famine Folios* series, and her publications include *Aloysius O'Kelly: Art, Nation, Empire* (Field Day, 2010), *The Tombs of a Departed Race: Illustrations of Ireland's Great Hunger* (Quinnipiac University Press, 2014), *In the Lion's Den: Daniel Macdonald, Ireland and Empire* (Quinnipiac University Press, 2016) and *Coming Home: Art and the Great Hunger* (Quinnipiac University Press, 2018).

Ciarán Reilly is a historian of nineteenth- and twentieth-century Ireland based at Maynooth University. His books include the co-edited *The Land Agent, 1700–1920* (Edinburgh University Press, 2018), *The Irish Land Agent, 1830–1860: the case of King's County* (Four Courts Press, 2014); *Strokestown and the Great Irish Famine* (Four Courts Press, 2014) and *John Plunket Joly and the Great Famine in King's County* (Four Courts Press, 2012).

Dawn Miranda Sherratt-Bado is a dual specialist in Irish and Caribbean Studies. She has taught at Maynooth University, the University of Edinburgh, and the Scottish Universities' International Summer School (SUISS). She is co-editor of *Female Lines: New Writing by Women from Northern Ireland* (New Island Books, 2017). She is author of *Decoloniality and Gender in Jamaica Kincaid and Gisèle Pineau: Connective Caribbean Readings* (Palgrave Macmillan, forthcoming). Dawn has also published in *Irish Studies Review*, *Breac*, *Callaloo*, *Open Library of Humanities*, and the *Sunday Business Post*. She is a regular contributor to *The Honest Ulsterman*, the *Dublin Review of Books* and *The Irish Times*.

Shelley Troupe is General Manager of Youth Theatre Ireland and has worked for a diverse range of companies in America and Ireland including the Galway International Arts Festival, the Irish Repertory Theatre (NYC), and the National Asian American Theatre Company (NYC). She completed her PhD at the National University of Ireland, Galway, and has published chapters and articles in *The Oxford Handbook of Modern Irish Theatre*, *The Palgrave Handbook of Contemporary Irish Theatre and Performance* among others.

Foreword

For many years, it was claimed that Irish culture contained a silence on the subject of the Great Famine. It was suggested that the events and losses of that time had been too traumatic; pundits claimed that Irish culture had managed to repress its memory and had, in response to extreme trauma, rapidly modernized, leaving the scars of that time resolutely in the past. During the period of the sesquicentenary commemorations of the Great Famine in the 1990s, the myth of silence was shown to be precisely that: and the time since those anniversaries has been marked by nothing if not the utter refutation of the idea that Irish culture remains without trace of the Famine. The subsequent 'recovery' of vast amounts of material—literary, historical, archaeological, sociological—attests not only to the richness of the cultural commentary that the Famine produced, but also to other gaps and aporia that have not yet been fully explored.

The International Network of Irish Famine Studies (INIFS) was established in 2014 by Dr Marguérite Corporaal with funding from the Dutch Research Council NWO (grant number 236-69-007) and co-funding from Helsinki University, Maynooth University, and Queen's University Belfast. Growing out of the body of scholarship that arose around the 150th commemorations of the Famine and challenging long-held misconceptions like that of cultural silence, the INIFS has rapidly become an important body for the study of the Irish Famine in international contexts. With collaborations between scholars in Ireland, Northern Ireland, England, the Netherlands, Finland, the United States, Poland, France, Canada, Japan and Brazil, the network has shown how much work remains to be done in relation to many aspects of Famine scholarship.

One of these aspects is the question of the material and visual legacies of the Famine. Pioneering research in the field has been performed by

network member Dr Emily Mark-FitzGerald and the fact that interrelated issues required examination led to an INIFS-hosted conference in March 2016 at Maynooth University, 'The Great Famine and Its Impacts: Material and Visual Culture'. The myth about the silence concerning the Famine had led to another: that the Famine had left little material or visual trace in Irish culture. The intense and obvious poverty of the period, the scarcity of all kinds associated with the 1840s, and the narrow sense of how material and visual legacies were typically construed all meant that an assumption was made that, in fact, the Famine had left little trace. The present volume, *The Great Irish Famine: Visual and Material Culture*, based on those proceedings, forcefully overturns this myth, as scholars in many disciplines—history, art history, media studies, literary studies, theatre and film studies—explore the complexity of evidence about the Famine's impacts on culture, and the myriad ways in which we see the multiple legacies of the period.

Maynooth University has been delighted to be a part of the INIFS, and was honoured to host the 2016 conference, from which this book has arisen. There is no doubt that a volume such as this one suggests the many ways in which our consideration of the Great Famine will continue to be extended and challenged—by transnational perspectives and by the shifting perspective that occurs when visual and material culture is analysed in a new way.

<div align="right">

Oona Frawley

</div>

Introduction
Famine Memory and its Industries –
Genealogies of Representation

Emily Mark-FitzGerald

University College Dublin

The 150th anniversary of the Great Irish Famine in the 1990s was a commemorative watershed in many respects, sparking a global surge in public attention and memorial practices domestically and across the diaspora. Since the sesquicentenary, scholarship has expanded from a focus on economic, social and political history and demography to encompass a wider range of cultural perspectives and methodologies. Such approaches have sought to identify the cultural forms through which the Famine in its own time was narrated, pictured and otherwise represented, and to investigate further how, when and why the Famine appears and disappears as referent for subsequent generations.

These studies of the longevity and variability of the Famine's cultural impact from the nineteenth century to the present have enriched our understanding of how what is often termed 'Famine memory' was transmitted and transformed through multi- and inter-medial practices. As corollary, the coalescence of 'Famine studies' is a significant development that signals both a highly interdisciplinary academic field of enquiry and one inextricably linked to the rise of memory studies.[1] The growth of Famine studies over the past two decades has been especially distinguished by its disciplinary breadth, its transnationality of approach, and the extent of international activity and collaborations by several generations of scholars.

This volume, which brings to light new material concerning the imprint of the Famine on Irish domestic and diasporic communities, extends the field of Famine studies by refocusing attention on the material and visual technologies, economies and epistemologies that have shaped Famine

1 Oona Frawley, 'Introduction', in Oona Frawley (ed.), *Memory Ireland*, vol. 3, *The Famine and the Troubles* (Syracuse, NY: Syracuse University Press, 2014), 3–4.

memories and legacies since the nineteenth century. Its contributions include new research by leading scholars from history, literature, drama, art history, material culture and cultural studies, collected here to promote new dialogues and to deepen our understanding of the Famine's cultural history and legacies.

The Famine may be distinguished from many other episodes in Irish history in its complexity of cause and effect, long duration and the global reverberations wrought through Famine and post-Famine migration and diasporic communities. Perhaps paradoxically, the slippery and protean nature of the 1840s Famine itself as 'event' and 'experience' has also ensured its persistent modern presence. Indeed, the remarkable longevity of Famine commemorative practice and acts of memory over the past century and a half owes a great deal to the Famine's adaptability and permeability as symbol, story and vessel for contemporary meanings and associations.

The present volume aims to map these visibilities in Ireland and beyond, whilst simultaneously cognizant that 'Famine memory' does not exist as any kind of stable, innately transferable or easily recoverable concept or entity. The global expansion of memory studies as an interdisciplinary field of study has exacerbated the multifarious ways in which 'memory' is named, identified and defined—to the point where it has become theoretically and functionally flabby, prompting calls for greater precision of language and application.[2] Whilst the concept of 'cultural memory' still usefully bounds a scholarly field that investigates how the past is encountered, perceived and used, the contributions to this volume evidence the value of more historically informed examinations of representational systems themselves. These include modes of production, consumption and viewership; and close readings of the symbols, images, sites and texts circulating within the visual and material cultures of their respective periods. In so doing, they call attention to the constructedness of 'memory' itself, highlighting how knowledge and recollection of past events is inextricable from the ontologies of visual and material media used to re-present such histories.

A primary objective of this volume is to present new research on genealogies of Famine representational practices that shifts away from universalizing discourses of 'cultural memory' to more robustly historicized perspectives. In several important ways, our contributors offer a riposte to common assumptions about the nature of Famine histories and their legacies. The first is to direct attention to the diversity of responses to, and engagements with, the Famine in the nineteenth century and beyond.

2 Jeffrey K. Olick, Vered Vinitzky-Seroussi and Daniel Levy, 'Introduction', in Jeffrey K. Olick, Vered Vinitzky-Seroussi and Daniel Levy (eds), *The Collective Memory Reader* (Oxford: Oxford University Press, 2011), 3–62.

Collectively, the essays demonstrate, through recourse to a diverse array of primary material, a multiplicity of reactions to the Famine that range from satire, romanticization and economic opportunism to strategies of deflection or censure. That an event as extended and complex as the Famine should have generated such mixed legacies is not surprising. However, the common construction of the Famine as utter social collapse or universal cultural irruption deserves greater modulation than has often been the case within scholarship to date.

As noted in the Foreword to this volume, many of our authors' wide-ranging identifications of Famine referents throughout the later nineteenth and early twentieth centuries complicate notions of a 'silence' on the Famine by succeeding generations. The validity of this characterization remains debatable and contentious. What is revealed in this book is a variegated arc of Famine memory characterized by periods of intensity and dormancy dependent on historical circumstance, and these chapters add significantly to the body of scholarship on the Famine's cultural impacts throughout the late nineteenth and early twentieth centuries in particular, demonstrating a continuity (if not uniformity) of presence and affect in both Ireland and its diaspora. The wide timespan of the essays in this volume therefore serves as a corrective to the dominant scholarly focus on the 1990s anniversaries as the major period of Famine memory and retrieval.

Secondly, whilst scholarship in Famine studies has been primarily directed towards textual sources within history and literature, material and visual perspectives are still underdeveloped, especially in terms of evaluating contemporaneous evidence. Famine-era texts have received close inspection for their content and construction, but less so the material dimensions of their publication, dissemination and use. The intermediality of image and text has been occasionally analysed at length,[3] but less often the relationship between multiple forms of visual media, as, for example, between practitioners of painting, print and photography who work across genres in the nineteenth and early twentieth centuries.

Too often the inherent value and complexity of historical Irish art and images as primary evidence—as opposed to their use for illustration purposes—is overlooked. Incorrect attribution of images, the lack of proper identification details and/or sources provided and the rather sloppy or casual use of visual material as illustration, remain endemic in many scholarly publications. The reverence accorded the text, or the archive, is not always

3 Scholarship exploring heavily hybridized forms such as *The Illustrated London News* has particularly exemplified useful intermedial approaches; see, for example, Peter W. Sinnema, *Dynamics of the Pictured Page: Representing the Nation in the Illustrated London News* (Aldershot: Ashgate, 1998).

extended to visual and material evidence, and Irish studies has been weaker for it. Nevertheless, several recent major exhibitions and publications in Irish visual art and material culture have shone light on the importance of these sources in their own right. Decade of Centenary exhibitions such as the National Gallery of Ireland's *Creating Ireland: Stories of Ireland through Art* (2016–17), the largest exhibition of Irish historical painting to date, made use of extensive loans to demonstrate the wealth of material held in diasporic and other international collections, and threads connecting nineteenth-century painting with earlier and later centuries.[4] Others, such as *Ireland: Crossroads of Art and Design, 1690–1840* (2015) at the Art Institute of Chicago, have overhauled perceptions of Irish art and material culture in the pre-Famine period, juxtaposing rich examples of fine art, furniture, architecture, decorative arts and textiles infused with dynamic perspectives on manufacture and consumption—an approach ripe for extension into the century following.[5] The Royal Irish Academy's magisterial five-volume project, *Art and Architecture of Ireland* (2015), has revisited nearly every major Irish artist, architect and period spanning the Middle Ages to the twentieth century, and will be a primary reference text for decades to come, re-energizing fresh perspectives on cultural history.[6]

Within Famine studies itself, the *Atlas of the Great Irish Famine* (2012) evidences in numerous essays and in its copious illustrations the heightened interest in, and knowledge of, Famine visual and material cultures. It is also testament to the value of geographical and archaeological perspectives—disciplines omitted from the current volume owing to space considerations and the outstanding achievement of the *Atlas* itself in this regard—sharpening awareness of Famine materialities and methodologies.[7] Quinnipiac University's *Famine Folio* series (2014–17) has further distilled much recent research in Famine cultural memory for wider public audiences, offering new and established voices in the field another platform for public history. All such efforts point towards a robust and sustained interest in Famine studies that extends beyond the boundaries of anniversary-led consciousness.

In addition to exhibitions and publication, advances in digitization by libraries, archives and museums have made many visual sources newly available to scholars, especially illustrated newspapers, photographs and

4 Brendan Rooney (ed.), *Creating History: Stories of Ireland in Art* (Dublin: National Gallery of Ireland/Irish Academic Press, 2016).

5 William Laffan and Christopher Monkhouse (eds), *Ireland: Crossroads of Art and Design, 1690–1840* (Chicago, IL: Art Institute of Chicago/Yale University Press, 2015).

6 Carpenter, Andrew (gen. ed.), *Art and Architecture of Ireland*, 5 vols (Dublin: Yale University Press/Royal Irish Academy, 2014).

7 John Crowley, William J. Smyth and Mike Murphy (eds), *Atlas of the Great Irish Famine* (Cork: Cork University Press, 2012).

lantern slides. This has enabled consultation of geographically distant collections, expanded the possibilities of diasporic cultural histories and further suggests a higher degree of visual literacy will be a prerequisite for future studies.[8] This is far from a static field: discovery of new material has consistently prompted re-evaluations of received histories,[9] and continued acquisitions and dissemination of visual material in public collections holds tremendous promise for future research.[10] Our contributors thus illuminate what knowledge is gained in Famine studies by shifting to an explicit focus on images, objects, spaces, rituals, rubrics and rhetorics of depiction, materiality and the dynamics of reception and consumption—all aspects inherent to visual and material studies methodologies.

Thirdly, this collection prioritizes methodologically close readings of specific engagements with the Famine past, grounding them in their historical and social contexts, as opposed to making truth-claims concerning universal or collective forms of a Famine social or cultural 'memory'. In so doing, it resists the tendency to collapse categories of Famine experience into an undifferentiated notion of cultural trauma that ignores the specifics of time, place and agency. Simultaneously, its essay contributions address transmedial transmission of Famine repertoires, thereby significantly enhancing contemporary and international debates— extending beyond Irish studies—about cultural transfer, genre and affect in memory research.

In turning its attention to the production, reception and consumption of visual and material objects and images, this volume implicitly and explicitly activates four key theoretical concepts from the wider field of memory studies: premediation, multi-directionality, remediation and vernacular memory. As Peter Gray affirmed in a recent essay on the historiography

8 The new Lucerna Magic Lantern online resource (www.slides.uni-trier.de/), a product of the collaborative European project *A Million Pictures: Magic Lantern Slide Heritage as Artefacts in the Common European History of Learning* (2015–18) based at Utrecht University, is one such example of a cross-institutional collaboration sharing important new visual culture material.

9 Cinema and studies of 'screen culture' have particularly benefited from the proliferation of online resources and digitized collections: see, for example, Ludwig Vogl-Bienek and Richard Crangle (eds), *Screen Culture and the Social Question, 1880–1914* (New Barnet: John Libbey Publishing, 2014).

10 Quinnipiac University's *Great Hunger Museum* in Connecticut has specialized in Famine-related exhibitions and development of visual resources since its opening in 2012, including its online database of Famine illustrations and articles. Other newly digitized visual resources, such as the Public Record Office of Northern Ireland's Historical Maps Viewer (launched in 2016), will enable detailed research by layering Ordnance Survey maps between 1832 and 1986 with extensive datasets on sites, buildings and landmarks.

of the Famine, 'Self-consciously "historical" writing on the Great Famine began even before the catastrophe had ended'.[11] The various, conflicting and multi-media interpretations of the Famine actively in play during the later nineteenth century demonstrate the extent to which historical, political and artistic chroniclers of the Famine in its immediate aftermath *already* anticipated the historicizing of the event and sought to influence these processes. In other words, its future memory was premediated by narrators and artists who recognized the function of representation *itself* as an enormously powerful and persuasive mode of communication. Of course, this concept has long been active within art history under another guise— that of iconography and iconology—but premediation further acknowledges the role of narrative and time, as well as the formal qualities of media, in constructing Famine representations for future audiences.

The field of Irish Studies has faced some challenges in embracing genuinely transnational historical approaches, as national or comparative methodologies have traditionally dominated Irish historiography,[12] yet within Famine and migration studies transnational and 'multidirectional'[13] approaches have firmly taken root over the past decade.[14] Recent histories now increasingly account for interrelationships between diasporic countries and the synchronic and diachronic impact of the Famine on transatlantic communities. Such perspectives are echoed by the non-hierarchical and horizontal lines of enquiry pursued by our contributors, who uncover mnemonic traditions and layered cultural influences that interact and can be tracked across a transatlantic range of disparate sources.

Astrid Erl and Ann Rigney's contention that '"remembering" is better seen as an active engagement with the past, as performative rather than as reproductive'—central to their definition of remediation[15]—is here explored by many of our contributors in formalist terms. That the past shifts in

11 Peter Gray, 'The Great Famine in Irish and British Historiographies, *c.*1860–1914', in Marguérite Corporaal, Christopher Cusack and Lindsay Janssen (eds), *Global Legacies of the Great Irish Famine: Transnational and Interdisciplinary Perspectives* (Oxford: Peter Lang, 2014).

12 Niall Whelehan, *Transnational Perspectives in Modern Irish History: Beyond the Island* (London: Routledge, 2015).

13 Michael Rothberg, *Multidirectional Memory: Remembering the Holocaust in the Age of Decolonization* (Stanford, CA: Stanford University Press, 2009).

14 Within migration studies, see, for example, Enda Delaney and Donald M. MacRaild (eds), *Irish Migration, Networks and Ethnic Identities since 1750* (London and New York: Routledge, 2007); in Famine studies, see Marguérite Corporaal, Christopher Cusack and Lindsay Janssen (eds), *Global Legacies of the Great Irish Famine: Transnational and Interdisciplinary Perspectives* (Oxford: Peter Lang, 2014).

15 Astrid Erll and Ann Rigney (eds), *Mediation, Remediation, and the Dynamics of Cultural Memory*, vol. 10 (New York and Berlin: De Gruyter, 2009), 2.

response to present concerns is by now a truism. However, in the case of the Famine, the translation of media such as painting, print and text into more explicitly performative forms such as television, film, ritual, commemoration and dramatic performance provides rich ground for analysis of remediation as process, and as an index of public attention to Famine.

Finally, this collection mirrors a wider shift in the value now assigned to vernacular culture within Irish historical practice. In 2007, Guy Beiner's *Remembering the Year of the French: Irish Folk History and Social Memory* was deservedly hailed for its methodological rigour and a high standard of cultural analysis applied to a range of assiduously collected vernacular source material on the memory of 1798, including folklore, orality and local histories.[16] Arguably, in contrast to other areas of Irish historical enquiry, Famine historiography has long benefited from a keen eye to folklore, popular memory and scaled approaches incorporating the local—in the first instance by scholars such as Niall O Ciosain and more recently by others including Ciarán Ó Murchadha.[17] Yet the study of vernacular sources cannot logically be constrained to the distant past, or to folklore alone, and our contributors extend such interests in popular culture to phenomena including religious devotion, diaries, graphic novels and public commemoration.

Essays

The three sections of this book follow a roughly chronological sequence. In tracing the Famine's impact in Ireland and across the diaspora over almost two centuries, they exemplify an array of disciplinary approaches applied across a rich range of the Famine's visual and material cultures.

Section I, *Witness and Representation: Contemporaneous Depictions of Famine*, addresses forms of representation contemporary with the lived experience of famine in the 1840s, encompassing painting in the fine art tradition; satirical cartoons; private diary records and sketches; and images of epidemic and 'coffin ships'. Drawing upon lesser-known and often unpublished sources, each chapter evidences the struggle to bear witness to, or communicate visually, the impact and implications of Famine for various ideological purposes, both domestically and in the diaspora.

16 Guy Beiner, *Remembering the Year of the French: Irish Folk History and Social Memory* (Madison: University of Wisconsin Press, 2007).
17 Niall Ó Ciosáin, 'Approaching a Folklore Archive: The Irish Folklore Commission and the Memory of the Great Famine', *Folklore*, 115.2 (2000), 222–32; Ciarán Ó Murchadha, *Figures in a Famine Landscape* (London: Bloomsbury Academic, 2016).

Insofar as a canon of Famine visual culture may be said to exist, Daniel Macdonald's *Discovery of the Potato Blight* (1847) sits at its centre, the only known oil painting directly picturing the blight. Yet, until recently, very little has been known of the extent of his work and life, and Niamh O'Sullivan's chapter on Macdonald follows her groundbreaking exhibition and monograph on the artist, produced as curator of the Great Hunger Museum of Quinnipiac University in 2016.[18] In her analysis of a number of lesser-known works of Macdonald, situated within the milieu of Cork scholars and folklorists within which he was raised, O'Sullivan traces the recurrence of folklore and superstition in Macdonald's unusual and revealing compositions of rural life. O'Sullivan's new scholarship on Macdonald thereby augments her previous work on Irish art of the mid-nineteenth century, including her monograph on Aloysius O'Kelly and his work for *The Illustrated London News*,[19] and contributes to an expanded account of domestic Irish artistic practice and the persistence of folklore beliefs during and beyond the Famine period.

Peter Gray, long established as one of the primary political historians of the Famine,[20] here turns his attention to the satirical art of John Doyle (better known as HB) and his *Political Sketches* of Ireland in the 1840s. Often overlooked in favour of *Punch* (a subject on which Gray has previously written),[21] HB's cartoons record Doyle's sophisticated deployment of visual satire in response to the turbulent parliamentary politics of the period. Doyle's position as a London-based, middle-class Irish Catholic working for a predominantly English viewership informs his relatively conservative take on Irish affairs. Gray unpacks the specific political and allegorical references contained within these images, revealing the satirical nuances often lost on the modern viewer, and firmly re-inserts HB into Famine-period print culture.

Given the extent of the Famine's devastation, its impact is often narrated retrospectively as if pervasive or unified, irrespective of location, class and circumstance. Ciarán Reilly's chapter on the diaries and sketches of John Plunkett Joly, produced between 1843 and 1853, refutes such simplistic characterizations. The son of a Church of Ireland rector and then a student in Trinity College Dublin, Joly's record of social activities

18 Niamh O'Sullivan, *In the Lion's Den: Daniel Macdonald, Ireland and Empire* (Hamden, CT: Quinnipiac University Press, 2016).

19 Niamh O'Sullivan, *Aloysius O'Kelly: Art, Nation, Empire* (Dublin: Field Day Publications, 2010).

20 Peter Gray, *Famine, Land and Politics: British Government and Irish Society 1843–50* (Dublin: Irish Academic Press, 1999); Peter Gray, *The Making of the Irish Poor Law, 1815–43* (Manchester: Manchester University Press, 2009).

21 Peter Gray, 'Punch and the Great Famine', *History Ireland*, 1.2 (1993), 26–33.

in King's County (Offaly) conveys a life largely undisturbed by the Famine. Reilly's analysis of the ellipses and omissions of Joly's personal record of the Famine years is set against the contentious issue of culpability during the Famine. As such, it builds on Reilly's previous scholarship on the Strokestown estate and the role of the Irish land agent,[22] contributing a nuanced reflection on the variegations of local life during the Famine and demonstrating the value of diaries and sketchbooks as forms of first-hand material witness and record.

Few episodes of the Famine have left as indelible a cultural imprint as the coffin ships of 1847 and the mass mortality that accompanied passage to Canada that year. One of the most prolific scholars of the Famine in Canada,[23] Jason King, analyses a key document of this experience: Théophile Hamel's *Le Typhus*, a painting in Notre-Dame-de-Bon Secours in Montreal depicting the efforts of the Grey Nuns during the 1847 cholera epidemic in the city. King argues for the explicit influence of Gericault's *Raft of the Medusa* on Hamel's painting, and the function of coffin ships and fever sheds as composite and palimpsestic images whose presence as 'mortuary spectacles' thereafter extends to subsequent refugee crises.

In Section II, *Negotiating Form: Famine/Post-Famine Modalities and Media*, contributions address Famine and post-Famine visual and material legacies from the mid-nineteenth century to the mid-twentieth century. Collectively, they evidence how Famine-related representations recur across a wide range of media for diverse and international audiences, demonstrating Famine's visibility and currency across a range of modalities.

Lisa Godson's scholarship on Irish material culture, which includes her recently edited collection on 1916[24] and a forthcoming monograph on Irish religious ceremony, material culture and affect, is here extended to a study of the post-Famine devotional revolution, tracked through the manufacture and use of religious objects. Her use of subject–object relational theoretical models (with reference to the political theology of Giorgio Agamben) illuminates the relationship between materiality and spirituality during this formative period of Irish Catholicism. Drawing on evidence in diocesan and

22 Ciarán Reilly, *Strokestown and the Great Irish Famine* (Dublin: Four Courts Press, 2014); Ciarán Reilly, *The Irish Land Agent, 1830–60: The Case of King's County* (Dublin: Four Courts Press, 2014).

23 King's contributions to the field include the development of the Irish Famine Archive, an online repository of eyewitness accounts of the Famine migration to Canada in 1847–48 (http://faminearchive.nuigalway.ie/). See also Marguérite Corporaal and Jason King (eds), *Irish Global Gigration and Memory: Transatlantic Perspectives of Ireland's Famine Exodus* (London: Routledge, 2017).

24 Lisa Godson and Joanna Brück (eds), *Making 1916: Material and Visual Culture of the Easter Rising* (Liverpool: Liverpool University Press, 2015).

convent archives, the *Irish Catholic Directory* and other periodicals, Godson introduces new perspectives on devotionalism as enacted through a diverse array of objects, rituals and spatial configurations, as well as patterns of consumption.

Melissa Fegan's previous work on Famine travel writing, journalism and novels has been pivotal in its application of cross-medial perspectives to literary material, and her recent publications on Irish hotels have moved further into experiential aspects of nineteenth-century tourism.[25] Her chapter in this section discusses lacemaking as cottage industry, instrument of genteel philanthropy and alternative relief work during the Famine. In stark contrast to the English image of the miserable or morally suspect seamstress popular in Victorian depiction, the virtue of Irish lacemaking is represented in novels, paintings and journalism as a suitable occupation of the 'deserving poor', thus identifying how material cultures may also function textually. Gender perspectives have formed one of the richest veins of analysis in Famine studies of recent years,[26] and Fegan here argues for diverse codings of lacemaking as parables of self-help stimuli for charitable aid, as well as an impetus to emigration.

Fintan Cullen—a pre-eminent figure for many decades in the field of nineteenth-century art history, and curator (along with Roy Foster) of the influential National Portrait Gallery exhibition *Conquering England: Ireland in Victorian London* (2005)[27]—here offers a provocation as to whether the notion of a 'definable Ireland-based Irish art' is tenable. His critique of the dominance of national boundaries in the discipline of Irish art history is read across examples of Boston School paintings of domestic servants from the early twentieth century. Rarely classified as works of 'Irish art', these works are reframed by Cullen's assertion that the intersection of art history and diasporic studies demands a reassessment of an 'exilic art history' shared beyond the confines of national borders. Whilst a post-Famine Irish diasporic art history remains aspiration rather than reality, recent work on the Irish as agents and subjects of empire offers one possible model for such expanded cultural histories.

25 Melissa Fegan, *Literature and the Great Irish Famine 1845–1919* (Oxford: Clarendon Press, 2002); Melissa Fegan, 'The Moral Economy of the Irish Hotel from the Union to the Famine', in Susanne Schmid and Monika Elbert (eds), *Anglo–American Travelers and the Hotel Experience in Nineteenth-Century Literature: Nation, Hospitality, Travel Writing* (London: Routledge, 2017).

26 This includes a recent volume co-edited by two of our contributors: Christine Kinealy, Jason King and Ciarán Reilly (eds), *Women and the Great Hunger* (Cork: Cork University Press, 2017).

27 Fintan Cullen, *Ireland on Show: Art, Union and Nationhood* (Farnham: Ashgate, 2012); Fintan Cullen, Roy Foster and Fiona Shaw (eds), *Conquering England: Ireland in Victorian London* (London: National Portrait Gallery, 2005).

Moving into the late 1930s, Bryce Evans offers a fascinating study of a previously unexamined Famine 'failure': Liam O'Flaherty's ill-starred attempt to persuade Hollywood director John Ford to adapt his novel *Famine* for the screen. Details of O'Flaherty's colourful career in film are interwoven with an account of his pursuit of the fickle Ford, based on archival sources and correspondence between O'Flaherty, Ford and other producers. Evans ultimately demonstrates how Ford's interest in Irish material was constrained by assessments of its marketability and Ford's perception that *Famine*'s resonances with the Great Depression in the United States had been pre-empted by his film *The Grapes of Wrath*, based on Steinbeck's novel. Evans's previous publications on food history and Irish history[28] are informing current work towards a new book on the centenary of the Famine in the 1940s, a much-neglected subject on which further scholarship will be widely welcomed.

Finally, Section III, *Legacy: Postmemory and Contemporary Visual Cultures*, turns its attention to recent contemporary engagements with Famine memory. The longevity of Famine representation, intersections with earlier forms of visual culture and the influence of new forms of 'seeing' and 'remembering' the famine in contemporary culture unite its considerations of theatre, public memorials, television drama and graphic novels.

Shelley Troupe's examination of Tom Murphy's seminal play *Famine* as staged in 1968, 1982 and 2012 illuminates the influence of production and political/social context on shifting meanings of the work over time. Troupe situates each iteration and reception within the specifics of stage production, including scenography, management, publicity and critical reviews. She further outlines the occasional clash between the play's marketing by Druid Theatre and the playwright's assertion that it did not concern the historical Famine. The play's capacity to act as referent for international and Irish catastrophes reinforces its power as performance as well as text. Troupe lends her insight as a dramaturge and scholar[29] to assess how audiences and critics have variously received a play that has, as Murphy declared, acquired 'a life of its own'.

Comparative famine studies are extended to the far north via Andrew G. Newby's chapter on the commemoration of the Great Finnish Famine of the 1860s. The commemorative culture surrounding this 'forgotten' famine, during which nearly 10 per cent of Finns died, is compared with

28 Bryce Evans, *Ireland During the Second World War: Farewell to Plato's Cave* (Manchester: Manchester University Press, 2014).

29 Shelley Troupe, 'When Druid Went to Jail: Returned Migrants, Irish Prisoners, and Tom Murphy's *Conversations on a Homecoming*', *Irish Studies Review* 22.2 (2014), 224–37.

the Irish case. An authority on the Finnish famine and Finnish/Irish studies whose research has sparked a resurgence of public interest in Finnish famine memory,[30] Newby identifies the existence of Home Rule in Finland, a disjuncture between Finnish emigrants and the experience of famine and the privileging of other catastrophes in the national imaginary as reasons for the official muting of its memory. Although no national monument yet exists, Newby's ongoing work in locating, mapping and documenting local monuments (based on similar work on Irish commemoration) has nevertheless uncovered a hitherto-unknown tradition of vernacular and visual famine memory. The symbolism, inscription and historical particulars of each example are explored, leading Newby to qualify the common description of Finns' 'amnesia' about the famine as partial and selective, and characterizing current and future Finnish commemoration as far more hesitant and sparsely enacted than the Irish case.

Along with her ERC-funded research group based at Radboud University in the Netherlands, Marguérite Corporaal (both a contributor to and one of the co-editors of this volume) has made immense contributions to the international networking of Irish Famine scholars and the study of transcultural memory in Famine popular literature.[31] Her chapter here connects this work to more recent popular culture, namely *The Hanging Gale* television drama broadcast by RTÉ and BBC in 1995. Corporaal contextualizes the drama within the sesquicentenary of the 1990s, but specifically centres her analysis on its representation of sectarian conflict, gender and landscape. She traces its visual and narrative motifs to earlier templates, expounding on the format's transference and transformation of these 'travelling memories' of Famine and use of existing cultural (visual and narrative) repertoires.

Finally, Dawn Miranda Sherratt-Bado's chapter tackles the intersection of postmemory and graphic narrative within a frame-by-frame reading of the graphic novel *Gone to Amerikay* (2012), written by Derek McCulloch and illustrated by Colleen Doran. Developing previous scholarship on Irish postmemory and literature, she explores the 'spectre' and 'uncanny' as mnemonic devices now translated to visual form. The appearance of a Famine migrant as a 'revenant' with the graphic novel is analysed as a reminder and expression of traumatic experience, emblematic of unresolved

30 Newby's current project funded by the Academy of Finland (2012–17) is entitled 'The Terrible Visitation: Famine in Finland and Ireland, *c.*1845–1868: Transnational, Comparative and Long-Term Perspectives'; see also Andrew G. Newby, *Éire na Rúise: An fhionlainn agus Éire ar thóir na saoirse* (Dublin: Coiscéim, 2016).

31 Marguérite Corporaal, *Relocated Memories of the Great Famine in Irish and Diaspora Fiction, 1847–1870* (Syracuse, NY: Syracuse University Press, 2017).

Famine histories, albeit one that elides Famine and post-Famine historical specifics. Echoing her forthcoming monograph on postcolonialism and diasporic literatures,[32] Sherratt-Bado affirms the ontology of the graphic novel and its fragmentations as especially suited to visual expressions of postmemory.

The Future of Famine Memory

Contrary to any expectation it would exit the commemorative stage following its sesquicentenary in the 1990s, Famine memory has remained a crowded and contentious field over the past 20 years. In the popular domain, hardly a week goes by when *Irish Central* (the 'sister website' of the Irish-American newspaper the *Irish Voice*) does not feature some Famine-related story: between July and the end of September 2016, it posted 36 different stories related to the Famine (on average, three every week). Memorials to the Famine, both in Ireland and abroad, continue to be utilized as rallying points to draw attention to contemporary humanitarian and political crises, including, in 2016–17, the potential impact of the new US administration's immigration reform on the undocumented Irish and responses to the Mediterranean refugee crisis, organized at famine monuments in Europe, North America and Australia.[33] Fault lines of memory are exposed as commemorative communities clash over meaning and message, as in the recent controversy over a new Famine memorial planned for the city of Glasgow.[34] And, as recently as February 2017, a bill was introduced in the Houses of the Oireachtas to fix a recurring date in the government calendar as National Famine Commemoration Day, which would permanently anchor an annual day of commemoration that has taken place since 2008.

Two decades of near-perpetual commemoration and the persistent pursuit of historical parallelisms do not, however, equate to a rigid 'memory industry' that has built up around the Famine. In my own earlier fieldwork, surveying hundreds of public commemorative projects to the Famine over

32 Dawn Miranda Sherratt-Bado, *Decoloniality and Gender in Jamaica Kincaid and Gisèle Pineau: Connective Caribbean Readings* (Basingstoke: Palgrave Macmillan, 2018).

33 See, for example, Michael McHugh, 'Europe "Should Learn the Lessons of the Irish Famine" in Current Refugee Crisis: New Memorial Unveiled at National Famine Commemoration at Glasnevin Cemetery', *Irish Independent*, 11 Sept. 2016; 'Concern about Trump's Position on Emigration, Climate Change: Vigil Held at Famine Memorial in Ballytivnan in Sligo' (radio broadcast). Ocean FM News, 23 Jan. 2017; 'President Higgins likens refugees to those who fled Famine', *RTÉ* online, 9 Oct. 2017.

34 Jody Harris, 'Memorial to Irish Famine Victims Planned for Celtic Chapel after Tribute Including Scots Branded "Offensive"', *The Herald* (Scotland), 21 Sept. 2017.

the course of a decade, very few of the characteristics one would associate with an industry could be observed: namely, some form of centralized control, figures of overt dominance in the commemorative field or a singular economy in which they operated.[35] Famine memory-work in the 1990s and 2000s was fluid, primarily grassroots in nature as opposed to centrally organized and vernacular in character. It was highly particularized according to local or regional site, and generally organized by small collectives of local individuals. These characteristics have not substantively changed in the succeeding years, and, as the chapters in this volume affirm, the mobility and mutability of Famine memory have always attended its representation over time. More usefully, the 'industries' of remembering the Famine should be effectively seen and understood in the plural, with heightened attention to their publics, praxes, consumers and prosumers.

By considering the strong societal impact and dissemination of visual representations of the Famine, and the role of material cultures in the negotiation of painful emotions as well as troubled pasts, we hope this volume will significantly further understanding of the multidimensional impacts, afterlives and experiences of the Famine. In advancing new approaches to the study of Irish memory and materiality, this book demonstrates how memory studies *itself* can and should be understood as a social, cultural, political and material construct, with a history and a historiography of its own. In so doing, it advocates a future of Famine studies more productively based in the intent to dissect, rather than uncritically staple together, those three tendentious words 'Irish cultural memory'.

35 Emily Mark-FitzGerald, *Commemorating the Irish Famine: Memory and the Monument* (Liverpool: Liverpool University Press, 2013).

I Witness and Representation: Contemporaneous Depictions of Famine

1

The Bond that Knit the Peasant to the Soil: Rural Lore and Superstition in the Work of Daniel Macdonald

Niamh O'Sullivan

Ireland's Great Hunger Museum, Quinnipiac University

The Great Hunger (1845–52) is perceived as a turning point in Irish history; Joep Leerssen usefully describes it as a 'saddle period', 'a ridge between two different worlds, like the col in a mountain range, a watershed marking the transition from one territory into another'.[1] The scale of the devastation, the loss of life and the leeching of the land, far from dispelling superstition associated with pre-Famine Irish culture, ratcheted up the superstitious and supernatural terrors already deeply embedded in vernacular Irish culture. Notwithstanding the efforts of antiquaries and folklorists to cleanse popular culture of such practices, and efforts by the clergy at 'a deliberate or unconscious kind of theological pacification campaign to drain the energy out of popular beliefs in magic, defiant celebrations of death, and wild displays of quasi-pagan faith',[2] superstition lingered in Famine-era Ireland. While this persistence is evidenced within folklore itself, it is also apparent in Irish art of the period, and particularly in the work of Daniel Macdonald, which makes visible a continuity of influence of folklore and superstition from the pre-Famine period and beyond.

Daniel Macdonald (1820–53) was pre-eminently a painter of national character.[3] *Public Characters* (1843), his graphic swipe at his Cork compatriots, features grandees and dandies, politicians and beggars, dog executioners and ballad singers—the witty, the wealthy, the corrupt and the

1 Joep Leerssen, *Hidden Ireland, Public Sphere* (Dublin: Arlen House, 2002), 12.
2 Charles Townshend, 'The Making of Modern Irish Public Culture', *Journal of Modern History*, 61.3 (1989), 541.
3 The first retrospective exhibition of Daniel Macdonald's work, *In the Lion's Den: Daniel Macdonald, Ireland and Empire*, took place in Ireland's Great Hunger Museum, Quinnipiac University, Connecticut, in 2016.

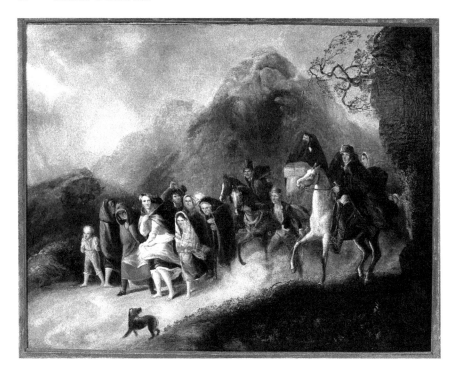

1.1 Daniel Macdonald, *Sídhe Gaoithe/The Fairy Blast* (1842), oil on canvas,
89 cm × 115 cm
National Folklore Collection, University College Dublin

disreputable of that city in the 1840s. His characters play music and dance,
make *poitín* and get drunk, court and marry, fight and die, pray to God and
fear the fairies. His fascinating study of rural superstition, *Sídhe Gaoithe/
The Fairy Blast* (1842) (Figure 1.1) demonstrates his penetrating insight
into rural Ireland in the pre-Famine era.[4] Depicting a group of travellers

4 *Sídhe Gaoithe/The Fairy Blast* (1842) was presented to the Irish Folklore Commission
by Senator E.A. Maguire in 1952. For commentary, see *The Southern Reporter and
Cork Commercial Courier*, 15 Sept. 1842; *Amharc Oidhreacht Éireann/Folk Tradition
in Irish Art, an Exhibition of Paintings from the Collection of the Department of
Irish Folklore* (Dublin: UCD Press, 1993); Tom Dunne, 'The Dark Side of the
Irish Landscape: Depictions of the Rural Poor, 1760–1850', in Peter Murray (ed.),
Whipping the Herring: Survival and Celebration in Nineteenth-Century Irish Art
(Cork: Cork University Press, 2006), 78; Christine Casey, 'Painting Irish Folk Life:
The Picture Collection', in Críostóir Mac Cárthaigh, Séamas Ó Catháin, Ríonach uí
Ógáin and Seosamh Watson (eds), *Treasures of the National Folklore Collection/Seoda
as Cnuasach Bhéaloideas Éireann* (Dublin: Comhairle Bhéaloideas Éireann, 2010),
98–99; Nesta Butler, 'Daniel MacDonald', in Nicola Figgis (ed.), *Art and Architecture
of Ireland*, vol. 2, *Painting 1600–1900* (Dublin and New Haven, CT: Royal Irish

accosted by a 'fairy blast' as they make their way in dark night through a mountain pass, the painting was accompanied by an eerie verse designed to send shivers up the spine; however, as we shall see, the sources and origin of the painting reveal it as thoroughly anchored in scholarly knowledge of Irish superstition and folklore.

Exhibited in Cork in 1842, the painting can be seen as a visual confluence of the researches of Macdonald's father, James McDaniel,[5] a well-known member of the Cork intelligentsia, and Thomas Crofton Croker, the well-known antiquary, into the psyche of the peasantry.[6] Croker was the first to publish material on fairy legends and the beliefs, superstitions, manners and customs of the Irish people—he was the most important folklorist and antiquary of his time—but what had not been known prior to the Macdonald retrospective in Ireland's Great Hunger Museum in 2016 was the extent to which Croker's material was supplied, unacknowledged, by James McDaniel. The connections between Croker, McDaniel, and Macdonald, and the milieu in which they worked, are very important, revealing both the persistence of superstition and the usage of myth and folklore as a means of representing hardship and rural experience in Ireland during the Famine period.

McDaniel's Influence on Croker

McDaniel, the painter's father, was an erudite folklorist, painter, carica-turist, inventor and musician, deeply involved with the vibrant cultural life of early nineteenth-century Cork, where there existed a community of ethnographers, philosophers, folklorists, antiquaries, poets, satirists and classicists. In addition to Thomas Crofton Croker, active in this circle were Samuel Carter Hall, William Maginn, Daniel Maclise, Father Francis Sylvester Mahony, John Hogan and Jeremiah Joseph Callanan, to name but a few.

Academy and Yale University Press, 2014), 353–54; Niamh O'Sullivan, *In the Lion's Den: Daniel Macdonald, Ireland and Empire* (Hamden, CT: Quinnipiac University Press, 2016), 37–44; Angela Bourke, *Voices Underfoot: Memory, Forgetting, and Oral Verbal Art* (Hamden, CT: Quinnipiac University Press, 2016), 8–10.

5 Far from the Irish artisan stock they were long assumed to be, the Macdonald family entertained Scottish aristocratic pretensions. When James McDaniel discovered that he was the 8th Macdonald of Castleton and had a claim to the important Annandale and Hartfell peerage, he reverted to the name Macdonald, as did his children.

6 For more detailed discussion, see Angela Bourke and Niamh O'Sullivan, 'A Fairy Legend, a Friendship, a Painting: Thomas Crofton Croker, James McDaniel, and Daniel Macdonald's *Sídhe Gaoithe/The Fairy Blast*', *Éire-Ireland*, 51.2–3 (2016), 7–22.

McDaniel's correspondence with Croker reveals a shared interest in the persistence and influence of rural superstition and use of 'charms'; as one missive from McDaniel in 1819 observes:

> In a savage state, man is degraded below the brute creation by superstitions which are both sanguinary and absurd. [...] Where popery prevails, as in Ireland, the various denominations of Christianity may be classed into two general bodies, the Catholic (so called) and the Protestant; a prohibition of the general use of the scriptures in the one denomination and the privilege of free enquiry in the other accounts for the surprising differences between vulgar Protestants and Papists of the same community. [...] [The Protestant] resorts to medicinals while the poor Catholic looks to charms for deliverance, which never staggers his faith even if it deceives his expectations.[7]

Details of folk customs and superstitions in other letters from McDaniel to Croker clearly influenced the latter's publications on Irish folklore, and later found themselves represented in the artwork of McDaniel's son, Daniel. In Croker's book *Researches in the South of Ireland, Illustrative of the Scenery, Architectural Remains, and the Manners and Superstitions of the Peasantry* (1824), for example, he recounts how, on New Year's Eve, 'a cake is thrown against the outside door of each house by the head of the family, which ceremony is said to keep out hunger during the ensuing one; and the many thousand practical illustrations of the fallacy of this artifice have not yet succeeded in producing conviction of the same': this story comes directly from a McDaniel letter to Croker in 1820.[8]

Many of the superstitions narrated by McDaniel to Croker concerned children. Croker's tale (also from 1824) of a woman giving a porringer (a type of small bowl) to some beggars so that her deceased child would not go without in the next world is likewise taken from McDaniel.[9] On one occasion, Croker went so far as to relate a story told him by McDaniel in a letter of 1820 as if he had overheard it himself:

> I remember once overhearing a contest between a poor man and his wife

7 James McDaniel to Thomas Crofton Croker, 29 Aug. 1819, Cork City and County Archives, Croker Correspondence, vol. 1, no. 63.

8 Thomas Crofton Croker, *Researches in the South of Ireland Illustrative of the Scenery, Architectural Remains, and the Manners and Superstitions of the Peasantry* (Dublin: Irish Academic Press, 1981), 233; James McDaniel to Thomas Crofton Croker, 23 Jan. 1820, Cork City and County Archives, Croker Correspondence, vol. 1, no. 67.

9 Croker, *Researches*, 170; James McDaniel to Thomas Crofton Croker, 23 Jan. 1820, Cork City and County Archives, Croker Correspondence, vol. 1, no. 67.

respecting the burial of their infant. The woman wished to have the child laid near her own relation, which her husband strongly opposed, concluding her attachment to her friends was superior to her love for him, but he was soon convinced by his wife's argument, that as her sister had died in childbirth only a few days previously, she would afford their poor infant suck, which nourishment it might not have if buried elsewhere.[10]

In this same letter, McDaniel shared with Croker a grotesque 'changeling' story and described how parents could distinguish their own child from a changeling insinuated into the house by the fairies, the real child having been removed to be a playmate or, if older, a nurse of fairy children. Again, Croker closely transcribed McDaniel's tale in his subsequent publication:

Fairies are diminutive spirits that bewitch children & when children decline their parents suppose that they are substitutes deposited with them in exchange for their offspring. Such children are frequently placed on a shovel and carried to a dunghill, where they are supposed to lie for a certain time with a view to discern whether this is the case. When children are thus exposed to cold they conclude that a natural disorder had caused the symptoms of decay & they treat the child with more tenderness from the notion that if the child had been a fairy that it would not brook such indignity.[11]

Superstitious beliefs like these marked symbolic boundaries, facilitating the organization of knowledge and thought outside standards of literacy; and such stories about enchantments harboured many meanings. Nuala Ní Dhomhnaill, for example, has suggested in her poem 'An Bhatráil' that changeling stories offered coded ways of talking about child abuse,[12] and the stories could also express the otherwise unmentionable social stigma associated with the many landlords who were sexual predators.[13] As the English traveller Arthur Young observed in 1776:

A landlord in Ireland can scarcely invent an order, which a servant, labourer or cottar dare refuse to execute. Nothing satisfies him but an

10 Croker, *Researches*, 168–69; James McDaniel to Thomas Crofton Croker, 23 Jan. 1820, Cork City and County Archives, Croker Correspondence, vol. 1, no. 67.

11 Croker, *Researches*, 85–86; James McDaniel to Thomas Crofton Croker, 23 Jan. 1820, Cork City and County Archives, Croker Correspondence, vol. 1, no. 67.

12 Nuala Ní Dhomhnaill, *The Astrakhan Cloak*, trans. Paul Muldoon (Loughcrew: Gallery, 1992), 24–27.

13 See Séamas Mac Philib, 'Ius Primae Noctis and the Sexual Image of Irish Landlords in Folk Tradition and in Contemporary Account', *Béaloideas* 56 (1988), 97–140.

unlimited submission. Disrespect or anything tending towards sauciness he may punish with his cane or his horsewhip with the most perfect security, a poor man would have his bones broke if he offered to lift his hand in his own defence [...] Landlords of consequence have assured me, that many of their cottars would think themselves honoured by having their wives or daughters sent for to the bed of their master; a mark of slavery that proves the oppression under which such people must live.[14]

Many of these stories, moreover, had tragic subtexts, concerning childhood illness, disability, malnutrition and death, which were often viewed as the fault of parents.[15] Perhaps unsurprisingly, such stories proliferated when the Famine led to hungry and despairing parents making appalling choices— between feeding a child who might already be dying and giving a stronger child a chance of survival.[16]

There was a widespread appetite for this material. The first edition of Croker's *Fairy Legends and Traditions of the South of Ireland* (1825), for instance, the publication of which followed *Researches in the South of Ireland*, sold out within a week.[17] However, the initially positive reactions to these 'twilight tales of the peasantry' were followed by accusations of plagiarism. Mutterings from contributors to *Fairy Legends* such as Thomas Keightly and Samuel Carter Hall, who were unacknowledged, led to outright criticism from others, including a savage lampoon in verse by A.A. Watts in 1832 (and more recent measured criticisms by B.G. McCarthy, Maureen Murphy and others).[18] The furore caused journalist William Maginn to leap

14 Arthur Young, *A Tour in Ireland, 1776–1779*, vol. 2 (London: Cadell, 1780), 127–28. In literature, there are a few post-Famine texts that suggest abuse or young women being forced to work for a landlord and thereby being open to sexual assault. There are also cases of young women seduced by landlords or their sons. An example is Edmund and Julia O'Ryan, *In re Garland: A Tale of a Transition Time* (London: Thomas Richardson and Son, 1870). With thanks to Marguérite Corporaal for this suggestion.

15 Sir William Wilde, *Census of Ireland Report, 1851*, Part V (Dublin: Alexander Thom and Sons, 1856), vol. 1, 455.

16 Angela Bourke, *Voices Underfoot*, 23.

17 Its fame spread wide when it was translated into German by the Grimm brothers in 1826, and into French by P.A. Dufour in 1828.

18 See A.A. Watts (ed.), *Literary Souvenir; or, Cabinet of Poetry and Romance* (London: Longman, Rees, Orme, Brown and Green, 1832), 236; S.C. Hall, *Recollections of a Long Life from 1815–1883* (London: Bentley, 1883), vol. 1, 180; B.G. McCarthy, 'Thomas Crofton Croker 1798–1854', *Studies*, 32 (1943), 539–56; Maureen Murphy, 'Croker, Thomas Crofton', *Dictionary of Irish Biography*: http://dib.cambridge.org (accessed 1 Mar. 2017); for general discussion on Croker and plagiarism, see Terry Eagleton, 'Cork and the Carnivalesque', in *Crazy John and the Bishop and Other Essays on Irish Culture* (Cork: Cork University Press, 1998), 158–211; Kosok Heinz, 'Thomas Crofton Croker, the Brothers Grimm and the German Image of Ireland', in Claire

to Croker's defence, declaring that the stories were ancient and universal, and that their originality lay in the telling. Indeed, Maginn insisted, Croker was 'very candid in acknowledging his obligations to others'.[19] And, while Croker did not acknowledge his debt to McDaniel in the conventional way, he seems to have acknowledged the debt by calling a number of the protagonists in *Fairy Legends* 'MacDaniel'.[20]

For example, in 'The Two Gossips' from *Fairy Legends*, Croker tells us that 'there was a young couple whose name was MacDaniel'.[21] Having transferred James and Catherine McDaniel, gentry of Cork city, to a new house near rural Carrigaline, Croker writes that they had 'a fine, wholesome-looking child, that the fairies determined on having in their company, and putting a changeling in its place'.[22] At that time, young Daniel Macdonald was approaching his fifth birthday: just the right age, and gender, for a fairy abduction.

According to Croker's story, Mrs MacDaniel has a 'gossip' (a friend) called Norah Buckeley. Passing the MacDaniels' house one evening, Mrs Buckeley decided not to call on her friend, because the fairies were about, for along the road from Carrigaline one whirl of dust followed another, 'which was a plain sign that the good people were out taking their rounds, and she had pains in her bones with dropping so many *curchies* (courtesies)'. But, as Mrs Buckeley passed her friend's house, a window was lifted up,

> and her gossip's beautiful child without any more to do handed out; she could not tell, if her life depended on it, how, or by whom: no matter for that, she went to the window and took the child from whatever handed it, and covered it well up in her cloak, and carried it away home with her.[23]

By uttering the ejaculation 'God keep all here from harm!'—the correct antidote—Mrs Buckeley foiled the abduction. When she returned the

O'Reilly and Veronica O'Regan (eds), *Ireland and the Irish in Germany: Reception and Perception* (Baden-Baden: Nomos Verlag, 2014), 85–103.

19 William Maginn, *Blackwood's Magazine*, 18 (July 1825), 55–61.
20 I am indebted to Professor Angela Bourke for bringing this story to my attention and for sharing her knowledge of Irish folklore so generously with me.
21 Another story, 'The Haunted Cellar' (Croker, *Fairy Legends*, 149–68), extols the hospitality of the McCarthy family. James's wife, Catherine, was a McCarthy, while Billy MacDaniel features in 'Master and Man' (181–98).
22 Croker, *Fairy Legends and Traditions of the South of Ireland* (London: John Murray, 1825), 81–84. Daniel Macdonald was christened on 2 July 1820, in the Anglican Church of the Holy Trinity, Cork; *Fairy Legends* appeared in London bookshops in March 1825: O'Sullivan, *Lion's Den*, 20; Francesca Diano, *Fairy Legends* (Cork: Collins Press, 1998), xxi.
23 Croker, *Fairy Legends*, 81–82.

next morning, she found Mrs MacDaniel complaining that her child was fractious. The gossip was delighted to tell her that the cranky child had been left by the fairies, but she had managed to save the real child, whom she reunited with its mother. Furthermore, the story concludes, 'a stout young man he is at this day'.

This was not Croker's first publication of a 'fairy wind' story: only the previous year, in *Researches*, he had described how

> An eddy of dust, raised by the wind, is attributed to the fairies journeying from one of their haunts to another; on perceiving which, the peasant will obsequiously doff his hat, muttering 'God speed ye, God speed ye, Gentlemen'; and return it to his head, with the remark, 'good manners are no burthen', as an apology for the motive, which he is ashamed to acknowledge. Should he, however, instead of such friendly greeting, repeat any short prayer, or devoutly cross himself, using a religious response, the fairy journey is interrupted, and if any mortals are in their train, the charm by which they were detained is broken, and they are restored to human society.[24]

It is clear, then, that the changeling story, with its eddies and the salutations, the dangers of travel and the use of 'benedictions' to invoke health and divine protection—which, as we will see, later appear in young Macdonald's painting *Sídhe Gaoithe*—most likely originated with McDaniel.

Macdonald's *Sídhe Gaoithe/Fairy Blast* (1842)

While superstition may imply primitivism and suggest a credulous people, it also allowed multi-layered narratives to function at different levels: unfettering anxieties and providing opportunities for behavioural guidance. As Sir William Wilde put it, 'these matters of popular belief and folklore, these rites and legends, and superstitions, were after all, the poetry of the people, the bond that knit the peasant to the soil'.[25] Nearly two decades after Croker's *Fairy Legends and Traditions*, Macdonald's *Sídhe Gaoithe/ Fairy Blast* demonstrated his respect for and understanding of that bond. The young Macdonald had clearly paid close attention to these stories told by his father and subsequently by Croker, as the poem which accompanied his painting, and which was published in the exhibition catalogue, speaks

24 Croker, *Researches*, 81.
25 William Wilde, *Irish Popular Superstitions* ([1852] Dublin: Irish Academic Press, 1979), 10–11.

of familiar 'Fairy-strokes' and 'vicious pranks' that might bear catastrophic consequences:

The dreaded Sídhegaoidhe marks enchanted ground,
Where Fairy Elves with vicious pranks abound.
The timid Peasant fearfully moves on,
All apprehensive of some fate unknown.
A train of hidden ills invade his head,
From Fairy-strokes with visitation dread.
Circles of dust in sportive eddies play.
Anon a twirling column blocks the way.
Brisk miniatures of men, a rambling host,
Their motions active as the flying dust.
Until perchance a current sweeps from view,
The mystic cloud, and leaves him to pursue
The journey homeward, to his safe abode,
There to sum up the horrors of the road.

The bilingual title, highly unusual for the time, might signal a society already divided—one about to be rent asunder—but it could also suggest, conversely, a shared experience and co-existing forms of remembrance, including remembrance of the kind of lore that Macdonald's social circle had been so concerned with. The painting depicts a desolate mountain pass in the dead of night, through which a 'huddle' flees from an unseen malevolent fairy host. The group has travelled from the other side of the mountain, having attended a fair or pattern, perhaps, and is laden with a barrel and boxes, intended for some communal event, possibly a wedding or a wake. Accosted by a fairy blast, the group bend their shoulders to the wind and move in unison, each intent on his or her own survival.

Led by a barefooted girl, the women are shawled or cloaked in the West Cork manner, the men hatted according to their social stations. Surprisingly, the group comprises individuals from across the classes travelling together: landlord, farmer and wife on horseback, and tenants on foot. Despite the reality of deprivation even before the Famine, the peasants look reasonably well fed and clothed, and clean and colourful enough to appeal to London art-buyers. Regardless of class, all are confronted with the same evil force. Stories of 'spirits' haunting strategic points on journeys home in the dark were common in folkloric traditions. In the poem accompanying the painting, references to the dreaded *sídhegaoidhe* and 'enchanted ground' would have done nothing to dispel the fear that sinister beings were about, and in fact the poem explicitly directs our reading of the painting. A *sídhegaoidhe* is a rush of wind or whirlwind, and *síghaoth* is a more sinister

fairy wind or blast; the words sound the same, and their meanings became conflated.

Expressions of folklore lend themselves best to oral narration, making Macdonald's painting all the more fascinating. In the painting, the gust of wind envelops the travellers, and is watched intently by the terrified women. Two of the men lift their hats or hold on to them as the blast passes, but, contrary to the recommended antidote, neither blesses himself. Since, as we have seen, and as Macdonald would have been aware, children were most often the target of the fairies, the reaction of the youths in the painting is of particular interest. There were many stories about boys being absconded, and young women taken as fairy wet-nurses, to be replaced by cantankerous changelings, thus reinforcing social restrictions on women and children being in remote places at night. The little boy on the left looks as if he has been electrified. Interestingly, contrary to rural practice, he is dressed as a boy (boys wore dresses, until they were breeched, precisely to confound the fairies). One girl beside this little boy has perhaps also been 'enchanted', as she has already turned and moved out of step with the group, possibly to join the fairy host; alternatively, she could also be seen to obey at least a part of another possible procedure for self-protection, turning to face it.[26]

Contemporaneous reviews of the painting, such as that in the *Southern Reporter and Cork Commercial Courier* (15 Sept. 1842), praised McDonald for his impressive grasp of peasant life:

> This picture illustrates one of our rural superstitions—a remnant of the Pagan mythology of the early days of Ireland. It represents a group of peasantry in a mountain pass, assailed by a whirlwind of dust, supposed by them to indicate a fairy progress, and sometimes a fairy combat: the onslaught of two rival factions of the 'good people'. The deprecatory 'God speed ye gentlemen' of the credulous countrymen accompanies the dusty movement, and thereby they hope to avoid the evils of 'the blast', or the crimping which substitutes a sickness-wasted denizen of fairyland for a hale inhabitant of our own nether regions. Mr. M. has well caught up the spirit and character of such an incident and produced a very attractive picture. There is a judicious gradation in his grouping, and his tone is generally excellent. Some of the figures are purely intensely Irish,

26 In Seán Ó Súilleabháin's *Handbook of Irish Folklore* (compiled in 1940 as a field guide for the Irish Folklore Commission's collectors), the entry for 'Fairy Wind' suggests that 'the correct procedure when a fairy wind approached: face it or turn one's back to it; throw something into the wind saying "May all the bad luck of the year go with you!" or "*Mh'olc agus mh'urchóid leat!*"' (Dublin: Educational Company of Ireland Limited, 1942), 477.

from the brawny open-chested peasant of the center group to the smug mounted farmer on his left, who evidently bids God speed to 'their honours', as they whirl past him.

The critique, however, also noted what it considered some technical defects in the handling:

> The background, a mountain elevation, seems to us to overhang rather much: the distance in fact not being well kept and the aerial perspective to be defective. The near tints of some portions of the middle groups strike us also as a little crude and the yellow in the drapery of his principal female figure requires certainly to be toned down, in as much as the harmony of colouring is injured by it; but these are minor defects, whilst the whole, we regard Mr. Macdonald as a young artist from whom we have high expectations.

While Victorian fairy paintings are relatively common, paintings of Irish superstition are rare, especially by Irish artists. Macdonald's work is thus not only important as art, but as a visual document of superstition. Irish peasants believed (more than disbelieved) in 'the little people', invisible to the eye, and considered neither their diminutive size nor their euphemistic names any protection against their malevolence. Fairies were thought to make their presence felt at times of change, mostly at night, and far from human observation. Country people would have avoided travelling under such conditions, and the eerie scene in Macdonald's painting would appear to vindicate their fears. However, the earlier reference in Croker's *Researches* to the 'shame' associated with superstition is interesting. In the centre foreground, the man with the red skullcap wears the cloak of a rebel (fitted with a device to hold a folded pike), redeeming, perhaps, the honour of the gullible. Superstitious they may be, but, his presence suggests, Irish peasants do not accept their repression without a struggle. Circumventing hostile forces was a matter of rural pride, whether it be fairies, landlords, or the forces of law and order. This, it later became apparent, would be a dominant theme in Macdonald's work.

Although completed before the Great Famine, this painting may further be seen as a harbinger of the horror ahead; it is worth recalling Susan Sontag's argument that, for later viewers, images can become 'memories' of events that have yet to occur.[27] Macdonald's painting adumbrates the prognostications of William Carleton's *Black Prophet*, a novel written in

27 Susan Sontag, *Regarding the Pain of Others* (New York: Picador, Farrar, Straus and Giroux, 2003), 18.

1846 at the height of the Great Hunger, but looking back at the 1817 and 1822 famines, when the prophet cries out the rhythmic words:

> Look about you, and say what is it you see that doesn't foretell famine—famine—famine! Doesn't the dark, wet day, an' the rain, rain, rain foretell it? Doesn't the rottin' crops, the unhealthy air, an' the green damp foretell it? Doesn't the sky without a sun, the heavy clouds, an' the angry fire of the west foretell it? Isn't the airth a page of prophecy, an' the sky a page of prophecy, where every man may read of famine, pestilence, an' death?[28]

Carleton's prophet asks for the landscape to be read and interpreted, and we can read Macdonald's canvas in a similarly prophetic mode: the fact that the group is travelling or migrating, the dark and threatening landscape, and, finally, the title that urges us to watch for malevolent forces, all suggest the 'horrors'—the word that appears in the accompanying poem—to come. Macdonald's informed and perspicacious visualization thus opened up multiple possibilities for interpretation, then and now.

Folklore and *The Fighter* (1844)

Later works by Macdonald show a similar interest in the role of superstition and folklore in Irish life, immediately before and during the Famine years. While his 1847 painting *An Irish Peasant Family Discovering the Blight of their Store* (National Folklore Collection, University College Dublin; 1847) does not concern itself with superstition, it is justifiably renowned as the only known painting representing the blight itself, and has been extensively discussed in Irish art historical literature to date.[29] An earlier painting, from 1844, *The Fighter* (private collection; Figure 1.2), is a startling and lesser-known image possessing a confrontational force unusual in Irish art history, and is relevant to the study of folklore. This painting shows Macdonald to have been knowledgeable about the parlous social, religious, economic and political conditions in the Irish countryside in the pre-Famine period and is an extension of his interest in the depiction of rural folklore and custom.

28 William Carleton, *The Black Prophet: A Tale of Irish Famine* (London: Lawrence and Bullen, 1899), 14.

29 For detailed analysis of *An Irish Peasant Family Discovering the Blight of Their Store*, see Emily Mark-FitzGerald, *Commemorating the Irish Famine: Memory and the Monument* (Liverpool: Liverpool University Press, 2013), 16–20; and Niamh O'Sullivan, *In the Lion's Den: Daniel Macdonald, Ireland and Empire* (Hamden, CT: Quinnipiac University Press/Ireland's Great Hunger Museum, 2016), 73–79.

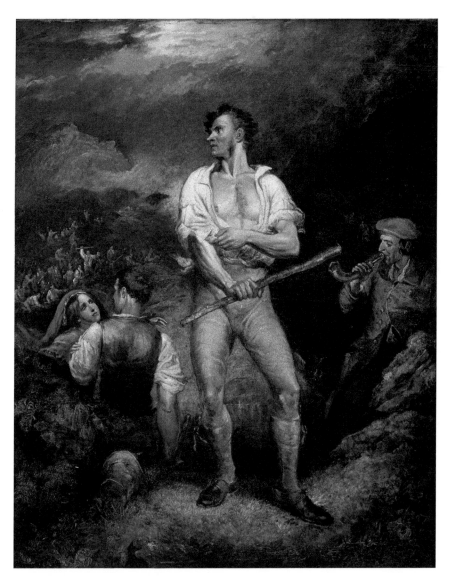

1.2 Daniel Macdonald, *The Fighter* (1844), oil on canvas, 128.3 cm × 102.2 cm
Collection of Sir Michael Smurfit

There was an old folklore belief that good harvests were dependent on the fairies and were decided by battles between neighbouring troops. Faction fighting was thus customary at the feast of Lughnasa as symbolic re-enactments of fairy battles and had become a well-established representational subject by the time of Macdonald's painting. *The Fighter*, however, also relates to a more complex story of bitter grievances which had emerged in response to the failure of the 1798 rebellion; tithes extracted from poor Catholics to pay elite Protestant clergy; the post-Napoleonic economic crash; the 1817 famine and another in 1822. From the late eighteenth century, the population had expanded at a phenomenal rate. In 1801, it was 5.2 million; by 1841, it was over 8 million, with the result that there was increasing competition for limited resources, in what was becoming a vastly overpopulated countryside. The wartime boom of 1793–1813, with the increase in food prices and land and rent values, had brought prosperity to the larger farmers, but the ensuing slump meant disaster for the majority of tenants. Moreover, the move from tillage to pasture, with widespread evictions, reduced opportunities for rural employment, which had a bearing on the level of unrest. By the 1840s, high food prices, low wages and rapacious landlords evicting tenants and putting land on the market to obtain higher rents, fuelled widespread resentment, as poor Irish Catholic peasants attacked rack-renting, mainly English Protestant landlords, and agitation assumed a form of proto-nationalism. Oath-bound secret societies—from the Whiteboys to the Rockites—organized nocturnal raids against land grabbers, tithe collectors and landlords, with lethal effect. The sedition extended to maiming, rape, kidnapping, arson and murder. The police and yeomanry distributed harsh justice, meting out prison sentences, deportations and executions.

Macdonald's *Fighter* represented many of these tensions. Secret societies were typically led by charismatic chiefs, as we see here. Apart from the activities of secret societies, in the early decades of the nineteenth century, fairs and patterns were also marked by ferocious pitched battles. Fights— revenge for family or neighbourly slights, and Romeo and Juliet-type friction between feuding families—became the stuff of legends. At one 1807 fight in Golden, County Tipperary, 20 were killed. Outsiders saw such fighting as barbaric, but the protagonists believed it to be an honourable and patriotic form of social regulation. Fighting also had political and psychological dimensions, enabling men, otherwise emasculated, to demonstrate their virility. By displaying not only individual strength but community mobili-zation, fighting gave comfort to a downtrodden people, and kept the concept and practice of sedition alive, that would in time serve the business of 'the nation'.[30]

30 For historical discussions on aspects of faction fighting, see Thomas Moore, *Memoirs*

Invariably, fights kicked off with the wheel. Wheeling involved the leaders storming along a strip of no-man's-land between the factions, hurling insults at the opposing team until the bait was taken, the sticks were tapped and crossed, and they laid into each other. The captains pranced up and down the lines in a most provocative manner, goading the enemy, no less than their own, to a frenzy. Macdonald's captain is *contrapposto*, actually on the wheel, his head still to one side, his body already turned to stomp back down the line. Although often fuelled by alcohol, fights were not spontaneous, but had their own conventions. The venue was often inaccessible, making policing difficult: if the authorities intervened, the opponents would immediately unite and attack the military or constabulary, their common foe. In Macdonald's representation, the men clamour down the mountain, rushing to the fray.[31]

Faction leaders, invariably men of the poorest class, wielded massive power regionally. Moreover, they had a magnetic effect on young women.[32] Indeed, whilst the contemporary Irish agrarian violence is a direct or indirect referent of the painting, the ardent lovers centred in the composition may provide an alternative explanation for the fight. If the young man does not survive, his sweetheart will grieve until her own dying day. However, there is no attempt to stop her man, and her last look is one of such intensity and desire that it empowers him. In any event, Macdonald's painting crystallizes how, as Joep Leerssen put it, '[r]ustic popular culture [was] canonized into the very essence and bedrock of national identity',[33] combining the symbolism of fighting within rural folklore, its significance as a form of colonial resistance and the romantic associations of the fighting Irish 'hero' or chieftain.

of Captain Rock, the Celebrated Irish Chieftain, with Some Account of his Ancestors. Written by Himself (London: Longman, Hurst, Rees, Brown, Orme and Green, 1824); Croker, *Researches*; and Mr and Mrs S.C. Hall, *Ireland: Its Scenery, Character, &c.* (London, How and Parsons, 1841), vol. 1. For history, analysis and interpretation, see Patrick D. O'Donnell, *The Irish Faction Fighters of the 19th Century* (Dublin: Anvil Books, 1975); Galen Broeker, *Rural Disorder and Police Reform in Ireland, 1812–36* (London: Routledge & Kegan Paul, 1970); Samuel Clark and James S. Donnelly, Jr. (eds), *Irish Peasants: Violence and Political Unrest, 1780–1914* (Manchester: Manchester University Press, 1983); Luke Gibbons, 'Between Captain Rock and a Hard Place: Art and Agrarian Insurgency', in Tadhg Foley and Sean Ryder (eds), *Ideology and Ireland in the Nineteenth Century* (Dublin: Four Courts, 1998), 23–43; Emer Nolan, 'Irish Melodies and Discordant Politics: Thomas Moore's Memoirs of Captain Rock (1824)', *Field Day Review*, 2 (2006), 41–54; O'Sullivan, *In the Lion's Den*.
31 Croker, *Researches*, 230–31.
32 Hall, *Ireland*, 44, 171.
33 Joep Leerssen, *National Thought in Europe: A Cultural History* (Amsterdam: Amsterdam University Press, 2006), 195.

Painting the People

During the Famine years, whether from protectiveness or shame, lack of courage or skill, except for some notable depictions of eviction, and the recent discovery of a remarkable peasant funeral by Macdonald, Irish artists tended to avoid the appalling conditions in which the majority lived. However, a number of English artists—Henry Mark Anthony, Frederick Goodall, Francis Topham and Alfred Fripp—did visit the West of Ireland in the mid-1840s, where they painted homely scenes of impoverished domesticity, and scenes of religious ritual and superstition, some sweetened for British audiences, indicative of the level of tolerance of the art market, others of considerable ethnographic importance.

It was not just that the depiction of famine-ravaged bodies challenged the skills of artists, but the conceptual frames of reference of the time ensured that artists brushed over the worst aspects, allowing shorthand features such as tattered rags, spiky hair and dirt to imply the rest. The few attempts to breach the barrier in illustration rarely crossed over into painting. For these reasons, Macdonald's 1847 painting *An Irish Peasant Family Discovering the Blight of their Store* is remarkable for its time.

Nevertheless, Macdonald did not abandon his representation of other aspects of Irish peasant life during the Famine period. In the ink drawings *Preparing for Mass* (Crawford Art Gallery, 1847) and *Preparing for Bed, Scene in an Irish Cabin* (Crawford Art Gallery, 1847), for example, he shows small tenant farmer families attending to their religious duties, the detailed interiors suggesting more informed affection than condescension. His father may have viewed Catholicism as lamentably entwined with superstition, but there is more humour than malice in his son's representations. These are interesting scenes, suggesting that life goes on during the Famine, and included the persistence of traditional beliefs and rituals. On the wall of the cabin in *Preparing for Bed*, for instance, can be seen a sketch of 'St Brigid', one of Ireland's patron saints, with strong associations with pagan festivals.

Another work, *Soul Beggars* (Crawford Art Gallery, 1847; Figure 1.3), probably set at St Colman's Well, County Galway, is richly allusive of the porous boundaries between religious belief and superstition. In AD 559, Queen Rionach gave birth to Colman, her husband having attempted to drown her and her unborn child because of a prediction that their son would outshine his father. Divine Providence led two monks—one blind and one lame—to her, and she asked them to baptize her son. The blind monk pulled up some rushes and a well sprung up, splashing his eyes and curing his blindness; the lame monk washed his leg and was cured; and with that water St Colman was baptized. Vernacular Catholicism clung to traditional beliefs and rituals that included such holy wells and calendric

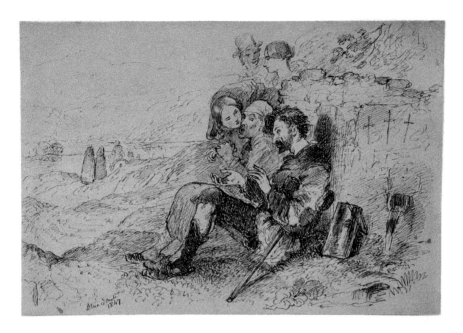

1.3 Daniel Macdonald, *Soul Beggars* (1847), ink on paper, signed and dated:
D. Macdonald, 1847, 7.5 × 10.6 in / 19 cm × 27 cm
Crawford Art Gallery, Cork

customs. Over 3,000 holy wells in Ireland were visited at the great festivals, especially *Samhain*, when the boundaries between the living and the dead were dissolved. These individual wells became associated with specific ailments, such as fertility or lameness or blindness, and thus fulfilled important medicinal, spiritual and social needs.

A further Macdonald work from 1847, the *Hedge Schoolmaster* (Crawford Art Gallery), blends references to superstition and sedition as seen previously in *The Fighter*, also channelled through a dissident figure. Macdonald's schoolmaster is pictured here intent on sharpening his quill, for purposes educational and possibly seditious. In hedge schools, lessons in life and lawlessness, as well as literacy and the classics, in both Irish and English, were taught. Although hedge schoolmasters—usually itinerant poets and scholars (and sometimes 'spoilt priests')—epitomized Gaelic Ireland, they insisted on teaching English, the language of social mobility, commerce and emigration.[34] Many authored rebellious ballads, and were known to

34 See Gearóid Ó Tuathaigh, *I mBéal an Bháis: The Great Famine and the Language Shift in Nineteenth-Century Ireland* (Hamden, CT: Quinnipiac University Press,

use inflammatory books in promoting agrarian militancy, in many cases writing the threatening notices warning landlords to stop their avaricious practices. The schoolmaster diffused republican ideas as he moved from parish to parish, and he carried the oaths and regulations for recruiting to secret societies. His polemical writings, ballads, poems and night-time tales stoked memories of injustices, recent and distant, to the great relish of their audiences. They were thus a modernizing force in nineteenth-century Ireland but were well aware of the power and potential of superstition to incite or regulate behaviour.

Conclusion

As the century progressed, negative perceptions of a brutish Irish peasantry moderated, and Macdonald's contribution to a more nuanced represen-tation should be acknowledged. He was an acute observer of everyday life. His *Sídhe Gaoithe/Fairy Blast* may depict a peasantry in the thrall of superstition but, even though an early work, did not descend into patroni-zation. Before long he developed a robust form of realism that humanized Irish rural people—not stereotyped, nor aggrandized, nor romanticized. Simultaneously, he ran an enormously successful portrait practice, attended by members of the royal family and the aristocracy in London. By 1853, he was seen as an up-and-coming artist in both Ireland and England: his skill and wit, his audacity and originality were recognized, but, all too cruelly, cut short. On 11 February 1853, aged 32, he died of enteric fever. Following his death, his sister Jane (an artist not without interest) took over as 'Sister and Successor to the late Mr. D. Macdonald'. The convulsions of the Famine eventually subsided, but nothing would be the same again. The aftershocks were such that in the decades that followed superstition was diametrically ridiculed and desperately resorted to in an effort to reconnect to a past beyond retrieval. In capturing something of the atmosphere of nineteenth-century Irish life prior to the Famine, Macdonald remains an important figure.

2015); Niall Ó Ciosáin, *Print and Popular Culture in Ireland, 1750–1850* (Basingstoke: Palgrave Macmillan, 1997); Garret Fitzgerald (ed.), *Irish Primary Education in the Early Nineteenth Century* (Dublin: Royal Irish Academy, 2013).

2

HB's Famine Cartoons:
Satirical Art in a Time of Catastrophe

Peter Gray

Queen's University Belfast

The 'Political Sketches' of John Doyle, which he produced anonymously and in a numbered sequence from 1829 under the cypher 'HB', dominated the market for visual political satire in London in the 1830s. A markedly less savage and more allusive caricaturist than his Georgian predecessors— Dorothy George represented the 'Political Sketches' as embodying a transition 'from the uninhibited old school to a decorous new one'—Doyle's work did much to visualize the political controversies of the period, at least for a middle- and upper-class English market reached primarily through subscription and print-shop sales.[1] His pre-eminent position slipped in the following decade, not least due to the emergence and rapid success after 1841 of the weekly satirical magazine *Punch*, which employed his son Richard Doyle from 1843, and which inspired a number of imitators. However, HB's 'Political Sketches' continued to appear in batches at roughly monthly intervals during each parliamentary season until summer 1849 (with one final print coming out in 1851), and to attract attention and commentary in the London press, especially in *The Morning Post* and *The Times*.

As a middle-class Irish emigrant and observant Catholic, Doyle continued to take a keen interest in Irish affairs long after he had settled in London, albeit refracted through an increasingly bitter antipathy towards Daniel O'Connell and the politics of Repeal. His commentary on the politics of his native country was also shaped by a keen sense of the taste of his largely conservative English audience. Unlike his earlier works, Doyle's sketches from the later 1840s have attracted little scholarly attention and are rarely reproduced. This chapter considers how Doyle addressed the Irish

1 Dorothy George, *English Political Caricature 1793–1832: A Study of Opinion and Propaganda* (Oxford: Clarendon Press, 1959), 218–19.

crisis of the Great Famine through a number of cartoons produced as part of the 'Political Sketches' series, placing these within the contexts of Doyle's artistic career, the visual culture of political caricature in the later 1840s and the political controversies of the period.

John Doyle as 'HB'

Doyle was born in 1797, the son of a Dublin silk merchant whose family originated in the minor Catholic gentry of County Tipperary, a social origin of which he was intensely proud. Trained as an artist at the Royal Dublin Society schools, he initially specialized in equestrian and portrait works (including one of the Lord Lieutenant Earl Talbot), with occasional landscapes. Emigrating to London at some point between 1817 and 1821, he had moderate success in the capital. However, a difficulty in finding patrons and illness related to working in oils led him towards specialization in the new technique of lithography, for which he developed a talent. His collaboration with the publisher Thomas McLean in producing the 'Political Sketches' series from 1829 appears to have generated a comfortable income to support Doyle and his family—he had married the Dubliner Marianne Conan in 1820 and was to coach his four sons rigorously for artistic careers.[2] Following Marianne's death in 1832, her brother Michael Conan and his wife joined the household in London.[3]

It appears Doyle returned only infrequently to Ireland, although he maintained contact with family connections there. One of his relatively few distinctly Irish 'serious' works, an undated chalk and pencil sketch entitled 'An Irish Funeral', now held in the University of Dundee collections, may date from one of these return visits. It is an unusually demotic scene for an artist whose work tended towards elite subjects, depicting as it does a rural funeral procession, headed by keening women, observed with reverence by a peasant family.[4] Despite his reputation for good-natured non-partisanship in the 'Political Sketches', Doyle's personal politics can, as he admitted himself, be traced through his satires, and were further revealed in an autobiographical memorandum he sent to the Conservative Prime Minister Sir Robert Peel in early 1842, identifying himself as 'HB' and requesting government

2 Helen Andrews, 'John Doyle', in James Maguire and James Quinn (eds), *Dictionary of Irish Biography* (Dublin: Royal Irish Academy, 2009): http://dib.cambridge.org (accessed 1 Mar. 2016); Rodney Engen, *Richard Doyle* (Stroud: Catalpa Press, 1983), 11–13.

3 For Michael Conan's influence on his grand-nephew, Arthur Conan Doyle, see Engen, *Richard Doyle*, 16.

4 'Life lines', www.dundee.ac.uk/museum/exhibitions/line/ (accessed 1 Mar. 2016).

employment. His early politics, he confessed, had been shaped by support for Catholic Emancipation and moderate reform; but since the concession of the first in 1829, and the passage of the Reform Act in 1832, he had come to regard further Catholic agitation in Ireland as illegitimate and any 'popular innovation' in the British constitution as inexpedient.[5] While it was clearly in his interest as a petitioner for government favour to highlight his conservative credentials, his assertions are for the most part borne out by the contents of his graphic work. He appears to have been preoccupied with Daniel O'Connell, who appeared in more than 200 of the 917 'Political Sketches', and whose career after 1829 appeared to Doyle to embody a demagogic combination of radicalism, nationalism and Catholic grievance politics. As he stated to Peel in 1842, 'I could not [...] without strong disapprobation and some shame, view the subsequent proceedings of the Catholic party [...] under the misguidance of Mr O'Connell,—though in this opinion I had the pain to differ from some near friends and relatives whom I know to be men of high principle'.[6]

HB's vituperative treatment of O'Connell has attracted the attention of scholars such as James McCord and Fintan Cullen, so I will refer here briefly to just two examples from the sketches as illustration.[7] First, 'Satan Alias the Arch Agitator' ('Political Sketches', No. 457, 1 Dec. 1836) is an example of how O'Connell frequently (although not always) drew a more ferocious representation untypical of HB's usually more mannered and 'polite' pictorial satires, while also illustrating the artist's reliance on literary or visual models: there is a quotation from Milton's *Paradise Lost* at the bottom relating to the poet's characterization of Satan.[8] The second, 'Looking Out' (No. 480, 8 April 1837), demonstrates Doyle's typical technique of parodying existing artworks, which Fintan Cullen has addressed in detail elsewhere. In this case, as McLean's *Illustrative Key* to the Sketches helpfully identifies, the referent is a portrait of a poacher (*c.*1828) by the contemporary artist H.P. Parker of Newcastle. Despite O'Connell's claims

5 Doyle memorandum, in Doyle to Peel, 11 Jan. 1842, British Library, London, Peel Papers, Add MS 40500, ff. 312–324.

6 Doyle memorandum, in Doyle to Peel, 11 Jan. 1842, British Library, London, Peel Papers, Add MS 40500, ff. 312–324.

7 James N. McCord, 'The Image in England: The Cartoons of HB', in Maurice O'Connell (ed.), *Daniel O'Connell: Political Pioneer* (Dublin: Institute of Public Administration, 1991), 57–71; Fintan Cullen, 'Visual Parody and Political Commentary: John Doyle and Daniel O'Connell', in Ciaran O'Neill (ed.), *Irish Elites in the Nineteenth Century* (Dublin: Four Courts Press, 2013), 233–47. See also Fintan Cullen, 'Robert Peel, John Doyle and Visual Parody', in R.A. Gaunt (ed.), *Peel in Caricature: The 'Political Sketches' of John Doyle ('H.B.')* (Bristol: The Peel Society, 2014), xxxiii–xxxvii.

8 HB, 'Satan, Alias the Arch Agitator (Daniel O'Connell; Richard Lalor Sheil)' (1 Dec. 1836), lithograph: National Portrait Gallery (UK), NPG D41391, available from www.npg.org.uk/collections.

to sole reliance on 'moral force' in political action, the representation of 'Repeal' as a pistol flags Doyle's opinion that the nationalist campaign and O'Connell's leadership of it were inherently violent.[9]

Writing to Peel in 1842, Doyle suggested that HB's political mission was now 'complete' in the wake of the Conservatives' electoral victory of the previous year, and that he would now prefer retirement from the work of caricature. However, Doyle later revised his opinion and returned to the drawing board with greater intensity, due to his failure to attain personal or governmental patronage from the premier and, perhaps as importantly, due to the eruption of O'Connell back into the political limelight in 1843 as he launched his 'Repeal Year' campaign of mass outdoor agitation. O'Connell's campaign was followed by subsequent challenges to Peel's authority from the ultra-Protestant and agriculturalist wing of his own Conservative Party over the Maynooth Grant and Corn Law crises in 1845–46. Irish nationalism in its revived forms continued, Doyle clearly believed, to require mockery and the drawing of public attention to its internal divisions and contradictions. In 'Dropping It like a Red Hot Poker' (No. 822, 28 Dec. 1844) HB depicts a clownish O'Connell beset by the harlequin figure of the Young Ireland romantic nationalists on one side, and 'crotchety' Ulster agrarian radical William Sharman Crawford on the other, finding it impossible to handle safely the latter's 'Federalist' alternative to Repeal of the Union.[10] In 'A Brummagim martyrdom' (No. 864, 9 May 1846), the Limerick MP and future revolutionary William Smith O'Brien is satirized for over-dramatizing as 'martyrdom' his brief incarceration in an apartment in the Palace of Westminster for refusing to sit on a select committee on British railways. O'Brien defended his obstinacy as being justified by British misgovernment of Ireland in spring 1846, now manifested in mass hunger in the wake of the first potato failure in 1845: he had warned the Commons that '100,000 of his fellow creatures were famishing' and that this would have violent consequences in Ireland.[11] Doyle chose only to highlight O'Brien's self-serving hyperbole on imprisonment and O'Connell's hypocrisy in publicly supporting a man who was aligning himself with his Young Ireland

9 HB, 'Looking Out' (28 April 1837), print: Tabley Collection at the University of Manchester, available from https://archive.cartoons.ac.uk, ref. no. mudyx50; Thomas McLean, *An Illustrative Key to the Political sketches of H.B., from No. 1 to No. 600* (London: McLean, 1841); see also Cullen, 'Visual Parody'.

10 HB, 'Dropping It like a Red Hot Poker' (28 Dec. 1844), print: Tabley Collection at the University of Manchester, available from https://archive.cartoons.ac.uk, ref. no mudyx1h.

11 HB, 'A Brummagim Martyrdom' (9 May 1846), print: Tabley Collection at the University of Manchester, available from https://archive.cartoons.ac.uk, ref. no mudyxf3; Robert Sloan, *William Smith O'Brien and the Young Ireland Rebellion of 1848* (Dublin: Four Courts Press, 2000), 148–56.

critics, but he could not for long himself ignore the food crisis besetting his homeland, or dismiss it so easily as windy rhetoric.

HB and the Famine

Doyle's pictorial response to the Famine was shaped both by his personal ideological and career perspectives, and by the genre conventions he had established and adhered to in the 'Political Sketches' since 1829. These continued to take the high politics of Westminster as their default point of focus, rarely straying 'out of doors'. This was a constraint which did not apply to the new illustrated satirical press most successfully represented by *Punch*, which happily imagined 'King Dan' holding court at the Tara Monster Meeting, or the hapless British Chartist strapping on home-made armour in his kitchen before the mass reform meeting at Kennington in 1848. It is consequently the high politics of Famine policy that HB principally addressed, although he did this in common with both British and Irish national and provincial newspapers, which reported parliamentary debates in detail and editorialized regularly on what was said in the chambers.

In dramatizing these debates, frequently with mythological and artistic allusions, HB continued to produce images for the consumption of a metropolitan and moneyed audience, while perhaps at the same time seeking to interpret events for himself and to persuade others of certain policy preferences. At two shillings per print (the hand-coloured versions were even more expensive), relatively few could purchase his 'Political Sketches', although there is evidence that public viewing of new works displayed in print shop windows was still common. Press coverage of each new HB release was more patchy than it had been in previous years, with the High Tory *Morning Post* now replacing the politically non-aligned *The Times* as the most regular reviewer. Interestingly, the *Post*'s columns were often reprinted in the Irish Conservative press, not just in the *Dublin Evening Mail*, but also in provincial papers such as the *Armagh Guardian* and the Monaghan-based *Northern Standard*.[12] Correspondents in middle-class Irish Catholic papers such as the Dublin *Freeman's Journal* also assumed their readers would be familiar with HB's sketches.[13] The extent of distribution of Doyle's satires in Ireland is unknown, but, as in Britain,

12 See, for example, *Dublin Evening Mail*, 22 Jan. 1845; *Armagh Guardian*, 28 Jan. 1845; *Northern Standard*, 5 Apr. 1845.
13 For instance, the *Freeman's Journal* of 4 July 1845 defended Hogan's bust of O'Connell against critics, noting it would be 'recognised at first glance by any one whose memory of the original is not perhaps too much biased by a familiarity with H.B.'s caricatures'.

discussion of his images appears to have been disseminated more widely that the prints themselves.

However, in the first year of the crisis, 1845–46, Ireland is largely absent from the sketches, barring the residual representation of O'Connell and the ludicrous 'martyrdom' of Smith O'Brien already noticed. This was not a year of mass mortality in Ireland, and one in which parliamentary business was dominated by debates on the repeal of the Corn Laws and the split this provoked within the ruling Conservative Party. In representing this, Doyle avoided linking the parliamentary crisis to the Irish subsistence one, ironizing Peel's political about-turn on the Corn Laws (which he now pressed forward with repealing) and the unlikely alliance he was forming with the bourgeois-radical Anti-Corn Law League. Doyle also portrayed Peel in heroic mode as the Gulliver-like vanquisher of his Lilliputian critics (No. 865, 'Gulliver Capturing the Enemies Fleet', 29 May 1846), and as a Caesar—the political hero brought down by a treacherous cabal of lesser enemies (No. 872, 'The Fall of Caesar', 18 July 1846).[14] In another cartoon, the wild Protectionist claim that Peel might soon proceed to repeal the Act of Union and abolish the Irish Church Establishment is mocked as a fanciful nightmare. HB's generally sympathetic portrayal of Peel's démarche on the Corn Laws naturally attracted more favourable comment from the liberal *Daily News* than the protectionist-conservative *Morning Post*, which observed in April 1846 that 'however much of humour H.B. may infuse into his illustrations of public events, he cannot prevent them from affording ground for very melancholy reflection'.[15]

Peel's government finally collapsed in June 1846 on a specifically Irish measure. While prepared to support the Prime Minister over the abolition of the Corn Laws, the Whig opposition and Daniel O'Connell's Irish Repealers rejected the government's Irish Coercion Bill, introduced to deal with an upsurge in agrarian crime in response to distress and threatened evictions. They voted with the Protectionist Conservatives, who had defected from Peel's party, to defeat it. This provided Doyle with the subject of an 'Irish Faction Fight' (No. 869, 18 July 1846), which deployed a range of Irish stereotypes, but added the Whig leader Lord John Russell and the Protectionists Benjamin Disraeli and Lord George Bentinck to the more

14 HB, 'Gulliver Capturing the Enemies Fleet' (29 May 1846), print: Tabley Collection at the University of Manchester, available from https://archive.cartoons.ac.uk, ref. no. mudyx5d; 'The Fall of Caesar' (18 July 1846), print: Tabley Collection at the University of Manchester, available from https://archive.cartoons.ac.uk, ref. nos. mudyxwj.

15 *The Daily News*, 19 Feb. 1846; *The Morning Post*, 19 Feb. and 16 Apr. 1846. *The Daily News* continued to praise HB's sketches as superior in technique and content to their French counterparts. See, for example, 13 Apr. 1848.

predictable mob of O'Connell and his partisans, armed with shillelaghs, now closing in on the doomed Peelites.[16] The ostensible subject would have been a familiar one to English audiences through representations such as Irish author William Carleton's short stories, which depicted such confrontations as recreational violence and the object of amusement,[17] and paintings and engravings of Donnybrook Fair popular since the eighteenth century.[18]

Despite his previous record in the 1830s of propagating a strongly negative stereotype of Russell as a weak minister unable to resist the bullying influence of O'Connell (with malign consequences for both Ireland and the United Kingdom), Doyle's portrayal of his policy as the new Prime Minister from July 1846 was surprisingly benevolent—at least until he came out of retirement in 1851 to mock Russell's adherence to the anti-Catholic campaign, got up against the so-called 'Papal Aggression' of the restoration of Catholic territorial sees in Great Britain.[19] In one of his first represen-tations of Russell's premiership, 'Sailing before the Wind: with Breakers Ahead' (No. 873, 19 August 1846), Russell is depicted in classical garb as the pilot of a small boat successfully navigating the reef of Irish coercion, propelled by strong following winds provided by O'Connell, Peel (the Peelites were then backing Russell's minority government), and *The Times* newspaper. Opposition from the Protectionists was to be anticipated but portrayed as being some way off as yet.[20] This sunny image was part of HB's last set for the parliamentary session of 1846, appearing just as the second, and catastrophic, potato failure was manifesting itself in Ireland, and the new government introduced the emergency Labour Rate Act to overhaul the public relief works system, but before the full implications of the renewed failure were known or understood in the metropolis.[21]

When Doyle returned to the political sketches as parliament assembled

16 HB, 'An Irish Faction Fight' (18 July 1846), print: Tabley Collection at the University of Manchester, available from https://archive.cartoons.ac.uk, ref. no mudyx95.

17 William Carleton, 'Battle of the Factions', in *Traits and Stories of the Irish Peasantry* (Dublin: W.F. Wakeman, 1834), vol. 2, 267–39; Kevan O'Rourke, 'The Fighting Irish: Faction Fighting as Leisure in the Writings of William Carleton', in Leeann Lane and William Murphy (eds), *Leisure and the Irish in the Nineteenth Century* (Liverpool: Liverpool University Press, 2015), 130–46.

18 Faction fighting at the Dublin fair led to the coining of the term 'donnybrook'; notable nineteenth-century visual examples of Donnybrook Fair include George du Noyer (1830); William Brocas (1840s), Samuel Watson (1847), Erskine Nicol (1859) and Edward Glew (1865).

19 For the depiction of Russell in the 1830s, see McCord, 'The Image in England'.

20 HB, 'Sailing before the Wind, with Breakers Ahead and a Narrow Escape' (19 Aug. 1846), print: Tabley Collection at the University of Manchester, available from https://archive.cartoons.ac.uk, ref. no mudyxx9.

21 For the Labour Rate Act, which amended the public works to inhibit 'useful' works and place greater financial burdens on the Irish landowners, see Christine Kinealy,

for a new session in late January 1847, the full weight of the crisis had fallen on the island and was now dominating Westminster business. Perhaps surprisingly, HB's continuing confidence in Russell's management of the Irish situation appears evident in No. 878—'A new way to drive over an old road: now alas sadly out of order' (11 Feb. 1847). Here Russell is the self-assured driver of the Irish jaunting car of policy, steering it adroitly (or thus it appears) along the road between the parallel ruts of 'Irish improvidence' and 'English prejudice'. His parliamentary passengers, the Protectionist Conservatives Lord George Bentinck and Robert Inglis, praise his driving by declaring, 'How nicely he avoids the ruts on both sides of the road. We must step down & assist him the next hill he comes to', although, ominously, Bentinck suggests that railroads might be better for such uphill work.[22] This image appeared in the context of Russell's announcement on 25 January 1847 of a new government scheme of temporary relief, to meet distress through gratuitous outdoor relief in cooked food (provided by a network of 'soup kitchens'), with further loans for seed distribution and the waiving of half the debt of the failing public works system.[23]

This parliamentary consensus on Irish policy was not to last and became frayed as delay after delay impeded the establishment of the 'emergency' soup kitchen regime and the government moved towards dismantling the public relief works, laying off tens of thousands of workers before any effective replacement was in operation. In March 1847, Bentinck introduced his Irish Railways Bill as an alternative to the government's reliance on non-reproductive public works, private charity and the stalled emergency food relief scheme. Bentinck's bill attracted support from many observers in both countries frustrated at the apparent negativity and penal aspects of government policy but was opposed by the administration and the remaining followers of Robert Peel as a subsidy to both the British railway lobby and to the Irish landed interest: as much of the funding would go to the latter in the form of land purchase. Doyle was clearly attracted by the subject (as well as by Bentinck's ebullient personality—he produced a sympathetic portrait following Bentinck's early death in 1848),[24] and chose to represent this in heroic-mythological form in March 1847. In No. 881, 'Perseus Flying to the

This Great Calamity: The Irish Famine 1845–52 (Dublin: Gill & Macmillan, 1994), 90–92.

22 HB, 'A New Way to Drive over an Old Road' (11 Feb 1847), print: Tabley Collection at the University of Manchester, available from https://archive.cartoons.ac.uk, ref. no mudyx5q.

23 Peter Gray, *Famine, Land and Politics: British Government and Irish Society 1843–50* (Dublin: Irish Academic Press, 1999), 264–65.

24 This was nevertheless criticized by *The Morning Post*, on 13 November 1848, as a mere sketch not worthy of its subject.

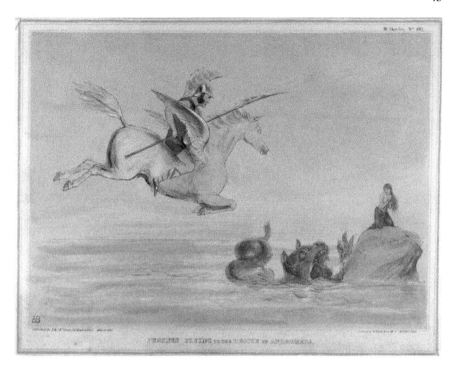

2.1 'HB' (John Doyle), 'Political Sketches' No. 881, 'Perseus Flying to the Rescue of Andromeda' (Thomas McLean, London, March 1847), colour lithograph, 27.1 cm × 35.9 cm
John Johnson Collection, The Bodleian Library, University of Oxford

Rescue of Andromeda' (Figure 2.1), Bentinck stands in for the Greek hero, with the feminine personification of Ireland as Hibernia taking the form of Andromeda threatened by the sea-monster clearly identified by the label 'Famine'.[25] Not satisfied with a single commentary on this theme, Doyle produced a second version in No. 883 'The Centaur Nessus Carrying off Deianira', which was based loosely on a painting in the Louvre by Guido Reni, of 1619. Here Bentinck is depicted as Nessus, carrying off across the river Deianira/Hibernia (holding her by a bond labelled 'railways') from her husband Hercules (an unlikely Lord John Russell).

However, Bentinck's failure is presaged by both the narrative of the myth (Hercules shoots Nessus dead) and Hibernia's reluctance to renounce Russell: most Irish Liberal and Repeal MPs voted with the government when the railway bill was made a matter of confidence, albeit with hints of

25 HB, 'Political Sketches', No. 883 (13 March 1847), print. John Johnson Collection, Bodleian Library, University of Oxford. Available via https://www.vads.ac.uk.

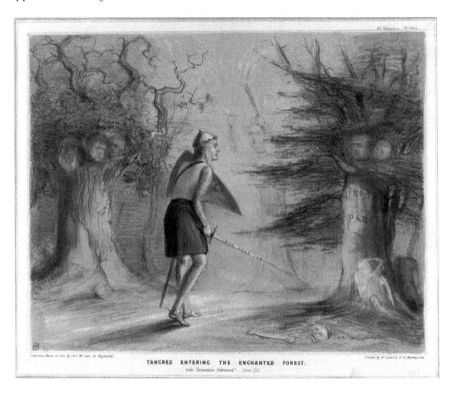

TANCRED ENTERING THE ENCHANTED FOREST.

2.2 'HB' (John Doyle), 'Political Sketches' No. 884, 'Tancred Entering
the Enchanted Forest' (Thomas McLean, London, 31 March 1847), colour
lithograph, 28 cm × 34.5 cm
John Johnson Collection, The Bodleian Library, University of Oxford

forthcoming revenge towards him for her abandonment.[26] Turning to yet
another myth to illustrate Bentinck's defeat, in No. 880 (March 1847), HB
has 'The Fates', represented with the faces of the former and current Whig
chancellors of the exchequer, Francis Baring and Charles Wood, and former
Conservative chancellor, Henry Goulburn, shown indifferently cutting the
thread of Bentinck's railway bill (all had denounced it in the Commons) and
hence destroying a potential lifeline for famished Ireland.[27]

HB's treatment of this subject through fanciful classical allusions risked

26 HB, 'The Centaur Nessus Carrying off Deianira' (13 March 1847), print: Tabley
Collection at the University of Manchester, available from https://archive.cartoons.
ac.uk, ref. no mudyxxa.
27 HB, 'The Fates' (March 1847), print: Tabley Collection at the University of Manchester,
available from https://archive.cartoons.ac.uk, ref. no mudyx5n.

reducing a serious subject to the level of absurdity, which was probably not his intention, although inherent in his mode of allusive caricature. Press commentary on the use of mythological allegory in this set of mid-March 1847 was not favourable.[28] At the end of that month Doyle's publisher released another sketch addressing the problems of formulating an Irish relief policy, also refracted through allegory—in this case a scene from Tasso's sixteenth-century Crusading epic *Jerusalem Delivered*. In No. 884 (31 March 1847), Russell, in the guise of the hero Tancred, attempts to find his way through the enchanted forest of Irish policy, armed with the sword of the 'Irish poor law', representing the Irish Poor Law Amendment Bill, then being debated in the Commons as the government's principal 'remedial' policy for Ireland (Figure 2.2). Behind Russell and fading from sight is O'Connell (who had withdrawn from parliament in February following the collapse of his health) and facing him is the 'Irish Party'—a loose and inchoate coalition of anti-poor law interests, represented by the former Whig minister and County Limerick landowner Lord Monteagle and by Smith O'Brien. In his only, and rather oblique, reference to the human costs of the Irish Famine, HB included here a number of bleached corpses lying at the base of his enchanted trees. However, the implication of the cartoon was strongly that responsibility for these lay with the forces of obstruction, not the ministry.[29] While the quality of the sketch impressed the correspondent of *The Morning Post*, its political meaning—that 'such an array might for a moment dash even Lord John Russell'—was implicit, as in Tasso's poem the hero Tancred was ultimately defeated by the occult power of the enchanted wood.[30]

In fact, the government was able to pass its 1847 Irish poor law amendment bill, albeit at the cost of conceding to the 'Irish Party' the addition of the Gregory clause amendment, denying relief to tenants holding more than a quarter acre of land. However, the decision to rely almost exclusively on locally raised rates on land, distributed through the massively overburdened and inefficient poor law system, led to widespread union bankruptcies, system collapse and further mass suffering, especially in the south and west of Ireland, which remained subject to repeated potato failure and mass destitution until at least 1850. While Russell had promised additional 'remedial measures', such as land reclamation and assisted emigration, to alleviate this crisis, nothing was done in 1847–48. This was

28 *The Morning Post*, 26 Apr. 1847.

29 HB, 'Tancred Entering the Enchanted Forest', No. 884 (31 March 1847), print. John Johnson Collection, Bodleian Library, University of Oxford. Available via https://www.vads.ac.uk.

30 *The Morning Post*, 26 Apr. 1847.

due to a combination of ideological resistance to further 'interference' and fiscal crisis draining the UK exchequer and rendering additional borrowing highly unpopular and difficult. Doyle chose, in cartoons of late 1847 and early 1848, to emphasize the latter as the cause of continuing stasis in Irish policy.

In No. 889, 'The State Waggon in Difficulties' (10 Nov. 1847), the waggoners Russell and Wood discuss unloading, at least temporarily, some of the burdens of national expenditure in order to get the 'state waggon' out of its rut of immobility and relieve the restive pack horse, here given the stereotypical face of 'John Bull', that is, the English taxpayer. The banking crisis of autumn 1847 (represented in the form of the 'Bank Charter 1844', the regulatory banking framework passed by Peel that had to be suspended amid threats of a run on the banks) and the collapse of 'Railway Mania'—which both threw British industry into recession and high unemployment—are referenced prominently. So too is the 'Irish Famine Loan, 8 Million', referring to the monies advanced to Ireland in 1846–47 to pay for the public works and soup kitchen relief systems.[31] The clear implication is that, as Charles Wood and his subordinate at the Treasury Charles Trevelyan were at this time constantly reiterating to Russell and the Irish government, any further expenditure for Ireland was politically impossible. The situation had improved little by spring 1848, when HB returned to the theme in No. 889, 'The Donkey Turned Restive at Last' (28 March 1848). John Bull's face is now transposed onto a donkey, overburdened with the costs of government, and preparing to revolt should the ministers add an emergency income tax increment of 2 per cent (on top of the 3 per cent which had been introduced by Peel's government as a 'temporary measure' in 1842).[32] The previous month the ministry had been humiliated in the Commons, forced to withdraw its proposed budget in the face of demands for fiscal retrenchment and the insistence by Radical MPs that Irish landlords bear the costs of reconstruction, or at least accept the extension of income tax to that country. This defeat was a personal blow to Russell in particular, whose policy options further disappeared in the face of the fiscal austerity that followed the budget debacle.[33]

31 HB, 'The State Waggon in Difficulties', No. 889 (10 Nov. 1847), print. John Johnson Collection, Bodleian Library, University of Oxford. Available via https://www.vads.ac.uk.

32 HB, 'The Donkey Turned Restive at Last' (21 March 1848), print: Tabley Collection at the University of Manchester, available from https://archive.cartoons.ac.uk, ref. no mudyxxp.

33 Gray, *Famine, Land and Politics*, 301–03.

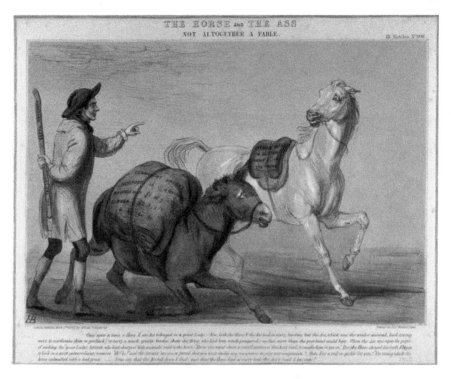

2.3 'HB' (John Doyle), 'Political Sketches' No. 908, 'The Horse and the Ass' (Thomas McLean, London, 15 March 1849), colour lithograph, 28 cm × 36 cm John Johnson Collection, The Bodleian Library, University of Oxford

'The Irish Problem'

For the next year Ireland stagnated as relief transfers from London dwindled to virtually nothing, charitable funds became exhausted and the poor law collapsed in much of the west. Mass clearances from late 1847 added greatly to the human suffering, and the mortality peak in winter 1848–49 approached that of 1846–47 in intensity. It was not until the start of the new session in February 1849 that Russell's government came up with a new initiative to justify a paltry advance of a further £50,000 to bail out the bankrupt poor law unions. This was the subject of HB's next comment on Irish affairs, No. 908, 'The Horse and the Ass' (15 March 1849) (Figure 2.3). Now the overladen ass no longer represents John Bull as the British taxpayer, but the western Irish ratepayer, collapsing under the burden of the inflated poor rates in the Connacht unions. Clifden and Westport in particular are itemized on the suffering beast's pack—a

situation due, the accompanying text suggests, 'more to misfortune than good luck'. A white horse (helpfully provided with an orange saddle by the hand colourist in the more expensive version), standing alongside and jibing at being asked to share the ass's burden, represents the Ulster unions, rated at a much lower level and seemingly now in apparently good (financial) health as the northeast recovered from both Famine and industrial recession. The policy instrument being illustrated here— apparently with HB's approval—is the rate-in-aid measure, which raised a surplus rate from the northern and eastern unions of Ireland to offset the immediate government loan to the still-famished western districts. Although Russell threatens the 'pampered' horse with the stick of higher assessed and income taxes, compliance is seemingly still not forthcoming.[34] Here, Doyle may have had in mind press reports of numerous protest meetings in the north, which witnessed rhetoric blaming the Catholic west for its own misfortunes, as well as proto-nationalist objections from figures such as the Dublin lawyer Isaac Butt, who declared that the rate-in-aid, by restricting the levying of the costs of assisting the west to Ireland alone, rendered the Act of Union 'a nullity'.[35] Doyle appears to have had little sympathy for either Ulster separatism or the incipient Home Rule politics of Butt, and to have accepted, at least temporarily, Russell's argument for the rate-in-aid as an essential intervention.

However, the rate-in-aid, once passed and implemented, turned out to offer little more than a sticking plaster on the gaping wound of Irish distress. By early 1849, it seems that Doyle, in common with many observers, continued to hope for a more sweeping remedial initiative that would offer brighter prospects to the devastated country. Rather surprisingly, given his previous indifference to such schemes, it was Robert Peel who in parlia-mentary speeches on 5 and 30 March 1849 called for a 'new plantation' to attract capital investment to the west of Ireland under the direction of a supervising commission in Connacht.[36] This was the subject of the last HB sketch to address the crisis in Ireland, simply entitled, 'The Irish Problem' (No. 910, 19 March 1849), which was accompanied by a Latin epigram observing that 'the peasant sits waiting until the river shall have passed away'. Russell and Peel are depicted as farmers standing on the bank of a river labelled 'famine, misery, turbulence'; the former is hunched

34 HB, 'The Horse and the Ass' (15 March 1849), print: Tabley Collection at the University of Manchester, available from https://archive.cartoons.ac.uk, ref. no mudyxy4.

35 James Grant, 'The Great Famine and the Poor Law in Ulster: The Rate-in-Aid Issue of 1849', *Irish Historical Studies*, 27.105 (1990), 30–47.

36 Hansard Parl. Deb. (series 3) vol. 103, cols 179–92 (5 Mar. 1849); vol. 104, cols 87–117 (30 Mar. 1849). Peel's point of reference was the Ulster Plantation of 1609.

in defeat and leaning on the rickety staff of the 'Irish poor law', as having abandoned his waste land bill. Approaching him, Peel proposes that they take up his dropped accoutrements—the spade labelled 'private enterprise' and capital—and 'boldly ford the stream' to the further bank, which is helpfully designated as containing 'Millions of acres lying waste; tens of thousands of the population idle yet willing to work—either starving or shut up in buildings ironically called work-houses'. HB obviously approved of Peel's idea, albeit with the caveat (voiced in response by Russell) that 'I wish you had found out all this a little sooner'.[37]

The Times, after a lengthy gap in commenting on the 'Political Sketches', felt obliged to provide a description of this print, 'for [the] many who do not receive political caricatures as fast as they come out, and do not walk very often down the Haymarket or St James's', that is, where the popular print shops were located.[38] The paper was, however, using this primarily as a peg on which to hang an editorial lauding Peel's vision. Excited by the idea of a new, providentially ordained and capitalist 'plantation' of Connacht along the lines of the early seventeenth-century plantation of Ulster, the editorial fantasized at length about its likelihood of success. 'The Thunderer' was not alone in using HB as a point of reference in commenting on Peel's scheme. The Cork-based liberal-Catholic paper, the *Southern Reporter*, while generally supportive, noted that 'It is only a pity, as Lord John Russell is made to say in "H.B.'s" caricature of the two rustics, that we had not all known this a little sooner'.[39]

Peel's 'new plantation' proposal raised some excitement in both Britain and Ireland, but there was neither the political will nor the fiscal resource to see through its more interventionist elements. Ultimately, the government proceeded only with the section to facilitate the sale of mortgaged lands, which was enacted through the 1849 Encumbered Estates Act. This allowed for speculative land purchases, by Irish as well as British buyers, but offered nothing for those rendered destitute and vulnerable by repeated potato failures, clearances and lack of employment; indeed, even worsening their situation by provoking a further wave of clearances to render land 'unencumbered' of 'surplus population'.[40] In the absence of effective state intervention, only the combination of the fading of the ravages of potato blight, continued mass emigration into the early 1850s and a gradual recovery

37 HB, 'The Irish Problem' (19 March 1849), print: Tabley Collection at the University of Manchester, available from https://archive.cartoons.ac.uk, ref. no mudyxy0.

38 *The Times*, 28 Mar. 1849. The article was also published in the *Evening Mail* of the same day, and subsequently summarized in a number of British and Irish provincial papers, such as the Cork *Southern Reporter*, 31 Mar. 1849.

39 *Southern Reporter*, 7 Apr. 1849.

40 James S. Donnelly, *The Great Irish Potato Famine* (Stroud: Sutton, 2001), 158–59.

in the agricultural and industrial sectors began to lift Ireland out of distress—
but at the cost of the loss of a quarter of the island's population to Famine
mortality and emigration by 1851.

Conclusion

In April 1848, *The Morning Post* declared that 'HB is essentially English—
there is no doubt of that'.[41] By this time, the identity of the artist was generally
well known in the political world, although not universally among the
reading public. But if the *Post*'s correspondent was wrong as to the national
origin of the artist, was it a reasonable deduction to make on the grounds of
the political orientation and sensibilities of the 'Political Sketches'? Doyle's
long residence in London as well as his personal politics had distanced him
from the O'Connellite or Whig-Catholic leanings of most of his middle-
class Catholic counterparts in Ireland, especially after the grant of Catholic
emancipation in 1829. The commercial constraints of producing prints
marketable to a 'polite' middle- and upper-class metropolitan audience
reinforced this personal tendency towards political conservatism, which in
turn was augmented by his pursuit of official patronage from Peel in 1842
and, again unsuccessfully, from Russell in June 1850.[42] As an ambitious
man, both for himself and his family, Doyle appears to have embraced the
opportunities offered by the English market while attempting to retain a
Catholic, if not a stridently Irish, personal identity while producing for that
market. In this he was not dissimilar to other Irish middle-class émigrés
active in the London artistic and literary world of his day, such as Thomas
Moore, a friend and admirer of the 'Political Sketches'.[43]

Ireland itself did not support a domestically produced caricature market
in the 1840s. With the exception of the series of 12 anonymous prints
entitled 'Hints and Hits', published in Dublin to support O'Connell in 1844,
and the anti-O'Connell squibs in William McComb's Belfast-published
book *The Repealer Repulsed* in 1841, little seems to have been produced (or
at least to have survived) from this decade.[44] It is unclear whether the one

41 *The Morning Post*, 5 Apr. 1848.
42 John Doyle to Lord John Russell, 20 June 1850, cited in Engen, *Richard Doyle*, 85–86.
43 Cullen, 'Visual Parody', 233. For the milieu of the middle-class London émigré
 community, see R.F. Foster, '"An Irish Power in London": Making It in the Victorian
 Metropolis', in Fintan Cullen and R.F. Foster (eds), *'Conquering England': Ireland in
 Victorian London* (London: National Portrait Gallery, 2005), 12–24.
44 Peter Gray, '"Hints and Hits": Irish Caricature and the trial of Daniel O'Connell,
 1843–4', *History Ireland*, 12.4 (2004), 45–51; Patrick Maume (ed.), *The Repealer
 Repulsed! A Correct Narrative of the Rise and Progress of the Repeal Invasion of Ulster:*

single sheet surviving in the British Library's collection of satirical prints for 1847, satirizing the wealth of the established Church while Ireland starved, was even produced in Ireland.[45]

Despite his compromises to conservative taste and English sensibilities, a continuing strain of concern for Ireland's predicament may be discerned in Doyle's satirical work, not least in his sympathetic representation of attempts to find policy 'solutions' to the Famine crisis, and avoidance of representations of Irish political discord after 1846. Unlike *Punch* and its rivals, he made no reference to the O'Connell–Young Ireland split that summer over the principle of using force in politics, nor to the subsequent militant agitation and desperate attempt at rebellion made by the Young Irelanders in 1848. However, despite his own belief that his sketches were 'an agent of some little influence' in politics,[46] their effectiveness in addressing the enormity of the Famine was tightly circumscribed by the conservative genre of Westminster-oriented satire he had himself moulded since the late 1820s, which proved grossly inadequate for the expression of strong political opinions. In contrast, artists in the satirical periodical press had greater imaginative freedom, while of course also remaining focused on serving the desires of their consumers.

This could cut both ways; John Leech in *Punch* developed an overtly hostile representational line on the Irish (peasants and nationalist agitators alike), tending to demonize both as brutally barbarian and ungrateful. At the same time, John Doyle's son Richard, drawing for the same publication, could in 1846 produce more sympathetic images of the Irish peasantry as deserving objects of charity, albeit counterweighted by a 'British' expectation that self-help by spadework would follow the distribution of alms.[47] *Punch*'s editorial line ultimately proved too antagonistic for 'Dickie' Doyle, although it was over its aggressively anti-Catholic stance on the 'Papal Aggression' rather than its anti-Irish position that he was to resign in 1850.[48] Rivals to *Punch*, such as the short-lived *Puppet Show* (1848–49) appear to have shared this inconsistency. One 1849 cartoon (probably by the French artist Paul Gavarni), 'While the Crop Grows, Ireland Starves', clearly drew on Richard Doyle's earlier representation of the deserving

Dr Cooke's Challenge and Mr O'Connell's Declinature, Tactics and Flight (Dublin: UCD Press, 2003).

45 Anon., 'Servants of the Lord, Rendering an Account of Their Stewardship during the Famine of 1847' (1847), lithograph: British Museum Print Collection, ref. 1868,0808.13081. Available via www.bmimages.com.

46 Doyle Memorandum.

47 [Richard Doyle], 'Union is Strength', *Punch*, 17 Oct. 1846.

48 See Peter Gray, '*Punch* and the Great Famine', *History Ireland*, 1.2 (1993), 26–33; Engen, *Richard Doyle*, 89.

Irish poor, but, more assertively than HB's discussion of similar themes, explicitly called for direct action to relieve the suffering alongside the pet policy projects of Russell and Peel.[49] In contrast to these more emotive images, John Doyle's Famine sketches must be regarded as a failure, at least in terms of shaping public opinion; however, they may offer some insight not only into visualization of the high politics of the event, but also into how one middle-class diasporic figure represented it to himself and to others.

49 'While the Crop Grows, Ireland Starves', *Puppet Show*, 13 May 1849.

3

The Famine Diaries and Sketches of John Plunket Joly

Ciarán Reilly

Maynooth University

In the 1940s, a county Donegal woman relayed to the Irish Folklore Commission the sense of loss experienced by local communities during the Great Famine when she suggested that:

> The years of the Famine, of the bad life and of the hunger, arrived and broke the spirit and strength of the community. People simply wanted to survive [...] Recreation and leisure ceased. Poetry, music and dancing died. These things were lost and completely forgotten. When life improved in other ways, these pursuits never returned as they had been. The Famine killed everything.[1]

Likewise, the nineteenth-century novelist William Carleton noted that 'a brooding stillness lay over all nature: cheerfulness had disappeared'.[2] While the sentiments of the Donegal woman and William Carleton were mirrored in many parts of Ireland, there were some communities which were unaffected by the calamity.[3] Such behaviour of course raises questions about social responsibility and culpability.

The issue of culpability is one which to date has been largely overlooked

1 Quoted in Roger McHugh, 'The Famine in Irish Oral Tradition', in Robert Dudley Edwards and Thomas Desmond Williams (eds), *The Great Famine: Studies in Irish History, 1845–52* (Dublin: Browne & Nolan; 1956), 434–35.

2 William Carleton, *The Black Prophet: A Tale of Irish Famine* (Dublin: Simms & McIntyre, 1847), 17.

3 See, for example, Breandán Mac Suibhne, '"Bastard Ribbonism": The Molly Maguires, the Uneven Failure of Entitlement and the Politics of Post-Famine Adjustment', in Enda Delaney and Breandán Mac Suibhne (eds), *Ireland's Great Famine and Popular Politics* (London and New York: Palgrave Macmillan, 2016), 186–233.

by historians and others. Indeed, as Cormac Ó Gráda has argued, 'several areas of the Famine await exploration by scholars, not least the part played by farmers, shopkeepers and townspeople, or more generally the middle classes, in preventing or exacerbating mortality'.[4] Undoubtedly, the Famine left a legacy of bitterness amongst local communities where people vied for land and survival. A handful of local accounts allude to such behaviour, including the memoirs of the Donegal man, Hugh Dorian, who maintained that:

> those who attained land then held on, heedless of the sorrow in the breasts of others; not only that but they were anxious to get more. Hence bitter feelings were manifest between father and son, neighbour and neighbour, one without protection striving to recover, the other with the landlord at his back, not holding on but trying to become more firm and to add more.[5]

Similarly, some years later, County Cork landowner William Bence Jones asserted:

> Every good tenant soon found out that a broken tenant being put out might mean a substantial gain to himself, one very dear to his heart; he got the field close to his own house that he had coveted all his life, his own Naboth's vineyard, which had been the cause of endless strife from the mutual trespass of his own and his neighbour's cattle.[6]

Perhaps more tellingly, the aforementioned Carleton, writing at the height of the Famine, aptly captured the rapacity and meanness of many who sought to benefit at the expense of others. In his 1847 novel, *The Black Prophet*, he wrote:

> There is to be found in Ireland, and, we presume, in all other countries, a class of hardened wretches, who look forward to a period of dearth as to one of great gain and advantage, and who contrive, by exercising the most heartless and diabolical principles, to make the sickness, famine and general desolation which scourge their fellow-creatures, so many sources of successful extortion and rapacity, and consequently of gain for themselves.[7]

4 Quoted in Toibin and Ferriter, *The Irish Famine*, 7.
5 Dorian, *The Outer Edge of Ulster*, 239.
6 William Bence Jones, *The Life's Work in Ireland of a Landlord Who Tried to Do His Duty* (London: Macmillan and Co., 1880), 102.
7 Carleton, *The Black Prophet*, 67.

While there is ample evidence of 'hardened wretches' vying for their 'Naboth's vineyard' in the contemporary sources, there is little about the normality of life and how certain sections of the community were unaffected by the calamity. Insight into these communities can be gained, for example, from the world of John Plunket Joly (1826–58), the son of a Church of Ireland rector, through his voluminous sketches and diary entries which span the Famine years.[8] For Joly and his family in King's County (now Offaly), life seemed undisturbed by the Famine, where music, dancing and shopping remained constant features of their daily routine.[9] In his diary covering the period 1843 to 1853, and accompanied by several hundred sketches, everyday life in King's County is depicted. These entries and drawings provide remarkable evidence of the Irish midlands during these years, highlighting the behaviour of the local community during the Famine years. Although issues such as culpability and social responsibility are difficult to define, and a more detailed study would be necessary properly to quantify it, this chapter considers the behaviour of one local community in order to understand the variety of experiences in Famine Ireland.[10] Thus the Joly diary entries and sketches, which for the most part appear crude

8 The wider experience of the Joly family during the Famine has been examined in Ciarán Reilly, *John Plunket Joly and the Great Famine in King's County* (Dublin: Four Courts Press, 2012).

9 The Joly diaries, located in the National Library of Ireland and Trinity College Dublin, cover the period 1843–48 and 1851–58. These latter years are marked by Joly's accession to the rectory of Clonsast (when he succeeded his father) and also by his marriage to Julia Anna, daughter of Frederick, Count Lusi. Diaries for the period 1849–50 do not survive, coinciding with the period that Joly spent in England prior to his ordination. In addition to these, a smaller diary, covering the period July to August 1846, records the travels of the Joly brothers to Belgium.

10 Although the sesquicentenary commemoration of the Great Famine witnessed an outpouring of local, national and multi-disciplinary studies, the issue of culpability was not properly addressed or answered. However, a number of scholars including Colm Toibin, Cormac Ó Gráda, James S. Donnelly, Jr. and Christine Kinealy regarded the issue as being intertwined with the so-called 'silence' or reluctance to talk about the Famine amongst later generations. Others, such as Richard Hayes and Christopher Morash, suggested that historians were unwilling to venture into 'one of the largest and darkest areas of Irish history without a strong compliment of colleagues bearing an arsenal of varied disciplinary weapons'. However, in analysing the role of the historian during the sesquicentenary commemorations in the mid-1990s, Mary Daly cautioned about 'rushing to attribute responsibility, culpability and blame' suggesting that there were other issues regarding the Famine which were more pressing. For more, see, for example, Colm Toibin and Diarmaid Ferriter, *The Irish Famine* (London: Pluto Press, 2004), 7; James S. Donnelly, Jr., *The Great Irish Potato Famine* (Stroud: Sutton, 2001), 209; Christine Kinealy, *A Death Dealing Famine* (London: Pluto Press, 1997), 2; Richard Hayes and Christopher Morash (eds), *Fearful Realities: New Perspectives on the Famine* (Dublin: Irish Academic Press, 1996), 9; and Mary E. Daly, 'Historians and the Famine: A Beleaguered Species?', *Irish Historical Studies*, 30.120 (1997), 591–601.

and unsophisticated, provide remarkable evidence of social gatherings and other forms of community engagement during the Famine years, all of which challenge the casual assumption that the years fractured local society and that 'the Famine killed everything'.[11]

The Jolys

Born in 1740 in the town of Charneux, near Liège in modern-day Belgium, Jean Jasper Joly was to become the patriarch of his family in Ireland. In 1767, Joly met William Robert FitzGerald, then Lord Kildare and later the second duke of Leinster, who was undertaking his 'Grand Tour' of Europe.[12] Having grossly overspent, Lord Kildare, it is believed, received a loan of £1,000 from Joly to enable him to continue on his tour. Delighted by this act of generosity, FitzGerald invited him to be his personal secretary. Together they travelled across Europe, visiting amongst other places Milan, Venice, Dresden and Berlin, before eventually reaching Ireland in October 1769. Quickly settling into life in Ireland and his new role as Kildare's private secretary, Jean Jaspar Joly became a Freemason of Dublin City in 1774, and later that year converted to Protestantism. The following year he was promoted to the position of doorkeeper of the Irish House of Lords, a lucrative post with an annual salary of £100.[13] For over 50 years until his death in 1825, Jean Jasper Joly was a close confidant of the second duke of Leinster. The family connections were further underlined by the fact that some of Joly's children were born at Carton House, Leinster's country house near Maynooth, while others were christened in the duke's townhouse, Leinster House in Dublin. In addition, Joly frequently used the duke's influence to acquire positions of employment, in places from Dublin Castle to the rectory of Clonsast in King's County.[14] From 1801 to 1803, Henry Joly, a son of Jean Jaspar, was

11 In Seamus Deane, *The Field Day Anthology of Irish Writing*, 204.
12 The meeting between Lord Kildare and Joly is not recorded in the letters of the second duke of Leinster to his mother. See Brian FitzGerald, *Correspondence of Emily, Duchess of Leinster (1731–1814)*, 3 vols (Dublin: Stationery Office, 1949). However, the family history contained in the Joly papers in the National Library of Ireland does mention the connection with Lord Kildare, later the Duke of Leinster.
13 'A volume containing typescript copies of pedigree and miscellaneous documents relating to the family of Joly from 1380 with biographical notes on individual members of the family. Compiled by Jasper Joly, Dublin, 1969'. National Library of Ireland MS 16,524.
14 See, for example, the diary of Henry Joly on 13 Aug. 1802: using the second duke's influence, Henry called on Mr Wickham, the Chief Secretary at Dublin Castle, to obtain a position for Charles Joly.

tutor to the duke of Leinster's children at Carton, while later still, in 1835, the purchase of an estate in County Clare came as a direct result of help from the third duke of Leinster.

In 1816, the Joly family first settled in King's County (County Offaly) when the aforementioned Henry, now Reverend Dr Joly, was granted the rectory of Clonsast. Located in north-east King's County and bordering both county Kildare and Queen's County (County Laois), the parish of Clonsast was said to have been 'far off all beaten tracks, beside the great bog of Allen and so the people retained most of the ancient Irish characteristics and were to a certain extent unaffected by what is commonly referred to as progress'.[15] On the eve of the Famine, almost a quarter of the parish lay under bog, and it was estimated that it would cost over £12,000 to carry out reclamation. Such unproductiveness gave rise to local poverty, with the poor huddled in makeshift accommodation on the edges of the bog. Indeed, a decade before the Famine, the Reverend Joly concurred that poverty was exacerbated by such housing and noted that a large proportion of the population clamoured for cabins which were 'wretched' and 'made of turf sods, extremely damp and poorly furnished'.[16] His description was comparable to that of Reverend James Colgan, who wrote that at the nearby town of Edenderry 'there are very many poor housekeepers' and that 'families are in a pitiable condition'.[17]

On the eve of the Famine, social, religious and political tensions in King's County reached dangerous levels. Indeed, it was even claimed of King's County that 'not a night passes without an outrage being committed in the county which bids fair to out rival—in deeds of blood and savage barbarity, neighbouring Tipperary'.[18] In May 1843, the murder of the land agent John Gatchell was something of a cause célèbre in the locality and epitomized the social problems which existed in King's County on the eve of the Famine. Gatchell was shot returning from Edenderry, where he had applied for eviction notices to be served on tenants. What is of particular relevance here is that the murder took place in the immediate world of the Joly family. The murder and trial caused a sensation in the barony. Rather surprisingly, then, and given the family's involvement in the investigation, Joly in his personal diary simply notes 'John Gatchell, shot on the road from Clonad opposite Clonkan', and provides no further commentary on

15 'Statement of Colonel Eamon Broy', National Archives of Ireland, Bureau of Military History Statement, WS 1280.

16 *Report from Her Majesty's Commissioners of Inquiry into the State of the Law and Practice in Respect to the Occupation of Land in Ireland* (Dublin: A. Thom, 1845), 574.

17 Rev. James Colgan, Edenderry to relief commissioners, 31 Mar. 1846, National Archives of Ireland, RLFC, 3/1/1098.

18 *The Times*, 25 Dec. 1844.

the murder.[19] This was to be a familiar theme, as Joly remained oblivious to the Famine which unfolded around him. The parish of Clonsast was by no means spared the horrors of the Famine years and there were widely reported instances of the depravations that they wrought. Perhaps the most sensational of these was the case of Kate Lawler, whose 'putrid remains were found in a ditch near Captain Nelson's garden' in early 1847.[20] On another occasion, two corpses were found at a place called 'Timmy's' cross in Clonsast, the victims having succumbed to hunger.[21]

As the winter of 1845 passed, the poor of Clonsast were starving. In January 1846, the daughter of an impoverished local family pleaded with Mary Joly, a sister of the diarist, for money, which was said to have caused the latter some distress.[22] On another occasion (Figure 3.1), a group of 'paupers', led by a man named Gorry, threateningly sought relief at Hollywood House, the Jolys' home, in the middle of the night.[23] On this occasion, Joly and his brother Jasper accompanied their father to the door, armed with a gun: evidence that the people had resorted to desperate measures.

As the hunger continued and the local elite did little to prevent it, it was only inevitable that the poor became involved in crime. The Jolys were frequently targeted and erected new gates on all of their fields in order to prevent the theft of crops and livestock. However, their attempts were not always entirely successful, and in January 1847, Henry Joly, a brother of the diarist, attended a fair at Mountmellick in an attempt to identify five lambs which were stolen. The culprit, Johnny Brown, was later sentenced to six months' imprisonment and was depicted in the diaries being led away to prison. Lacking compassion for Brown's plight, Joly captions the sketch with the words 'bad luck to auld dirty arse'.[24] Interestingly, Joly's sketch of Brown being led away to the local court was one of only a handful of such descriptions, and in general he did not sketch the 'paupers' or indeed give any insight into the lower orders.

In the summer of 1846, alarm soon turned to panic in King's County with the realization that a second crop of the potato had failed. This panic coincided with the Jolys' excursion to the Belgian town of Charneux, where the family searched for information on their ancestry. The trip is

19 'Diary of John Plunkett Joly, 4 May 1843', National Library of Ireland, MS 17,035.
20 'Notebook of James Dillon, King's County Coroner, 1846–53', Offaly History Archives, Tullamore, OHS 51.
21 Clonbullogue I.C.A., *The Life, the Times, the People: Clonbullogue, Bracknagh and Walsh Island* (Tullamore: 'The Committee', 1993), 229.
22 See 'Joly diary', various entries.
23 'Joly diary', 6 Jan. 1847.
24 'Joly diary', 2 Jan. 1847.

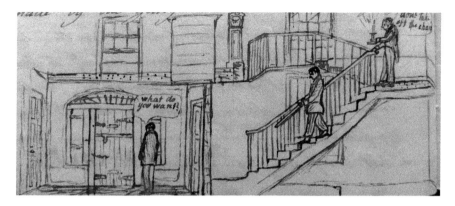

3.1 'Seeking Relief at Hollywood House', John Plunket Joly diaries, 6 January 1847, MS 17,035
Courtesy of National Library of Ireland

significant given what the Jolys witnessed, and also for the activities that they engaged in. Their journey to Charneux via Holyhead included visits to Liverpool, Birmingham, London and Ostend, marked in each instance by high dining. While Joly was selective in what he sketched on this trip (in London he sketched St Paul's, Trafalgar Square, Nelson's Pillar and a statue of the Duke of Wellington), he does provide a written description of Famine emigrants, noting that there were 'many Connacht people in the fore part of the ship and in among the pigs'. Further describing the experience, he notes that during the night 'a drunk bagpiper played and the people danced on the boat'. Many of these people, sick and hungry, were fleeing Ireland, and Joly stayed up late 'looking at the sick people sprawled about the deck'. His own experience contrasted sharply. Arriving at Ostend, the Jolys dined on 'soup, sole, beef, fowl, apple pie, egg pudding, cakes, gooseberries, currants and a bottle of wine'. At Charneux, where their grandfather had been born, they ate 'bacon, eggs, potatoes, kidney beans, bread, cheese and ale'. Indeed, the trip is littered with entries about the consumption of wine, ale, beer, cider and spirits. On one occasion, Joly noted that 'we drank strong ale which, with the heat of the day, made Henry and I so stupid that we could not dine that evening'.[25]

On their return to Ireland, the brothers were greeted at Rathangan, County Kildare, by the 'great smell from the rotting potato stalks everywhere', one of the few times that Joly refers to the potato blight in his diaries.[26] Instead, his entries of the Famine years are characterized by

25 'Joly diary', undated (but July 1846).
26 'Joly diary', 9 Aug. 1846.

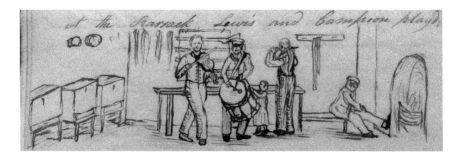

3.2 'Playing Music at the Barracks', John Plunket Joly diaries, 22 August 1847,
MS 17,035
Courtesy of National Library of Ireland

musical entertainment and other forms of leisure and neglect the unfolding
catastrophe. Music in particular played a significant role in Joly's life and
that of the local community. When in June 1846, for example, the 'new
potatoes' were dug early because of the fear that they would be lost to
blight, there was an evening of celebration, with villagers 'dancing to the
sweet music of Campion's flute' and other instruments.[27] Indeed, such was
the interest taken in these activities that Joly organized for a band master
to teach those interested in playing instruments. He also consulted with
local men who had an interest in music, including one man, Farrell, who
had a large collection of musical instruments including a clarinet, fiddle
and violin. Farrell was a wealthy local miller, and dances were frequently
held at his mill. Joly also employed John Delaney, a music master from
Portarlington, at 10 shillings per month, to teach musical instruments and
dance. Delaney's lessons included dancing (particularly the polka), singing
and lilting. Emphasizing that such musical gatherings were not open to
all classes, in August 1847, Joly noted how Delaney taught 'a select group
the first principles of polite dancing'. As depicted in the diaries, lessons
usually took place at Hollywood House or at the police barrack at nearby
Clonbullogue.[28] Such occasions were far removed from the reality of life
in Famine Ireland, as depicted in Figure 3.2, where, 'at the Barrack',
Constables Lewis and Campion play music with another man. In the
background a young girl watches while a man warms himself by the fire.

27 'Joly diary', 18 June 1846.
28 In 1900, the 'Joly band', established in 1851, was still in existence and numbered over
 40 members. Indeed, music, song and dance continued to play a part in Clonsast
 after the Famine, and tradition of music at social gatherings such as 'saving the hay'
 continued long into the twentieth century in the parish.

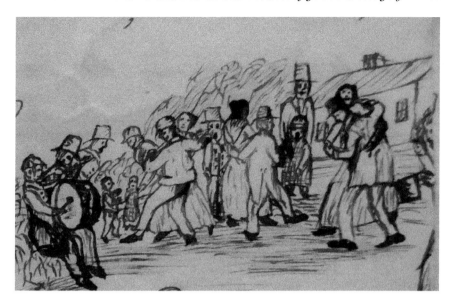

3.3 'Dance at Killahan', 8 May 1846, John Plunket Joly diaries, MS 17,035
Courtesy of National Library of Ireland

It could be argued that such gatherings prevented the police from carrying out official duties, and that the money paid to the music master that Joly employed could have been put to more effective use in relieving local poverty, given the extent to which the population decreased in the parish of Clonsast during the Famine years.[29]

Throughout the Famine, Joly continued to play music and was the principal organizer of dances, recitals and other related activities in Clonsast. These social gatherings were certainly not obliterated by the Famine and the evidence for Clonsast suggests that those who were fortunate enough to remain in employment also shared in such entertainment. For example, in May 1846, at a social event at Killahan, near Bracknagh (Figure 3.3), 'George Redding caused a dance to take place on the road, where Thomas Corcoran played the pipe and I the drum while three couples danced and the spectators shouted manfully'. Joly suggests that such occasions were spontaneous, highlighting that the people were willing to engage in these activities. Similarly, in September, Joly noted how they had 'a march of

29 For example, within the parish of Clonsast there was a marked decline in population in several townlands. The townland of Aghameelick, declined by 61 per cent, Bracknagh by 36 per cent, Clonmore by 35 per cent, Clonsast Lower by 32 per cent, while the village of Clonbullogue declined by 50 per cent.

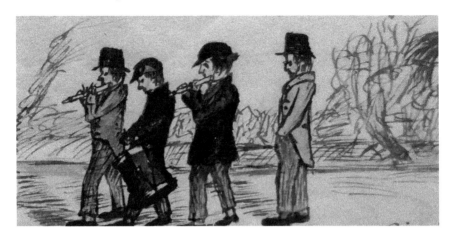

3.4 'A March of Flutes and Drum from Berminghams to Behans', 1 September 1846, John Plunket Joly diaries, MS 17,035
Courtesy of National Library of Ireland

flutes and drum from Berminghams to Behans, a party of Connacht men following us'; the latter, perhaps, looking for relief, although they were not depicted in the sketches (Figure 3.4). The following day, the crowds gathered again, expecting to see 'some good dancing on the road, but as Chapman cut his fingers, he only had one round'. Another dance occurred the following evening at Behan's, where 'Patsy Kelly and Julia Bean' were 'dancing to the music of Chapman's flute'. In November, they assembled for music in Clonbullogue as Joly 'beat the drum, while Henry and John Behan played the fiddle'. Later the same month, he noted that Johnny and Denis Dempsey were at Hollywood House, where there was 'dancing and sport until 1am'. In January 1847, one of the worst months of the Great Famine owing to the severity of the weather, he notes that 'Henry, I and Natty Kelly played [music] along the road'.[30]

Music and dancing also accompanied farm work and the gathering of the harvest. In August 1847, for example, after 36 loads of hay were drawn from Clonbullogue, Joly and others enjoyed an evening of 'lively entertainment' at which Ned Charmychael played the fiddle while John Connell and Patsy Kelly danced (Figure 3.5). Joly's sketch provides evidence of Charmychael playing as the hay is delivered to Hollywood House, much to the delight of the workers. Music was an integral part of Joly's life and seldom does a day pass during the Famine years without some reference to these activities. The musical gatherings were often carried out by travelling musicians,

30 'Joly diary', 11 Jan. 1847.

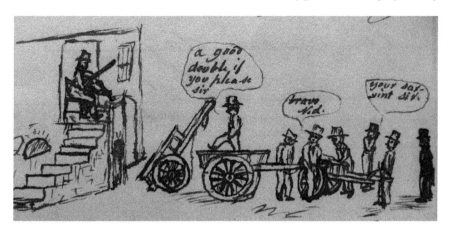

3.5 'Lively Entertainment after Harvest at Clonbullogue', 13 August 1847, John Plunket Joly diaries, MS 17,035
Courtesy of National Library of Ireland

including a man named 'Joyce', a professional fiddler from Tullamore who travelled the county. Despite the best efforts of Father Matthew and the temperance movement at Clonsast, musical gatherings and harvest work often resulted in the consumption of large amounts of alcohol. On one such occasion, after the washing of sheep in the Figile river, Joly noted: 'young Hanibo made sick by whiskey'.[31]

The Jolys also spent lavishly during the Famine years on items which included musical instruments, chairs, wardrobes, beds, tables and, most importantly, books, adding to their ever-expanding library. Indeed, the purchase of books was a weekly, if not daily, occurrence during the Famine, and reflected their interests and advanced knowledge. These books included *The Gardeners Almanack*, *The Vicar of Wakefield*, three volumes of the *Library of Wilful Knowledge on Vegetable Substances*, *Outlines of History* by Lardner and Smillis's *Philosophy of Natural History*. A lover of nature, Joly daily sketched birds, animals, plants and insects that form an alternative picture to the one of the Famine-ravaged Irish landscape. In April 1846, for example, he was perturbed to find that people were robbing birds' nests in their predicament. The people's condition was in stark contrast to the diet of his pet rabbits, who were fed 'curled cale, boiled potatoes and sometimes a bunch of parsley, of which they are very fond'.[32] Joly also took an interest in antiquarian pursuits, visiting castles

31 'Joly diary', 14 July 1846.
32 'Joly diary', 9 Apr. 1846.

and historic sites across the midlands, sketching and making drawings of these. Other excursions included a trip in June 1847 to Monasterevin to see the progress of the railroad works, where John Plunket sampled 'cheese and cider'.[33] The brothers also made frequent shopping trips to Dublin, where they visited and purchased goods in shops such as Andrew's, Bewley's, Cranefield's, Piggot's and Pim's. The evening was usually spent in Dublin Castle, the Hibernian Academy or the Queen's Theatre.

The foregoing examples of the normality of life for Joly and the local community would suggest that they were oblivious to the plight of those in their immediate world. Or had they become accustomed to death and destitution? Perhaps it was indicative of Joly's blindness to the suffering of the people in general that he noted in his diary the large gathering of people in December 1846 to 'slide on the ditch at Kit Cassidy's' following a heavy fall of snow.[34] His perception was that the harsh winter conditions offered some form of sport, which of course hid the realities of life. It was another indication that families such as the Jolys were largely unaffected by the calamity. At Hollywood House, the Joly family continued to dine as they did before the onset of Famine. In August 1846, for example, on a rare occasion, Joly noted 'we had bread for dinner for want of potatoes'.[35] On another occasion, he remarked that the family had grated some rotten potatoes to make starch, 'they being useless for food'.[36] There was certainly indifference to the plight of many who were evicted locally. This was particularly true of the clearances on the neighbouring estate at Bracknagh belonging to Lord Ashtown, where 57 houses were knocked down in one day. It is interesting that a clearance of 700 people could have generated so little reaction. In his personal diaries, Joly makes little reference to the clearance, except noting, on 20 June 1851, 'most of the houses of Bracknagh pulled down'. Nor does he provide a sketch of the clearances, which naturally would have left a lasting impression, with cabins torn down as the village was razed to the ground and the local landscape altered forever.[37] The apparent lack of empathy with the plight of those affected by the clearances was probably the result of the friendship between Ashtown and the Jolys; indeed, the diaries record that the former was a regular visitor at Hollywood House.

The Bracknagh clearances are just one example of Famine-related events which occurred in Joly's world and for which he offers little commentary.

33 'Joly diary, 15 June 1847.
34 'Joly diary', 6 Dec. 1846
35 'Joly diary', 14 Aug. 1846.
36 'Joly diary', 24 Aug. 1846.
37 'Diary of Rev John Plunket Joly, 1851–1858', 20 June 1851, Trinity College Dublin MS 2299/1–2.

These are curious omissions, particularly because Joly provides detailed accounts of the suffering of his own family during these years. In January 1848, for example, his mother, Martha, died after several days' illness, surrounded by the neighbours and friends who had stayed up all night. Joly describes his mother's death thus:

> The Mrs breathed quick and drank spoonful's [*sic*] of wine frequently till four o'clock pm. Jasper being with her all day after which time she slept a few minutes and seemed quite easy and calm in her breathing which became slow and gradually weaker at ¼ before five when she awoke, fixed her eyes on Jasper and died, pleasantly calm. The Dr and Mary standing beside her bed, Jasper supporting her head.

Accompanied by his friend Pat Redding, Joly left for the nearby village of Rathangan to purchase deal boards to make his mother's coffin, which was lined with flannel. A painting of his mother was also made, so that a marble bust could be commissioned later. Family friends dug and filled in the grave, while others spread the sod. In his diary, Joly included a number of sketches depicting the death and burial of his mother, in stark contrast to that of the lower classes and particularly the case of Kate Lawler already alluded to.

While it could be argued that Clonsast may have been spared some of the horrors of Famine as experienced elsewhere, Joly makes no mention of distress in other places he visited, including Clare and Dublin, where he would surely have witnessed the devastation at first-hand. These included a visit to Kilrush, County Clare, by then one of the most Famine-ravaged towns in Ireland and close to the family's estate at Carrigaholt. This trip also included a visit to Limerick, where Joly sketched the town and stayed at the 'Clare Hotel'. Again, the diaries offer no insight into the conditions or plight of the people of Clare or Limerick. Likewise, away at Trinity College, Joly's studies were undisturbed by the onset of Famine. These 'pleasant' experiences included visiting relations; taking long walks in and around the city with his companion, John O'Regan; and frequenting bookshops and libraries. In June 1846, he received an allowance from his father, and was also in receipt of a scholarship from the college, evidence of his outstanding academic ability.

Conclusion

'That year is all over, a good one it was, that the next may be as good'. Thus, John Plunket Joly brought his diary for year 1846 to a conclusion

almost fifteen months after the arrival of the potato blight in Ireland. This entry heralding in 1847, or 'Black '47' as it would come to be known, was typical of the lifestyle led by Joly, his family, friends and neighbours. His diaries and sketches provide us with a rare glimpse of a life undisturbed by the Famine years. An examination of the social world of the Jolys during the Famine contrasts greatly with the plight of the inhabitants of Clonsast. Spending was not curtailed during the Famine years and the brothers enjoyed many of the same pleasures they had done in previous years. Although it can be argued that the Jolys played an integral role in the provision of relief in the parish of Clonsast, more could have been done or at the very least their social and leisure pursuits could have been curtailed. The diaries are remarkable for the paucity of references to hunger, death or Famine-related diseases. Even where the Famine was referenced, there was little discussion or illustration elaborating upon the widespread suffering. For example, after a visit with Matt Goodwin to the Edenderry workhouse, where there were over 1,800 inmates, in August 1847, Joly does not offer any insight into general conditions or what they saw.

The Joly Famine diaries present a considerable challenge to historians and a number of questions remain. Why did Joly choose to record and sketch the things that he did? Why did he deny the obvious death and destitution which he must have witnessed first-hand in Clonsast or on his numerous visits to Dublin, Clare and elsewhere? By way of conclusion, it is worth noting that by the mid-1850s, by which time he had succeeded his father as rector of Clonsast, Reverend John Plunket Joly regularly preached to his congregation about death, disease and suffering. On one occasion he referred to death, which 'has made us so familiar with it that we don't think of it. We see daily instances before our eyes of what we ourselves must come to both young and old folk around us dying'.[38] Was it simply a case that Joly witnessed so much death during the 1840s that it did not merit inclusion in his diaries or sketches?

Although these were private diaries, written with the belief that they were unlikely to be seen again or by the public at large, at the very least they offer something of a barometer about the issue of culpability and social responsibility. Although, as James Donnelly, Jr. has cautioned, 'the facts have not all been gathered, or are they likely ever to be', issues such as culpability continue to be contentious in the study of the Great Irish Famine. Examination of communities during the 1840s provides the potential to reveal how the Famine played itself out at a local level. With the availability of heretofore unexamined primary sources, not least

38 'Sermons of Rev John Plunket Joly', National Library of Ireland, MS 8523.

of them the Joly Famine diaries, new light is shed on the Famine, and in particular the issue of culpability, which has long been problematic in Irish historiography.

4

Mortuary Spectacles:
The Genealogy of Images of the Famine Irish
Coffin Ships and Fever Sheds

Jason King

Irish Heritage Trust

This chapter examines the genealogy of the images of the 'coffin ships' and 'fever sheds' and traces their historical moment of origin. More specifically, it considers the power of those images to shape public reaction and government policy in response to the Irish Famine migration of 1847–48. David Wilson has convincingly argued that Thomas D'Arcy McGee first coined the phrase 'sailing coffins' in March 1848, 'and before long the boats that carried famine migrants across the Atlantic became known as "coffin ships"'.[1] D'Arcy McGee's 'sailing coffins' is a curiously literary construction, a verbal expression devoid of visual referent. Above all else, the image of the coffin ship is evocative of migrants in peril. This is precisely what is lacking in almost all visual but not textual representations of the Irish Famine migration. In her groundbreaking study, *Commemorating the Irish Famine: Memory and the Monument* (2013), Emily Mark-FitzGerald notes that 'scenes of emigration' are 'more numerous and varied than any other type of Famine-related subject pictures', yet they almost never feature migrants in danger.[2] Similarly, Niamh O'Sullivan observes that there is 'a discrepancy between the images and texts in describing the reality of the emigrant experience [...] No image matches the horror of the written eyewitness accounts'.[3]

Nevertheless, there is one contemporary painting, created in 1847, that does depict the suffering of Irish emigrants and the horror of the

1 David Wilson, *Thomas D'Arcy McGee: Passion, Reason, and Politics: 1825–1857* (Montreal and Kingston: McGill-Queen's University Press, 2008), vol. 1, 192.

2 Emily Mark-FitzGerald, *Commemorating the Irish Famine: Memory and the Monument* (Liverpool: Liverpool University Press, 2013), 30.

3 Niamh O'Sullivan, *The Tombs of a Departed Race: Illustrations of Ireland's Great Hunger* (Hamden, CT: Quinnipiac University Press, 2014), 57.

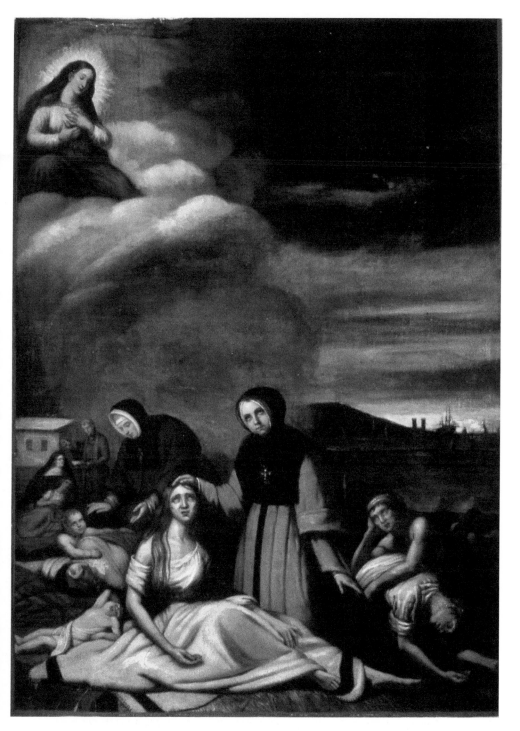

4.1 Théophile Hamel, *Le Typhus* (1848)
Collection of the Congrégation de Notre Dame de Montréal, Marguerite
Bourgeoys Museum; photographer Normand Rajotte

coffin ships at the moment of their arrival in the fever sheds of Montreal: Théophile Hamel's *Le Typhus* (Figure 4.1). During that summer, tens of thousands of typhus-stricken Irish emigrants were cared for by the Grey Nuns and female religious orders in the city's fever sheds, where up to 6,000 perished and were buried in the immediate vicinity.[4] *Le Typhus* records their suffering and provided the centrepiece of an exhibition that I curated from April 2015 to March 2016 with Christine Kinealy of Ireland's Great Hunger Institute and the Arnold Bernard Library at Quinnipiac University entitled 'Saving the Famine Irish: The Grey Nuns and the Great Hunger'.[5] The exhibit then transferred in 2016–17 to the Centaur Theatre and the Grey Nuns' Hospital National Historic Site in Montreal and the Glasnevin Museum, EPIC, The Irish Emigration Museum in Dublin and Maynooth University's Russell Library.[6] It features correspondences between Hamel's painting and the eyewitness accounts written by the Grey Nuns and female religious communities that cared for Famine emigrants, whose digitized annals can be found in the Irish Famine Archive.[7]

This chapter first considers Théophile Hamel's *Le Typhus* and its historical moment of composition, exploring the influence of French Romanticism, and especially Theodore Géricault's *Raft of the Medusa* (1819), on Hamel's work, and the aesthetic strategies Hamel employs to represent the plight of migrants in mortal peril. It also traces the popular memory of the coffin ships to the painting's historical moment of creation, as one of a number of verbal and visual representations of the Famine Irish migration to the Canadian colonies in the autumn of 1847. Elsewhere I have argued that the most detailed accounts of the suffering of Famine emigrants in North America are contained in the annals of the Grey Nuns, whose care for fever victims was also represented in other textual and visual

4 According to Kerby A. Miller, 100,000 of the most destitute took the cheaper passage to British North America, and up to a third of them perished at sea or in the fever sheds at the quarantine station at Grosse Isle, Montreal, further upriver on the St Lawrence. Kerby A. Miller, 'Emigration to North America in the Era of the Great Famine, 1845–55', in John Crowley, William J. Smyth and Mike Murphy (eds), *Atlas of the Great Irish Famine* (Cork: Cork University Press, 2012), 214–15.

5 See https://www.qu.edu/on-campus/institutes-centers/irelands-great-hunger-institute/grey-nuns-and-the-great-hunger.html (accessed 3 Dec. 2016).

6 See www.glasnevinmuseum.ie/news/saving-the-famine-irish-the-grey-nuns-and-the-great-hunger.cfm; René Bruemmer, 'Irish famine exhibit celebrates courage of Montreal's Grey Nuns', *Montreal Gazette*, 11 Apr. 2016: http://montrealgazette.com/news/local-news/irish-famine-exhibit-celebrates-courage-of-montreals-grey-nuns (accessed 3 Dec. 2016).

7 Jason King (ed.), 'Irish Famine Archive': http://faminearchive.nuigalway.ie (accessed 3 Dec. 2016).

works, including *Le Typhus*.[8] Although the genealogy of the images of the coffin ships and fever sheds originates primarily in verbal rather than visual representations of the Irish Famine migration, it also derives from Hamel's painting that is most closely associated with these textual sources. Hence, I want to trace these images of migrant mortality and mental distress to the late arrivals of emigrant vessels in the autumn of 1847.

The imagery of migrant mortality helps to define Géricault's painting, McGee's 'sailing coffins' and the cultural memory of the coffin ships. Marguérite Corporaal and Christopher Cusack have tracked this memory to a corpus of nineteenth-century novels in which, they argue, 'the coffin ships facilitate the development of microcosmic Irish "imagined communities", functioning as "heterotopias" where the cultural clashes experienced in the homeland and the pending assimilation in the New World have to be negotiated'.[9] Joseph Pugliese also employs Foucault's concept of the 'crisis heterotopia' to envision the Italian island of Lampedusa and Christmas Island near Australia, which were nineteenth-century penal colonies and twenty-first-century sites of immigrant detention, as past and present 'border zones of the dead'.[10] In other words, the compression of cultural and social tensions into the confined setting of the steerage and the fever sheds helps create and define mortuary spectacles that become palimpsestic and recur in subsequent maritime disasters and migration crises. These border zones of the dead can be discerned in a set of composite and disparate textual and visual renderings of the Irish Famine migration from which the popular image of the coffin ship was comprised.

Tracing 'Le Typhus': Géricault and Hamel

In the mid-nineteenth century, Théophile Hamel was one of Quebec's most successful painters. He was born in 1817 in Sainte Foy, near Quebec City, and became apprenticed to Quebec's most prominent artist, Antoine Plamondon, at the age of 16. 'It was doubtless on Plamondon's advice that Hamel set out for Europe in 1843', notes R.H. Hubbard, 'armed with a

8 Jason King, 'The Remembrance of Irish Famine Migrants in the Fever Sheds of Montreal', in Marguérite Corporaal, Christopher Cusack, Lindsay Janssen and Ruud van den Beuken (eds), *Global Legacies of the Great Irish Famine: Transnational and Interdisciplinary Perspectives* (Oxford: Peter Lang, 2014), 249–54.

9 Marguérite Corporaal and Christopher Cusack, 'Rites of Passage: The Coffin Ship as a Site of Immigrants' Identity Formation in Irish and Irish American Fiction, 1855–85', *Atlantic Studies*, 8.3 (2011), 345.

10 Joseph Pugliese, 'Crisis Heterotopias and Border Zones of the Dead', *Continuum*, 23.5 (2009), 663–79.

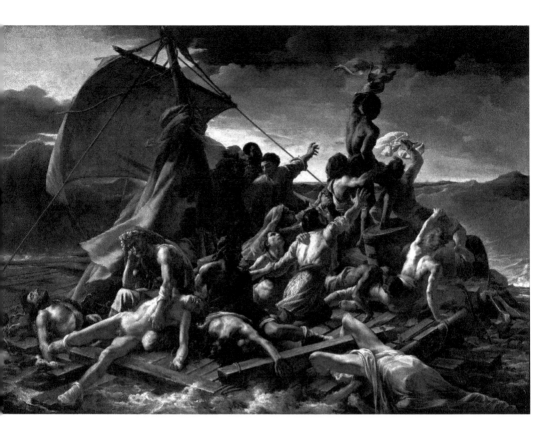

4.2 Théodore Géricault, *The Raft of the Medusa* (1818/19), oil on canvas,
491 cm × 716 cm
Louvre Museum, Accession number INV 4884

few commissions to make copies of European masterpieces',[11] including
Theodore Géricault's *Raft of the Medusa* (Figure 4.2).[12] Hamel then returned
to Quebec City in August 1846 and remained there for little over a year,
before moving to Montreal in the late autumn of 1847. Like most people in
Montreal, he personally observed the Irish Famine influx and was exposed
to the threat of infectious disease even before he was commissioned to paint
Le Typhus by the city's Bishop Ignace Bourget on 13 August 1847.[13] Indeed,
Bishop Bourget declared: 'I will display a votive offering, [...] a painting

11 R.H. Hubbard, *Antoine Plamondon and Théophile Hamel: Two Painters of Quebec*
 (Ottawa: National Gallery of Canada, 1970), 35.
12 Jacques Des Rochers, 'Le Typhus, History of a Painting', in Patricia Simpson and
 Louise Pothier (eds), *Notre-Dame-de-Bon-Secours: A Chapel and Its Neighbourhood*
 (Montreal: Fides, 2001), 93.
13 Dan Horner, '"The Public Has a Right to be Protected from a Deadly Scourge":
 Debating Quarantine, Migration, and Liberal Governance during the 1847 Typhus
 Outbreak in Montreal', *Journal of the Canadian Historical Association*, 23.1 (2012),
 65–100; King, 'Remembrance of Irish Famine Migrants', 258–60.

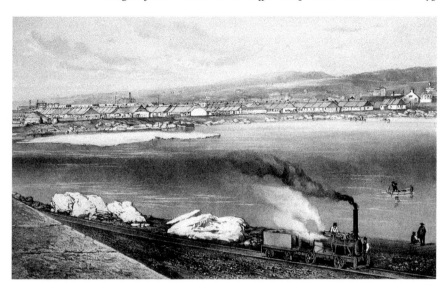

4.3 Anonymous, *Temporary Locomotive, Workmen's Houses and Workshops* (1860, 19th century), coloured ink on paper, 42.2 cm × 58.6 cm
Gift of Mr David Ross McCord, M15934.46 © McCord Museum

representing the typhoid epidemic trying to enter the city but stopped at the gates by [the Virgin Mary's] powerful protection'.[14] The painting features a continuous narrative of the nuns who tended to Famine migrants based on Hamel's eyewitness impression.

Hamel's vantage point is significant, because it positions the artist at the south-western perimeter of the sheds, on the far side of Windmill Point where they were relocated away from the city in August 1847, in a location that was restricted to visitors to the site.[15] As Jacques Des Rochers notes, Hamel's 'view from this perspective and the presence of a shed place the scene in its original setting'.[16] An 1852 Endicott & Co. lithograph from the vantage point of Mount Royal offers a diametrically opposing perspective to that of Hamel's in *Le Typhus*. The lithograph contains a sweeping north-east view of the city of Montreal and distant fever sheds from the near side of Windmill Point, behind which Hamel's painting was envisioned.[17] Moreover, the only photograph of the fever

14 Des Rochers, 'Le Typhus', 92.
15 Sheila Doyle Dreidger, *An Irish Heart: How a Small Irish Community Shaped Canada* (Toronto: HarperCollins, 2010), 49–50.
16 Des Rochers, 'Le Typhus', 93.
17 Marian Scott, 'Montreal, Refugees and the Irish Famine of 1847', *Montreal Gazette*, 12 Aug. 2017. The lithograph is reproduced in the article: http://montrealgazette.

sheds, taken by William Notman from a more southerly vantage point after they were renovated in 1858 to house workers building the city's Victoria Bridge,[18] was also engraved as a colour print in James Hodge's *Construction of the Great Victoria Bridge in Canada* (Figure 4.3).[19] The lithograph, photograph and the engraving all attest to the accuracy of Hamel's rendering. Hamel installed *Le Typhus* on 21 May 1848 in the ceiling of the city's Notre-Dame-de-Bon-Secours church, where it can still be seen today.[20] Between August 1847, when the painting was commissioned, and its completion in May 1848, the fever sheds of Montreal were continuously occupied by Irish emigrants and the Grey Nuns, who cared for the emigrants on a daily basis. Their annals and Hamel's painting record the same harrowing 'scene in its original setting' as it transpired.

Despite its provenance as one of the only contemporary paintings of the Irish Famine migration, Hamel's *Le Typhus* has attracted relatively little interest. *Le Typhus* expresses not only Hamel's impression of suffering Irish emigrants, but also incorporates figures from Theodore Géricault's *Raft of the Medusa*, the defining masterpiece of maritime distress. As Jacques Des Rochers notes, 'the two male figures on the extreme right are taken from the famous painting of Géricault'.[21] In tracing Géricault's influence, Hamel's formal incorporation of figures from *The Medusa* as well as his scenic composition of distressed migrants needs to be considered.

Hamel was inspired by Géricault's depiction of shipwrecked victims in a moment of crisis and by the latter's graphic portrayal of death. Géricault had completed *The Raft of the Medusa* in 1819, three years after the ship *Medusa* became marooned on a sandbar off the coast of Senegal and members of its crew were cast adrift on a ramshackle vessel for ten days, during which they succumbed to cannibalism and murder before being rescued by the *Argus*. The painting captures the moment at which they desperately signal the *Argus*, as it begins to disappear over the horizon.

com/feature/montreal-refugees-and-the-irish-famine-of-1847 (accessed 28 Nov. 2017). Credit: McGill University Rare Books and Special Collections.

18 William Notman, *Construction Buildings from Top of Bridge, Victoria Bridge, Montreal, QC, 1858–59*. McCord Museum, Montreal N-0000.392.2.2: http://collections.musee-mccord.qc.ca/scripts/large.php?Lang=1&accessnumber=N-0000.392.2.2&idImage=153944 (accessed 23 Jan. 2017).

19 Anon., *Temporary Locomotive, Workmen's Houses and Workshops*. McCord Museum, Montreal M15934.46. Print. McCord Museum. http://collections.musee-mccord.qc.ca/scripts/large.php?Lang=1&accessnumber=M15934.46&idImage=165750 (accessed 23 June 2017). The engraving can also be found between pages 76–77 of James Hodge, *Construction of the Great Victoria Bridge in Canada* (London: John Weale, 1860).

20 Jason King (ed.), 'Irish Famine Archive', 67: http://faminearchive.nuigalway.ie/docs/grey-nuns/TheTyphusof1847.pdf (accessed 23 Jan. 2017).

21 Des Rochers, 'Le Typhus', 93.

In his composition of the painting, Géricault famously brought home body parts from the morgue and interviewed the raft's survivors to depict their suffering in extremis.[22] The *Raft of the Medusa* is often interpreted not only as a harrowing history painting, but also as an allegory about Restoration France, in which the wreck signifies the foundering of the French ship of state after the return of the Bourbon monarchy following Napoleon's defeat in 1815. The ship's captain appears to epitomize the appointment of royalist émigrés to positions of influence. Géricault broke with the conventions of neoclassicism in his choice of subject matter and in his emphasis on ordinary mariners and their desperate struggle for survival, in place of the plight of their leaders. As Jonathan Myles notes:

> Géricault's major painting brings the spectator right up to the action, revealing the artist's early and persistent understanding of the power of the close-up. In *The Raft*, such a procedure insists on the terrifying distance between the seemingly futile agitation of the survivors and the almost imperceptible fleck of *The Argus* on the horizon. This symbolically asserts the gulf between the peril of the abandoned and the distant attitude of the leaders of the expedition.[23]

Indeed, Géricault depicts the very moment in which the survivors are roused by the prospect of rescue while others have succumbed to despair. This tension between the expectation of salvation and the abandonment of hope is at the heart of the painting, the fulcrum of which divides the sailor signalling the ship at the top right from the crouched figure at the bottom left who cradles a corpse, displaying a vacant stare.

This survivor seems to suffer more from mental anguish than the physical degradations of the splayed bodies that surround him. He appears curiously detached and disengaged from the action, removed from the observer's line of vision that scans the horizon in search of salvation, like the other figures in Géricault's painting. Indeed, as the raft's crew lurch to the right to gain the attention of the *Argus*, the only living figure left amongst the group of corpses in the bottom of the frame looks almost eerily composed. Despite the commotion that surrounds him, he seems anomalous, hopeless and immobile.

This figure of despair is precisely the one that Hamel incorporates into *Le Typhus*. In his description of the painting, Jacques Des Roches notes that:

22 Jonathan Myles, *Medusa: The Shipwreck, The Scandal, The Masterpiece* (London: Pimlico, 2008), 169–77.
23 Myles, *Medusa*, 186.

in the upper level, the Blessed Virgin in the clouds is separated from the temporal world in the lower level. Depicted diagonally from foreground to background are a Grey Nun, a Sister of Providence and a priest administering the last rights to a dying person with the help of a Hôtel Dieu nun. In the background, between the Saint Lawrence [river] and Mount Royal are the city and the bell towers of Notre Dame.[24]

Thus, the axis of the image draws the viewer from the figure of the Virgin Mary in the top left of the frame to the despondent survivor that Hamel copied from Géricault in the bottom right. Elsewhere I have noted that *Le Typhus* is not simply a commemorative image but a medium of intercession, in which the Bishop summons the Virgin Mary to halt the typhus epidemic from entering the city under her 'powerful protection'.[25] I want to suggest further that the threat of typhus is portrayed quite literally in the painting, as the Virgin Mary appears not only to perch on billowing clouds but also to block the miasma and vaporous fumes that were mistakenly believed to cause the disease from spreading into the city.

The diagonal in Hamel's image is defined by this line of vision from the Virgin to the despondent figure clutching a corpse. As in *Raft of the Medusa*, the figure seems oblivious of his surroundings, beyond hope of rescue and the reach of the female religious sisters who provide succour and the prospect of salvation. Furthermore, as in Géricault's painting, he seems already to have joined the ranks of the dead, whose scattered bodies and limbs lie haphazardly amongst the living. Like Géricault, Hamel attempts to use cloud formations and brightening skies on the horizon with a ship's mast in the far distance to signify the prospect of rescue and the resolution of crisis, but one that does not extend to the despondent figures in the foreground. Indeed, Hamel's composition of clustered living and dead bodies thronged together in a seething mass, and his close-up portrayal of their mental anguish and physical suffering, is directly influenced by Géricault, who helped him envision this scene as a harrowing, mortuary spectacle.

24 Des Rochers, 'Le Typhus', 92.
25 Jason King, 'Remembering Famine Orphans: The Transmission of Famine Memory between Ireland and Quebec', in Christian Noack, Lindsay Janssen and Vincent Comerford (eds), *Holodomor in Ukraine and Great Famine in Ireland: Histories, Representations and Memories* (London: Anthem Press, 2012), 124.

Verbal and Visual Images of Coffin Ships

More broadly, Hamel's painting provides a composite image, a montage of the huddled masses of typhus victims who arrived in Montreal's fever sheds throughout the summer of 1847. It is a composite image, in the sense that its chronology is diachronic rather than synchronic. The three orders of nuns depicted in the continuous narrative of the painting never stood alongside one another but rather worked in succession to care for fever victims whilst their ranks were thinned by the same affliction. In a more fundamental sense, *Le Typhus* also encapsulates a form of tension between the face of the individual migrant and the image of the crowd, one that would become a recurrent feature of visual representations of mass migration. Indeed, this tension between the face and what Liisa Malkki terms the 'anonymous corporeality' of the crowd is inherent in any depiction of mass displacement.[26] At first glance, it might seem that this tension can be resolved by focusing on the face of the individual migrant, emphasizing the solitary figure within the crowd. But Hamel's incorporation of Géricault's despondent survivor provides a salutary reminder that the individual migrant is no less anonymous or meaningful a signifier of traumatic upheaval than images of huddled masses. The sheer despondency of his expression negates any impression that he can make comprehensible their plight. His eyes provide no window into the soul. They attest only to his anonymous corporeality, like the scattered corpses that surround him.

This image of mental anguish also complements the most compelling verbal descriptions of the coffin ships. As noted, Hamel moved to Montreal in the autumn of 1847 when fewer vessels were arriving from Ireland but mortality rates in the city's fever sheds remained very high. Moreover, he was in Montreal in November 1847 when the last of the coffin ships reached Quebec and New Brunswick with former tenants from Lord Palmerston's estate in Sligo, such as the *Richard Watson* and *Lord Ashburton*, on which over 100 migrants had died. These last of the coffin ships caused public outrage and press indignation in Quebec City and Montreal. They also provided a catalyst for reform of the Passenger Acts. Tyler Anbinder and Desmond Norton have examined the Palmerston assisted emigration scheme in detail, but neither has fully considered its press coverage and impact on political opinion.[27] In particular, two letters from Stephen De Vere in Toronto on

26 Liisa Malkki, 'Speechless Emissaries: Refugees, Humanitarianism, and Dehistoricization', *Cultural Anthropology*, 11.3 (1996), 388.

27 Tyler Andbinder, 'Lord Palmerston and the Irish Famine Emigration', *Historical Journal*, 44.2 (2001), 441–69; Desmond Norton, 'Lord Palmerston and the Irish Famine Emigration: A Rejoinder', *Historical Journal*, 46.1 (2003), 155–65; Desmond

30 November and Adam Ferrie in Montreal on 1 December influenced British parliamentarians into legislating Passenger Act reform. Both letters emphasized the spectacle of huddled, mentally disturbed migrants, and stricken women and children, that is also reproduced in Hamel's painting. The genealogy of the image of the coffin ships can be traced not only to D'Arcy McGee's 'sailing coffins', but also to these composite sources that record the late arrivals of transatlantic vessels from Lord Palmerston's estate in November 1847.

The imagery of catastrophe in Hamel's painting and the Grey Nuns' annals emanates from this historical moment. On 26 September 1847, the Grey Nuns (the order pictured in the foreground of the painting) had returned to tend to fever victims after convalescing for two months. They recorded in their annals what transpired in the sheds, recalling:

> carts filled with coffins slowly passing in the direction of the cemeteries in the early hours of the morning. We still see the mass of tombs prepared daily to receive new victims. Death lingered continually over the ambulances like an imprisoned shadow enveloping all those who dared penetrate it.[28]

Moreover, the Grey Nuns also register the moment of arrival of the last of the coffin ships and their dying passengers on steamers in Montreal. According to their annal:

> It was November 24th at 11 o'clock in the evening; a steamboat charged with three hundred sick came from GROSSE ISLE, arriving at the port. We sent as many vehicles as we could procure and the doctors directed themselves at the same time with stretchers to help transport the sick. When we saw the disembarkation of the ship we realized that [...] more than eighty had died during the voyage, which meant that the nurses passed a great part of the night transporting cadavers that had been placed in the SHED where their bodies were kept until the following day when they would be brought to the cemetery. These poor unfortunates arrived in a state difficult to describe. Nature and the elements seemed to be mourning these poor victims. A torrential rain was falling, thunder was groaning with fury and in the midst of this terrible noise we heard the cries and the groans of the sick and the dying who, thrown about pell-mell and not being able to support the jolting of

Norton, *Landlords, Tenants, Famine: The Business of an Irish Land Agency in the 1840s* (Dublin: UCD Press, 2006), 44–65.

28 King, 'Irish Famine Archive', 79–80.

transport, gracefully asked to be placed in the bad-weather shelter, in order to expire in peace. Finally we were able to place these poor sick in their designated SHEDS.[29]

This frenetic scene recalled by the Grey Nuns is defined by the sudden arrival of a mass of stricken emigrants huddled together amongst the dead. The chaotic impression of scattered bodies and the 'cries and the groans of the sick and the dying [...] thrown about pell-mell' lends both the annal and Hamel's painting a heightened sense of crisis. The crepuscular setting of the painting that shades from darkness into light seems to frame this harrowing image of distressed emigrants at night.

This spectacle is largely corroborated by press accounts of the sudden appearance of the last of the coffin ships.[30] There are some discrepancies between the religious annals and newspaper reports of emigrant casualties and dates of arrival in port. In fact, the episode the Grey Nuns recall most likely occurred earlier in the season on 26 June, when over 800 emigrants were left abandoned on Montreal's wharf. As recounted in a letter the next day by the Secretary of the Montreal Board of Health, Mr. T.S. Brown:

> On reaching the long shed, at the present landing place for emigrants, we found it, to our surprise, completely crowded, and learned that the steamer 'Queen', arrived at five o'clock P.M., had landed 831 individuals—*souls* I do not say, for some had left their bodies—who had been taken from four vessels lying off Grosse Isle
> [...]
> We found a number of sick under the Shed, which the Police placed in carts, by direction of our medical men, and transported to the hospitals—two were so far gone, that I understand they died on the carts [...] In visiting the same Shed, this morning, I found that several deaths had occurred in the night, and emigrants have continued dying there through the day [...] [from] this avalanche of deceased and dying people, thrown daily upon our wharves.[31]

'This avalanche of deceased and dying people' fell upon the city's wharves and fever sheds on the very last day that the Grey Nuns were in attendance on Irish emigrants, before they had to withdraw to recuperate and cede

29 King, 'Irish Famine Archive', 90–91.
30 See André Charbonneau and André Sévigny, *1847 Grosse Île: A Record of Daily Events* (Ottawa: Canadian Heritage, Parks Canada, 1997), 256–63.
31 *Montreal Gazette*, 12 July 1847.

their place to the Sisters of Providence.[32] In their annals of 26 June, they recall that 'the situation became more and more alarming, the number of sick is always growing', without making reference to the arrival of the steamer, which they perhaps confused with events later in the season.[33]

Nevertheless, the Grey Nuns had returned to the fever sheds when passengers from the last of the coffin ships, the *Lord Ashburton* and the *Richard Watson*, reached Montreal in the first week of November, following the closure of the quarantine station at Grosse Isle. The lateness of the season, the poor condition and clothing of the emigrants, and the sheer numbers of widows and orphans (who are also central figures in Hamel's painting) led to considerable press censure. Shortly after the arrival of the *Richard Watson*, the *Quebec Mercury* reported:

> these poor creatures from Lord Palmerston's estate [...] had become almost a by-word for wretchedness [...] They were penniless and in rags, without shoes or stockings, and lying upon the bare boards—not even having straw! [...] Three poor children—infants [...] [were] sitting on the bare deck, *perfectly naked*, huddled together shivering [...] The mother is a widow, and in rags.[34]

According to the *Montreal Herald*,

> Probably there are few cases on record where such wholesale sickness and suffering have been experienced as among the immigrants of 1847 [...] How was it with the Lord Ashburton with its 470 souls. One hundred and twenty died before they reached Montreal, although all despatch was used in forwarding them on from Quebec—and one quarter more went into hospital before three days after landing here. Probably not one half of the whole number were living to usher in the new year.[35]

The *Montreal Gazette* was equally withering in its coverage of the arrival of passengers from the *Lord Ashburton* on the steam ship *Alliance*. It published correspondence from Quebec City dated 1 November:

> And a true November day it is:—dull, rainy, and unpromising [...]

32 Jason King (ed.), 'Grey Nuns Famine Annal', *Ancien Journal*, 1 (1847), 34. http://faminearchive.nuigalway.ie/docs/grey-nuns/GreyNunsFamineAnnalAncienJournal VolumeI.1847.pdf (accessed 3 Dec. 2016).

33 King, 'Grey Nuns Famine Annal', 35.

34 *Quebec Mercury*, 11 Nov. 1847; reprinted in *Limerick Reporter*, 7 Dec. 1847.

35 *Montreal Herald*, 15 Feb. 1848.

News was received from Grosse Isle, yesterday, of the arrival of the Lord Ashburton [...] It appears she sailed with 450 passengers, from Liverpool, on the 13th of September, and that during the voyage upwards of one hundred of the poor creatures, on their way here, paid the debt to nature. In addition to this mortality, it is reported that seven of the crew are now ill of fever, and from forty to fifty of the remaining passengers [...] Is it not monstrous that, at so late a season of the year, 450 people should be sent here to perish, or starve![36]

As the Canadian press reacted with increasing indignation to the arrival of the last of the coffin ships, the physician on Grosse Isle, Dr Douglas, rejected the accusation that the *Lord Ashburton*'s passengers had been treated under his care as 'a cargo of slaves'.[37]

The Irish press was no less scathing than Canadian newspapers when the wretched condition of the passengers was made public. 'A large portion of those Irish slaves were captured on the lands of [...] Lord Palmerston', mocked the *Cork Examiner*, 'and from disfiguring the classic fields of Sligo, were sent to a fitting death in the fever sheds of Canada'.[38] 'And this Lord Palmerston is one of the ministry who have declared as their maxim that "the property of Ireland must support the poverty of Ireland"', ridiculed the *Dublin Weekly Nation*.[39] Ultimately, the arrivals of the *Lord Ashburton* and *Richard Watson* so late in the season and the conspicuous destitution of their passengers engendered strong press reactions and public indignation on both sides of the Atlantic.

'An Altered Man': Image, Text, Policy

These press accounts had little impact on government policy, however. Much more influential were two letters sent by Adam Ferrie and Stephen De Vere to Earl Grey, Secretary of the Colonies, within 24 hours of one another at the end of November 1847, which were both subsequently published. Adam Ferrie was a member of the Canadian Legislative Council and chairman of Montreal's Emigration Committee. On 1 December, prompted by the arrival of the *Lord Ashburton* and *Richard Watson* in the city, he published an open letter to Earl Grey bitterly condemning Irish landlords such as Lord Palmerston and Major Mahon and their agents for

36 *Montreal Gazette*, 8 Nov. 1847.
37 *Montreal Transcript*, 6 Nov. 1847.
38 *Cork Examiner*, 6 Dec. 1847.
39 *Dublin Weekly Nation*, 22 Jan. 1848.

endangering emigrants. 'In many instances from six to eight hundred were huddled together in one indiscriminate mass', he wrote, 'being double the number the vessels were capable of accommodating with any degree of comfort or safety', akin to 'the vile and heartless traffic of the slave trade'.[40] Like much of the press, Ferrie singled out for particular opprobrium:

> the last cargo of human beings which was received from Lord Palmerston's Estate [...] by the 'Lord Ashburton', the captain of which but a few days since died of the prevailing fever, and consisted in all of one hundred and seventy four men, women, and youths; of which eighty seven were almost in a state of nudity.[41]

In his emphasis on desperate and dying, poorly clad emigrants 'huddled together' in an 'indiscriminate mass', Adam Ferrie supplies much of the imagery of the coffin ships that was reproduced in press accounts and mirrored to a degree by Hamel's painting, although he discreetly replaces nudity with an approximation of classical drapery.[42] Ferrie also stresses the mental anguish more than physical suffering of fever patients. 'The remnants now scattered over various portions of the Province have become dispirited in mind and in many instances utterly reckless of their future condition and fortunes', he claims.[43] Indeed, Ferrie accentuates their psychological distress, disorientation and indifference to their fate as symptoms of poor maritime regulation and landlord neglect.

Twenty-four hours earlier, Stephen De Vere also sent a letter from Toronto describing the harrowing conditions on the coffin ships that would shock a House of Lords select committee into reforming the Passenger Acts. His decision to accompany tenants from his estate at Curragh Chase in County Limerick in the steerage of a transatlantic vessel gave him a unique, eyewitness perspective on the dangers they faced. The letter that he wrote on 30 November 1847 was read aloud by Earl Grey in the House of Lords and still provides the most influential and widely cited description of the coffin ships:

> Before the emigrant has been a week at sea he is an altered man. How can it be otherwise? Hundreds of poor people, men, women, and

40 Adam Ferrie, *Letter to the Rt. Hon. Earl Grey, One of Her Majesty's Most Honorable Privy Council and Secretary of State for Colonial Affairs; Embracing a Statement of Facts in Relation to Emigration to Canada during the Summer of 1847* (Montreal: Printed at the Office of 'the Pilot', 1847), 9. See also *Dublin Weekly Nation*, 22 Jan. 1848.

41 Ferrie, *Letter*, 11.

42 I am grateful to Emily Mark-FitzGerald for this observation.

43 Ferrie, *Letter*, 13.

children of all ages, from the drivelling idiot of ninety to the babe just born, huddled together without light, without air, wallowing in filth, and breathing a fetid atmosphere, sick in body and dispirited at heart, the fevered patients lying between the sound in sleeping places so narrow as almost to deny them the power of indulging, by a change of position, the natural restlessness of the disease, by their agonized ravings disturbing those around them and predisposing them, through the effects of the imagination, to imbibe the contagion; living without food or medicine except as administered by the hand of casual charity, dying without the voice of spiritual consolation and buried in the deep without the rites of the Church.[44]

Like Adam Ferrie, Stephen De Vere foregrounds the mental angst of Irish emigrants more than their physical torments. His 'altered man', prone to 'agonized ravings', who is 'dispirited at heart' bears a close resemblance to Ferrie's scattered migrant remnants 'dispirited in mind' as well as Hamel's despondent survivor, so influenced by Géricault. They are cognate figures under psychological pressure, composite images of mental distress. They display apathetic, despondent and vacant faces amidst the crowd in motion, epitomize the traumatic upheaval of the mind mid-journey or at journey's end. Indeed, De Vere contends that the migrants' mental disturbance predisposes 'them, through the effects of the imagination, to imbibe the contagion'. The deterioration of the psyche precedes the body's collapse.

 This has become the most influential image of the coffin ship and was instrumental in shaping policy, though its provenance remains little known. In his classic study, entitled *A Pattern of Government Growth, 1800–1860: The Passenger Acts and Their Enforcement* (1961), Oliver MacDonagh contends that Stephen De Vere's 'letter made a profound impression on the commissioners. It is scarcely too much to regard it as the basis of most of their future legislation for ship life'.[45] MacDonagh's claim appears all the more remarkable given his broader argument that incremental measures rather than motivated individuals influenced the regulation of 'the emigrant trade and the passenger vessels [which] involved, in one way or another, a most important range of forces which brought the early modern state into existence'.[46] 'No organized pressure group [...] concerned itself with the

44 Stephen De Vere, *Minutes of Evidence before Select Committee on Colonization from Ireland, letter to the Select Committee*, 30 Nov. 1847, in *British Parliamentary Papers, Emigration* (Shannon: Irish University Press, 1968), vol. 5, 45–48.

45 Oliver MacDonagh, *A Pattern of Government Growth, 1800–1860: The Passenger Acts and Their Enforcement* (London: MacGibbon and Gee, 1961), 191.

46 MacDonagh, *A Pattern*, 7.

safeguarding of voluntary emigration', MacDonagh contends; 'no political party or parliamentary interest took it up'.[47]

Nevertheless, Stephen De Vere's harrowing description of the coffin ships was the exception that proved the rule. His famous letter read aloud in the House of Lords can be traced to the unpublished diary entries and letters that he wrote during the transatlantic voyage and after his arrival in Canada. On 20 February 1847, De Vere declared his intention 'to emigrate to Upper Canada about the middle of April, taking with me some of my people, [...] pauperized by the loss of the potato crop'.[48] It was not until he had witnessed the suffering of Irish emigrants at sea and in the fever sheds of Grosse Isle, Montreal and in Toronto that he began to write his letter in July of 1847. In his journal entry on Monday, 19 July, De Vere notes that he 'wrote a paper describing the treatment of passengers on board emigrant ships with sundry suggestions for ensuring better arrangements'.[49] He does not complete his letter, however, until the month of November after the uproar about the last of the coffin ships. On 30 November, he records 'preparing dispatch' and then 'dispatch my letter' the following day.[50] Two months later, on 12 February 1848, De Vere notes with satisfaction:

> a report of a public meeting in Toronto, adopting almost verbatim my views as to the necessity of improvement in the emigration system. Thus I have the satisfaction of finding my opinions supported by the Canadian public, & at the same time likely to be adopted by the English ministry.

Indeed, the very moment his impressions of the coffin ships began to shape government policy was recorded in a letter on 31 January 1848 from Eliot Warbourton to De Vere's younger brother, the Victorian poet, Aubrey De Vere. 'I was at the Colonial Office on Saturday, where I found its secretary [...] in raptures', Warbourton wrote, 'about a letter he had received from Stephen. He said [it] was just what he wanted in stating his experience in his brave enterprise of emigrating as a pauper—he had "made the dumb to speak"'.[51] In 'emigrating as a pauper' and ostensibly giving 'the dumb' a voice 'to speak', Stephen De Vere defined the lasting image of the coffin ship and helped shape 'future legislation' for emigrant protection. He registered the predicament of migrants in transit that led to a change in policy. Even so, he was dismayed that the legislation he had inspired increased levies for

47 MacDonagh, *A Pattern*, 326–27, 7.
48 Stephen De Vere, Trinity College Dublin MS 5075, 1846.
49 Stephen De Vere, Trinity College Dublin MS 5061, 22.
50 Stephen De Vere, Trinity College Dublin MS 5061, 57.
51 Eliot Warbourton, Trinity College Dublin MS 5053, 1–10, 6.

emigrant ships that raised prices and thereby undermined the passenger trade he had sought to safeguard.[52] His verbal image of migrants in peril helped shape policy, but inadvertently closed off avenues of escape from Ireland.

Ultimately, De Vere envisioned the mentally anguished 'altered man' whose traits attest to the harrowing conditions on the coffin ships. The arrival of the last of these coffin ships was registered in a wide array of composite sources, such as the 'imprisoned shadows' of the Grey Nuns annals, contemporary press accounts, the eyewitness testimonials of De Vere and Ferrie, and Hamel's painting, all of which took shape in the autumn of 1847. *Le Typhus* is important because it closely 'matches the horror of [these] written eyewitness accounts',[53] especially in its portrayal of the dead and the mentally distressed. This is not to deny that the painting is derivative or even claim particular significance for it in the development of Hamel's oeuvre, which is defined by his portraits of prominent Canadian ecclesiastical and political figures.[54] Moreover, Hamel found impetus from Géricault to imagine the physical and psychological degradation of Famine migrants that is absent in contemporary paintings. Géricault's influence can be traced in Hamel's figure of the despondent survivor that more readily bridges the divide between these visual and verbal representations of the Irish Famine migration than any other image from 1847. He appears anomalous in both *The Raft of the Medusa* and *Le Typhus*, a stranded migrant who stares into space, a presentiment of later crises. His predicament is that of forced migrants past and present, the involuntarily displaced who succumb to despair like De Vere's altered man. These composite images comprise part of the visual legacy of the Famine migration as a mortuary spectacle, harrowing impressions of coffin ships and fever sheds as meagre vessels of the dead.

52 Stephen De Vere, letter to Lord Monteagle, 29 Feb. 1848, Trinity College Dublin MS 5075a/2 1847, 91–93; letter to Lady De Vere, 10 Apr. 1848, Trinity College Dublin MS 5075a/2 1847, 118; letter to Aubrey De Vere, 14 May 1848, Trinity College Dublin MS 5075a/2 1847, 155; letter to G. Widder, Esq. 8 June 1848, Trinity College Dublin MS 5075a/2 1847, 173; letter published in *Western Canadian*, 16 June 1848, Trinity College Dublin MS 5075a/2 1847, 183, 188–89.

53 O'Sullivan, *Tombs*, 57.

54 Raymond Vézina, 'Théophile Hamel', q.v. *Dictionary of Canadian Biography* (Toronto: University of Toronto Press, 1976), vol. 9: www.biographi.ca/en/bio/hamel_theophile_9E.html (accessed 23 Jan. 2017).

II Negotiating Form: Famine/Post-Famine Modalities and Media

5

'Thus Crucifixes Became the Norm': System, Affect and Display in Post-Famine Catholicism

Lisa Godson

National College of Art and Design

Introduction

In his memoirs, Joseph Prost reflected on his first visit to Ireland. An Austrian missionary with the Congregation of the Most Holy Redeemer (Redemptorists), he recalled his time in Limerick in the 1850s, where the local churches were so 'poverty-stricken' that he and his confrères had to bring with them the fundamental tools for the key rituals of Catholicism: 'a chalice, a ciborium, ostensorium, censer (*Rauchfass*), vestments, etc'.[1] Prost further diagnosed material impoverishment in the devotions of the people, and took action against the bareness of their ecclesiastical and domestic spaces. He instructed a Limerick painter to make black crosses and attach 'alabaster-like white Christ figures'; the resulting objects were placed in his store window and were admired by people who stood outside 'all day long'. He helped the painter to order crucifixes from 'a Belgian merchant', providing him with 'considerable business' and 'thus', he claimed rather grandly, 'crucifixes became the norm in Irish churches and homes'.[2]

The Redemptorists' activities in Limerick were part of the parish mission movement, described by Emmet Larkin as 'the single most important factor' in consolidating changes in Irish Catholic practice in the aftermath of the Famine of the 1840s.[3] The movement involved various European religious orders travelling to almost all the 1,000 Catholic

1 Joseph Prost, *A Redemptorist Missionary in Ireland, 1851–1854: Memoirs by Joseph Prost*, trans. and ed. Emmet Larkin and Herman Freudenberger (Cork: Cork University Press, 1998), 49.
2 Prost, *A Redemptorist Missionary in Ireland*, 48–49.
3 Emmet Larkin, Introduction to Prost, *A Redemptorist Missionary in Ireland*, 11.

parishes in Ireland, preaching about the basic tenets of faith and the means of salvation. The typical mission has been described as a blitzkrieg that brought 'a parish into a rapid conformity',[4] and the 'anti-proselytising instrument *par excellence*'[5] partly due to the various orders' opposition to the Protestant missionary societies active during the Famine. The 'missioners' brought a wealth of religious objects with them and instructed the faithful in their use and meaning. Although Prost exaggerated his personal agency, from the 1850s, crucifixes did indeed become the norm in Ireland, alongside an array of other items including elaborate liturgical implements, cheap pious images, rosary beads and incense. These portable artefacts were one aspect of the physical reshaping of Irish Catholics' experience after the rupture of Famine. Their material world was re-ordered, including the individual body of the believer, their home, ecclesiastical spaces, streetscapes and wider environment. The nature of that material culture, and how it was presumed to direct Irish Catholics in particular ways, is the focus of this chapter.

Following a consideration of new values and modes of behaviour in the wake of the Famine, the chapter turns to an analysis of how certain forms of religious material culture were central to the praxeological and conceptual undertakings deemed necessary for Irish Catholics to carry out their religious duties, develop a personal relationship with the divine and participate in a transnational expression of faith. Three aspects of this are considered: Catholic material culture as system; as inspiring a culture of affect; and as display, ranging across ecclesiastical, domestic and civic space.

The chapter is informed by the political theology of the philosopher Giorgio Agamben and (less overtly, but important in terms of how his thinking informed Agamben) Michel Foucault. Of particular significance are Agamben's concept of 'acts of separation' and his excavation of duty as central to the model ethical subject. In his essay, 'In Praise of Profanity', he discusses how all sacred objects derive their power by being removed from common use through specific 'acts of separation', arguing for a new politics whereby a 'reverse consecration' might happen and objects be returned from the realm of the sacred into common use.[6] His study of the origins of modern concepts of duty informs the approach taken here due to his focus on the priest as a model ethical subject.[7] While Agamben's work on

4 James H. Murphy, 'The Role of Vincentian Parish Missions in the "Irish Counter-Reformation" of the Mid-Nineteenth Century', *Irish Historical Studies*, 24.94 (1984), 154.

5 Murphy, 'The Role of Vincentian Parish Missions', 155.

6 Giorgio Agamben, *Profanations*, trans. Jeff Fort (New York: Zone Books, 2007).

7 Giorgio Agamben, *Opus Dei: An Archaeology of Duty*, trans. Adam Kotsko (Palo Alto, CA: Stanford University Press, 2013).

the theological origins of modern political thought is usually considered as paradigmatic, whereby the sacred and the priest might be considered as analogous to the state and government, his work is also germane for thinking in more literal and historical terms about the actual priesthood and actual objects specifically denoted as sacred. Foucault's concepts of disciplinarity and techniques of the self inform the essay in relation to how the regulatory use of material culture worked to form a specifically Catholic modern subjectivity.

The Famine and the 'Devotional Revolution'

The changes in Irish religious expression in the second half of the nineteenth century were famously tagged by Emmet Larkin as a 'devotional revolution'.[8] In his analysis, generally taken in tandem with the almost contemporary work of David Miller,[9] the 'revolution' involved an increase in religious personnel, institutions and a spectacular increase in religious observance: for example, with Mass attendance increasing from less than 40 per cent of the population in the pre-Famine era to over 90 per cent by the 1890s.[10] Larkin attributes much of the success of the revolution to the influence of Paul Cullen, the first Irish cardinal, and his recruitment and disciplining of clerics. The ratio of clergy to people greatly increased, and the Church extended its involvement with its flock through an expanded participation in their spiritual, political, intellectual and physical lives.[11] A key aspect of this involved the building of churches—in 1752, there were 832 'simple Mass houses', which were 'little more than thatched sheds with clay floors', but by the late nineteenth century, at least 24 major cathedrals and more than 3,000 'substantial churches' had been built.[12]

8 Emmet Larkin, 'The Devotional Revolution in Ireland, 1850–75', *American Historical Review*, 77.3 (1972), 625–52.

9 D.W. Miller, 'Irish Catholicism and the Great Famine', *Journal of Social History*, 9 (1975), 81–98.

10 See Eugene Hynes, *Knock: The Virgin's Apparition in Nineteenth Century Ireland* (Cork: Cork University Press, 2008), 99; Miller, 'Irish Catholicism and the Great Famine'; David W. Miller, 'Mass Attendance in Ireland in 1834', in Stewart J. Brown and David W. Miller (eds), *Power and Piety in Ireland, 1760–1960: Essays in Honour of Emmet Larkin* (Belfast and Notre Dame, IN: Queen's University of Belfast/University of Notre Dame Press, 2000), 158–79.

11 In 1840, the ratio of priests to people was 1:3000, by 1850 1:2100, by 1871 1:1560. For nuns, the figures were 1:6500 (1840), 1:3400 (1850), 1:1100 (1871). Figures are derived from Roy Foster, *Modern Ireland 1600–1972* (London: Allen Lane, 1988), 338.

12 Thomas Kennedy, 'Church Building', *A History of Irish Catholicism*, vol. 5, *The Church Since Emancipation* (Dublin: Gill & Macmillan, 1970), 1–8.

Larkin places the acquiescence of the Catholics of Ireland to new forms of religious expression and experience firmly in the context of the Famine, particularly in relation to demographic shifts and 'gigantic psychological shock'.[13] David Miller similarly states 'the famine played an important role in this vast social change'.[14] In *Das Kapital*, Karl Marx wrote that the 'Irish famine of 1846 killed more than 1,000,000 people, but it killed poor devils only',[15] and, although not wholly true, starvation and emigration certainly affected the poorest most dramatically. In religious terms, the demographic effect of the Famine was not just a matter of population loss, thereby increasing the ratio of priests to people, but also cultural loss, because the majority of those who died or emigrated were adherents of the vibrant vernacular religious culture which had rivalled that of the official Church in the pre-Famine era. Kerby A. Miller describes post-Famine Ireland as 'culturally orphaned',[16] and Angela Bourke similarly pronounces the Famine as a 'cultural cataclysm'.[17] She suggests an abrupt hastening of modernity in its wake, within which the new material culture of Catholicism might be gleaned: for example, by makeshift dwellings giving way to standardized housing and a new authoritarianism that was expressed via 'furious opposition on the part of the institutions of church and state to the uncentralised and unstandardised forms of knowledge and creative endeavour'.[18] In general, the post-Famine era saw a majority culture that S.J. Connolly describes as 'more affluent, more prudent, and aspiring to new models of propriety', and that to the Catholic clergy was 'far more amenable to the discipline they sought to impose'.[19] This is echoed by sociologist Tom Inglis's description of institutional religion in Ireland from the mid-nineteenth century as a 'civilising process'.[20] For most commentators, this involved the promotion of a strict code of moral discipline

13 Larkin, 'Devotional Revolution', 648.
14 Miller, 'Mass Attendance in Ireland in 1834', 82.
15 Karl Marx, *Capital: A Critique of Political Economy*, trans. Ben Fowkes (Harmondsworth: Penguin Classics, 1990), 861.
16 Kerby A. Miller, *Emigrants and Exiles: Ireland and the Exodus to North America* (Oxford: Oxford University Press, 1985), 132.
17 Angela Bourke, 'The Baby and the Bathwater: Cultural Loss in Nineteenth-Century Ireland', in Tadhg Foley and Seán Ryder (eds), *Ideology and Ireland in the Nineteenth Century* (Dublin: Four Courts Press, 1998), 79–92.
18 Bourke, 'The Baby and the Bathwater', 80. See also Kevin Whelan, 'Pre-and Post-Famine Landscape Change', in Cathal Póirtéir (ed.), *The Great Irish Famine* (Cork and Dublin: Radio Telefís Éireann/Mercier Press, 1995), 19–33; James O'Shea, *Priests, Politics and Society in Tipperary 1850–1891* (Dublin: Wolfhound, 1983).
19 S.J. Connolly, *Priests and People in Pre-Famine Ireland, 1780–1845* (Dublin: Gill & Macmillan, 1982), 277.
20 Tom Inglis, *Moral Monopoly: The Rise and Fall of the Catholic Church in Ireland* (Dublin: UCD Press, 1998).

and self-improvement to a population that was receptive to such values, interpreted as part of an *embourgeoisement* and modernizing process.

As with so many aspects of life in the second half of the nineteenth century, the Famine has been treated by historians as a watershed for religion: for example, by P.J. Corish, who describes it as 'a great divide in the religious history of the Irish Catholic community'.[21] In particular, the demographic and cultural changes ushered in by the Famine are viewed as crucial factors in embedding the form of religion that took root in Ireland in the second half of the nineteenth century. The nature of that 'new' religious culture was Tridentine and ultramontane, involving a concern with the reception of the sacraments, the believer's relationship with God and the supremacy of Rome, implying obedience to the institutions of the Church. The widespread changes in Irish Catholicism partly involved an intensification of certain phenomena under way in wealthier parts of the country since the dismantling of the penal laws from the late eighteenth century culminating in the Roman Catholic Relief Act (or 'Catholic Emancipation') of 1829. This leads some historians to discount Larkin's 'revolution' thesis in favour of one of Tridentine 'evolution'.[22] However, such a perspective implies a slow, inevitable movement towards a more perfectly canonical Catholicism and would seem to discount the significance of nineteenth-century ultramontane theology which sought to standardize religious practices throughout Europe. Nor does it fully address the speed of devotional change and involvement of the wider population from the late 1840s.

Material culture was central to the 'revolution' in Irish Catholic experience. This centrality can be sought partly in relation to a population that came more firmly into the ambit of the institutional Church and were more aspiring to the spiritual capital offered by adherence to its regulations. In my previous work involving the transcription and analysis of advertisements that appeared in the *Irish Catholic Directory* between 1838 and 1898, the periodization for the introduction to Ireland of particular object-types indicates a timeframe for how the material culture of Catholicism in Ireland changed dramatically over the course of those

21 P.J. Corish, 'The Catholic Community in the 19th Century', *Archivium Hibernium*, 38 (1983), 26.

22 See, in particular, Thomas G. McGrath, 'The Tridentine Evolution of Modern Irish Catholicism, 1563–1962: A Re-examination of the "Devotional Revolution" thesis', *Recusant History*, 20.4 (1991), 512–23. For further debate on the 'Devotional Revolution' argument, see K. Theodore Hoppen, *Ireland since 1800: Conflict and Conformity* (London: Longman, 1989); Kevin Whelan, 'The Catholic Parish, the Catholic Chapel and Village Development in Ireland', *Irish Geography*, 16 (1983), 1–15; Corish, 'The Catholic Community in the 19th Century'.

60 years.[23] In summary, this traced the prevalence of advertisements for sacerdotal items such as altar vessels and vestments from the late 1830s, for devotional goods such as rosary beads and religious images from the 1850s and for specialist church fittings from the 1860s. How this pattern emphasized particular attributes of Catholic material culture is outlined below.

System

A key aspect of Tridentine Catholicism was the systematization of liturgical and devotional life, where the material distinctiveness of secular and religious realms was fundamental. As Giorgio Agamben explains, a sacred domain is asserted through 'acts of separation', religion being 'that which removes things [...] from common use and transfers them to a separate sphere'.[24] We can see how this separation was blurred in the eighteenth and early nineteenth centuries through information gathered on the physical state of Irish Catholicism by bishops carrying out diocesan visitations. Of primary concern was the blurring of the sacred and profane spheres; most seriously through the lack of adequate churches, but also involving clerical dress and discipline and ribald behaviour at ostensibly religious occasions.

For much of the population outside wealthier areas such as Dublin and the south-east, in the pre-Famine era liturgical ceremonies such as Mass and confession usually took place in the homes of the faithful through a system of 'stations', where (for example) tables covered in cloth stood in for altars.[25] Visiting ecclesiastics also expressed concern about the poor condition or even absence of the ritual objects necessary for priests to undertake their duties. S.J. Connolly cites many reports on the pitiable condition of Irish sacerdotal objects in *Priests and People in Pre-Famine Ireland*: for example, Bishop Sweetman of Ferns (episcopacy 1745–86) remarked of one priest: 'His ornaments were indifferent, except his alb was very dirty and the veil of his chalice scandalously broken and ragged; and the chalice itself very bad'.[26] As the central artefacts used in the celebration of Mass and to administer the sacraments, it is not surprising that altar vessels became the focus of material reform, and were the main

23 Lisa Godson 'Charting the Material Culture of the Devotional Revolution: The Advertising Register of the *Irish Catholic Directory*, 1838–98', *Proceedings of the Royal Irish Academy*, 116C (Dublin: Royal Irish Academy, 2016), 265–94.

24 Agamben, *Profanations*, 74.

25 For example, see the description of a 'station' in William Carleton, *Traits and Stories of the Irish Peasantry* (Dublin: William Curry Jr. & Co. 1830).

26 Connolly, *Priests and People*, 78.

object-types mentioned in the earlier years of the register of the *Catholic Directory* (the late 1830s), with advertisements for new vessels taken out by those whose trade involved working with precious metals such as jewellers or horologists.

These objects were deeply systematized. The precise nomenclature of the set that the Redemptorist missionaries brought around with them indicates their specialist nature: chalice, ciborium, ostensorium, censer. Furthermore, while earlier advertisements focused on chalices, later ones indicate an almost burdensome specificity—an advertisement for an ecclesiastical warehouse in Dublin in 1859 includes chalices, ciboriums, remonstrances, pyxes, thuribles, tenebrae candlesticks, paschal candlesticks, coronas and monstrances.[27] As ritual objects that were part of an interlocking system, each had a clearly defined function that was central to the efficacy of the ceremony with which they were performed. They were also highly specialized in form under the regulations of the Roman Missal that dictated, for example, that the chalice 'should be at least eight inches in height'.[28] Their very substance and manufacture were also governed by rules regarding the materials they were made from, the ways they might be handled and who was permitted to make them. For example, the chalice had to be made of gold or silver, and the paten, if made of anything other than gold, had to be gilt on the concave side. Only 'by way of exception in case of extreme poverty' might a chalice be made of stannum (an alloy of tin and lead), although the cup still had to be of gilt on the inside, and 'those made of glass, wood, copper, or brass are not permitted'.[29]

To be fit to be used in the Mass, the vessels had to be consecrated by a bishop; they were sacralized according to the most solemn form of blessings, called constitutive, 'so called because they permanently depute persons or things to Divine service by imparting to them some sacred character'.[30] The 'act of separation' here was partly effected through the episcopal blessing, but as these items were made sacred, they could become profane again: for example, by being misused or broken in particular ways,[31] an example of the power of the church to sacralize and de-sacralize objects. It is notable that advertisers in the *Irish Catholic Directory* publicized that they were authorized by the ecclesiastical authorities to handle and repair

27 Advertisement for John Donegan, *Irish Catholic Directory* (1859), 416.
28 Augustin Joseph Schulte, 'Altar Vessels', q.v. *The Catholic Encyclopedia* (New York: Robert Appleton Company, 1907), vol. 1: www.newadvent.org/cathen/01357e.htm (accessed 10 Oct. 2016).
29 Schulte, 'Altar Vessels'.
30 Patrick Morrisroe, 'Blessing', q.v. *The Catholic Encyclopedia*, vol. 2: www.newadvent.org/cathen/02599b.htm (accessed 5 Nov. 2016).
31 Schulte, 'Altar Vessels'.

these objects, denoting the direct mediation of the institutional church in their form and manufacture. For example, in 1848, the Dublin 'Watch and Clock Maker' Ralph Walsh advised that he 'is licensed, by his Grace the Archbishop, to handle consecrated articles'.[32]

Such systematization extended also to the vestments or *vestes sacrae* the priest wore, again of specialist name and fabric. For celebrating Mass, at the very least a parish priest was expected to wear the amice, alb, cincture, maniple, stole and chasuble, and such vestments were further codified by design and colour depending on the times of the liturgical year or the nature of the Mass celebrated (for example, purple for Lent, Advent and Rogation Days and black for All Souls' Day and Requiem Masses), and by material (typically cloth of silver or gold). However, reports on Irish parishes in the pre-Famine period often mentioned vestments that were incomplete or shabby: when the reforming Bishop James Doyle of Leighlin and Kildare (episcopacy, 1819–34) found inadequacies in one church, 'he tore the chasuble [...] into a hundred ribbons'.[33]

The advertisements in the *Irish Catholic Directory* indicate that splendid gold and silver vestments (or the fabrics for making them) were imported to Ireland through the 1840s and 1850s, particularly from Lyons, the centre of mechanized silk-weaving. The ability to purchase correct and full sets of vestments was partly due to the growing wealth of Irish Catholicism, particularly as parishioners became more able to contribute financially to the church, and as the numbers of churches and priests expanded. They were part of the vital equipment for new church sacristies, and their purchase can be viewed within the context of fundraising efforts to build and furnish churches, for which the money came from many sources including raffles, collections and bequests, partly through the 1844 Charitable Bequests Act.[34] A further stimulus was due to the ultramontane ideal of standardization. As Katherine Haas explains in her study of American vestments, by the 1840s, the design and appearance of vestments became far more standardized throughout the Catholic world, expressing 'key devotional Catholic tenets: the elevated position of the priest, the centrality of the Eucharist, and the internationalism and universality of the church'.[35] I would contend that the increased availability of vestments was also effected due to manufacturing techniques and new modes of distribution, in particular mechanized

32 Advertisement for Ralph Walsh, *Irish Catholic Directory* (1848), 562.

33 William John Fitzpatrick, *The Life, Times, and Correspondence of the Right Rev. Dr. Doyle, Bishop of Kildare and Leighlin* (Boston: P. Donahue, 1862), 113.

34 See Brendan Grimes, 'Funding a Roman Catholic Church in Nineteenth-Century Ireland', *Architectural History*, 52 (2009), 147–68.

35 Katherine Haas, 'The Fabric of Religion: Vestments and Devotional Catholicism in Nineteenth-Century America', *Material Religion*, 3.2 (2007), 193.

silk-weaving and the establishment of a network of agents between Ireland and continental Europe.[36]

With increased reception of the sacraments, more and more Irish Catholics came to experience the 'accurate' use of the correct ritual objects by the priest. This was not just a matter of witness. With the introduction of nominally multidenominational but de facto sectarian universal primary education in the 1830s and the increase in catechetical instruction, the faithful were expected to possess detailed knowledge of liturgical implements, and to have learned by heart about their form and use. What might these objects have communicated about the nature of religion? As well as their visual splendour that may have impressed the growing wealth and power of the Church on the congregation, their particularity worked in tandem with what Giorgio Agamben has described as the 'trinitarian economy' of the liturgy.[37] As Agamben notes, the celebration of the Mass is based on the concept of *ex opere operato*, meaning 'from the work worked', denoting that the effectiveness of the sacraments is derived not from any innate goodness of the priest through whose actions the sacrament is bestowed but because he is carrying out prescribed actions from his office *in persona Christi*, with Christ as the author and original 'worker' of the sacrament (*ex opere operato Christi*).

Agamben explains the enactment of the Mass as a 'paradigm of a human activity whose effectiveness does not depend on the subject who sets it to work and nonetheless needs that subject as an "animate instrument" to be actualized and rendered effective'.[38] As such, the efficacy of the sacraments is dependent on the precision of their enactment, involving an exactitude not only in the words of the priest (on which Agamben focuses), but also on the accurate use of the correct tools for each step of the ritual. Agamben's study of liturgical praxeology leads him to assert that the Christian priest, in being an instrument of God's power, is the model ethical subject, contrasting the priestly ontology of duty and office with the classical ethical ontology of being. In other words, the ethical nature of the priest derives from him systematically carrying out the divinely imparted duties of his office rather than his own character, whereas the classical understanding of ethics focused on the character of the individual. This is significant for post-Famine Catholicism, as it suggests that duty and the systematic following of the rules of the Church, including the correct use of objects,

36 For further details of this argument, see Godson, 'Charting the Material Culture of the Devotional Revolution'.

37 Giorgio Agamben, *The Kingdom and the Glory: For a Theological Genealogy of Economy and Government*, trans. Lorenzo Chiesa (Palo Alto, CA: Stanford University Press, 2011).

38 Agamben, *Opus Dei*, 28.

could lead to salvation, thus centralizing religious power in the persona of the priest and the power of the institution.

The systematization of religious objects, and their efficacy being dependent on specific conditions, was not confined to the priest at the altar. The post-Famine period saw the undermining of vernacular practices. In their place, 'the Church promoted a piety that was instructional and individualist based largely on the printed prayer book and catechism',[39] as well as a proliferation in the use of sacramentals (*sacramentalia*) by Irish Catholics.[40] These are defined as 'sacred signs which bear a resemblance to the sacraments' that 'signify effects, particularly of a spiritual nature, which are obtained through the intercession of the Church'.[41] Sacramentals are of central importance to understanding the experience of Catholics in post-Famine Ireland as they proliferated so widely, and clearly demarcated how the material world could mediate between an individual or community and the sacred.

Sacramentals have a rather complex classificatory system, but they include making designated gestures while saying specific prayers, the correct interaction with religious objects or substances and abstaining from certain foods at prescribed times. They are usually divided between acts (such as participating in public prayer) or giving alms or artefacts (such as using candles, holy water, *agnus dei* and rosary beads). Despite this binary distinction between acts and objects, all sacramentals involve a codified relationship with materiality, whether specifically focused on actual artefacts or not: for example, through prescribed utterances, or through learned body techniques such as genuflection and making the sign of the cross.

From the late 1840s, sacramental knowledge and actual objects were promoted and disseminated particularly by the missionary orders such as Redemptorists, Jesuits and Vincentians, and through confraternities and sodalities that often centred on particular devotions that had a sacramental element: for example, the Confraternity of the Brown Scapular, organized by the Carmelite order.[42] Catholics were also instructed in the use and meaning of sacramentals through various texts: for example, the widely distributed catechism by James Butler, Archbishop of Cashel, later modified as the 'Maynooth' catechism.[43]

39 Donal A. Kerr, *Peel, Priests and Politics: Sir Robert Peel's Administration and the Roman Catholic Church in Ireland, 1841–1846* (Oxford: Clarendon Press, 1982), 44.
40 See Larkin, 'The Devotional Revolution', 64–65.
41 'Catechism of the Catholic Church, No. 1667': www.vatican.va/archive/ccc_css/archive/catechism/p2s2c4a1.htm (accessed 18 Oct. 2016).
42 See Colm Lennon (ed.), *Confraternities and Sodalities in Ireland: Charity, Devotion and Sociability* (Dublin: The Columba Press, 2012).
43 See James Butler, *The Most Rev. Dr. James Butler's Catechism: Revised, Enlarged,*

As with liturgical material culture, there were highly detailed rules concerning the form, use and meaning of sacramental objects, and an exactitude required in the practices surrounding them. If the sacraments conferred grace, the sacramentals often had quantifiable benefits whereby their correct use accrued a reduction in temporal suffering after death through a system of indulgences, with variations introduced at different times. For example, from 1863, an indulgence of 50 days was attached to the making of the sign of the cross and the invoking of the Holy Trinity, but this expanded to 100 days if holy water was used in making the sign.[44]

A key difference between sacraments and sacramentals is that the efficacy of sacraments was defined as *ex opere operato*, transcending the moral status of the enacting priest, but with sacramentals it was *ex opere operantis Ecclesiae*, i.e. from the work of the Church. This meant that the power of sacramentals was contingent on the spiritual state of the individual who utilized them as determined by the Church, thus denoting the importance of the institutional framework within which these material practices were systematized and empowered. In her study of the material culture of Christianity, Colleen McDannell asserts that the highly detailed Church-given rules governing sacramentals 'must not be seen as trivial' as they exemplify the way authority 'is constructed and maintained not merely through overt coercion but also through the micromanagement of power'.[45] The expanded system of sacramentals denotes that Irish Catholics acquired new forms of material knowledge in the post-Famine period, emphasizing not only that the institution of the Church had power in the daily spiritual lives of the faithful, but that training was necessary to use religious objects properly.

As objects were codified according to the ways they might confer spiritual riches, they became more central to what it meant to be a practising Catholic. Just as liturgical ceremonies became increasingly housed in permanent ecclesiastical surroundings, so too did the increase in the use of sacramental objects emphasize a clear division between the everyday and the sanctified. Terry Eagleton asserts that 'religion in pre-Famine Ireland had blasphemously mingled the sacred and profane' and that, at its most extravagant, 'this popular culture could erupt into carnivalesque riot'.[46] If

Approved, and Recommended by the Four R.C. Archbishops of Ireland as a General
Catechism for the Kingdom (Dublin: The Catholic Book Society, 1836).

44 Ambrose St John (trans.), *The Raccolta Or, Collection of Indulgenced Prayers and Good Works to Which the Sovereign Pontiffs Have Attached Holy Indulgences*, 6th edn (London: Burns and Oates, 1910), 41.

45 Colleen McDannell, *Material Christianity: Religion and Popular Culture in America* (New Haven, CT: Yale University Press, 1995), 24.

46 Terry Eagleton, *Heathcliff and the Great Hunger: Studies in Irish Culture* (London:

post-Famine reforms involved a 'streamlining of the spirit',[47] the role of a standardized, regularized material culture must be reckoned with.

Affect

In his work on religion in pre-Famine Ireland, Michael Carroll remarks that popular Catholicism up to the late eighteenth century (and in many areas far later) was characterized by 'a decided *lack* of emphasis on figurative representation',[48] and many churches even up to the 1850s were unadorned by imagery. This may have been partly due to poverty, but the post-Famine period coincided with more materially based devotionalism throughout the Catholic world. As such, the second half of the nineteenth century saw the installation of statues and paintings in new churches and the increased distribution of cheap prints for Irish Catholics, who were introduced to visual representations of the Holy Family and a novel array of continental saints. These images were often coupled with devotions that promoted visual depictions as a way to become familiar with Jesus, Mary and religious scenes and personages. These ranged in size from around 5 inches × 3 inches (a scale for use by an individual) to royal quarto, 12½ inches × 10 inches (more suited for display). As Ann Taves has written, devotions, including the use of images, 'presupposed the existence of social relationships between faithful Catholics and supernatural beings and provided a means for interacting between them'.[49]

For example, devotion to the Sacred Heart of Jesus, based on the visions of Margaret Mary Alacoque (1647–90), became widespread in nineteenth-century Ireland, with sodalities and confraternities founded to encourage this piety.[50] A strong aspect of the devotion came to focus on images of the Sacred Heart: for example, in 1847, a Miss Dowling in Dublin advertised 'Italian and French Engravings', including prints of the 'Sacred Hearts of

Verso, 1995), 273.

47 Eagleton, *Heathcliff and the Great Hunger*, 274.

48 Michael P. Carroll, 'Rethinking Popular Catholicism in Pre-Famine Ireland', *Journal for the Scientific Study of Religion*, 34.3 (1995), 362.

49 Ann Taves, *The Household of Faith: Roman Catholic Devotions in Mid-Nineteenth Century America* (South Bend, IN: University of Notre Dame Press, 1986), 47.

50 See Catherine Lawless, 'Devotion and Representation in Nineteenth-Century Ireland', in Ciara Breathnach and Catherine Lawless (eds), *Visual, Material and Print Culture in Nineteenth-Century Ireland* (Dublin: Four Courts Press, 2010), 95–96; Katherine O'Driscoll, 'Reform, Instruction and Practice: The Impact of the Catholic Revival on the Laity in the Dublin Diocese, 1793–1853', unpublished PhD thesis (National University of Ireland Galway, 2016), 184.

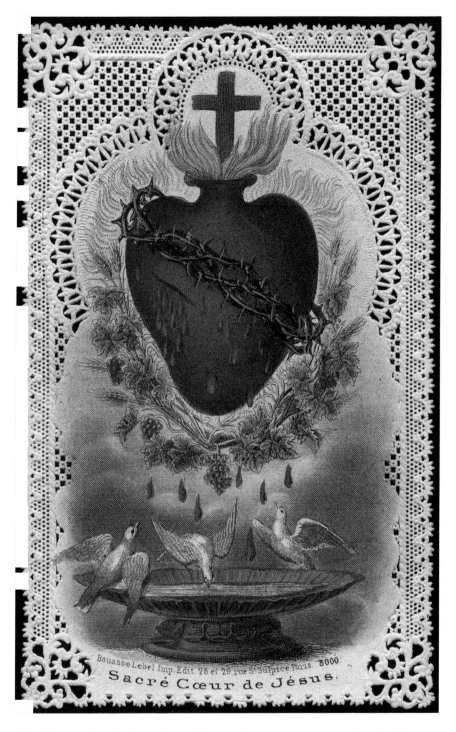

5.1 Bouasse-Lebel, Paris, Sacred Heart of Jesus devotional card (*c*.mid-19th century), cut paper and hand–painting
Courtesy of http://holycardheavensacredheartofjesus.blogspot.ie (Creative Commons licence)

Jesus and Mary';[51] and a number of depictions of Irish interiors, such as Aloysius O'Kelly's well-known *Mass in a Connemara Cabin* (1883), show 'the ubiquitous sacred heart print on the wall'.[52] The nature of the iconography changed over the course of the nineteenth century in Europe (and beyond), shifting from the direct depiction of a heart (Figure 5.1) to its integration into the figure of Christ, as in the French 'holy card' in Figure 5.2, where Christ deliberately exposes his heart and 'engages the pious viewer with a direct gaze, bringing the two parties together in an affective resonance'.[53]

In the nineteenth century, a newly affective form of spirituality domesticated the sacred, and created in believers a sense of belonging to a 'household of faith' that included 'Mary, the mother; and Jesus, the elder brother to all the angels, saints, and other Catholics, both living and dead'.[54] The devout were guided in how to understand and use images of the Sacred Heart in terms that likewise suggested a personal relationship through visual and physical interaction. The popular *Devotions to the Sacred Heart of Jesus*, printed in Dublin in 1851 from a French translation, counselled: 'A person who loves another, consoles himself in some manner for his absence by the possession of his portrait; he carries it about him, looks upon and frequently kisses it',[55] and advised readers to 'place a picture of the adorable heart of your Saviour [...] in some conspicuous place, so the sight of it may inspire you to love him, and kiss this image with the same devotion as the Sacred Heart itself'.[56]

While the agency of images and other religious objects was partly prescribed by the Church in terms of indulgences, further emotional benefits were also promoted, not least the sense of communication with and closeness to the divine that emphasized this affective dimension. The importance of this was described, for example, by Frederick William Faber in the best-selling *All for Jesus: or, the Easy Ways of Divine Love* (1854): 'We talk to the angels in their different choirs, as if they were, as they are, our brothers in Christ. We use beads, medals, crucifixes, holy water, indulgences, sacraments, sacrifices, for all this, as naturally as pen, ink, and paper, or axe and saw, or spade and rake, for our earthly work'.[57]

51 *A Complete Catholic Registry, Directory, and Almanack* [henceforth referred to as *Irish Catholic Directory*] (Dublin: Battersby, 1847), 10.
52 Claudia Kinmonth, *Irish Rural Interiors in Art* (New Haven, CT: Yale University Press, 2006), 184.
53 David Morgan, *The Sacred Heart of Jesus: The Visual Evolution of a Devotion* (Amsterdam: Amsterdam University Press, 2008), 28.
54 Taves, *Household of Faith*, 48.
55 *Devotions to the Sacred Heart of Jesus, and a Charming Little Devotion to the Holy Virgin, etc. etc.* (Dublin: James Duffy, 1851), 48–49.
56 *Devotions to the Sacred Heart of Jesus*, 60.
57 Frederick William Faber, *All for Jesus: or, the Easy Ways of Divine Love* (London: Richardson and Son, 1854), 115.

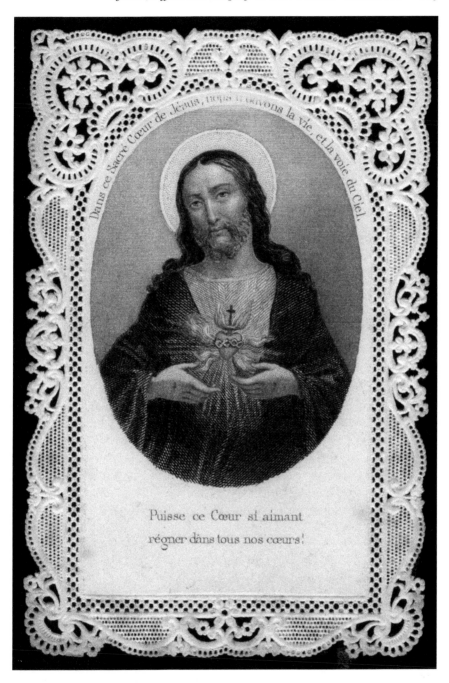

5.2 French devotional card depicting the Sacred Heart (*c*.1870), cut paper
Courtesy of http://holycardheavensacredheartofjesus.blogspot.ie (Creative
Commons licence)

The Council of Trent's ruling on religious images emphasized that due honour and veneration are to be given them, but warned of the danger of worshipping the images themselves, a theme accentuated in catechical literature. However, the sympathetic, affective dimension of piety was certainly promoted through prayers and spiritual exercises directed towards creating an empathy between the faithful and the image. As such, the emotional life of Irish Catholics was deeply predicated on the use of material culture to arouse religious feelings; as the historian of Christian imagery David Morgan writes, 'sacred objects and devout viewers engage one another in a variety of felt relations'.[58] Later in the nineteenth century, novels by Irish Catholic writers often emphasized the agency of statues and pictures in eliciting familial emotion on the part of the faithful. This occurs, for example, in Canon Patrick Sheehan's *My New Curate*, serialized in 1898, where a congregation reacts to a Christmas crib in these terms:

> I heard gasps of surprise and delight, exclamations of wonder, suppressed hallelujahs of joy; I saw adoration and tenderness, awe and love on the dimly lighted faces of the people. [...] Some were kneeling, and uttering half-frantic ejaculations of adoration, pity, and love [...] all around, the fervid Celtic imagination translated these terracotta figures into living and breathing personalities.[59]

Catholics had been encouraged to identify with the suffering of Christ at various times in history, with an 'affective economy' of particular significance in the medieval period.[60] An affectively oriented piety was increasingly encouraged in the nineteenth century. This was due to a number of factors, including the influence of Liguorian religiosity, and was supported by the more widespread availability of imagery. Of further significance was the cultivation of appropriate emotional responses to narrative and image as part of general social mores, often underpinned by a religious sensibility even when directed at ostensibly secular subject matter.[61] As such, the increase in object-mediated devotion in Ireland might be linked to broader consid-

58 David Morgan, 'The Look of Sympathy: Religion, Visual Culture, and the Social Life of Feeling', *Material Religion*, 5.2 (2009), 134.

59 Patrick Sheehan, *My New Curate* (Dublin: Talbot Press, 1900), 152. Cited by Ann Wilson in 'Irish Catholic Fiction of the Early Twentieth Century: The Power of Imagery', *New Hibernia Review*, 18.1 (2014), 30–49.

60 See, for example, Sarah McNamer, *Affective Meditation and the Invention of Medieval Compassion* (Philadelphia: University of Pennsylvania Press, 2010).

61 For example, see Pamela Fletcher, '"To Wipe a Manly Tear": The Aesthetics of Emotion in Victorian Narrative Painting', *Victorian Studies*, 51.3 (2009), 457–69.

erations of bourgeois sentimentality, social aspiration and behaviour within the post-Famine public sphere.[62]

Display

'Perhaps more than any other country in Europe', Ireland is a land of nineteenth-century churches, and throughout the century, the increasing buoyancy and wealth of Irish Catholicism was physically set in stone throughout the landscape.[63] The Famine interrupted construction in some cases, but its aftermath saw an intensive acceleration. While the prominent siting of new religious buildings gave Catholicism an enduring presence, other physical expressions of religion were evident in less permanent although still impressive media, through public rituals and ceremonies. This was particularly so from the 1850s. Despite Catholic Emancipation (1829), on the eve of the Famine the outward display of Catholicism was relatively muted. For example, Daniel Murray, Archbishop of Dublin (episcopacy, 1823–52) forbade the religious Order of the Sisters of Mercy to expose religious emblems in the street; and Bishop James Doyle of Kildare and Leighlin (episcopacy, 1819–34) 'wished to avoid anything that offended Protestant sensibilities, things like a clerical dress, or external shows, or processions through the streets'.[64] We can trace the spread of public ritual in the post-Famine period through newspapers and in particular the 'annals' section of the *Irish Catholic Directory*, where we find accounts of ecclesiastical events for the preceding year, with comprehensive descriptions of even quite modest ceremonies.

Cardinal Paul Cullen's love of spectacular 'Roman' ceremonial is well documented by historians, who often cite the episcopal processions at the opening of the Synod of Thurles in August 1850, ceremonial scenes that were witnessed by thousands of spectators and read about by thousands more as 'unexampled in our day for real magnificence'.[65] As the examples below demonstrate, descriptions of smaller events throughout the country,

62 See, for example, Maria Luddy's study of the relationship between philanthropy, emotion and religious behaviour of women during this period. Maria Luddy, *Women and Philanthropy in Nineteenth-Century Ireland* (Cambridge: Cambridge University Press, 1995).

63 Alistair Rowan, 'Irish Victorian Churches: Denominational Distinctions', in Raymond Gillespie and Brian Kennedy (eds), *Ireland: Art into History* (Dublin: Townhouse, 1994), 208.

64 Desmond J. Keenan, *The Catholic Church in Nineteenth Century Ireland: A Sociological Study* (Dublin: Gill & Macmillan, 1983), 31.

65 *Freeman's Journal*, 23 Aug. 1850, 3. For Cullen and ceremonial culture, see, for example, Oliver P. Rafferty, 'The Ultramontane Spirituality of Paul Cullen', in Dáire

involving less exalted participants, are deeply suggestive of the developing sensual experience of Irish Catholics as performers and audiences of public displays of devotion. The material culture of such events might be read in terms of costume and prop and also body technique, the ordered moving together in public space which expresses regulation and communality.

Thus, taking the 1853 edition of the *Directory* as a sample, we can read of the impressive rituals for the blessing and laying of the first stone of the church of St Michael the Archangel in Ballinasloe the previous April (1852), with details of a procession of clergy chanting psalms 'through the public streets of the town'.[66] Such ceremonies associated with church building were typical, with elaborate rituals held not only for the consecration of completed buildings but also for the inauguration and sacralization of elements of the building. The same month as the Ballinasloe procession saw ceremonies held at the church of St James in Dublin for the blessing of the new bell by the Archbishop of Dublin before a reportedly 'vast' congregation including a 'numerous body of Clergy' and children robed in crimson and white ministering 'with censers and frankincense'.[67]

The next month (May 1852), an 'imposing ceremony' was held at St Michael's Gorey, including a Eucharistic procession, involving 'little boys in scarlet soutan[e]s and red surplices', 'young ladies of the Loreto day school wearing white dresses, and bonnets to correspond, each holding a lighted wax candle, carrying a banner of the Blessed Sacrament' and 'the pensioners of the convent, arrayed in white, with long lace veils, and white rosettes, each carrying a basket of flowers, strewing them before the Blessed Sacrament'.[68]

These ceremonies had a number of functions. As well as being desirable from a ritual perspective, they were didactic, informing participants of the necessity to sacralize the components of the church, and they might also have served as occasions for direct instruction, as at St James in the Liberties area of Dublin, where the ceremony included a discourse preached by the Jesuit Henry O'Rourke on the significance of church bells. Ceremonies connected with church buildings may also have been useful in eliciting donations to complete the structures, as it was not uncommon for the first stone of a church to be laid 'without a clear idea of how long a building would take or [...] where the money was to come from'.[69] In this case, the foundation stone of St James was laid in 1842; in reference

Keogh and Albert McDonnell (eds), *Cardinal Paul Cullen and his World* (Dublin: Four Courts Press, 2011), 61–77.
66 *Irish Catholic Directory*, 321.
67 *Irish Catholic Directory*, 322–23.
68 *Irish Catholic Directory*, 324.
69 Grimes, 'Funding a Roman Catholic Church in Nineteenth-Century Ireland', 147.

to Famine conditions, the 1848 *Directory* reported that the work had been suspended 'due to lack of funds', and the bell was blessed seven years before the completion of the church in 1859.[70]

Ritual performance was also important at the level of the individual body. Physical self-mastery was figured as one aspect of being 'civilized', and one way this was materialized and embodied was through the ordering of gesture and movement necessary to be part of a religious procession. Participation also showed a clear deference to the Church's authority, and such acts of devotion were in marked contrast to pre-Famine practices where many religious observances took place beyond the control of the institutional church, such as 'patterns', which saw pilgrims visiting sites associated with particular saints and often indulging in riotous behaviour.

In discussing how clerics promoted certain ways of behaving in chapels in the nineteenth century, Cara Delay explains how 'bodily control, conformity, and order were each crucial in the church's campaign to reform unruly parishioners'.[71] Indeed, discipline was a key aspect of post-Famine Irish Catholicism. This was partly in the interior sense, for example, through the promotion of the examination of conscience necessary for confession. However, it was also in terms of actual body discipline, as performed and displayed through processions and ceremonies. Both confession and self-discipline are fundamental in Michel Foucault's account of the emergence of modern subjectivity, where he refers to 'docile bodies' that are capable of being trained.[72] The display of disciplined, docile, trained Catholic bodies in post-Famine Ireland was thus a significant materialization of the moral values promulgated by the Church, and an assertion of both the civility of the participants and the corporate power of the institution.

Conclusion

This chapter explored three key aspects of Catholic material culture in post-Famine Ireland: system, affect and display. To conclude, we might consider why a material culture perspective is a useful approach to understanding the history of Catholicism in the post-Famine period. An

70 *Irish Catholic Directory* (1848), 291. See also Christine Casey, *The Buildings of Ireland: Dublin: The City within the Grand and Royal Canals and the Circular Road* (London: Penguin, 2005), 629.

71 Cara Delay, '"The Gates were Shut": Catholics, Chapels and Power in Late Nineteenth Century Ireland', *New Hibernia Review*, 14.1 (2010), 18.

72 See Michel Foucault, 'Docile Bodies', in *Discipline and Punish: The Birth of the Prison*, trans. A. Sheridan (New York: Vintage Books, 1995), 135–69.

acknowledgement of the changed objects and spaces of Irish Catholics is not new; when Larkin originally proposed his 'revolution' thesis, he mentioned 'the use of devotional tools and aids' and that 'the whole world of the senses' was explored in a new way.[73] However, as with many subsequent scholars, he paints the nature of post-Famine religious material culture in broad brushstrokes; a deeper analysis might enable us to understand this phenomenon better from the perspective of the faithful.

The schema outlined in this chapter offers one way of understanding the nature of that material culture in relation to those who consumed it and co-produced its meaning. The more general import of the changing physical co-ordinates of religion might be gleaned from historians who have worked on the impact of the Famine on Irish experience. As explained earlier, the predominant characterization of the social, cultural and even mental changes associated with that period have tended to focus on the decimation of a dynamic vernacular culture and its replacement by a culture more in thrall to centralized forms of power and ideas of respectability. This characterization has also informed work on the sociology of religion in Ireland: for example, Tom Inglis's influential study *Moral Monopoly*, in which he suggests that the type of Irish Catholic religiosity that came to prevail in this period was 'legalist-orthodox', centred on strict adherence to Church rules and regulations.[74] The systematic, rule-governed nature of many of the religious objects explored in this chapter would seem to support this argument.

However, whereas Inglis and others tend to emphasize the power of the institutional church in accounting for the upsurge in Irish Catholic religiosity in the post-Famine period, they do not provide a full picture of the more emotional and affective dimensions of religion. This matter is of course more difficult to research and find evidence for, but the tracing of the development of certain imagery like the Sacred Heart and further investigation into primary material such as diaries, school syllabuses and correspondence do suggest ways into understanding something of the inner lives of Catholics in this period. Also, while the material culture of religious display might be interpreted as a show of authority, we should not forget its theatricality, and how it afforded novel forms of sensuous delight. Research into religion and the Famine has tended to focus on the actions taken by the Church and its clerics: for example, in relation to relief,[75] or the characteri-

73 Larkin, 'Devotional Revolution', 645.

74 Inglis, *Moral Monopoly*, 12. Inglis has adapted this typology from Max Weber, *Economy and Society*, ed. Guenther Roth and Claus Wittich (Berkeley: University of California Press, 1968), vol. 1, 422–39.

75 See Donal Kerr, *The Catholic Church and the Famine* (Blackrock: The Columba Press, 1996).

zation of the Famine as a largely Catholic phenomenon (despite recent work demonstrating that it also disproportionately affected poor Protestants).[76] A fuller account of the impact of the Famine on the religious experience of Irish Catholics should include a better understanding not only of the power of the Church as an institution but how new material ways of interacting with and understanding the divine opened up new ways of seeing, behaving and believing.

76 See Ian N. Gregory and Niall A. Cunningham, '"The Judgement of God on an Indolent and Unself-Reliant People"? The Impact of the Great Irish Famine on Ireland's Religious Demography', *Journal of Historical Geography*, 51 (2016), 76–87.

6

'This Most Humane Commerce': Lacemaking during the Famine

Melissa Fegan

University of Chester

Item 86 in Fintan O'Toole's *History of Ireland in 100 Objects* is a lace collar from Youghal, which 'epitomises one of the more remarkable achievements of Irish women in the second half of the nineteenth century—the creation from scratch of a world-class craft industry' (Figure 6.1).[1] The collar's aesthetic appeal is secondary to its significance as an artefact linked imaginatively, if not literally, to the Famine. It was exhibited at the Royal Dublin Society in 1906, but is a legacy of the foundation of lace-schools in Ireland during the 1840s and 1850s by nuns and middle-class women for the purpose of providing an income for girls whose families were directly affected by the Famine. The Presentation Convent in Youghal is frequently cited as the origin of the Famine lace industry. Mother Mary Ann Smith took a piece of old Italian lace, unravelled its threads one by one, and taught herself to make it, before teaching the girls at the convent school to do the same, and then opening a lace school in 1852.[2] In his 1886 history of Irish lace, Ben Lindsey hints at a reason why Youghal was an apposite location for the revival of lacemaking as a relief measure during the Famine: as the former home of Sir Walter Raleigh, it was 'the place where the first potato took root in Irish soil'.[3]

Lacemaking in Ireland had a longer history, however. While lace had been made commercially in Limerick and at Carrickmacross since the 1820s, most attempts to introduce lacemaking in Ireland were philanthropic rather than profit-driven. In 1743, Lady Arabella Denny had taught

1 Fintan O'Toole, *A History of Ireland in 100 Objects* (Dublin: Royal Irish Academy, 2013), No. 86.
2 Ada K. Longfield, *Catalogue to the Collection of Lace* (Dublin: Stationery Office, 1937), 58.
3 Ben Lindsey, *Irish Lace: Its Origin and History* (Dublin: Hodges, Figgis, and Co., 1886), 22.

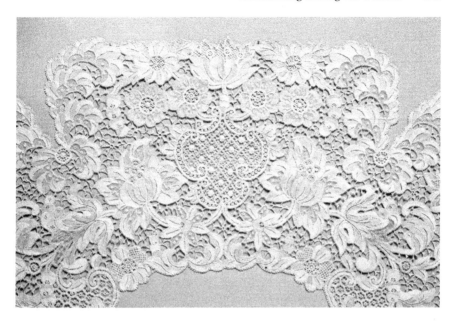

6.1 Lace collar (Youghal), 1906
Courtesy of National Museum of Ireland

'the famishing children in the poor-house' to make Bone lace, awarded prizes from the Dublin Society to the best lacemakers, and helped arrange for the exhibition and sale of their work.[4] Mother Mary Ann Smith's experience was prefigured by a number of women in the 1820s. Mrs Grey Porter, wife of the rector of Dunnamoyne in Carrickmacross, taught her servant to make lace by copying some she had brought from Italy, and the example spread to the 'deserving poor' of the area. Lady De Vere in County Limerick taught the mistress of a local school to copy lace she had bought in Brussels, and Lady O'Brien of Dromoland taught satin stitch embroidery as a relief measure in 1822—an experiment repeated by her daughter in 1846.[5] In John Banim's novel *The Anglo-Irish of the Nineteenth Century* (1828), Gerald Blount, the English-educated Ireland-hating Anglo-Irishman, is ambushed at a party in London by a group of philanthropic Irish ladies longing to read him reports about their successes in teaching needlework to poor Irish women. Miss De Vere tells him:

4 Lindsey, *Irish Lace*, 4; Longfield, *Catalogue to the Collection of Lace*, 50–51.
5 Lindsey, *Irish Lace*, 6–7; John Francis Maguire, *The Industrial Movement in Ireland, as Illustrated by the National Exhibition of 1852* (Cork: John O'Brien; London: Simpkin, Marshall and Co., 1853), 186–87.

when the institution at Clack-ma-cross was opened, ten women could not be found capable of doing the kind of work required; and in the course of seven months nearly two hundred were capable. Remark, too, that the neatness with which the articles are executed, such as lace, baby-linen, straw-platting, is the more praise-worthy, as it is done by the women in the evenings, *after they return from labouring in the fields.*[6]

Miss Flint also reports triumphantly that in Galway a woman who had been given a loan by a reproductive fund to buy wool for spinning refused to sell it when her family fell ill of fever: 'The struggle was severe, but her better feelings prevailed, and she was heard to exclaim, in her own expressive language, "No—*no* distress shall make me do that; it is a sacred trust"— There!'[7] While the women's competitive reporting is comic, these evidences of Irish industry and honesty are an early rebuke to Gerald's disdain for the Irish, and the neat and clean seamstresses are a pointed contrast to another Irishman at the party, the devious convert Cornelius O'Hanlon, who arrives wearing a 'national wrap-rascal' and hobnailed boots, mired in the mud of the London streets.[8]

In fact, the national costume of the Irish was generally assumed to be rags; in Charles Dickens's *Martin Chuzzlewit* (1843–44), Martin is astounded when he meets in New York 'a man with such a thoroughly Irish face, that it seemed as if he ought, as a matter of right and principle, to be in rags, and could have no sort of business to be looking cheerfully at anybody out of a whole suit of clothes'.[9] The ability to sew was therefore a key indicator of the capacity and desire of the Irish—specifically Irish women— to improve. In 'Learning to Sew', the second of Mary Leadbeater's *Cottage Dialogues among the Irish Peasantry* (1811), the prudent Rose chides the flighty Nancy for her reluctance to mend the rents in her gown: 'Being poor may make us go in old and threadbare clothes, but want of neatness and industry alone can keep us in ragged ones. Indeed, when I see a working man in ragged clothes, I can't help, in my own mind, blaming his wife, or sister, or mother'.[10] Irish raggedness was also a disincentive to charity; Rose points out that Lady Belfield gave a coat to Jack, whose old one was patched, rather than to Tom, whose coat hung in rags, because Jack was likely to

6 John Banim, *The Anglo-Irish of the Nineteenth Century: A Novel*, 3 vols (London: Henry Colburn, 1828), vol. 1, 247. Italics in original.

7 Banim, *The Anglo-Irish of the Nineteenth Century*, vol. 1, 249.

8 Banim, *The Anglo-Irish of the Nineteenth Century*, vol. 1, 199–200.

9 Charles Dickens, *Martin Chuzzlewit*, ed. Margaret Cardwell (Oxford: Clarendon Press, 1982), 286.

10 Mary Leadbeater, *Cottage Dialogues among the Irish Peasantry* (London: J. Johnson and Co., 1811), 10.

make good use of the gift, whereas Tom would quickly reduce the new one to rags 'for want of a stitch'.[11]

In her *Letters from Ireland* (1852), Harriet Martineau recorded that Leadbeater's daughter-in-law had taught fancy knitting to a bed-ridden woman and her daughters. More than 200 women and girls were now employed in the area making 'Spider Mitts', 'Impalpable Mitts', and 'Cobweb Mitts', 'and people who knew Stradbally thirty years ago are so struck with the improvement in the appearance of the place, that they declare that the lowest order of the cabins appears to them to be actually swept away'.[12] This is not an isolated example; Martineau describes how, 'In every house of the gentry one now sees sofas, chairs, screens, and fancy tables spread with covers of crochet-work—all done by the hands of peasant women', while in the south-west, 'lace of a really fine quality is made in cabins where formerly hard-handed women did the dirtiest work about the potato-patch and piggery'.[13] The Mayor of Cork, John Francis Maguire, says of a lace collar produced at the Blackrock school in the early 1850s: 'though it had not been washed, it looked as if it had not been touched by mortal fingers,—such is the neatness of the children, who have been drilled into a habit of cleanliness which had never been known in their homes before'.[14] Lacemaking provided an opportunity for the Irish poor not just to survive the Famine, but to improve in ways British and middle-class Irish observers very much approved of.

Industry and Regeneration

Irish lace was recognized as much more than a decorative object; it was freighted with national pride, moral value, cultural prejudice, imperial ideas of civilization, pity and hope for the future. The *Nation*, reporting on a meeting of the Board of Manufactures and Industry, was keen to emphasize that the Irish lace being prepared for the Great Exhibition represented more than just a charitable enterprise; it was also an indication of Ireland's wider industrial potential, and ability to compete internationally: 'The lace of Limerick has now attained a European reputation and pre-eminence! [...] Have we achieved all this in lace, and shall we despair of achieving as much in other branches [...]? Forbid it common sense, forbid it history!'[15]

11 Leadbeater, *Cottage Dialogues*, 10–11.
12 Harriet Martineau, *Letters from Ireland* (London: John Chapman, 1852), 67–68.
13 Martineau, *Letter from Ireland*, 68–69.
14 Maguire, *The Industrial Movement in Ireland*, 209.
15 'Manufacture Movement', *Nation*, 29 Mar. 1851, 2.

'Whatever may be said of the rest of the Irish nation', commented *The Morning Post* rather acidly, the lace displayed at the Dublin Exhibition in 1853 proved at least that 'its ladies are by no means in want of industry, taste, and ingenuity'.[16] Irish lace was highlighted in many reports of the 1851 Great Exhibition, a rare positive news story about the Famine, and a responsible means of charitable support. The correspondent for the *Lady's Newspaper* stated it was 'worthy of great attention' as 'a source of existence for many of the poor girls of the sister isle'.[17] The lace schools were praised as much as their product. Maguire described the Cork Embroidery School in 1852 as 'one of the noblest monuments of that active and practical charity which had its origin in the sad year of Famine',[18] while Mr and Mrs S.C. Hall said the ladies of Cork had 'rescued hundreds—nay thousands—from the gripe of misery and death', and they urged strangers to visit the embroidery school if they wanted to carry away 'pleasant memories of an Irish tour' in a country still ravaged by disease and famine.[19] For Asenath Nicholson, the industrial schools represented hope for the future in an otherwise blasted land:

> These schools, scattered through the island, in the midst of the desolating famine, looked, to the traveler, like some humble violet or flower, springing in the desert or prairie, where a scathing fire had swept over the plain [...] And looking upon these happy faces one might feel that Ireland is not wholly lost.[20]

These private initiatives, managed by women and nuns, were largely unsupported by government. Indeed, when the Belfast Ladies Relief Committee appealed to the British Treasury for financial assistance, they were informed that 'such intervention lay beyond the scope of government'.[21] Their popularity and effect was also in stark contrast to the public works and outdoor relief schemes. Unlike the notorious Famine roads, lacemaking was productive labour, with the potential to become a viable national industry. It provided work for women and girls who were generally neglected by the public works schemes. In a letter to the Central Relief Committee of the Society of Friends in 1847, Maria Edgeworth commented:

16 'The Dublin Industrial Exhibition', *The Morning Post*, 31 Oct. 1853, 3.
17 'The Great Exhibition: Pencillings by a Lady', *Lady's Newspaper*, 7 June 1851, 319.
18 Maguire, *The Industrial Movement in Ireland*, 194.
19 Mr and Mrs S.C. Hall, *Handbooks for Ireland: The South and Killarney* (London: Virtue, Hall & Virtue; Dublin: James M'Glashan, 1853), 26–28.
20 Asenath Nicholson, *Annals of the Famine in Ireland* (1851), ed. Maureen Murphy (Dublin: Lilliput Press, 1998), 80, 145.
21 Christine Kinealy, *This Great Calamity: The Irish Famine 1845–52* (Dublin: Gill & Macmillan, 1994), 166.

A poor woman the other day in thanking our vicar for the assistance he gave in employing men and boys, regretted that when as much was done for men, nothing has been thought of for women or children, who are, as she said, also anxious for work; if they could be employed and paid, they would work to their utmost.[22]

Edgeworth suggested that donating a small sum to buy materials and pay women for needlework and knitting would prove 'profitable in a pecuniary point of view, and in a much greater degree useful both now and hereafter in preventing them from losing the proper sense of shame, or becoming mere beggars and paupers, and sinking into idleness and consequent vice'. Patricia Lysaght notes that some women were employed on the roads, making drains and drawing stones, but they were paid less than the men, and concerns were expressed about their 'poor neglected children'.[23] Lacemaking had the advantage that it could be done from home, so children could be cared for, and cabins, more often than not associated with the dung-heap at the door, had to be improved in order to accommodate it: thatched roofs were lined and chimneys installed, and both space and worker kept clean and tidy to protect the fabric.[24]

Lacemaking also offered an alternative to the workhouse, not just for the individual, but her entire family. Susanna Meredith relates several examples of little girls who earned enough to take their families out of the workhouse one by one.[25] Maguire calculated that the 80 girls who had been discharged from the workhouse and were now supporting themselves with the help of St Mary's Industrial School were not only saving the ratepayer £320 a year, but were also 'the means of supporting a second person—a mother, a sister, or a young brother—whom she has taken out of the Workhouse, in consequence of having found employment'.[26] Meredith pointedly describes lacemaking as 'this system of "out-door relief"';[27] in contrast with the soup-kitchens, it provided a respectable and happy independence. While, as Margaret Kelleher has argued, women and children were frequently portrayed as the

22 Maria Edgeworth, 'Letter to Central Relief Committee (1847)', in Angela Bourke *et al.* (eds), *The Field Day Anthology of Irish Writing: Irish Women's Writing and Traditions* (Cork: Cork University Press, 2002), vol. 5, 698–99.

23 Patricia Lysaght, 'Perspectives on Women during the Great Irish Famine from the Oral Tradition', *Béaloideas*, 64–65 (1996–97), 79.

24 Claudia Kinmonth, *Irish Rural Interiors in Art* (New Haven, CT and London: Yale University Press, 2006), 110–11.

25 Susanna Meredith, 'Needlework v. Domestic Service', The Lacemakers: Sketches of Irish Character, with some Account of the Effort to Establish Lacemaking in Ireland (London: Jackson, Walford, and Hodder, 1865), 44–45.

26 Maguire, *The Industrial Movement in Ireland*, 221.

27 Meredith, 'Needlework v. Domestic Service', *The Lacemakers*, 45.

pre-eminent Famine victims,[28] the lacemaker offers a contrasting image of the heroic female saviour of the family. Maguire describes fishermen's families in Blackrock, once dependent on the 'strong and powerful father' and 'the vigorous son', now 'protected from hunger and misery by the fingers of the feeble child and saved from the workhouse by her cheerful and untiring toil'. One man, unable to find work, rose at 5 a.m. to hold thread for the daughter 'upon whose feeble hands, but practised skill and loving heart, depended his salvation from starvation or the workhouse'.[29] While the 1851 census shows a decline in the lace industry (from 337 weavers of lace and 318 manufacturers of lace in 1841 to 188 weavers of lace and 42 manufacturers of lace in 1851) there was an increase in laceworkers (from 1,207 to 1,905) and notably in laceworkers under the age of 15 (from 189 to 412).[30] Mrs Meredith also notes that the 1851 census returned 902 pupils in schools of embroidery, crochet, knitting, netting and tatting, 'but these figures did not represent the extent of the exertion to diffuse the knowledge of needlework'.[31] The figures also do not represent those who were enabled to emigrate during the Famine as a result of their earnings from lacemaking.

In *Eva O'Beirne; or, The Little Lace Maker*, one of a series of Catholic moral tales for children published in Dublin in 1856 by 'Brother James', 11-year-old Eva has helped support her family, since the death of her father from fever, through lacemaking. Her teacher, Sister Agnes, had gone to Belgium specially to learn how to make it, 'in order that she might introduce it here, and give the poor a better means of earning a comfortable livelihood'.[32] Eva sells her wares through a kindly milliner, who praises Eva to her genteel client, Mrs Butler Adair, not just for the quality of her work, but its evidence of her industry; Eva 'plied her fingers, night and day' not only to earn money, but also to inspire her brother Phil to work their ground.[33]

Unfortunately, the O'Beirnes are due to be evicted by the agent of their absentee landlord, who wants to consolidate the property and replace tenants with cattle. Luckily, Mrs Butler Adair is about to become engaged

28 Margaret Kelleher, *The Feminization of Famine: Expressions of the Inexpressible?* (Durham, NC: Duke University Press, 1997).

29 Maguire, *The Industrial Movement in Ireland*, 205–06, 237.

30 *Report of the Commissioners Appointed to Take the Census of Ireland, for the Year 1841* (Dublin: Her Majesty's Stationery Office, 1843), 440; *The Census of Ireland for the Year 1851, Part VI: General Report* (Dublin: Her Majesty's Stationery Office, 1856), 634.

31 Meredith, 'Lace-making in Ireland', *The Lacemakers*, 6.

32 'Brother James', *Eva O'Beirne; or, The Little Lace Maker* (Dublin: James Duffy, 1856), 2. Rolf Loeber and Magda Loeber identify him in *A Guide to Irish Fiction* (Dublin: Four Courts Press, 2006) as James Reynolds, a surgeon, apothecary and fiction writer, with a medical practice in Booterstown.

33 'Brother James', *Eva O'Beirne*, 2–3.

to the landlord, Sir Marmaduke Banbury, and persuades him that Sister Agnes is a better political economist than his agent: she has turned Eva into an artist, 'by whose skill our national character is raised, and by whose earnings, Mr. Wilson's own balance-sheet looks much pleasanter in his own eyes, at the year's end, than it would otherwise have done'.[34] Their visit to the O'Beirnes' clean and tidy cottage, and a lecture on lacemaking from Eva, confirms the good opinion, and Sir Marmaduke decides to stop the evictions, revise the rents, and grant long leases to the improving tenants, and also to spend his holidays in Ireland rather than going to Germany. As his soon-to-be wife is about to convert to Catholicism, it seems likely he will too. The story ends with Eva, now 'the happiest lace-worker of which any history ever made mention', the right-hand of the new Lady Banbury.[35] The *Freeman's Journal* praised the 'tone of Catholic morality' of Brother James's 'charming little Irish stories', as 'a quality which might be looked for in vain in the innumerable publications for children with which we are inundated by the London press'.[36] Equally unusual, however, is the portrayal at this time of a happy lace-worker.

The Starving Seamstress

The Irish needlewoman rescuing herself and her family from famine offers a fascinating counter-narrative to the prevailing discourse on the seamstress in England in the 1840s and 1850s, who had become 'a stylized symbol of the suffering caused by urban industrialism among the working poor generally'.[37] In a series of government reports, newspaper exposés, novels, plays, short stories and poems, the seamstress emerged as an innocent victim of capitalist exploitation, impoverished and exhausted by the demands of a tyrannical employer and the heartlessness of their wealthy clients, lured into prostitution or condemned to a lengthy decline and death.[38] She was also represented as starving, and in fact frequently evoked descriptions of Famine victims. *Punch*'s November 1843 article 'Famine and Fashion!' describes the case of a seamstress called Biddell, 'A wretched-looking woman [...] with a squalid half-starved infant at her breast', who was tried for pawning trousers she was making for the slop-seller Mr Moses

34 'Brother James', *Eva O'Beirne*, 17.
35 'Brother James', *Eva O'Beirne*, 31.
36 'Literature: Brother James's Tales', *Freeman's Journal*, 12 July 1856, 3.
37 Lynn M. Alexander, *Women, Work, and Representation: Needlewomen in Victorian Art and Literature* (Athens: Ohio University Press, 2003), 18.
38 See Beth Harris (ed.), *Famine and Fashion: Needlewomen in the Nineteenth Century* (Aldershot: Ashgate, 2005), 1–10.

to buy dry bread for herself and her two children.[39] The following month, *Punch* published Thomas Hood's poem 'The Song of the Shirt', probably the most significant and widely read version of the victimized seamstress. Hood's speaker, dressed in 'unwomanly rags', is sewing 'A Shroud as well as a Shirt'. She lives 'In poverty, hunger, and dirt' and her wages are 'A bed of straw, / A crust of bread—and rags'. She is famished and skeletal:

> But why do I talk of Death!
>> That Phantom of grisly bone,
> I hardly fear his terrible shape,
>> It seems so like my own—
>> It seems so like my own,
>> Because of the fasts I keep,
> Oh! God! that bread should be so dear,
>> And flesh and blood so cheap![40]

This was an important poem for Irish writers; Anna Maria Hall offered to write for *Hood's Magazine* for no remuneration, as a tribute to the author of 'The Song of the Shirt'.[41] Meredith used a stanza of 'The Song of the Shirt' as the epigraph to her book *The Lacemakers*, even though the image it presents is at odds with her intention of offering needlework as a symbol of regeneration. Most strikingly, in July 1847, the *Dublin University Magazine* published 'The Song of the Famine', a poem modelled closely on 'The Song of the Shirt'. Hood's two refrains, 'Work! work! work!' and 'Stitch! stitch! stitch!', emphasizing the monotonous labour of the seamstress, multiply into the triple exclamations of a famished mother: 'Want!', 'Food!', 'Home!' 'Death!', 'Cold!' and 'Sick!'[42] Both women are in rags and starving. Their city dwellings are similar: the seamstress's 'shatter'd roof' and 'naked floor' mirrored in the mother's 'miry floor' and 'dripping roof'. The urban setting of this Famine poem is relatively unusual, as Famine victims were frequently depicted in rural cabins.[43] The seamstress works 'Till the brain

39 'Famine and Fashion!', *Punch*, 4 Nov. 1843, 203. This passage cites a report in *The Times*, 27 Oct. 1843, 4.

40 Thomas Hood, 'The Song of the Shirt', *Punch*, 16 Dec. 1843, 260.

41 Susan Casteras, '"Weary Stitches": Illustrations and Painting for Thomas Hood's "Song of the Shirt" and Other Poems', in Harris, *Famine and Fashion*, 21.

42 'The Song of the Famine', *Dublin University Magazine*, 30.175 (1847), 102–04.

43 See, for instance, the 'wretched cabin by the roadside' in chapter 29 of William Carleton's *The Black Prophet* (1847), the 'miserable, low-roofed, damp, ragged tenement' in chapter 33 of Anthony Trollope's *Castle Richmond* (1860) and the mud cabin of the Molloys in vol. 2, chapter 17 of Margaret Brew's *The Chronicles of Castle Cloyne* (1885).

begins to swim', while the mother is fevered, 'With an aching, swimming brain'.

However, the misery of the mother far surpasses that of the seamstress. While the seamstress has at least 'A bed of straw', 'A table' and 'a broken chair', the mother has only 'a little straw', 'the empty space' where her kettle and pot should be and 'the naked coffin of deal' containing the dead body of her child. The seamstress's 'crust of bread' is more palatable than the 'hard crust' the mother had tried to feed to her son, which 'came too late': 'It lay dry between the dying lips, / And I loathed it—yet I ate'. 'The Song of the Shirt' ends with the wish that the song 'could reach the Rich!', but the mother's message is more urgent:

Beware before you spurn,
Ere the cravings of the famishing
 To loathing madness turn.

In using Hood's poem as a model, the author of 'The Song of the Famine' draws on the huge public sympathy demonstrated for the seamstress, a sympathy which was not always forthcoming for the Irish. That the misery of the English seamstress and the Irish Famine victim were paralleled is also confirmed by a comparison in *The Illustrated London News* in December 1849:

A great and just sympathy is just now excited by the sufferings of the needlewomen of the metropolis [...] But they at least find shelter; most of them have clothing; they manage to get food, though the supply is scanty; and the most crowded lodging-house of the metropolis is a palace compared with the Scalp, or burrowing hole, of the Irish peasant.[44]

In the Irish context, sewing is represented as an alternative to starvation, rather than the cause of it, and the seamstress, rather than a symbol of the economic exploitation of the poor by middle-class employers or clients, is generally supported by them: provided with instruction in needlework, with threads and materials, with access to a ready market, and frequently given the whole earnings of the exchange.

In English novels and visual representations, women were frequently criticized for being complicit in the destruction of the seamstress, as, for example, in John Tenniel's *Punch* cartoon, 'The Haunted Lady, Or "The Ghost" in the Looking Glass', from 1863 (Figure 6.2).[45] Part 4 of Charlotte

44 'General State of Kilrush', *The Illustrated London News*, 15 Dec. 1849, 394.
45 See Kenny Meadows's 'Death and the Drawing Room, or the Young Dressmakers

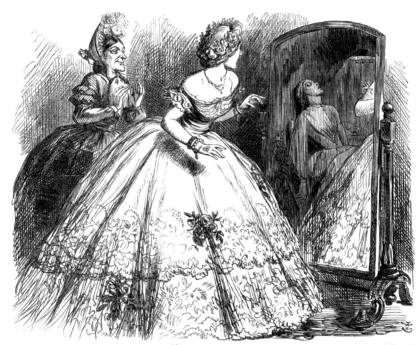

THE HAUNTED LADY, OR "THE GHOST" IN THE LOOKING-GLASS.

Madame La Modiste. "WE WOULD NOT HAVE DISAPPOINTED YOUR LADYSHIP, AT ANY SACRIFICE, AND THE ROBE IS FINISHED *À MERVEILLE*."

6.2 John Tenniel, 'The Haunted Lady, Or "The Ghost" in the Looking Glass' (1863), wood engraving, *Punch*, 4 July 1863
Reproduced with permission of Punch Ltd., www.punch.co.uk

Elizabeth Tonna's *The Wrongs of Woman* (1844) represents the misery of English lace-runners, who work 20 hours a day to supply the insatiable demands of 'a market that numbers among its customers, in one branch or another, every grade of society, from the Queen upon the throne to the village barmaid, who cannot serve beer out to her master's customers without a bit of edging to her simple cap'.[46] The country girl Kate Clarke is lured to a lace-district with the promise of a job which will keep her out of the factories her father dreads, but finds herself instead 'fettered [...] not

of England', *The Illuminated Magazine*, 1 (May–Oct. 1843), 97; John Leech's 'Pin Money/Needle Money', *Punch*, 23 Dec. 1849, 238; John Tenniel's 'The Haunted Lady, Or "The Ghost" in the Looking-Glass', *Punch*, 4 July 1863, 5.

46 Charlotte Elizabeth [Tonna], *The Wrongs of Woman: in Four Parts*, Part 4, *The Lace-Runners* (London: W.H. Dalton, 1844), 4–5.

less strongly than is the galley-slave by his iron chain' to the monotonous task of drawing out lace threads.[47] Her employer, the impoverished Mrs Collins, like most women of the district, exists on a pittance for running, hemming, pearling and mending machine-made lace, and relies on her children—one of whom, Sally, is as young as three—to work alongside her. Domestic tasks are ignored or performed hurriedly by her husband on his return from work. Her baby is drugged with laudanum to allow his mother to work unhindered; soon a 'breathing corpse of a babe [...] haggard, ghastly, and dwindling away', he catches measles and dies.[48] When Mrs Collins asks her employer for an advance to pay for the funeral and mitigate the costs of family illness, she is lectured on the imprudence of the poor having children, and a heavy hint is dropped that Kate might easily supply the family's deficit by selling herself: 'She's good-looking enough, and may find ways of helping you out, as many others do'.[49]

The story ends with Kate on the brink of the traditional fall of the seamstress into prostitution: destitute and desperate, she is last seen entering a theatrical establishment, her final words, muttered through clenched teeth, 'Let them answer it', an echo of Mrs Collins's imprecation:

[W]hen I began to put my little one to slave, I knew it was wrong and wicked; and I did it because I was forced to do it; and I laid the sin of it at the door of the rich manufacturer, to answer at the day of judgment for whatever harm might come to the bodies or souls of me or mine, from such unnatural starving. [...] Ay, and THEY SHALL ANSWER it![50]

Tonna goes further: it is not the rich manufacturer alone who will be punished for this suffering; 'England's sons' could have prevented 'this murderous crusade of wealth against poverty' through legislation, but had chosen not to interpose, and as for English women:

double shame, twice doubled be to the fair and fascinating daughters of England, who well know that they might, if they would, so bring the cause of their destitute sisters before the eyes, and so impress them on the hearts and consciences of those fathers, brothers, husbands, lovers, sons of theirs, as to rouse them to the fulfilment of a duty, for the due performance of which the Providence of God placed them where they are![51]

47 Charlotte Elizabeth [Tonna], *The Wrongs of Woman*, Part 4, 8.
48 Charlotte Elizabeth [Tonna], *The Wrongs of Woman*, Part 4, 47.
49 Charlotte Elizabeth [Tonna], *The Wrongs of Woman*, Part 4, 73.
50 Charlotte Elizabeth [Tonna], *The Wrongs of Woman*, Part 4, 57–58.
51 Charlotte Elizabeth [Tonna], *The Wrongs of Woman*, Part 4, 96–97.

Tonna's *Wrongs* are therefore not only done *to* women but *by* women and indicate a state of society so warped by the enslavement of the poor (and in particular of women) in industry that 'some fearful act of vengeance' by the Almighty is inevitably imminent: 'the fair inheritance of England's Queen is becoming but as a throne whose pillars rest on an awakening volcano'.[52]

By contrast, the industries begun by women in Ireland are, according to Meredith, a 'most humane commerce',[53] and the relationship between seamstress and lady is an ethical rather than a financial one. Lacemaking in Ireland is 'a war against misery, in which every woman's hand in the land was engaged—the delicate touch of the peeress assisting the rough fingers of the peasant'.[54] The Queen's patronage of Irish lace is frequently mentioned in reports of the Great Exhibition and national exhibitions, and in fiction: the lace Eva makes is 'fitted to adorn the person of a queen (and a good queen too)', while Meredith's Mary Desmond creates lace for the Queen's sunshade.[55] Rather than a volcano beneath the pillars of the throne, it was hoped that Irish industry would reinforce the bonds of the Union; philanthropic women 'taught the peasantry to see in their rulers their friends'.[56] While the English seamstress, separated from her family, was exposed to the dangers of the city, particularly of prostitution, and contagious disease in unhealthy workrooms, the Irish seamstress was learning to be industrious, obedient and clean, becoming a reliable and self-reliant prop for her family, and protecting them from the dangers of starvation and the workhouse. While the English seamstress was at the mercy of her employers and their wealthy clients, the Irish seamstress was educated, nurtured and supported by hers.

Bony Fingers and Commerce

However, Irish writers were heavily influenced by the discourse on the seamstress in English fiction. In Mary Anne Hoare's story 'The Knitted Collar' (1848), 14-year-old Mary Sullivan and her family are starving in

52 Charlotte Elizabeth [Tonna], *The Wrongs of Woman*, Part 4, 138.
53 Meredith, 'Ellen Harrington', in *The Lacemakers*, 98.
54 Meredith, 'Lace-making in Ireland', in *The Lacemakers*, 2.
55 'Brother James', *Eva O'Beirne*, 13; Meredith, 'Mary Desmond', in *The Lacemakers*, 356.
56 Lindsey, *Irish Lace*, 27. Reports of the Queen's expenditure in support of Irish lace contrast with accusations of meanness in charitable donations: James H. Murphy notes the longstanding myth that she gave only £5 to famine relief (she actually donated £2,500). James H. Murphy, 'Fashioning the Famine Queen', in Peter Gray (ed.), *Victoria's Ireland? Irishness and Britishness, 1837–1901* (Dublin: Four Courts Press, 2004), 24.

the attic of an old house in an Irish city in November 1846. Mary seems a composite of both the Irish and the English seamstress. She has learned the art of fine knitting 'while attending an excellent charity-school', and has been given thread by Jane Brown, emphasizing the charitable support of other women in her maintenance. Her father, a shoemaker who destroyed himself through drink, has been judged undeserving of charity, and his family 'literally left to perish' with him. Mary's attempt '*to do something*' challenges the stereotype of Irish apathy and indolence. But, like the English seamstress, Mary and those like her struggle to earn a pittance: 'The delicate fabrics, both in knitting and embroidery, which many a bony finger worked at till the hollow eye grew dim, were often disposed of for two or three pence beyond the price of the materials'.[57] The Irish lady who buys the collar from Mary in the street, Mrs Elliott, behaves more like the women in the English seamstress narratives, exploiting the vulnerable position of the impoverished child. Knowing that a milliner would charge five shillings for such fine work, she refuses Mary's price of two shillings, and offers one, dismissing Mary's plea that her parents and brothers are starving as 'the old story', and congratulating herself on the bargain. When she next sees Mary, a month later, the child, no longer able to knit due to her failing strength and the December light, has fainted while begging in the street; Mrs Elliott's husband finds the bodies of her parents and sister, and rescues her brothers. The remnant of the family, saved only indirectly by Mary's bony fingers, are cared for, and Mrs Elliott learns her lesson: 'though thrifty, as a housewife should be, in buying from rich tradespeople, [she] has never been known to cheapen the work of the poor, since the day on which she purchased the *knitted collar*'.[58] Hoare was from County Cork, and may well have known of the work of the convents and embroidery schools in enabling girls to earn a living from knitting and lacemaking, but her choice of a plot structure which aligns more closely with the English seamstress narrative is dictated by her publication in an English periodical, and her purpose in drawing attention to the immediate need for charitable donation for Famine victims. Presenting the child as a seamstress as well as a Famine victim might prove a more effective persuasion.

Susanna Meredith's *The Lacemakers*, published in 1865, offers another fascinating version of the narrative. Meredith had been widowed during the Famine; her husband, a doctor, died of cholera. Her father, the Governor of the County Gaol at Cork, had organized a soup kitchen,

57 Mary Anne Hoare, 'The Knitted Collar', in *Shamrock Leaves; or, Tales and Sketches of Ireland* (Dublin: James M'Glashan; London: Partridge & Oakey, 1851), 58–59. The story had previously been published in the *London Pioneer*, 6 Apr. 1848, 811–12.
58 Hoare, 'The Knitted Collar', 66–67.

and Meredith roused herself from her grief to open the Adelaide School to teach peasant girls to crochet lace. Her sister comments that 'Nothing gave her greater pleasure than to be told by any of her crochet pupils that they earned by a week's work what supported their father and mother and paid the week's rent, and such instances were not uncommon during the famine time'.[59] Meredith published two articles on 'The Cultivation of Female Industry in Ireland' in the *Englishwoman's Journal* in 1862, but, deciding that 'dry statistical statements do not inform anybody about Ireland' as '[t]here is some curious want of faculty in the Saxon constitution to digest this crude mass', she returned to the subject in *The Lacemakers* in 1865, reprinting the two articles, followed by three stories, because '[f]iction, decidedly, has done more than anything else to make known this *terra incognita*'.[60]

Of the three stories she presents, the two which offer a positive outcome feature Anglo-Irish women in reduced circumstances, who benefit much more from their 'humane commerce' than the girls they teach. In 'Ellen Harrington', the eponymous heroine, a little girl, nurses her aunt and uncle (the local clergyman) who contract fever while ministering to the local poor in 1848. Ellen, like Mary in 'The Knitted Collar', is 'the only person in the household able to do anything', and, following her aunt and uncle's deaths, she uses £5 given to her by a naval officer to buy thread and teaches children to make crochet edgings, which are sold in Cork. Her plan is to 'get quite rich' herself while 'the poor children will be earning a living'.[61] When Ellen is offered an opportunity to leave Ireland to study at the Kensington School of Art, she seizes it, but her eventual marriage to Dr Neligan and emigration to Australia is partly enabled by the girls she left behind; in gratitude for his comfort of the sick during the Famine, the girls give Dr Neligan a large parcel of lace, a notable sacrifice on their part, to help pay his passage to America, where he earns a lucrative living from the export of lace. In 'The Redeemed Estate', Meredith emphasizes that all classes suffered during the Famine. The genteel Fitzwalter sisters experience 'positive, real hunger' after their bankrupt father fakes his death and flees to the continent, and their potato crop is destroyed.[62] Unable to find situations as governesses due to the 'superabundance of the "reduced-lady" class', they begin making lace to support their family.[63] Initially, they are ashamed of their need for the money, working under

59 M.A. Lloyd, *Susanna Meredith: A Record of a Vigorous Life* (London: Hodder & Stoughton, 1903), 11, 13–16.
60 Meredith, 'Preface', *The Lacemakers*, viii–ix.
61 Meredith, 'Ellen Harrington', 68, 75–76.
62 Meredith, 'The Redeemed Estate', in *The Lacemakers*, 169.
63 Meredith, 'The Redeemed Estate', in *The Lacemakers*, 171.

cover of charity, but eventually the Fitzwalters become proud of and embrace their occupation: 'They had taken *to work*, and they liked it; and were determined to be independent'.[64] Their 'genius, dexterity and industry' provides an income for them and the poor girls they teach during the Famine, and helps to clear the debt from the estate.[65]

For Meredith, '[c]rochet was topographical', not only because stitches were localized and peculiar to particular areas, but because it expressed the national characteristics of its makers.[66] The Anglo-Irish women who took it up did so as a 'stern business effort', and 'kept it within rules and restrictions, according to the nature of their orderly habits'; the Celts embraced it as 'a wild enterprise', 'a poem wrought with passion', and to this disorderliness Meredith traced the failure of the industry. The inventiveness of the Celt, without the necessary artistic training, led to degenerate aberrations:

> Their crude fancies knotted and gnarled the thread into shapes so various and extraordinary, that to examine them became a study—not of lace, but of people. Poor little girls! their notions of beauty were as rudimentary as those of the early races; [...] They seemed, indeed, to begin at the beginning of woman's decorative conceptions, and unconsciously to produce the same forms that suggested themselves to the Babylonians, and to Pharoah's daughters, ignoring all that subsequent civilizations have done for feminine taste.[67]

In one of the factual chapters preceding the stories, Meredith describes a little girl who arrived as a 'small bundle of dark cloth, dripping wet' at the crochet-school of the Cork Poor Relief Society:

> The humanity of the object was scarcely discernible through the dirty encumbrance of its dishevelled hair, and the involution of an old cloak that composed its only garment. But this was a person, and had a mind of its own, though as untutored in the conventionalisms of civilized life as the gorilla of M. du Chaillu.[68]

This semi-human bundle of rags had begged a penny to buy a needle and thread and is celebrated for her success: 'This same child, through her

64 Meredith, 'The Redeemed Estate', in *The Lacemakers*, 180.
65 Meredith, 'The Redeemed Estate', in *The Lacemakers*, 202.
66 Meredith, 'Ellen Harrington', 90–91.
67 Meredith, 'Ellen Harrington', 86.
68 Meredith, 'Needlework v. Domestic Service', in *The Lacemakers*, 42–43.

exertions, enabled her mother and sisters to come out of the work-house
[…]. In a short time they had a little home, and have managed to keep
it'.[69] However, the disjunction between the barely clothed worker and the
decorative fabric she creates, and between the insistence on her personhood
and the comparison of her to a gorilla, is disturbing.

In the final story, 'Mary Desmond', Meredith depicts 'a thorough-bred
Celt' whose 'very rags were picturesque'; Mary's clothing—a soldier's
scarlet coat, a petticoat made from a blue bathing dress and a yellow
handkerchief—is accidentally assembled, yet mysteriously artful: 'how they
hung upon her, so as to drape her according to the laws and taste of
harmony, were mysteries, deepened by the knowledge of the way in which
Irish beggars obtained their clothing'.[70] She is extremely gifted with the
needle, but unmanageable. She fails to fulfil orders, ignores patterns, and
lies, as do the other uneducated workers: 'The cunning they displayed, and
the unprincipled treachery with which they behaved to every employer,
gave sad evidence of a very low state of morals'.[71] They are corrupted by the
sudden influx of money offered by lacemaking, spending it on fine clothes
and Temperance Balls, or, even worse, donations to Young Ireland, for
'Satan's power was also connected with busy fingers'.[72] Mary's friends, the
Gorman sisters, are so lacking in control that Mary colludes in a plot to
have them incarcerated in a Magdalen asylum—a system Meredith seems
to approve of as 'a good plan for getting them bodily out of harm's way'.[73]
Mary herself is embroiled in a melodramatic plot: she steals a painting
from her Protestant employers, the Blacks, under orders from her priest;
aids in the embezzlement of documents and cash from the Blacks by her
nationalist lover; and marries Miss Black's fiancé, who claims they are not
truly married as he is a Protestant, and abandons her and their child. At
the end of the story, Mary is in a situation familiar in English seamstress
narratives: a fallen woman, living in a filthy garret, miserable and ill. Her
baby dies, and she enters a Magdalen asylum.

By the time she wrote *The Lacemakers*, Meredith was living in London,
and very doubtful about the long-term viability of lacemaking in Ireland.
Her Adelaide School in Cork had closed in 1859, and while lace was still
being produced in the area, it was coarse and inferior, Meredith says,
due to the disinclination of the workers to take the trouble to produce
a premium product that could outlast the fluctuating demands of the

69 Meredith, 'Needlework v. Domestic Service', in *The Lacemakers*, 44.
70 Meredith, 'Mary Desmond', in *The Lacemakers*, 208–09.
71 Meredith, 'Mary Desmond', in *The Lacemakers*, 226.
72 Meredith, 'Mary Desmond', in *The Lacemakers*, 234.
73 Meredith, 'Mary Desmond', in *The Lacemakers*, 293.

market.[74] Meredith, and those such as Ben Lindsey and Alan S. Cole, who were calling for better education in lace design in Ireland in the 1880s, were disappointed that the possibility of an enduring craft industry was being squandered for short-term gain. However, as Jacinta Prunty points out, schools such as St Mary's Industrial Institute, set up by Margaret Louisa Aylward's Ladies Association of Charity in 1853, often failed because it was asking too much of destitute women to attend and persevere before they could earn enough to live.[75] It was perhaps also too much to expect those who undertook the work in desperation to develop into artists who valued the craft above the financial lifeline it offered. Heather Castles has argued that, judged as a source of permanent, well-paid employment, the efforts of women like Meredith were at best partially successful, but as a famine-relief initiative it was a highly effective intervention.[76] Even if many of those who were taught lacemaking abandoned it once they had earned enough to emigrate, its primary purpose had been served. The scheme was also successful in inspiring the middle-class women who founded the lace-schools to 'burst the bonds of conventionalisms';[77] many of those who would go on to lead the suffrage campaign or revolutionize women's education in Ireland, such as Anne Jellicoe and Anna Maria Haslam, began their public careers by setting up embroidery schools in their home towns during the Famine.[78] After moving to England, Susanna Meredith campaigned for women's access to employment, and founded an international network of prison missions to provide refuges and work for women leaving prison. This 'humane commerce' provided other tangible legacies than lace.

74 Meredith, 'Lace-making in Ireland', in *The Lacemakers*, 15–16.
75 Jacinta Prunty, 'Margaret Louisa Aylward', in Mary Cullen and Maria Luddy (eds), *Women, Power and Consciousness in 19th-Century Ireland: Eight Biographical Studies* (Dublin: Attic Press, 1995), 64.
76 Heather Castles, 'Hybrid Stitched Textile Art: Contemporary Interpretations of Mid-Nineteenth-Century Irish Crochet Lace Making', unpublished PhD thesis (University of Ulster, 2011), 113.
77 Meredith, 'Lace-making in Ireland', *The Lacemakers*, 6.
78 Anne V. O'Connor, 'Anne Jellicoe' and Mary Cullen, 'Anna Maria Haslam', in Mary Cullen and Maria Luddy (eds), *Women, Power and Consciousness in 19th-Century Ireland*, 128, 164.

7

Art and the Post-Famine Irish Diaspora in America

Fintan Cullen

University of Nottingham

Nineteenth- and twentieth-century American drama is rich in Irish diasporic references; less so the visual arts.[1] In Eugene O'Neill's *Long Day's Journey into Night*, set in 1912, written in 1941–42, and not published and first performed until 1956, the whole New England household of the Tyrone family and their domestic staff are of Irish origin. Yet that Irishness is not always seen in a positive light. It has been argued persuasively that O'Neill based the patriarch and main protagonist, James Tyrone, on his own father, James O'Neill, who had emigrated to America from Ireland in 1856—after the Famine.[2] In the play, Tyrone is endlessly criticized for his poverty-stricken Irish peasant origins and his concerns about overspending, the need for owning property and 'the fear', as his wife Mary puts it, of ending 'his days in poverty'.[3] These accusations form part of a conversation between Mary and Cathleen, the 'second girl', or under-housemaid, who is described by O'Neill as 'a buxom Irish peasant, in her early twenties, with a red-cheeked comely face, black hair and blue eyes'. As described by O'Neill, Cathleen is 'amiable, ignorant, clumsy, possessed by a dense, well-meaning stupidity'.[4] Indeed, in her interactions with the Tyrone family, we see her as uncouth, off-hand and decidedly dim. Unlike James Tyrone, a now renowned actor with a voice that is 'remarkably fine, resonant and flexible', Cathleen has failed to 'defeat the brogue' and speaks

1 See Maureen Murphy, 'From Scapegrace to Grásta: Popular Attitudes and Stereotypes in Irish American Drama', in John P. Harrington (ed.), *Irish Theater in America: Essays on Irish Theatrical Diaspora* (Syracuse, NY: Syracuse University Press, 2009), 19–37.
2 Murphy, 'From Scapegrace to Grásta', 32–33.
3 Eugene O'Neill, *Long Day's Journey into Night* (London: Jonathan Cape, 1966), 87.
4 O'Neill, *Long Day's Journey*, 44.

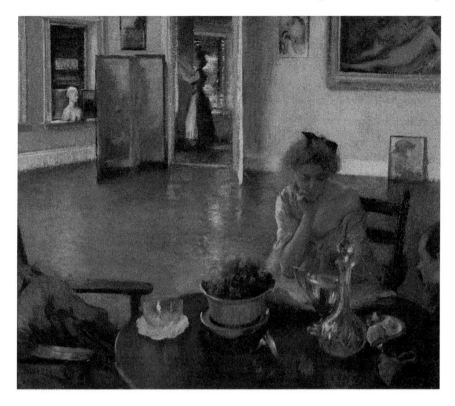

7.1 Edmund C. Tarbell, *The Breakfast Room* (*c.*1903), oil on canvas,
63.5 cm × 76.2 cm
Courtesy of the Pennsylvania Academy of Arts, Philadelphia
Gift of Clement B. Newbold, No. 1973.25.3

in a thick Irish accent: 'the impidence of him!', she says in Act III of 'the man in the drugstore'.[5]

Despite its psychological depth, O'Neill's play is riddled with such Irish stereotypes. By contrast, when we turn to the visual arts and examine Irish insertions into American art in the period that followed mass emigration to the United States as a result of the Famine and the crisis that it engendered, a more varied picture of the Irish domestic servant in a New

5 O'Neill, *Long Day's Journey*, 11, 88. See Edward L. Shaughnessy, 'O'Neill's African and Irish-Americans: Stereotypes or "Faithful Realism"?', in Michael Manheim (ed.), *The Cambridge Companion to Eugene O'Neill* (Cambridge: Cambridge University Press, 2006), 148–63, 155. For more on O'Neill and Irishness, see Murphy, 'From Scapegrace to Grásta', 32–33 and Joe Cleary, 'Irish American Modernisms', in Joe Cleary (ed.), *The Cambridge Companion to Irish Modernism* (Cambridge: Cambridge University Press, 2014), 174–94, 185–87.

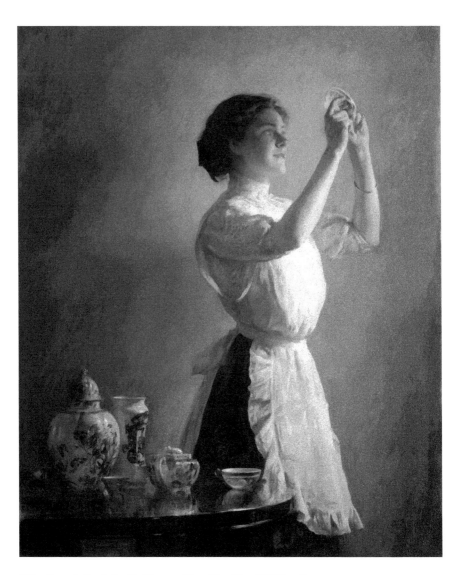

7.2　Joseph Rodefer DeCamp, *The Blue Cup* (1909), oil on canvas,
126.7 cm × 104.5 cm
Museum of Fine Arts, Boston. Gift of Edwin S. Webster, Lawrence J. Webster
and Mary S. Sampson in memory of their father, Frank G. Webster, 33.532
Photograph © 2018 Museum of Fine Arts, Boston

England household becomes apparent. This chapter looks at the work of two American artists, Edmund C. Tarbell (1862–1938) and Joseph Rodefer DeCamp (1858–1923), both of whom were part of the Boston School as well as members of the exhibition collective, The Ten American Painters (founded in 1897), and painted innumerable interiors which include maidservants with or without their employers.[6] In Tarbell's *The Breakfast Room* of *c*.1903 (Figure 7.1), we see a couple at breakfast, while a female servant stands in the background. In DeCamp's *The Blue Cup* of 1909 (Figure 7.2), a woman servant holds aloft a delicate cup and considers its translucence against the daylight. Given that the depiction of natural light dominates these two paintings and that they represent moments from modern life, both Tarbell and DeCamp have been defined by the American curatorial world as representations of American Impressionism. As articulated in a 1994 exhibition organized by the New York Metropolitan Museum of Art, in terms of composition and tone these works display an awareness of recent trends in European art yet suggest what the catalogue sees as 'satisfying lives [...] and the time for reflection'.[7] It is the contention of this chapter that by inserting an Irish diasporic element into the discussion of these Boston paintings they become more than scenes of domestic life. While these paintings cannot be described as even remotely radical, the very presence of possible Irish domestic servants in these works makes them part of an exilic art history. As such, by looking at Tarbell and DeCamp in this way, we add an Irish dimension to American art history and an American dimension to Irish art history.

While no information is given in either of these paintings as to the national backgrounds of the domestic servants represented, historical facts are worth considering. By 1900, 60 per cent of Irishwomen in the United States were in domestic service, while in Boston, where these paintings were produced, 50 per cent of the servants were Irish.[8] Both Tarbell and

6 For Tarbell and DeCamp, see Trevor J. Fairbrother, *The Bostonians: Painters of an Elegant Age, 1870–1930* (Boston: Museum of Fine Arts, 1986); Bernice Kramer Leader, *The Boston Lady as a Work of Art: Paintings by the Boston School at the Turn of the Century* (Ann Arbor, MI and London: University Microfilms International, 1980).

7 H. Barbara Weinberg, Doreen Bolger and David Park Curry, *American Impressionism and Realism: The Paintings of Modern Life, 1885–1915* (New York: Metropolitan Museum of Art and Harry N. Abrams, 1994), 257.

8 Dianne M. Hotten-Somers, 'Relinquishing and Reclaiming Independence: Irish Domestic Servants, American Middle-Class Mistresses, and Assimilation, 1850–1920', in Kevin Kenny (ed.), *New Directions in Irish-American History* (Madison: University of Wisconsin Press, 2003), 227–42. The literature on Irish domestic servants in North America is growing: see Hasia R. Diner, *Erin's Daughters in America: Irish Immigrant Women in the Nineteenth Century* (Baltimore, MD and London: Johns Hopkins University Press, 1983); Margaret Lynch-Brennan, *The Irish Bridget: Irish*

DeCamp participated in that statistic as they separately employed at least two Irish maidservants, yet that seems to have been the limit of their involvement with Ireland.[9] As such, this chapter echoes a key principle of this collection of essays, as stated in the introduction to this volume: that 'historically informed examinations of representational systems' need to be explored.[10]

The starting point for any analysis of an Irish diasporic art history is, naturally enough, migration. At least 7 million people emigrated from Ireland to North America between the early 1700s and the 1920s.[11] By 1870, three-quarters of those migrants lived in urban sites. Historians have thus described the Irish diaspora as a predominantly urban group.[12] As art tends to occur more within an urban area, the existence of an Irish post-Famine appearance in American paintings produced 50 years after that calamitous event offers us insight into the visualization of exile in art.

In the discipline of art history, we need to be more inclusive in defining a diasporic art history and acknowledge the important role of migration and its relationship with art production. Saloni Mathur has suggested that the gains of the integration of art history with migration are that they will allow for the exploration of 'the relationship of the visual arts to the forms of subjectivity produced by migration and displacement'. The study of art needs to be involved in 'challenging or consolidating the conditions of globalization and its histories; and the implications of a world that is understood as both inextricably interconnected and mercilessly blocked by the politics of barriers and boundaries for historiography, writing, and the narratives of art history'.[13]

Using terminology derived from Edward Said, Joe Cleary has referred to Ireland as 'an exemplary nursery of exilic consciousness'.[14] Given that

Immigrant Women in Domestic Service in America, 1840–1930 (Syracuse, NY: Syracuse University Press, 2009).

9 Elizabeth O'Leary, *At Beck and Call: The Representation of Domestic Servants in Nineteenth-Century American Painting* (Washington, DC and London: Smithsonian Institution Press, 1996), 220.

10 Marguérite Corporaal, Oona Frawley and Emily Mark-FitzGerald (eds), *The Great Irish Famine: Visual and Material Cultures* (Liverpool: Liverpool University Press, 2018), 2.

11 Kerby A. Miller, 'Emigrants and Exiles: Irish Cultures and Irish Emigration to North America, 1790–1922', *Irish Historical Studies*, 22.86 (1980), 97.

12 Kevin Kenny, 'Diaspora and Comparison: The Global Irish as a Case Study', *Journal of American History*, 90.1 (2003), 150.

13 Saloni Mathur, 'Introduction', *The Migrant's Time: Rethinking Art History and Diaspora* (New Haven, CT and London: Yale University Press, 2011), i–ix, viii.

14 For a discussion of Said's use of the term 'exilic consciousness', see chapter 2 in William V. Spanos, *Exiles in the City: Hannah Arendt and Edward W. Said in Counterpoint* (Columbus: The Ohio State University Press, 2012). For Cleary's comments, see

over the centuries Ireland attracted migrants into the country 'as colonial settlers' for whom 'Ireland was and was not home' and who maintained 'an outlander mentality', Cleary notes that 'a persistent pattern of outwards migration can also be observed', for example, in the 'Irish poor compelled to emigrate'. The result of this inward and outward migration left a seriously unstable and hybrid culture with the need to question the notion of anything resembling a definable Ireland-based Irish art. In other words, the examination of how Ireland was represented in the visual arts does not have to be about a narrowly conceived history of *Irish* art—one that is 'an exclusory preoccupation with defining a particular school'.[15] Rather it should be about the relationship between Ireland and the visual. Refocusing attention on the 'visual' compels a perspective that is not limited by national borders or national schools of art history, and thus can include a range of images produced by non-Irish artists throughout the world. The collection of data and imagery on Irish migrants over the past centuries will force students and academics, as well as institutional curators, to pay closer attention to the theme of diaspora in relation to the visual history of Ireland. A diasporic art history is often hidden and needs time-consuming investigation. As Mathur has suggested:

[T]he field of human and societal relationships brought into view through the paradigm of the migrant is [...] ambivalent and indeterminate; it represents some of the most difficult forms of entanglement and separation resulting from our collective condition, the unsettling crisis of dislocation and non-belonging, and the necessity of searching for alternative connections to communities of inhabitation over space and time.[16]

Stuart Hall has talked of the notion of 'imaginary reunification',[17] and the creation of a photographic account of the peoples of the Black Triangle, that is Africa, the Caribbean, the United States and the United Kingdom.

'Introduction: Ireland and Modernity', in Joe Cleary and Claire Connolly (eds), *The Cambridge Companion to Modern Irish Culture* (Cambridge: Cambridge University Press, 2005), 7.

15 Fintan Cullen, *Visual Politics: The Representation of Ireland 1750–1930* (Cork: Cork University Press, 1997), 1–2. David Fitzpatrick has said much the same, stating that 'Majority emigration means [...] that the study of Irish history must not be limited to Ireland'. Quoted by Enda Delaney in Richard Bourke and Ian McBride (eds), *The Princeton History of Modern Ireland* (Princeton, NJ and Oxford: Princeton University Press, 2016), 504.

16 Mathur, *The Migrant's Time*, ix.

17 Jonathan Rutherford (ed.), *Identity: Community, Culture, Difference* (London: Lawrence & Wishart, 1990), 224.

Irish art history needs to construct in visual terms a comparable Irish diasporic archive. For some years, archives of Irish visual material have existed in educational institutions in Dublin, but the focus has been on collecting data on Irish artists or artists who worked in Ireland.[18] Whilst a few art historians have in their own scholarship transcended such national framings, more needs to be done to collect data relating to the Irish diaspora, and conceptually reconfigure the boundaries of 'Irishness' in art. Transatlantic and transnational Irish history is becoming a sophisticated area of research, but, following Hall's suggestion, like Black history it needs to acknowledge the visual as more than just an area useful to illustrate an established narrative.[19] Instead, it needs to be acknowledged that the visual has a history of its own.

From at least the 1880s, the representation of Irish serving women in the United States had been predominantly negative. One particular stereotype, the menacing, simianized harridan who, it was suggested, dominated the American kitchen became commonplace, with the Irish domestic seen as a threat to a nativist America. In Frederick Opper's (1857–1937) humorous yet defiantly racist image dating from 1883, 'The Irish Declaration of Independence that We are All Familiar with', published in the magazine *Puck*, and one of many such illustrations that he produced over a long

18 Dublin has three such archives: the ESB Centre for the Study of Irish Art (CSIA), National Gallery of Ireland (www.nationalgallery.ie/reserach/csia.aspx); The Irish Art Research Centre (TRIAC), Trinity College Dublin (www.tcd.ie/History_of_Art/research/centres/triac/); and The National Irish Visual Arts Library (NIVAL), National College of Art and Design (www.nival.ie) (accessed 26 July 2014). The publications of Anne Crookshank and the Knight of Glin have informed us of the vast array of visual material by foreign artists who visited Ireland and Irish artists who went abroad, see *The Watercolours of Ireland: Works on Paper in Pencil, Pastel and Paint c.1660–1914* (London: Barrie & Jenkins, 1994) and *Ireland's Painters 1600–1940* (New Haven, CT and London: Yale University Press, 2002).

19 For insightful comments on transatlantic Irish history, see Kenny's 'Diaspora and Comparison' and his *The American Irish: A History* (Harlow: Longman, 2000); and J.J. Lee and Marion R. Casey (eds), *Making the Irish American: History and Heritage of the Irish in the United States* (New York and London: New York University Press, 2006). In Irish art historical studies, useful work is being done in this area by Emily Mark-FitzGerald, *Commemorating the Irish Famine: Memory and the Monument* (Liverpool: Liverpool University Press, 2013); Niamh O'Sullivan, '"All native, all our own, and all a fact": John Mulvany and the Irish-American Dream', *Field Day Review*, 11 (2011), 138–49; and Fionna Barber, *Art In Ireland since 1910* (London: Reaktion Books, 2013). See also the publications from Ireland's Great Hunger Museum and Quinnipiac University Press: in particular, Catherine Marshall, *Monuments and Memorials of the Great Famine* (Hamden, CT: Quinnipiac University Press, 2014) and Niamh O'Sullivan, *The Tombs of a Departed Race. Illustrations of Ireland's Great Hunger* (Hamden, CT: Quinnipiac University Press, 2014).

period, the Irishwoman is fearsome, a bully and out of control.[20] In many ways, Eugene O'Neill's Cathleen retains many of the stock stereotypes of the Irish domestic as had been visualized in Opper. By contrast, in their highly polished images of women in interiors, Tarbell's and DeCamp's canvases are a far cry from such stereotypes of Irish domestics. The Irishwoman now features in a well-ordered world: instead of an 'enormous redhead' in a dress decorated with shamrocks we see trim young women in starched aprons who do not raise their fists at their employers but attend to their chores or admire the material indicators of a civilized lifestyle.

Yet, as suggested by Elizabeth O'Leary, within these images we should be aware of the historical context where 'acute tensions' existed 'between Boston's upper classes and the ever-growing masses of immigrant workers'. As O'Leary goes on to say, these paintings do not 'convey the heightened discord between families and their Irish maids'.[21] In contrast with the threatening air of the earlier imagery of the domestic servant, a seemingly placid air of harmony pervades the paintings by Tarbell and DeCamp. But placidity can be illusory. In the painting by DeCamp, by looking at the blue cup, the servant woman is examining something that does not belong to her and is thus, it can be argued, transgressing her role. In the painting by Tarbell, we observe the discrepancy between the middle-class bohemia of the house owners in the foreground and the servant woman's un-involvement in such a liberal lifestyle. While the maid is suitably attired in her domestic uniform and is busy with her duties, the couple in the foreground do not converse but are shown reading or considering their food. Such a casualness of behaviour is heightened by the woman's state of semi-undress that is suitably echoed by the reclining nude in the Renaissance-like painting on the far wall.

If these Boston paintings represent Irish domestic servants in the early twentieth-century United States, and it is very likely that they do, is it legitimate to discuss these works as being part of an Irish post-Famine diasporic art history? It could be argued that by including representations of Irish domestic servants in the United States, the Boston School was not

20 See Fintan Cullen, *Ireland on Show, Art, Union, and Nationhood* (Farnham: Ashgate, 2012), 140, figure 4.8; see also Maureen Murphy, 'Bridget and Biddy: Images of the Irish Servant Girl in *Puck* Cartoons, 1880–1890', in Charles Fanning (ed.), *New Perspectives on the Irish Diaspora* (Carbondale and Edwardsville: Southern Illinois University Press, 2000), 152–75. For more on American cartoon imagery of the Irish, see L. Perry Curtis, Jr., *Apes and Angels: The Irishman in Victorian Caricature* (Washington, DC and London: Smithsonian Institution Press 1997) and chapter 7 in Rebecca Zurier, *Picturing the City. Urban Vision and the Ashcan School* (Oakland: University of California Press, 2006).

21 O'Leary, *At Beck and Call*, 213. For the 'enormous redhead', see Murphy in Fanning, *New Perspectives*, 169.

illustrating either exilic or diasporic consciousness because the works, using Paul Gilroy's argument, do not exhibit an 'equalizing, proto-democratic force of common territory'; nor do they suggest an interest in 'the social dynamics of remembrance and commemoration defined by a strong sense of the dangers involved in forgetting the location of origin and the process of dispersal'.[22] If one adheres to such criteria, these paintings sit uneasily within an accepted typology of 'post-Famine' representations of the Irish. Most of the art historical comment on these paintings has not focused on their role as cutting-edge examples of a diasporic aesthetic. O'Leary, one of the few academics to discuss these paintings in the context of Irish domestics in the United States, rightly refers to Tarbell and DeCamp as painting a 'conservative theme' in 'a conservative style'.[23] In the wider literature, discussion has concentrated on their 'nostalgic, retrospective quality' and when discussing DeCamp's *Blue Cup* it has been suggested that the parlour maid depicted 'seems temporarily exonerated from arduous work to provide an artistic vignette. Such detachment from the hard facts of wage labor is particularly characteristic of the Boston painters'.[24]

Twenty years after Opper's image, the New York company of Underwood and Underwood was producing humorous glass stereographs on the theme of Irish servants. The Underwoods' hugely popular series focused on the dull-witted nature of the Irish servant.[25] In one stereographic card entitled 'How Biddy served the tomatos [*sic*] undressed', dating from 1903, we see the Irish maidservant serving table in her nightdress due to her misunderstanding of the instructions given.[26] By contrast, in the Tarbell and DeCamp paintings, instead of condescension or risqué imaginings we get uncritical assimilation.[27] O'Leary, for example, has suggested that the woman in the DeCamp painting becomes an essay

22 Paul Gilroy, 'Diaspora and the Detours of Identity', in Kathryn Woodward (ed.), *Identity and Difference* (London: Sage Publications and The Open University Press, 1997), 318.

23 O'Leary, *At Beck and Call*, 216.

24 Kramer Leader, *The Boston Lady*, 56; and Weinberg, Bolger and Curry, *American Impressionism and Realism*, 257.

25 See William C. Darrah, *The World of Stereographs* (Gettysburg, PA: W.C. Darrah, 1977), 65–68; also O'Leary, *At Beck and Call*, 241–42. For this continuation of the derogatory commentary on Irish servants in the United States, see Geraldine Maschio, 'Ethnic Humor and the Demise of the Russell Brothers', *Journal of Popular Culture*, 26.1 (1992), 81–92. Many thanks to Marion Casey for this reference. See also April Schultz, 'The Black Mammy and the Irish Bridget: Domestic Service and the Representation of Race, 1830–1930', *Éire-Ireland*, 48 (2013), 176–212.

26 Archives Center, Smithsonian Institution, National Museum of American History, Washington, DC, Box 2.1.2 [70] 66596.

27 See Cullen, *Ireland on Show*, 140–42. For more on assimilation, see Noel Ignatiev, *How the Irish Became White* (New York and London: Routledge 1995).

in the then recently fashionable cult of Aestheticism, and that by admiring the delicate blue cup the maid is indulging in the 'transforming power of culture'.[28] Equally, instead of debased national characteristics, we witness both artists' use of art historical quotations. Both Tarbell and DeCamp, along with many of their fellow Boston artists and others of the Ten group, had trained in Europe, and thus not surprisingly (as was observed when first exhibited in 1904) the painting by Tarbell, in its off-centred composition and cropped corners, has affinities with the works of Edgar Degas (1834–1917). Given the compositional dominance of the beam of daylight and the carefully articulated detail of the porcelain and china on the well-polished table, DeCamp's *The Blue Cup* attempts to approximate the luminosity of Johannes Vermeer (1632–75).[29] The attention to light may well remind us of Vermeer, but the painting's focus on a single woman worker also reminds us of at least one other Dutch seventeenth-century visual precedent. The artist Gerard ter Borch (1617–81), who was influential on the young Vermeer, became famous for his everyday scenes involving women in domestic settings that hinted at a sexual subtext and veiled innuendo. While it is not suggested that such a theme is here being perpetrated by DeCamp, the artist did likewise alter his image to allow the viewer to speculate as to the woman's social status. Again, O'Leary usefully informs us that, 'In his preliminary sketch for *The Blue Cup*, DeCamp included the maid's dusting rag, which was draped over the edge of the table. He omitted the cloth in the final canvas and, consequently, eliminated the most obvious sign of domestic labor'.[30] The representation of Irish domestic servants as included in these Boston School paintings of the early twentieth century are no longer occasions for derogatory laughter as they had been for some decades previously, but now act as a means to display European high art ambitions.

Why do we need such a diasporic art history for things Irish or for any other cultural group? We need it because it announces the maturity of a national art history. Irish art history is thus broadened, as is American art history: the latter is now a well-established area of research, while

28 O'Leary, *At Beck and Call*, 252.
29 For the Degas connections, see Trevor J. Fairbrother, *Antiques* 131 (Jan. 1987), 224–35. See O'Leary, 'Edmund C. Tarbell's Painting of Interiors', *At Beck and Call*, 214 and chapter 6, in general, for the references to Vermeer. See also John Fagg, 'Near Vermeer: Edmund C. Tarbell's and John Sloan's Dutch Pictures', *Modernist Cultures*, 11 (2016), 86–117. For a comparable UK discussion of a revival of interest in Dutch genre painting and the depiction of servants, see Giles Waterfield, Anne French with Matthew Craske, *Below Stairs: 400 Years of Servants' Portraits* (London: National Portrait Gallery, 2003).
30 O'Leary, *At Beck and Call*, 253.

Irish art history needs to move beyond a biographical preoccupation.[31] To quote once more from Stuart Hall, the diasporic in art is not defined by 'essence or purity' but is about identifying things within a mixed society.[32] Such perspectives are especially vital in diversifying our understanding of post-Famine visual cultures, which may not conform to expectations of exile, estrangement or collective loss. The women in the Tarbell or DeCamp paintings, be they mistress or maid, are not involved in what O'Leary has referred to as 'the bothersome idiosyncrasies widely attributed to their ethnic group or class. These are paintings of "things hoped for" that offer a comforting antidote to the changing conditions beyond the mahogany parlour doors of the Black Bay district [of Boston]'.[33] The visual images of Irish women in late nineteenth-and early twentieth-century America is a yet-to-be fully explored site. The Irish servant women who appear in these Boston School paintings around 1900, as well as Irishwomen such as Elizabeth 'Bessie' Price, who acted as an artist's model for Abbott H. Thayer (1849–1921) in a wide range of paintings produced in New Hampshire from the late 1890s, are part of Irish visual history and need to be incorporated into the national story.[34]

A comparative methodology is one way to examine the diasporic in art. This has been done in the discussion of the French artist Gustave Courbet (1819–77) and the English artist Ford Madox Brown (1821–93) in terms of how Famine-cra Irish migrants feature in two very well-known paintings of the mid-nineteenth century.[35] In 1854, in Paris, while composing his immense *The Painter's Studio*, Courbet wrote to the art critic and novelist Jules Francois Felix Fleury-Husson (1820–89), known as Champfleury, commenting on how he was including in the canvas 'an Irishwoman suckling a child [...] I saw this woman in a London street wearing nothing but a black

31 This bias is exemplified most recently in at least two of the five volumes in Andrew Carpenter (gen. ed.), *Art and Architecture of Ireland* (Dublin, New Haven, CT and London: Royal Irish Academy and Yale University Press, 2014), vol. 2, *Painting 1600–1900* and vol. 3, *Sculpture 1600–2000*. Volume 5 on the *Twentieth Century* has an essay by Catherine Marshall on 'Diaspora and the Visual Arts', 134–40, but the focus is on Irish artists who went or have gone abroad or other artists who moved to Ireland. Her piece is not about Irish subject matter per se, which is the focus of the chapter in this book.

32 Rutherford, *Identity*, 235.

33 O'Leary, *At Beck and Call*, 217.

34 See Nelson C. White, *Abbott H. Thayer: Painter and Naturalist* (Hartford: Connecticut Printers, 1951), 66–69, 75–77; and Ross Anderson, *Abbott Handerson Thayer* (Syracuse, NY: Emerson Museum, 1982), 68–73. See also Fintan Cullen, 'From Mythical Abstractions to Modern Realities: Depicting the Irish Émigrée', in Fintan Cullen and R.F. Foster, *'Conquering England': Ireland in Victorian London* (London: National Portrait Gallery, 2005), 54–65.

35 See Cullen, *Visual Politics*, chapter 4.

straw hat, a torn green veil and a ragged black shawl, and carrying a naked baby under her arm'.[36] This Irish migrant sits on the floor, in the centre of Courbet's painting next to the artist's easel, exposing what Linda Nochlin has referred to as her 'bare, flabby, pale unhealthy legs', and as such 'she swells to the dimensions of an insurmountable, dark stumbling block on the highway to constructive progress'.[37]

A decade later, in London in 1865, in the exhibition catalogue that accompanied the display of *Work*, Brown described how he had included representations of Irish migrants as well as such famous contemporaries as the philosopher Thomas Carlyle and the Christian Socialist Frederic Denison Maurice.[38] All feature in a painting which is made up of types representing different aspects of 'work' in the metropolis while in the background are the Irish 'on the shaded bank', a range of 'characters out of work: haymakers in quest of employment; a Stoic from the Emerald Island, with hay stuffed in his hat to keep the draught out, and need for his stoicism just at present, being short of baccy; a young shoeless Irishman, with his wife, feeding their first-born with cold pap'.[39] The focus here is on Irish emigration and poverty, and by placing it within a British context a transnational perspective is permitted. That transnational perspective is increased when Brown's painting is contrasted with Courbet's earlier Irish insertion in terms of the prominence of the Irish presences in the two canvases and the detailed textual expositions offered by both men.

By extension, the examination of Irish-related visual material in the United States in the late nineteenth century and early twentieth century allows us to identify a discernible Irish dimension to an otherwise American art history, one that is inextricable from a history of Irish migration accelerated during the Famine and in its aftermath. When we look at a celebrated early twentieth-century American image such as *Paddy Flannigan* (1908) (Figure 7.3) by George Bellows (1882–1925), we need to analyse such a work so as to articulate an interest in an Irish diasporic presence. Over the past decades, art historical discussions of Bellows's painting of *Paddy Flannigan* have ignored the boy's ethnic origins and

36 Arts Council of Great Britain, *Gustave Courbet, 1819–1877* (London: Arts Council of Great Britain, 1978), 254.
37 Linda Nochlin in Sarah Faunce and Linda Nochlin (eds), *Courbet Reconsidered* (New Haven, CT and London: Brooklyn Museum and Yale University Press, 1989), 27–28; more recently, Nochlin has discussed the Irishwoman in Klaus Herding and Max Hollein (eds), *Courbet: A Dream of Modern Art* (Ostfilhern: Hatje Cantz Verlag, 2010), 76–77, where she reproduces a relevant drawing from the Cabinet des Arts graphiques in the Louvre.
38 See Cullen, *Visual Politics*, 136–38.
39 Cullen, *Visual Politics*, 138.

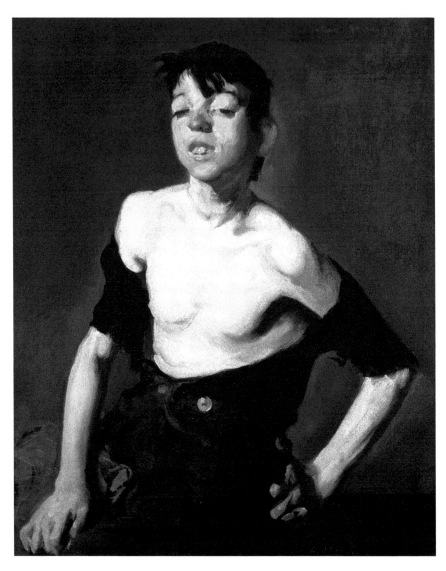

7.3 George Wesley Bellows, *Paddy Flannigan* (1905), oil on canvas, 76.8 cm ×
64.1 cm
Private Collection
Photograph © Christie's Images/Bridgeman Images

focused instead on comparing the image to Caravaggio (1571–1610) or Frans Hals (*c*.1582–1666) or quoting a 1908 review which refers to the painting as a 'pearl of the gutter'.[40] Such old master comparisons or expressions of sentiment underplay the point of Bellows's painting as a contribution to the multi-ethnic New York world of the early twentieth century. More usefully, Robert Snyder and Rebecca Zurier have written about Bellows's painting of a teenage boy with a distinctively Irish name and how it shares the 'characteristic[s] of scrappiness that was assigned to all young Irishmen in the conventions of the time', and they say that it offers a 'fairly positive' representation. Paddy Flannigan, they suggest, 'may be thin, but there is nothing cruel about [him]'.[41] In addition, one could say that the artist's use of a large vertical canvas usually associated with the portraiture of the elite has the potential to be a subversive statement. The tanned face and arms of this 'sly, sensual' boy are contrasted in unsettling magnitude with his scrawny white torso.[42] Bellows's 'challenging portrait' of a cocky youngster is a defiant image of an emerging Irish presence in America.[43]

In discussing such a painting, what we must avoid is the sentimental popularism of the sort that followed the display of Bellows's painting at the Metropolitan Museum of Art in New York in Spring 2013: that Paddy had finally made it to the Met. One blog posted on an Irish-American website commented on how 'This painting of this poor boy that must have suffered so much from poverty and neglect breaks my heart. But it brings home what many Paddy's [*sic*] suffered in the early days in New York'.[44] Instead, in articulating an Irish diasporic art history, we need seriously to analyse these representations in terms of the history of migration and the visual awareness of an Irish diaspora in urban America. In doing this, we must go beyond the usual suspects be they Bellows or John Sloan (1871–1951) and the gritty realism of the Ashcan group to include a broader social and aesthetic spectrum of representation. While in 1906 Sloan could ridicule DeCamp and other artists who were scheduled to serve on the annual jury of the Pennsylvania Academy of Fine Arts as 'the poor Boston Brand of American Art!', we need to tease out Irish diasporic representation by

40 Michael Quick, Jane Myers and Marianne Doezema, *The Paintings of George Bellows* (New York: Harry N. Abrams, Inc., 1992), 185; George Brock *et al.*, *George Bellows* (Washington, DC: National Gallery of Art, 2012), 50.

41 Rebecca Zurier, Robert W. Snyder and Virginia M. Mecklenburg, *Metropolitan Lives: The Ashcan Artists and their New York* (New York and London: National Museum of American Art, Norton and Co., 1995), 125; see also Zurier, *Picturing the City*, 237–38.

42 For the 'sly and sensual' comment, see Weinberg, Bolger and Curr, *American Impressionism and Realism*, 303.

43 Marianne Doezema, in Brock *et al.*, *George Bellows*, 50.

44 Blog by Patricia Farrell, 20 Jan. 2013: http://Irishamerica.com/2013/01/portraits-of-the-Irish-paddy-at-the-met (accessed 22 July 2014).

analysing a wide range of visual material which includes the not-so-obvious as in the works of artists from the Boston School.[45]

The visual history of Irish themes in the post-Famine era should not of course be confined to the United States, for, as Kevin Kenny and other historians have argued, it should include the examination of Irish settlements in Britain, Australia, New Zealand, Canada and elsewhere. The English-born Charlotte Schreiber's exhibition in 1879 in imperialist Toronto of her large painting entitled *The Croppy Boy* is an intriguing example of such an Irish theme on show in Canada where the unthreatening visualization of Irish agitation ironically led to her being accepted into the Canadian Academy of Arts.[46] The worldwide spread of significant paintings dealing with emigration was recently exemplified in the 2016 exhibition *Creating History: Stories of Ireland in Art* at the National Gallery of Ireland where a number of nineteenth-century works had to be borrowed from outside Ireland.[47]

While the recent creation of a post-Famine Irish diasporic art history archive housed in the National Gallery of Ireland in Dublin is to be greatly welcomed, we still have a way to go in finding out the extent of what material there is and to resist constraining artists and art within single national contexts.[48] The equally recent *Artist and Empire* exhibition at Tate Britain highlighted, albeit in relatively limited fashion, a number of Irish emigrants as contributors to empire in nincteenth-century India and Afghanistan.[49]

45 Quoted by Patricia Hills, 'John Sloan's Images of Working-Class Women: A Case Study of the Roles and Interrelationships of Politics, Personality, and Patrons in the Development of Sloan's Art, 1905–16', in Marianne Doezema and Elizabeth Milroy (eds), *Reading American Art* (New Haven, CT and London: Yale University Press, 1998), 346n35.

46 Kenny, 'Diaspora and Comparison', 136; see also Enda Delaney and Donald M. MacRaild, 'Irish Migration, Networks, and Ethnic Identities since 1750: An Introduction', *Immigrants and Minorities*, 23.2–3 (2005), 127–42. For Schreiber's painting, now in the National Gallery of Canada, see Brendan Rooney (ed.), *Creating History: Stories of Ireland in Art* (Dublin: National Gallery of Ireland/Irish Academic Press, 2016), 194–95. For further examples of Irish themes penetrating North American visual culture, see Cullen, *Ireland on Show*, chapter 4.

47 The non-Irish borrowings included paintings from collections in the UK and the United States: Watts's *The Irish Famine* (*c*.1845–50); Kelly's *A Tear and a Prayer for Erin (An Ejectment in Ireland)* (1848); Barker's *Irish Immigrants* (*c*.1847) and Butler's *Listed for the Connaught Rangers: Recruiting in Ireland* (1879); see Rooney, *Creating History*, 180–81, 184–85, 234–35, 244–45.

48 See commentary on works featured in the NGI exhibition *The Pathos of Distance* (2015–16) by Kathryn Milligan and Mia Shirreffs, https://bit.ly/2tHod3U (accessed 23 June 2018).

49 Alison Smith, David Blaney Brown and Carol Jacobi (eds), *Artist and Empire: Facing Britain's Imperial Past* (London: Tate Publishing, 2015), 18–19, 120–21, 128–29, 172–73, and 175.

However, a thorough art historical investigation into the role of the Irish and Irish emigrants as both agents and subjects of Empire has yet to be written, although it is a subject of increasing interest amongst cultural theorists and historians.[50]

A visit to a range of major museums in the United Kingdom, France, across North America and elsewhere, observing painted Irish figures or painted Irish objects that are celebrated as being British, French, American or Canadian, makes one realize that we need to become aware that the diaspora is a feature of art, and should be brought into the discussion of a 'national' experience that is anything but. Ireland's huge Famine and post-Famine exodus and the ensuing proliferation of Irish themes feature repeatedly in the art of the other nations, and excavations of these interlinked visual histories need to be included more prominently in discussions and analysis. The benefits of such an approach will be a gain for both the history of art as well as diaspora studies. However, interdisciplinarity will be the greatest beneficiary as the presence of the visual will be strengthened 'around the table of Irish cultural studies'.[51]

50 For Ireland and empire, see Kevin Kenny (ed.), *Ireland and the British Empire* (Oxford: Oxford University Press, 2004) and Joe Cleary, 'Amongst Empires: A Short History of Ireland and Empire Studies in International Context', *Éire-Ireland* 42.1–2 (2007), 11–57.
51 Cullen, *Visual Politics*, 2.

8

The Greatest Famine Film Never Made

Bryce Evans

Liverpool Hope University

In September 1944, as the centenary of the Famine arrived, the author of arguably its greatest commemoration in literature—Liam O'Flaherty— found himself pacing frustratedly around his room in the plush Lombardy Hotel, New York City. He was penniless, and he was hungry. 'I have not paid my room rent and yet I have only eight dollars for food until Wednesday', he wrote pathetically to confidante Kitty Tailer. New York was getting the author down; with its noise and impersonality, the claustrophobia of the big city was starting to overwhelm him. O'Flaherty was miserable, and it was not just New York he had it in for. He was disillusioned, he declared, with 'the Anglo-Saxon world' in general.[1]

It was not supposed to have turned out like this. Seven years earlier, in 1937, O'Flaherty's novel *Famine* had been published to widespread acclaim (Figure 8.1). His great literary contemporary Seán O'Faoláin called the book 'tremendous', 'biblical', containing 'a compression of emotion only to be found in the great books'.[2] Typical book-cover endorsement hyperbole it was not: *Famine* has stood the test of time as a terrific read, one which addresses Ireland's mid-century catastrophe directly and unsentimentally. The book was the first of O'Flaherty's romantic-realist historical trilogy: *Famine* (1937), *Land* (1946) and *Insurrection* (1950). Together, these books cover events in Ireland between 1845 and 1916. Possessing as he did a keen awareness of modern Irish history and the centrality of the Famine to it, O'Flaherty was proud that his book was the most widely read evocation

1 O'Flaherty to Taylor, 3 Sept. 1944, in A.A. Kelly (ed.), *The Letters of Liam O'Flaherty* (Dublin: Wolfhound Press, 1996), 297.
2 Seán O'Faolain, book-cover endorsement of O'Flaherty, *Famine* (London, Gollancz, 1949).

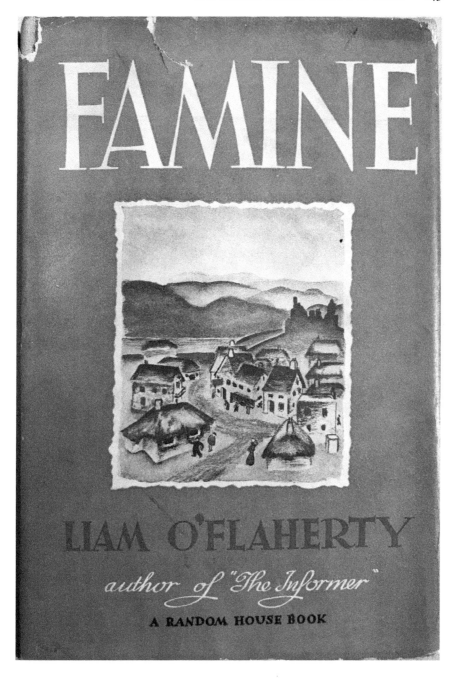

8.1 Liam O'Flaherty, *Famine*, 1st American edition (New York: Random House, 1937)
Courtesy of National Library of Ireland

of those terrible years during the centenary period: a commemorative era mistakenly viewed as 'silent'.

But O'Flaherty desired more than just literary success: he wanted a Hollywood blockbuster. He had deliberately made his novel filmic and, thanks to its subject matter, knew that it would hold particular appeal for an Irish-American audience.[3] As there was almost no indigenous cinema industry of note in Ireland at the time,[4] the author looked to the United States, and, in February of 1937, with the novel accepted for US publication by Random House, he headed for New York, confident that the book's success would lead to its adaptation as a movie. Having worked in Hollywood before, O'Flaherty knew that it could take years to get film projects off the ground, but if *Famine* was to be a blockbuster success during the centenary period (*c.*1945–52) he had a good eight to 15 years left to pursue its development. Unfortunately, O'Flaherty would spend a good chunk of the period 1945–52 broke and melancholy, frustrated in his efforts to have his best novel adapted as the epic film of Ireland's Great Hunger.

O'Flaherty was born on the Aran Islands in 1896. He was well educated, first at Rockwell College, then Blackrock College and finally University College Dublin. In 1915, aged 19, he joined the British Army and served in France. He survived the war, but at the nightmarish price of shell shock, which earned him his discharge in May 1918. In his own words, he 'set out to conquer the world' in August 1918, 'from the Aran Islands'. A jack of all trades with an abiding wanderlust, O'Flaherty then held a succession of jobs including trimmer on a coal steamer (he jumped ship in Rio de Janeiro, but 'didn't like the place'); lumberjack; 'hobo carpenter'; miner in Canada; and labourer in a Boston biscuit factory. He returned to the Aran Islands in 1921 where he 'meditated on [...] the uncertainty of life, and the constant tribulation to be met in this world' before travelling to Dublin on the cusp of the Irish Civil War in December 1921. By this time a confirmed socialist and self-appointed leader of a group of unemployed workers in the city, he earned notoriety by raising the red flag over Dublin's Rotunda building. He would soon immortalize the fratricidal nature of the conflict in his short story *The Sniper* (1922).[5]

O'Flaherty, then, had lived a full and turbulent life before he started work on *Famine*, aged 37, in 1933. Those who came across this island-man were struck by his lean frame, clipped haircut and searing blue eyes: clues

3 See Margaret Kelleher, *The Feminization of Famine: Expressions of the Inexpressible?* (Durham, NC: Duke University Press), 110–12; Terry Eagleton, *Heathcliff and the Great Hunger: Studies in Irish Culture* (London: Verso, 1995), 13.

4 See Kevin Rockett, Luke Gibbons and John Hill, *Cinema in Ireland* (London: Croom Helm, 1987).

5 Kelly, *The Letters of Liam O'Flaherty*, 8.

to the intensity of his character. Due to the lasting effects of the shell shock sustained in the First World War, O'Flaherty's mental state was sometimes precarious; he was irascible, self-important, eccentric and always on the move. Perhaps inevitably, then, he gravitated to Hollywood and assumed the latest of his many incarnations: becoming a Hollywood scriptwriter.

Ford and O'Flaherty: The Perfect Couple

It was in this new role that Liam O'Flaherty met the celebrated director John Ford. The two men soon discovered that they shared more than a fierce temperament and penchant for alcohol: they shared a common heritage too. Ford, who had made his name making westerns, was born John Martin Feeney in 1894. His father Seán, who was from Spiddal, County Galway, emigrated to Boston in 1872. Four of his brothers had made the journey before him and were active in the American Civil War. Seán Feeney married Aran Island woman Mary Curran in 1875 and they relocated to Portland, Maine, where Ford was born the following year. Ford kept with him a photograph of the Feeney home—a small, whitewashed thatched cottage beside a dry-stoned wall—and an image which would not look out of place in the Irish Tourist Board's stock collection.[6]

Fiercely proud of his west of Ireland roots, Ford liked to Gaelicize his name as Seán Aloysius O'Fearna, and named the 110-foot yacht where he worked on movie projects and boozed with Hollywood A-listers *Araner* in dedication to his mother.[7] An avid reader of literature and history, Ford possessed a large dose of Irish historical grievance to match his hard-drinking Irishman image. A visit to Ireland during the truce period of the Irish War of Independence in late 1921 heightened this feeling. Ford claimed to have travelled back on the same mailboat crossing on 2 December 1921 as Michael Collins, who was returning from the Anglo-Irish Treaty negotiations at Westminster with the famous 'Proposed Articles of Agreement'.[8]

As with many Irish Americans, Ford's Irish identity was underlined by a deep-set bitterness concerning the Famine. In 1952, during the filming of the East African hunting romp *Mogambo*, Ford came across an English huntsman, an advisor to the project, who claimed to be descended from

6 Feeney family tree, Irish Film Institute, Lord Killanin papers, Box 183 99/33.
7 Scott Eyman, *Print the Legend: The Life and Times of John Ford* (New York: Simon and Schuster, 2015), 15; Bill Levy, *John Ford: A Bio-Bibliography* (Westport, CT: Greenwood, 1998), 18.
8 Luke Gibbons, *The Quiet Man* (Cork: Cork University Press, 2002), 42.

the Barons Wallscourt. Ford duly treated him with cruelty on set for weeks. The reason, bemused cast and crew later discovered, was that the Wallscourts had owned a large Galway estate on which a number of Ford's antecedents laboured before allegedly being forced onto Famine ships.[9] This was Ford's way of achieving historical restitution of sorts. During a break in filming for a Tanzanian safari, Ford wrote to Galwegian film mogul Michael Morris (Lord Killanin) in an attempt to confirm the link. He complained to Killanin of 'an awful SHIT named Colonel Hartland-Mahon here', adding that he was 'acting as our camp manager'.[10]

Killanin, who divided his time between Spiddal and Bel Air, was more than a professional contact for Ford; he provided the Irish-American director with a link back to Ireland. A typical note from Ford to Killanin might request 'a few snaps of Spiddle [*sic*] for I have a great nostalgic feeling for the place'.[11] Temperamentally, though, Ford was closer to O'Flaherty, who was rougher-hewn than Killanin. After coming across one another on the Hollywood scene, Ford and O'Flaherty hit it off immediately. Although they did not share the same politics, they were naturally attracted to one another's work, and in 1935 Ford directed a version of *The Informer* (an O'Flaherty novel about the IRA published in 1925) with Victor McLaglen in the lead role. After rejection by every other studio in Hollywood, RKO Pictures agreed to take on the project and were rewarded when the film won four Academy Awards and made a quarter of a million dollars.[12]

In contrast to Ford, O'Flaherty was recompensed poorly from the movie's takings.[13] This was a harbinger of things to come and an early source of what would become the author's deep-seated scorn for Hollywood. It was a contempt he shared with his great literary contemporary and fellow socialist Seán O'Casey, John Ford's other favourite Irish writer. After adapting O'Flaherty's *The Informer*, Ford moved on to his next Irish project: Sean O'Casey's Easter Rising play *The Plough and the Stars* (1936). Ford would later employ O'Casey's wife Eileen in *Young Cassidy*, his biopic about the author.[14] By the late 1930s, however, O'Casey had fallen out of favour: after watching the movie the Dublin playwright told Ford that he

9 Donald Sinden, *A Touch of the Memoirs* (London: Hodder & Stoughton, 1982), 174.

10 Ford to Killanin from Tanzania on safari, 14 Dec. 1952, Irish Film Institute, Lord Killanin papers, Box 120, 07/1410.

11 Ford to Killanin, 11 July 1946, Irish Film Institute, Lord Killanin papers, Box 120, 07/1408.

12 Tag Gallagher, *John Ford: The Man and his Films* (Berkeley: University of California Press, 1984), 122.

13 Kelly, *The Letters of Liam O'Flaherty*, 282.

14 Dan Ford to Killanin, 27 Sept. 1976, Irish Film Institute, Lord Killanin papers, Box 183 99/33.

hated his adaptation of *The Plough and the Stars* and relations between them soured.[15]

Meanwhile, O'Flaherty's admiration for Ford remained undented and his early years in Hollywood were charmed, as he dabbled in screenwriting and mixed with the cream of Hollywood talent on the *Araner*. He struck up a friendship with Zeppo Marx, the youngest of the Marx brothers, and they enjoyed holding zany chats in a mixture of Yiddish and Gaelic together, never comprehending one another fully.[16] But *Famine* always loomed as the greater project for O'Flaherty. Importantly, it was also a work in which Ford had expressed his faith, promising he would make a film out of it one day. O'Flaherty wrote to Ford in June 1935, excusing himself 'for dashing off the way I did without saying goodbye' but explaining that he had to 'get back home to put *Famine* on the stocks'. Capturing the closeness that had developed between the two men, he continued, 'I think *Famine* is going to be great, and you need never feel ashamed, I assure you, that it's dedicated to you. I'm going to hammer out every word from the depths of my soul'.[17]

Famine Published

As the earlier exchange between the two men shows, Ford's disdain for the Anglo-Irish did not extend to his confidante Lord Killanin. Killanin was London-born but descended from the Morrises, one of 14 powerful Catholic families making up the 'Tribes of Galway' who lost much of their land after the Cromwellian conquest of Ireland. Despite using his title for all it was worth professionally, Killanin—later President of the International Olympic Committee—was at pains to point out that he was descended from an Irish Catholic family of modest landholdings and not Anglo-Norman stock.[18] He too, like O'Flaherty, could claim to be a 'cousin' of Ford's through Galwegian familial connections. A great uncle of his had been put out to foster parentage with Ford's grandfather's family and to the small whitewashed cottage which Ford regarded as the family homestead. Killanin's great uncle had therefore seen Ford's father off from Queenstown (Cobh, in County Cork) to America. Ford, an unashamed sentimentalist, made much of this romantic connection and regarded Killanin, like O'Flaherty, as his cousin. Ford first met Killanin in London in 1937,

15 Dan Ford to Killanin, 27 Sept. 1976, Irish Film Institute, Lord Killanin papers, Box 183 99/33.

16 Kelly, *The Letters of Liam O'Flaherty*, 252.

17 O'Flaherty to Ford, 3 June 1935, in Kelly, *The Letters of Liam O'Flaherty*, 274.

18 Frances Hallahan to Killanin, 10 Jan. 1986, Irish Film Institute Lord Killanin papers, Box 183 99/33.

where the latter was a journalist just returned from covering the second Sino-Japanese war.[19] Killanin wanted to get into the movie industry and had the money, while Ford was already renowned as a director. Both wanted to make Irish films. Ford in particular wanted to make an epic movie that would capture the nationalist narrative of Irish history. It was a connection that boded well for O'Flaherty in his desire to get *Famine* on film.

In that same year, 1937, *Famine* was released by the London publisher Victor Gollancz, followed by an American version published by Random House in New York. As promised, it *was* great. Despite being turned down by a succession of publishers who thought its theme too gloomy, *Famine* is not a maudlin novel; rather, like most of O'Flaherty's works, it elevates a spirit of resistance. Naturally enough, there is ill health aplenty—tuberculosis, typhus, cholera, rickets, madness. Even before the blight, which announces itself with a pungent smell, there's a bitterness to the story: "'Ugh!' Martin said as he looked up the Valley. "I wish the first man that had settled here had broken his neck before he reached it'".[20]

Yet, amidst the tragic arc of the novel there is also hope. This comes in the resilience of the story's heroine, young mother Mary Kilmartin, who gives birth during the blight but is determined that her child will not perish. At the novel's end (and surely with one eye trained on its film adaptation), O'Flaherty introduced the mystical figure of the 'man with the yellow hair': a symbolic rebel who will emigrate to America to continue 'the fight for Liberty'.[21] O'Flaherty, who certainly had Ford's at-times misty-eyed directorial style in mind when writing those lines, never left the reader in doubt as to his politics, writing that the 'tyrant Queen' Victoria had 'stripped us of all power and devoured our substance', an anti-imperialistic turn of phrase which resembles the writing of the famous Fenian John Mitchel. Servants of the crown are shown in an unequivocally poor light, while the local landlord, a lecherous bully with mutilated genitalia, assumes an evil of monstrous proportions.[22]

Nevertheless, the book resists a simplistic account of the Famine as a one-dimensional story of English culpability.[23] Catholic priests' narrow obsession with guarding their starving flock from proselytism by Protestants is condemned. Similarly, O'Flaherty lampoons the naive providentialism of the older generation, who insist 'God sends famine to remind us of

19 Killanin to Hallahan, 30 Dec. 1985, Irish Film Institute, Lord Killanin papers, Box 183 99/33.
20 O'Flaherty, *Famine* (London: Gollancz, 1949), 29.
21 O'Flaherty, *Famine*, 444.
22 O'Flaherty, *Famine*, 164.
23 Gunilla Bexar, 'John Mitchel's The Last Conquest of Ireland (Perhaps) and Liam O'Flaherty's Famine: A Question of Tone', *Critical Quarterly*, 5.1 (2007), 73–90.

our sins'.[24] The aged and infirm are not just victims of starvation but their own ignorance. This hard edge, drawn directly from the author's first-hand experience of life as unceasing struggle, is reiterated at the book's conclusion: 'them that will not fight can die of famine, and may the devil roast them'.[25] Whereas the Anglo-Irish aristocracy are characterized as uncaring, O'Flaherty reserves his venom for home-grown enemies of the people, in particular the 'rising Catholic petty middle class traders'.[26] 'God bless this famine', remarks Hynes, the novel's greedy embodiment of this class, who takes advantage of the government's failure to distribute supplies at cost price by driving up food prices.[27]

The novel was made for film—unashamedly so, in fact: inside the dust jacket of the first edition was a direct plea that it be adapted as a movie.[28] The busy Ford, however, was not taking the bait, and in 1939, O'Flaherty wrote to his director 'cousin' to tell him about interest in *Famine* he had received from a French film company. O'Flaherty had been working with French director Jeff Musso on the film *Le Puritain*, which came out in 1938.[29] He assured Ford he had told the French 'you were the only person that could do *Famine*, which is true'. The French company had then instructed Ford to 'come and do it' and promised the director 12 million francs if he would. Ford, however, was 'filled up' for the year. 'It would have been fun if you could have come', wrote O'Flaherty, sounding increasingly like a lonely schoolchild shunned by the more popular kid: 'they would have got out the whole town to welcome you'. The letter reinforced O'Flaherty's devotion to Ford. Uncharacteristically, it was full of a flattery bordering on adulation, with O'Flaherty heaping praise on Ford's latest cowboy picture *Stagecoach* and repeatedly telling him how good it had been to see him in New York when they had last met. Then he got to the point. 'What do you advise me to do about *Famine*?' he asked bluntly. Do you think Hollywood will let you do it? And if not should I let this fellow do it in French? [...] Excuse this rambling letter, Jack, it's practically the first one I have written in years except to my daughter. I'm going to see her next week and try and get my wife [fellow writer Margaret Barrington] to divorce me at the same time. Quelle vie! Jesus! [...] This is an empty bloody world, Jack', O'Flaherty signed off, 'with such a few people in it and they are scattered.

24 O'Flaherty, *Famine*, 274.
25 O'Flaherty, *Famine*, 444.
26 O'Flaherty, *Famine*, 80.
27 O'Flaherty, *Famine*, 274.
28 O'Flaherty, *Famine*, 29.
29 Peter Costello, 'Liam O'Flaherty', *Dictionary of Irish Biography*: http://dib.cambridge.org (accessed 12 July 2016).

They that have eyes to see and ears to hear are scarce, old son. Well! God damn it, all my love to you, Liam'.[30]

Dust Bowl Drama

Ford's busy schedule was far from the only factor behind the failure of *Famine* to make it to the big screen as the centenary approached. An alternative and contemporary plight was happening in America at the same time, one which both O'Flaherty and Ford saw as reminiscent of Ireland's Great Hunger. At the time *The Informer* was being shot, O'Flaherty wrote a film script entitled *Dust Over Kansas*.[31] Although it never made it to the screen, the subject matter was significant. In the 1930s, the widespread fall in agricultural prices in the United States was accompanied by a series of dust storms on the prairies, and the Dust Bowl phenomenon brought desperation, desolation and mass migration from the afflicted Midwest states. Immortalized by the characters of John Steinbeck and the lyrics of Woodie Guthrie, the great agricultural crisis of America's Great Depression overshadowed the centenary of Ireland's Great Famine.

For some, the parallels between the Famine and the Dust Bowl were too obvious to ignore. The mass deaths may have been missing from the Dust Bowl era, but the other ingredients were there: the poverty and suffering of a white population; hunger, tragedy and consequent migration; the helplessness of a mass of people seemingly caught on the wrong side of history. O'Flaherty aside, one person who felt the comparison more acutely than most was John Ford. The Pulitzer Prize-winning evocation of the catastrophe by John Steinbeck in *The Grapes of Wrath* (1939) prompted Ford to translate it to film in 1940. Explaining why he had chosen to make the film, Ford made the link explicit, claiming that he had been attracted to the story because it 'was similar to the famine in Ireland, when they threw the people off the land and left them wandering on the roads to starve'.[32]

In spite of such rhetoric, Ford's film is a sanitized version of *The Grapes of Wrath*. The film's producers, nervous about being seen to give out socialist messages, ensured a more upbeat denouement than that found in the novel. Still, the parallels with Famine Ireland (which Ford emphasized) are apparent: from the big bleak windswept landscapes to the constant

30 O'Flaherty to Ford, 15 Mar. 1939, in Kelly, *The Letters of Liam O'Flaherty*, 292.

31 Susan Delson, *Dudley Murphy: Hollywood Wildcard* (Minneapolis: University of Minnesota Press, 2006), 157.

32 Joseph Paul Moser, *Irish Masculinity on Screen: The Pugilists and Peacemakers of John Ford, Jim Sheridan and Paul Greengrass* (London: McFarland, 2013), 105.

longing for food. Natural disaster is the immediate enemy of the Joad family, the impoverished tenant-farmer protagonists. Human greed and callousness are the criminal forces in this tragedy, with the forced evictions of the cabin-dwelling Joads carried out by agents of wealthier men, and all in the name of progress. Then there is the death, whether of children, 'bellies puffed out', or the demise of the older generation—a central theme in O'Flaherty's *Famine*.[33]

The journey from Oklahoma to the promised land in the west provides clear resonance with that 'biblical' exodus of *Famine*. 'We got to get across' is the determined refrain of those crossing the desert. And to what? Squalor and prejudice. 'Them Okies ain't human', remarks one observer of their sad trail.[34] One critic argues that, at Ford's direction, Henry Fonda's Tom Joad, the angry young man of the piece, seems to embody the post-Famine Irish rebel spirit.[35] At first, Tom is frustrated by the futility of immediate vengeance, of not knowing who to shoot—the agent who delivers the notice to quit? The local young man driving the bulldozer? The company? The bank in Tulsa? His sense of injustice, of course, grows into a determination to achieve broader social justice for the starving masses against the 'one fella with a million acres'.[36]

Ford's association of Dust Bowl suffering with the phenomenon of famine was not lost on the critics. *Time* magazine complained that 'Pinkos who did not bat an eye when the Soviet Government exterminated three million peasants [a reference to the Ukrainian famine of 1932–33] [...] will go for a good cry over the hardships of the Okies'.[37] Audiences, however, did not make the same connection and the film's commercial success catapulted Ford towards the play *Tobacco Road*. The playwright Arthur Miller claimed *Tobacco Road* was the first play he ever saw, when his mother took him to see it on Broadway as a teenager; he did not like it.[38] Ford's 1941 film adaptation of this popular Dust Bowl drama again featured a family of poor old Okies facing eviction by the bank, but this time they were comical:

33 *The Grapes of Wrath*, feature film directed by John Ford, produced by Darryl F. Zanuck, screenplay by Nunnally Johnson, starring Henry Fonda, 1940 (United States), 20th Century-Fox Film Corp.

34 *The Grapes of Wrath*, feature film directed by John Ford.

35 See Thomas Flanagan, 'The Irish in John Ford's Films', in Michael Coffey and Terry Golway (eds), *The Irish in America* (New York: Hyperion, 1997), 191–95.

36 See also Elizabeth Anne McHugh, 'Irish Famine Immigration and Dust Bowl Migration: A Comparative Study', unpublished MA thesis, Humboldt State University, 2005; Jack Morgan, 'Thoreau's "The Shipwreck" (1855): Famine Narratives and the Female Embodiment of Catastrophe', *New Hibernia Review*, 8.3 (2004), 47–57; Joseph McBride, *Searching for John Ford: A Life* (London: Faber & Faber, 2003).

37 Whittaker Chambers, *Time Magazine*, 12 Feb. 1940.

38 Martin Gottfried, *Arthur Miller: A Life* (London: de Capo, 2003), 9.

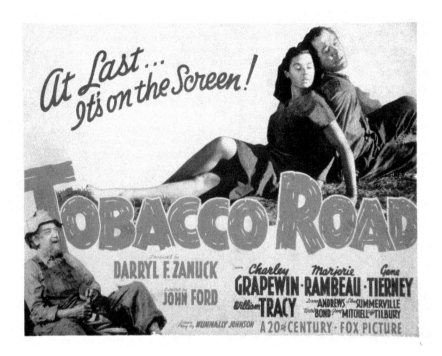

8.2 Film poster, *Tobacco Road*, directed by John Ford, starring Ward Bond, Charley Grapewin (aka Charles Grapewin), Gene Tierney, 1941, trademark and copyright © Twentieth Century Fox Corporation
Courtesy of Everett Collection/Mary Evans

inbred, turnip-munching savages, dirty and feckless (Figure 8.2). One thing seems clear: it was a lot easier to feel sorry for the Coadys of *The Grapes of Wrath* than for Jeeter Lester, the toothless patriarch in *Tobacco Road*.

By 1941, therefore, Ford and Hollywood had done famine-esque suffering: first as tragedy, second as farce. There was also an economic and political context to this shift in representation, as the demise of the Okie as a subject of pity had come with the wartime upsurge in the American agricultural economy. With rising European demand for American food, the hunger of the Dust Bowl was rapidly receding in the popular consciousness. Now the suffering of Midwestern sharecroppers was hammy, only fit for spoof and satire. In many ways, then, the conception of *The Grapes of Wrath* as a famine film meant that Ford never made what would almost certainly have been the greatest movie about the Great Famine, had he adapted *Famine* from O'Flaherty's masterpiece novel and translated its powerful scenes onto reel. Instead, the Second World War was to intervene in Ford's career in a massive way, drawing

him into propaganda work for the American government. Perhaps, though, by 1940, the great film of Irish Famine had already been made by proxy: starring Henry Fonda and set on the plains of Oklahoma rather than the wilds of Connaught.

Hollywood Cemetery

O'Flaherty, however, was still Stateside and still harbouring the idea of *Famine* appearing in bright lights above cinema foyers up and down America. There were mounting problems with his vision, however. It was not just that the topic of starvation had 'been done' in *The Grapes of Wrath*, and it wasn't the fact that starvation held little natural commercial appeal anyway. It was that O'Flaherty was rapidly alienating himself from some of Hollywood's big hitters, the very people he needed onside if the project was ever to be realized.

First, there was his politics. On 16 February 1941, a 23-year-old John F. Kennedy turned up to New York City's Town Hall Theater with hundreds of others to hear O'Flaherty's public lecture 'Hands Off Ireland', a defence of Eire's wartime neutrality.[39] The topic, and O'Flaherty's left-leaning politics, would have endeared him neither to America's Anglophile future president nor to Hollywood's top producers. His card had already been marked by the moralists on this score, too: Hollywood's chief film censor (Joe Breen, an Irish-American Catholic) had forced the watering-down of *The Informer* back in 1935 and viewed O'Flaherty as little more than a communist propagandist.[40]

Then there was O'Flaherty's open contempt for Hollywood, which had amplified as his fortunes declined. This found its way into his 1935 novel *Hollywood Cemetery*, in which a hard-drinking Irish writer (clearly O'Flaherty) becomes frustrated by the money-grubbing vacuity of the American film industry. Pointedly, the story features a talented movie director (clearly Ford) who wants to make a good picture. The producer, however, is a shallow industry type preoccupied with profit and obsessed with finding a sexy female lead. As the project flounders, the writer flees to Mexico.[41] It was a fictional flight that mirrored O'Flaherty's own tendency to run away.

39 Kelly, *The Letters of Liam O'Flaherty*, 294.
40 Gregory D. Black, *Hollywood Censored: Morality Codes, Catholics, and the Movies* (Cambridge: Cambridge University Press, 1994), 297.
41 Brett L. Abrams, *Hollywood Bohemians: Transgressive Sexuality and the Selling of the Movieland Dream* (Jefferson, NC: McFarland, 2008), 39–41.

Lastly, there was his unpopularity among producers. In various insiders' accounts of Hollywood in this era, at the time a regular game of poker took place between the top producers. Providing a pre-echo of the McCarthy-era purges of left-wing actors and writers, countless individuals were discussed across the card table and assessments made of their politics and willingness to conform to industry norms.[42] O'Flaherty may have been many things, but he could certainly never have been accused of conformism. If the accounts are true, he would have been an obvious *persona non grata*.

But whether the legend of the poker game is true or not, O'Flaherty was busy offending Hollywood's producers in his own inimitable way. In 1941, Ford brought him in to work on *How Green Was My Valley*. O'Flaherty was co scriptwriter on the film, which was set in a Welsh mining village, but pulled out halfway through. The producer, Daryl F. Zanuck, consequently refused to pay O'Flaherty, claiming breach of contract. However, O'Flaherty, who seemed always to find himself in debt and had once complained to Ford, 'Jews are funny people',[43] needed the money. Returning to the studio the following day, armed with a pistol, he marched over to Zanuck before holding the gun to the terrified producer's head.[44]

Thus, by the first centenary year of 1945, *Famine* had little chance of making it as a movie. O'Flaherty was broke, and whatever royalties were coming in were being used to pay off his tax bills at home.[45] His letters from The Lombardy betray loneliness, his disillusionment punctuated only by a fleeting excitement at the abundance of the American plate: 'we had a super excellent meal at the San Remo [a restaurant in Greenwich village]. We had minestrone, steak and ice cream. And bread, what bread!'; 'went into a tiny place where I remembered eating eight years ago. Then I got soup, Yankee pot roast with vegetables (enormous helping), Apple pie, bread and butter ad lib, coffee, all for thirty five cents'.[46] It was a sad finale to his Stateside experiences.

By 1946, O'Flaherty was back in Dublin and looking forward to the re-publication of *Famine*, certain that the book would 'have a big sale as long as this left-wing tendency lasts'.[47] Later in the year, with the film rights to *Famine* up for grabs, it seemed that the movie might be made after all. A British production company owned by Belfast-born director Brian

42 Susan Delson, *Dudley Murphy*, 157.
43 O'Flaherty to Ford, 15 Mar. 1939, in Kelly, 292.
44 Kelly, *The Letters of Liam O'Flaherty*, 294.
45 Kelly, *The Letters of Liam O'Flaherty*, 294.
46 O'Flaherty to Tailer, 31 Aug. 1944, 292; O'Flaherty to Tailer, 3 Sept. 1944, 297, in Kelly, *The Letters of Liam O'Flaherty*.
47 O'Flaherty to Peters, 30 Sept. 1946, in Kelly, *The Letters of Liam O'Flaherty*, 300.

Desmond Hurst was, he reported, 'making an offer to buy the rights for two thousand pounds provided I do a treatment gratis'. But O'Flaherty had 'no particular desire to do a treatment'; he would do one for 'five hundred pounds', he told his agent. But he wanted 'the total amount before I sign the contract'. O'Flaherty was, by this point, playing hardball. Hurst was granted a one-year option at £100 on the film rights to *Famine* with a purchase price of £5,000.[48] On New Year's Day 1947, during a very bleak Irish midwinter, the *Irish Press* reported on an interview with Hurst, then riding high from his 1946 war picture *Theirs Is the Glory*, who claimed that the Rank Film Corporation had bought the film rights of *Famine*.[49] Nothing was to come of this toing and froing, however, with British producers as sceptical as their American counterparts about the marketability of a film about starvation. O'Flaherty, who had written the book for Ford, was still holding out for the Hollywood treatment. He was to be disappointed.

Famine as Uncommercial

Hollywood's reticence over *Famine* would be repeated post-war, reflecting a transitional period of stage and screen in America. A new era in drama opened with *A Streetcar Named Desire*, Tennessee Williams's brawling smash-hit play of 1947, charting the decline of the Old South and the rise of the industrialized New South while echoing *The Grapes of Wrath* in portraying the uglier side of the march of progress. Part of this new wave was Eugene O'Neill's *The Iceman Cometh*, performed in the same year. Perhaps most telling in explaining why *Famine* never made it as a film, Arthur Miller's *Death of a Salesman* (1949) was very nearly rechristened after its producers deemed the inclusion of the word *Death* in the title too morbid to sell, an opinion confirmed by a survey in which 98 per cent of respondents agreed.[50] This was a transitional time exacerbated by a mounting Cold War atmosphere of fear and suspicion following Mao's victory over nationalist China in 1949 and the coming of McCarthyism in 1950.

However, for O'Flaherty, perpetually in want of money to buy food, get drunk, fix his teeth, or to settle one debt or another, the definitive Hollywood version of *Famine* would remain the great dream. In 1951, Lord Killanin established Irish film house Four Provinces Productions. John Ford was on the board and so was Brian Desmond Hurst. When Four

48 O'Flaherty to W.N. Roughead, 14 Dec. 1946, in Kelly, *The Letters of Liam O'Flaherty*, 301.
49 *Irish Press*, 1 Jan. 1947.
50 Gottfried, *Arthur Miller: A Life*, 16–147.

Provinces was set up, their first 'tentative idea' was to adapt *Famine*, with Killanin telling Ford that a script would be written on the novel and, if successful, distributed through the Rank Corporation.[51] Killanin knew that O'Flaherty harboured a gnawing desire to get *Famine* on the big screen and, like Ford and Hurst, much admired him as a writer. The establishment of Four Provinces also offered O'Flaherty a clear route around the opposition of Hollywood's producers. The only trouble was getting hold of him. The restless author, who was unable to stay in one place for any prolonged period, continued to escape, just like his fictional alter ego in *Hollywood Cemetery*, in 1949 to Cannes and then, variously, to London and Dublin. His one anchor was Kitty Tailer, a relative of 29th US President Warren Harding, an affluent divorcee and his soulmate, without whom he was 'a lost puppy'.[52] And, like a lost puppy, O'Flaherty tended to roam unpredictably, with Killanin's letters to him at diverse hotel addresses all going unanswered, until coincidence intervened, and he bumped into the wayward O'Flaherty one day on the King's Road in London. Killanin informed him that he and Ford had in mind an adaptation of *Famine* and assured him that they both regarded it as a serious literary work. Killanin wrote to Ford to tell him about the chance meeting, telling him that O'Flaherty was still 'very excited' about working with him on *Famine*.[53]

Unfortunately, the project fell through yet again, with money the concern once more. Writing to Killanin in 1951, Ford admitted his 'misgivings' about *Famine*. The 57-year-old director was recovering from a double hernia at the time, an ailment that (with typical machismo) he attributed to jumping out of helicopters and climbing mountains as part of his US naval duties. It was not so much the subject matter but the scale of the project that alarmed Ford. He told Killanin that adapting *Famine* 'would entail rather elaborate production and layout'. He still wanted to make an Irish film that would be a 'grand historical document', but at that stage was envisaging a lower budget black-and-white War of Independence film in which many of the characters would be living veterans.[54] Ford had talked to Maureen O'Hara about it, he told Killanin, 'and after a three hour hysterical outburst [...] she agreed, due to my persuasive powers and a swift kick in the arse'.[55] This film was

51 Killanin to Ford (undated), Irish Film Institute, Lord Killanin papers, Box 120, 07/1409.

52 O'Flaherty to Tailer, 1 Sept. 1944, in Kelly, *The Letters of Liam O'Flaherty*, 296.

53 Killanin to Ford, 27 Nov. 1951, Irish Film Institute, Lord Killanin papers, Box 120, 07/1410.

54 Killanin to Ford, 27 Nov. 1951, Irish Film Institute, Lord Killanin papers, Box 120, 07/1410.

55 Ford to Killanin, 25 Oct. 1951, Irish Film Institute, Lord Killanin papers, Box 206, 06/9.

never to see the light of day, and neither was an alternative 'grand historical document': an epic of the life of Charles Stewart Parnell penned by senior Irish civil servant Conor Cruise O'Brien.[56] It was clear that *Famine* was not the priority for Ford.

After Four Provinces turned down *Famine*, Ford's most famous 'Irish film' was released. *The Quiet Man* (1952), starring John Wayne and Maureen O'Hara, was a much safer commercial proposition for American audiences and went on to earn a handsome $3.8 million at the box office.[57] With the return home to Ireland of Wayne's character from America and the strains of the 'wild colonial boy', the film could be said to speak to the legacy of Irish emigration, if not the Famine directly. Ford's ever-present sense of historical grievance came to the fore again. He was determined to film the movie near his antecedents' home-place, first favouring his father's village Spiddal, from which his parents had emigrated, before settling on Cong, County Mayo, claiming it was from where the Feeneys were originally driven. Scenes of the fiercely independent Mary Kate Danaher (Maureen O'Hara) herding sheep, or the endless alcohol-driven riotous assemblies, could be said to belong to the pre-Famine pastoral genre.[58]

Yet *The Quiet Man* was a love story first and foremost, with Mary Kate tamed by Sean Thornton (John Wayne), the returned emigrant. It was thus more commercially viable than a film set during the Great Hunger. The film was originally set to feature an IRA sub-plot, but this was later erased from the script.[59] Revealingly, O'Flaherty was not consulted and had no input into the film. Ford, it seems, had 'upgraded' his real-life IRA man from O'Flaherty, whose role in the revolutionary period was peripheral at best, to Ernie O'Malley, a leading IRA commander during the War of Independence and Civil War. Ford remained fascinated by the revolutionary period, and in a letter to Killanin in 1947 accompanying a food package (an indication of how hard things were in Ireland at the time), described himself as still having 'a Sinn Féin heart'.[60] By all accounts, Ford and O'Malley got on famously, and stories of their bonhomie echo those of Ford and O'Flaherty years earlier. O'Malley appeared in the film's credits as 'IRA Consultant' and attended on the set every day during shooting.[61] O'Malley was a Mayo man and, like Killanin and O'Flaherty and many

56 Killanin to Tyrone Power, 17 Oct. 1957, Irish Film Institute, Lord Killanin papers, Box 183, 99/869.
57 Gallagher, *John Ford: The Man and his Films*, 499.
58 Gibbons, *The Quiet Man*, 7–12.
59 Gibbons, *The Quiet Man*, 34.
60 Ford to Killanin, 8 Dec. 1947, Irish Film Institute, Lord Killanin papers, Box 120, 07/1409.
61 Gibbons, *The Quiet Man*, 42.

others from that corner of Ireland who came into contact with John Ford, soon earned the title of Ford's 'cousin'. It must have been increasingly clear to O'Flaherty that the special affection he held for Ford had never been as strongly reciprocated.

Later Efforts to Contact O'Flaherty

Shortly after filming finished on *The Quiet Man* Ford would complain to Killanin that he had not 'seen or talked to O'Hara since we finished. She spends most of her time in Mexico with her coloured millionaire. She's a greedy bitch and I wonder if she'd accept any terms'. But he had also to admit that 'of course her name in an Irish film has value'.[62] This last reflection is illustrative: to Ford and Four Provinces Productions, O'Hara had commercial value and, as usual, *this* was paramount. Money was an overriding priority with which O'Flaherty was very familiar, yet he was not willing, as he saw it, to sell out. It is easy to see why. The all-too-obvious cultural branding of the company presaged Killanin and Ford's turn to more commercially viable paddywhackery such as *The Leprechaun Stories* of Seamus O'Kelly. Four Provinces even included miniature shillelaghs in their company Christmas cards. And, despite his declaration of a 'Sinn Féin heart', Ford was a businessman too, writing to Killanin at one point to ask him to pack the board with more Lords: 'your name and degree seem to excite a lot of interest in people who have read it in our letterhead. Do you think it worthwhile to get another peer? Nelson? Wicklow? Longford?'[63] O'Flaherty would have been aware, too, that his passionate desire to see *Famine* on film was being used as bait by Killanin, who longed to avail himself of the Aran Islander's writing ability to develop more profitable projects. For all his mention of *Famine*, Killanin wanted O'Flaherty to write him 'something safe and commercial which would give scope for shooting in Ireland [...] a good sporting story, preferably a racing one might be best—Ford has jumped at this'.[64] The racing scene in *The Quiet Man* was evidently the inspiration for this particular idea and O'Flaherty, it seems, was understandably unwilling to cheapen his name.

As well as their more commercial projects, Ford and Killanin went on to realize partially the idea of a 'grand historical document' in *The Rising of*

62 Ford to Killanin, 21 Sept 1951, Irish Film Institute, Lord Killanin papers, Box 120, 07/1410.

63 Ford to Killanin, 26 July 1954, Irish Film Institute, Lord Killanin papers, Box 183, 99/132.

64 Killanin to O'Flaherty, 8 Dec. 1951, Irish Film Institute, Lord Killanin papers, Box 183 99/411.

the Moon (1957), a trilogy of historically set stories originally entitled *Three Leaves of a Shamrock* and adapted from stories by writers Frank O'Connor, Lady Gregory and Martin McHugh. They had tried unsuccessfully to recruit O'Flaherty to the project. Killanin told him he wanted to make 'three short stories [...] by one or three Irish writers—O'Connor, O'Flaherty, O'Faolain?', adding, 'Jack is most enthusiastic. Any ideas you have would be most welcome, but I think we may really get going'.[65] Ford was supportive of 'the four short plays idea—a Frank O'Connor, Liam O'Flaherty, a comedy bit, and end up with one technicolor. I always feel that the Irish are short story writers and not novelists'.[66] Again, it is clear how the idea might have offended O'Flaherty's literary sensibilities. All the great Irish writers of his generation had, like him, started out writing short stories, but all wanted to write the great novel. And, of the literary triumvirate of O'Connor, O'Flaherty and O'Faoláin, arguably only O'Flaherty had succeeded in doing so.

In any case, O'Flaherty was still proving maddeningly elusive. In July 1954, Killanin wrote to Ford, who was about to travel to Honolulu, to update him on several projects that Four Provinces Films were undertaking. 'I am trying to contact Liam O'F who has just left Dublin', he complained. 'As you know, he said he was only too anxious to work with us'. Killanin's unacknowledged letters betray his frustration at not being able to contact the writer. 'Are you still in Dublin?', starts one frantic dispatch to the author. 'Someone told me you had left for the continent [...] My project with John Ford is moving forward swiftly, and I would very much like to talk to you about it [...] If you are in Dublin this would be simple [...] If you are abroad perhaps you could let me know your whereabouts'.[67] But O'Flaherty, as usual, was AWOL, and appears not to have responded.

Getting Liam O'Flaherty's *Famine* on screen was never going to be easy. Ford had nursed the idea of *The Quiet Man* since picking up the short story by Maurice Walsh in 1936, and it would take him the best part of 16 years to raise the funding and interest to realize the film. This fact alone provides an inkling of the hurdles thrown up by producers who refused to envisage O'Flaherty's *Famine*, a much more problematic proposition, as a box-office hit. For Hollywood, *Famine* was just not the type of uplifting story that its producers were interested in, John Ford or no John Ford. As Killanin

65 Killanin to O'Flaherty, 8 Dec. 1951, Irish Film Institute, Lord Killanin papers, Box 183 99/411.
66 Ford to Killanin, 24 Oct. 1952, Irish Film Institute, Lord Killanin papers, Box 120, 07/1410.
67 Killanin to O'Flaherty, 25 July 1954, Irish Film Institute, Lord Killanin papers, Box 183 99/407; Killanin to Ford, 26 July 1954, Irish Film Institute, Lord Killanin papers, Box 183 99/133.

put it, 'the Americans are always interested in Ireland but not necessarily financially!'[68] As his *Irish Times* obituary put it, Ford 'was basically a simple man, with simple, old fashioned values which sometimes betrayed him into excesses of sentimentality. But on his home ground, the Wild West or the Deep South, his mastery was complete'.[69] The same might have applied to the wild west of Connemara, but it was not to be. This is a shame, since the film version of *Famine*—hitting screens during the supposedly 'silent' centenary commemoration period—would almost certainly have become *the* seminal film about Ireland's Great Famine.

68 Killanin to Enno Stephan, 9 June1959, Irish Film Institute, Lord Killanin papers, Box 183, 99/379.
69 *The Irish Times*, 3 Sept. 1973.

III Legacy: Postmemory and Contemporary Visual Cultures

9

Tom Murphy and Druid Theatre's *Famine*s: Developing Images and Contexts, 1984 and 2012

Shelley Troupe

Maynooth University

'[*Famine*] has, as a play', Tom Murphy writes, 'a life of its own and, tired of history, tired of me, it continues its own process of discovery to its own conclusions, now with me, the author, not in the ascendancy but in pursuit'.[1] Like Murphy, the audience is also in pursuit of the play, searching for meanings and answers. The word *theatre* is derived from the Greek word *theatron*, or seeing place, making it an inherently visual medium. It is, then, the theatrical productions of *Famine* that allow spectators a glimpse of the conclusions Murphy mentions. Emily Mark-FitzGerald notes in the introduction to this volume that 'knowledge and recollection of past events is inextricable from the visual and material media used to re-present such histories'. Likewise, audiences' understanding of theatrical performances are dependent on social, historical and political moments—both those of the past and those in which they are presented. Through the socio-historical and socio-political contexts of Druid Theatre's productions of Murphy's *Famine* in the Ireland of 1984 and the Ireland of 2012, the resonance of the potential meanings of Murphy's play come to light. Murphy has always contended that, despite its title and its setting, the play is 'not really about the history of the Irish Famine at all. Living in the 1960s, I found that I was a Famine victim, that it wasn't over'.[2]

By interrogating Druid's productions of Tom Murphy's *Famine*, this chapter shows how the producing company's realization of the play constructs it in a particular way for audiences, which may not align with

1 Tom Murphy, *Plays: 1*, rev. edn (London: Methuen, 1997), ix.
2 Flyer for Druid's 1984 production of Tom Murphy's *Famine* in *Druid Theatre Company*, MS T2/99, James Hardiman Library, National University of Ireland, Galway.

either the playwright's intentions or with audiences' understanding of it, activating the theoretical concept of remediation that Mark-Fitzgerald identifies in this volume's introduction. To do so, the chapter provides a framework for examining the images associated with these productions, discusses the 1968 premiere of the play at the Abbey's Peacock Theatre and investigates Druid's two productions of the play. For example, Druid's first production of *Famine* in 1984 offers an interesting juxtaposition to Murphy's words above. Certainly, in 1984, the play's themes resonated as Ireland once again faced societal changes including secularization, recession and an increased rate of migration. However, Druid's marketing tactics encouraged the assumption that the play concerned the historical Famine, in direct contrast with the playwright's contention that it did not. Perhaps not surprisingly, the topicality of the play was overshadowed by these decisions and thus the reception reflects those choices. By 2012, however, Druid demonstrates a direct engagement with the contemporaneousness of Murphy's play through its marketing, set and costumes, which assert the interconnection between past and present and insist, in Brechtian fashion, that the audience make a connection between the nineteenth-century period shown on stage and the world outside of the theatre. In this way, Druid constructs Murphy's play in a particular way for audiences who are, like Murphy, in pursuit of meaning.

Tom Murphy, Druid Theatre and Their Artistic Partnership

Irish playwright Tom Murphy entered a formal artistic partnership with Galway-based Druid Theatre in September 1983 when he became Druid's Writer-in-Association. This affiliation saw Druid reimagine two of Murphy's earlier works—*Famine* (1968) and *On the Outside* (1959)—and premiere two new plays, *Conversations on a Homecoming* and *Bailegangaire* (both 1985). At the time of the association, Tom Murphy was a seasoned Irish theatre veteran whose plays had been produced in London and Dublin and who sat on the board of the Abbey Theatre, Ireland's National Theatre. Born and raised in the west of Ireland, Murphy began his adult life in the 1950s as a blue-collar worker, an experience that shaped his work as a writer; and many of his plays focus on the lives and struggles of individuals who, whether they be factory workers or returned migrants, society deems different. *A Whistle in the Dark* (1961) is, perhaps, his best-known play internationally. Set in the early 1960s, the play centres on Michael Carney, an Irish labourer who has emigrated to England, leaving his extended family behind him—or so he thinks. The play's violent conclusion, in which Michael inadvertently kills his brother, reinforces

the idea that emigration does not allow Michael to escape Ireland or his familial ties. Famously, the Abbey Theatre rejected the play, paving the way for its 1961 East End London debut and subsequent West End transfer, an unusual phenomenon at a time when most Irish plays premiered in Dublin before transferring to London. *Whistle*'s success prompted Murphy's relocation to London where, for the next nine years or so, the writer worked for television while experimenting with playwriting styles. For instance, Murphy's *Famine* uses scenes that draw on Bertolt Brecht's ideas of Epic Theatre, providing a stylized glimpse into the lives of people struggling with the effects of the Famine. After returning to Ireland in the early 1970s, and premiering several plays, primarily at the Abbey Theatre, the remainder of the decade was marked by theatrical ups and downs. By the time Murphy paired with Druid in 1983, however, his career was in the ascendant. He had two plays in that year's Dublin Theatre Festival, including the Abbey Theatre's world premiere of *The Gigli Concert* (1983); it received much praise including Harvey's Irish Theatre Awards for Best Play and Best Actor. Thus, by the time Murphy joined Druid as Writer-in-Association in September 1983, he was an accomplished playwright emerging from a quiet period of his career, and the venture provided him with, in Murphy's words, 'rejuvenation'.[3]

'Rejuvenation' is also a term describing Druid's role in developing not only Galway theatre but the city itself. Alongside a rich history of amateur dramatics, Galwegians had experienced semi-professional Irish-language drama, presented since 1928 at An Taibhdhearc (the national Irish language theatre of Ireland), and the work of visiting professional theatre companies such as the Irish Theatre Company and the Abbey Theatre. Druid's creation in 1975, however, marked the foundation of the first professional theatre company to succeed outside Dublin in the Republic of Ireland. In July of that year, two recent college graduates, Garry Hynes and Marie Mullen, joined forces with semi-professional actor Mick Lally to produce three shows in a summer repertory: John Millington Synge's *The Playboy of the Western World* (1907), Kevin Laffan's *It's a Two-Foot-Six-Inches-Above-the-Ground World* (1970) and Brian Friel's *The Loves of Cass Maguire* (1966). At first, Druid performed in the activities hall of a local school and, later, a converted hotel event room. In 1979, the company opened the doors of Druid Lane Theatre, a refurbished warehouse, giving Galway its first permanent professional theatre space and invigorating the surrounding area. Not content performing only in Galway, Druid began small-scale touring as early as 1976, and by 1983, the company had developed from a small, local theatre in the west of Ireland to one working to increase its international

3 Ronit Lentin, 'Playwright Returns from His Exile', *Irish Press*, 26 Sept. 1983, 9.

visibility with two visits to the Edinburgh Festival Fringe. Along the way, Druid, which was committed to bringing theatre to audiences who may not otherwise have an opportunity to see it, solidified its touring network in Ireland, and gave a national voice to the regions that lay outside of Dublin. Druid's next step in its organizational development brought the regions, chiefly the west of Ireland, wider acclaim by joining forces with Murphy in 1983. That partnership assisted Druid in creating an expanded touring network, furthering its international presence.

After their formal partnership ended in 1986, Tom Murphy returned to the Abbey Theatre to serve as its inaugural Writer-in-Association. Garry Hynes, who had directed the majority of Murphy's plays during the association, moved on to become Artistic Director of the Abbey from 1991 to 1994 and presented several Murphy plays during her tenure. In 2009, a serious re-engagement between Druid and Murphy began with Druid's production of *The Gigli Concert*. Directed by Garry Hynes, that event marked Druid's inauguration of the newly refurbished Druid Lane Theatre. That production, in conjunction with Druid's 35th anniversary celebration in 2010 (featuring excerpts of Murphy's plays, among others), led to *DruidMurphy*, Druid's 2012 marathon theatre event showcasing three of Murphy's plays: *Conversations on a Homecoming*, *A Whistle in the Dark* and *Famine*.

The association of Tom Murphy and Druid Theatre brought together creative partners that were tied to the west of Ireland and held similar artistic visions. Druid has been based in Galway since its founding in 1975, and Murphy was originally from Tuam, a town located about 20 miles north of Galway. Although each party's work is influenced by the location, Druid and Murphy independently subvert stereotypes associated with the west of Ireland. Murphy works against any prior constructed meanings of that place, and presents what Una Chaudhuri calls the 'geopathology' of the area. Chaudhuri defines the term as representing '[t]he problem of place— and place as *problem*', a phenomenon that she says 'informs realist drama deeply, appearing as a series of ruptures and displacements'.[4] Geopathology is evident in the play under consideration in this chapter; the peasants in *Famine* suffer geopathologically on a natural level and on a man-made level: the potato blight kills their main food source and their landlords evict them from their homes. Murphy's work, then, shows his opposition to a traditional depiction of the west of Ireland as an enchanted place filled with contented people. Such resistance is also palpable in Druid's productions such as their 1982 version of *The Playboy of the Western World*, a show which presented

4 Una Chaudhuri, *Staging Place: The Geography of Modern Drama* (Ann Arbor: University of Michigan Press, 1997), 55; original emphasis.

a distinctly anti-pastoral Ireland. Druid's Pegeen Mike scratched as she wrote out her shopping list, including her wedding accoutrement and a fine-toothed comb for the nits that caused her itchiness; the dirt floor of the shebeen left a haze of dust when disturbed by barefoot peasants; and Sarah Tansey and her friends were decidedly dirty (and probably smelly, as well).[5] Such stage pictures interrogate an idyllic Ireland and relate to the following analysis of images Druid includes on materials used to represent their 1984 and 2012 productions of Tom Murphy's *Famine*.

The Image Framework

Druid, like most theatre companies, uses promotional images on marketing materials to sell their shows. Here, I broaden the definition of 'performance' and 'production', suggesting that it begins *before* audience members take their seats in the theatre. An audience exists prior to the moment when the house lights go down and the stage lights go up, since public announcements of the plays (in hard copy or electronic formats), such as advertisements, flyers, posters and pre-production press all target audiences *before* they purchase tickets and arrive at the theatre. Notably, such public announcements most often rely upon visual images that are consumed by the audiences, informing their larger reading of the play in question.[6]

In *Reading Images*, Julia Thomas notes the importance of our understanding of such visuals: 'There is a sense [...] in which looking is always a type of reading because it involves interpreting what is seen. Even when we seem to absorb or passively consume what we look at we continue to differentiate between things and thereby rely on a linguistic and cultural knowledge of them'.[7] When we view images from theatre productions, then, we rely on 'linguistic and cultural knowledge' for our interpretation. In what follows, Druid's 1984 and 2012 productions of Tom Murphy's *Famine* illustrate not only how the play comments on each period in Irish history, but also how the producing company's realization of the play—from the marketing flyer to scenographic elements—constructs it in a particular way

5 Comments on Druid's production are gleaned from viewing a video of the performance at Druid's office.

6 For a discussion of what programme images suggest to audience members, see Willmar Sauter's essay, 'Reflections on *Miss Julie*, 1992: Sensualism and Memory', in Willmar Sauter (ed.), *The Theatrical Event: Dynamics of Performance and Perception* (Iowa City: University of Iowa Press, 2000), 158–64.

7 Julia Thomas, *Reading Images* (Basingstoke and New York: Palgrave Macmillan, 2000), 5.

for audiences. In this sense, the play's impact extends beyond what we tend to consider the performance space of the theatre.

Tom Murphy's *Famine* (1968)

Famine was first produced in the Abbey's intimate studio space, the Peacock, in May 1968, transferring to the Abbey Theatre's main stage in June, and returning to the Peacock in July. In November 1969, the play received its London premiere at the Royal Court Theatre while Murphy's *A Whistle in the Dark* was staged Off-Broadway in New York. On the surface, *Famine* examines the effects of the 1846 potato crop failure on the people of Glanconor. The community unravels, ravished by hunger, death and forced migration. Murphy also shows the difficulty associated with the experience of pre-migration, which is embodied by the character John Connor. A village elder and a descendent of the high kings of Ireland, Connor's highly developed sense of place is deeply rooted in the land and prevents him from emigrating. Murphy also underscores the moral issues famine causes. As Mother, Connor's wife, observes, 'These times is for *anything* that puts a bit in your own mouth'; she later steals turf and food from her neighbours, resulting in their deaths.[8] In the play's penultimate scene, Mother convinces Connor to kill her and their living children, so he may survive. In these ways, Murphy highlights the immorality and community dissolution that accompanies famine.

Although *Famine* originates from an actual event in Irish history, Murphy undermines a strictly historical representation of the Famine; rather, his goal is to write about the deprivation he observed in mid-twentieth-century Ireland. Critical responses to *Famine* in Ireland and to the 1969 London production, however, diverge when thinking through Murphy's intention for the play and whether it focuses on the effects of the Famine *in Ireland*. After the play opened in Dublin, *The Sunday Press* found that it took on a broader meaning: '[T]he play completely transcends the historical interest of its subject matter [and although] the play does not mention the fact that vast resources are being used to devastate Vietnam while Bihar starves [...] the parallel [...] is inescapable'.[9] By comparing the play's themes to India's famine and by mentioning the Vietnam War, the critic surmises that the themes of the play rise above even Murphy's intention for *Famine*. The play, then, becomes an international story, not merely an Irish one.

8 Tom Murphy, *Famine* (Dublin: Gallery Press, 1977), 33; original emphasis.
9 'A Triumph at the Peacock', *The Sunday Press*, 24 Mar. 1968, in the papers of Tom Murphy, Trinity College Dublin MS 11115/6/2/6.

Writing for *The Irish Times*, Leslie Faughnan's critique also related *Famine* to international events rather than to Irish society, and concentrated on the Poor People's Campaign, which was launched in Washington, DC in May 1968. During the protest, Resurrection City, an encampment, was set up on the National Mall, calling legislators' attention to America's impoverished people: "'The Famine times, god help us" are as valid a myth for the theatre as any in our history, and in the year of Resurrection City as universal in reverberation as any playwright could wish'.[10] Observations such as these underscore an inability, or reluctance, to address *Famine* in terms of contemporary Ireland relative to the Famine, an event in Irish history that was, perhaps, best left to shadowy memories.

While the 1968 Dublin production was read in the light of international famines, the *Financial Times* contextualized the 1969 London opening of the play within English history: '[I]t does seem possible that the landlords and others who proposed these remedies did so with less heartless enthusiasm than Mr. Murphy (who is, of course, an Irishman) suggests'.[11] A feeling of defensiveness pervades this observation, perhaps because throughout the play Murphy makes clear England's culpability in the events of the historical Famine. The critic emphasizes his experience as an English person in opposition to Murphy, 'who is, of course, an Irishman', suggesting that Murphy's depiction is somehow biased due to the playwright's nationality; however, the reviewer's criticism of Murphy reflects on his own inability to disengage from his predisposition as, presumably, an Englishman. It took nearly 30 years more before England formally acknowledged its complicity in the precipitating events of the Famine. In 1997, then Prime Minister Tony Blair offered England's first official apology for that country's role in exacerbating the devastating effects of the Famine through its free market policies and insufficient aid to Ireland, which is depicted in Murphy's play, when the villagers watch perfectly good grain being transported for export.

Although Irish and English critics reflected differences in their understanding of the 1968–69 productions, Brecht's Epic Theatre was a theme common among them. *The Sunday Press* observed of the 1968 Irish premiere that 'one is repeatedly reminded of Brecht. At even the most harrowing moments, one never forgets one is watching actors representing an event that happened more than a hundred years ago. One is moved, deeply moved: but the experience provokes questions, not tears. Like Brecht,

10 Leslie Faughnan, 'Play about the Famine', *The Irish Times*, 25 June 1968, 8.
11 A.B. Young, 'Royal Court: The Famine', *Financial Times*, 11 Nov. 1969, in Murphy Papers, Trinity College Dublin MS 11115/6/2/6.

Mr. Murphy makes you keep your distance'.[12] Rather than presenting the audience with a straightforward plot, Murphy used 12 distinct scenes to portray the struggles within Glanconor's community. In particular, John Connor's ambivalence towards the lack of food is a good example of Brecht's Epic Theatre in which, Roland Barthes suggests, 'the archetypical situations of the Brechtian theatre [...] may be reduced [...] to a single question: how to be good in a bad society?'[13] Connor grapples with that question throughout the play, insisting that he will 'do nothing wrong', although the community is falling apart in front of him.[14] However, Connor's way of doing nothing wrong is to do nothing at all: he relies on God and the hope that the government will provide food for him and his family. When Connor refuses a ticket to Canada, the Agent cannot tell him 'the reason why it is'.[15] The 'it' in the sentence refers to several queries: why it is the crops failed twice, why it is the community members are asked to emigrate, why it is no one provides them with food when they are starving, why it is that no one will tell them anything about the place to which they are asked to emigrate. Such queries relate to the reviewer's remark that the play, in the manner of Brecht's Epic Theatre, 'provokes questions, not tears'. An understanding of Murphy's *Famine*, as discussed above, then, sheds light on what topics, if any, Druid's 1984 and 2012 productions of the play may provoke for audiences.

Druid's *Famine*, 1984

At the time of Druid's first production of *Famine*, Ireland faced societal changes which made the play timely. Only five years after Pope John Paul II's 1979 visit to Ireland, it was apparent that the country was gradually becoming more secularized, highlighting the disparity between John Connor's faith and the fact any food God did deliver was being exported. In 1984, as Ireland experienced a recession, the rate of emigration had increased, connecting contemporary Ireland to the world of the play in which characters like Mark Dineen are forced to migrate from Ireland to Canada. By 1985, 18.2 per cent of the Republic's population was unemployed, linking the 1980s to the employment schemes in the play in which characters build a road to nowhere.[16] Conditions in late twentieth-

12 *The Sunday Press*, 'A Triumph'.

13 Roland Barthes, *Critical Essays*, trans. Richard Howard (Evanston, IL: Northwestern University Press, 1972), 72, 75.

14 Murphy, *Famine*, 33.

15 Murphy, *Famine*, 65.

16 Patrick Fitzgerald and Brian Lambkin, *Migration in Irish History, 1607–2007* (Basingstoke and New York: Palgrave Macmillan, 2008), 246.

FAMINE

by Tom Murphy

DRUID
THEATRE COMPANY

FAMINE, premiered in 1968, is generally regarded as one of the outstanding plays of modern Irish theatre. Set in the west of Ireland in the late autumn of 1846 and the Spring of 1847, it deals with the physical and spiritual decline of a rural community as a result of the effects of the potato blight. But although its setting is historical, FAMINE is a modern play. Mr. Murphy has said "It's not really about the history of the Irish Famine at all. Living in the 1960's, I found that I was a Famine victim, that it wasn't over. When one talks about famine, one generally thinks of the lack of food, starving people. But famine to me meant twisted mentalities, poverty of love, tenderness, affection; the natural extravagance of youth wanting to bloom — to blossom — but being stalemated by a nineteenth century mentality".

The central character is John Connor; he is the leader of the community as his family have by tradition been for generations. The nature of this leadership is called into question by the circumstances of the Famine and as its affects take hold we witness the unfolding of a terrible tragedy, not just for John Connor, but for almost all of his community.

The play is epic in quality and extraordinarily powerful. It provokes questions, not only as to the nature of the crises which overtook the Irish people in the middle of the last century, but as to the nature of the Irish people today.

This is a rare opportunity to see one of the most exciting plays of modern Irish theatre which, because of its size, is too infrequently staged.

VENUE: **SEAPOINT BALLROOM** SALTHILL, GALWAY.

DATES: Punt-fifty preview Sunday February 5th
Opens Monday February 6th
Two weeks (to Saturday 18th February only)
The production goes on tour from Feb. 19th.

BOOKING: Druid Lane Theatre 12 — 6.00 p.m.
(daily except Sundays, but including Sun. 5th)
By phone (091) 68617
Powells (4 Corners) 10.00 — 5.30 p.m.

PRICES: £4.
£3 students and OAP's and Unemployed. (With Cards).
£1.50 Preview tickets (Sunday 5th January).

9.1 Druid Theatre's marketing flyer (verso) for the 1984 production of Tom Murphy's *Famine* (1984), paper
Image courtesy of Druid and James Hardiman Library at the National University of Ireland, Galway

century Ireland were, in other words, challenging, and Murphy saw his 'historical' play as being relevant to present social conditions. A note by the playwright on the marketing flyer for the 1984 production (Figure 9.1) articulated his viewpoint:

> [The play is] not really about the history of the Irish Famine at all. Living in the 1960's [*sic*], I found that I was a Famine victim, that it wasn't over. When one talks about famine, one generally thinks of the lack of food, starving people. But famine to me meant twisted mentalities, poverty of love, tenderness, affection; the natural extravagance of youth wanting to bloom—to blossom—but being stalemated by a nineteenth century mentality.

However, as can be seen on the flyer, Murphy's words are visually overshadowed by the names of the company, the play and the venue.

Julia Thomas explains the importance of such choices for images generally: 'Deciding where to look is highly political because it involves deciding where *not* to look, what to exclude from sight'.[17] In this example, the reader's eye is directed not to Murphy's explanation, but to the title of the play and to Druid's name. Visually, this flyer tells us to look at 'DRUID THEATRE COMPANY' and 'FAMINE', which will be at 'SEAPOINT BALLROOM' in 'SALTHILL, GALWAY'; we are not urged to pay attention to Murphy's assertion that the play is 'not really about the history of the Irish Famine at all'. Furthermore, in contrast to Murphy's contention, the image on the front of the flyer (Figure 9.2) encourages the assumption that the play does, in fact, concern the historical Famine.

This image presents a male figure, his head turned to the reader's left, arms outstretched in a Christ-like pose, with skeletal community members at his feet. The man in the illustration presumably represents John Connor, a decidedly un-Christ-like character, who, instead of offering himself up for the salvation of others, kills his son and wife so he may survive. The illustration subtly represents a specific aspect of the play itself, showing in the foreground the figure of an emaciated woman with a baby at her breast. Early in *Famine*, characters are talking about previous crop failures and trade horrifying stories that they witnessed as a result. Brian says he saw '[a] child under a bush, eating its mother's breast. An' she dead and near naked'.[18] In this image, the woman is not under a bush, but among a throng of people.[19] She is just one of the millions of people

17 Thomas, *Reading Images*, 4.
18 Murphy, *Famine*, 17.
19 For an in-depth study of female images and the Famine, see Margaret Kelleher's

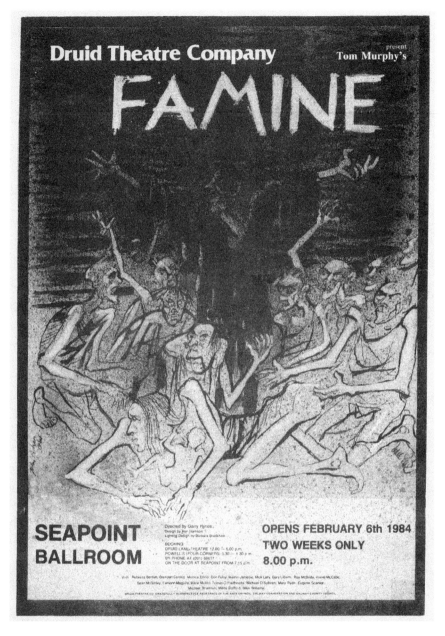

9.2 Druid Theatre's marketing flyer (recto) for the 1984 production of Tom
Murphy's *Famine* (1984), paper
Image courtesy of Druid and James Hardiman Library at the National University
of Ireland, Galway

that the Famine displaces due to death and migration. '[I]t is the image which is read first', Roland Barthes observes, 'and the text from which the image is constructed becomes in the end the simple choice of one signified among others'.[20] In other words, the 'picture is worth a thousand words'; in this example, then, the image on the flyer's front is more significant to our understanding of the play than Murphy's quote on the back. His statement points to one aspect of the Famine's legacy: the triumph of rationality over emotion that he saw in 1960s Irish mentality; but the image points to the physical suffering starvation creates, which eclipses the text on the back of the flyer.

Spectators entering the theatre to see Druid's *Famine*, then, did so with an expectation of the play that depended on whether or not they had absorbed the text on the back of the flyer. Perhaps unsurprisingly, the critics focused not on the contemporaneousness of the play's themes, but on the theatre space itself. The production, too large in scale to fit Druid's cosy 90-seat theatre, was produced off-site and outside of Galway's city centre in Seapoint Ballroom, a large dancehall in which Druid accommodated 350 to 400 spectators. A thrust stage was erected, and actors moved through the audience in attempts to replicate the intimacy of Druid's own theatre. This staging decision also echoes that of the 1968 premiere, which was presented in the round, and exploits aspects of Brecht's work. *The Tuam Herald* remarked on the 'succession of scenes' and *The Irish Times* described it as 'a sprawling epic of drama', so the press picked up on some of the production's Brechtian elements but failed to make direct comments on famine, either in Ireland or internationally, suggesting those topics may best be left undiscussed.[21]

Despite the lack of engagement on the part of the press, the Famine did hit home with audience members. When Druid toured the play around Connacht, the province that experienced the highest levels of population loss during the Famine, Tom Kenny's in-laws saw *Famine* in County Mayo. Writing in honour of Druid's 40th anniversary, the well-known Galway bookseller describes their reaction:

> There was not a word spoken in the minibus as they made their way back to a neighbour's house [...] where they finally began to talk about the play and its effect on them all. A discussion began which lasted on

 The Feminization of Famine: Expressions of the Inexpressible? (Durham, NC: Duke University Press, 1997).
20 Roland Barthes, *Image Music Text*, trans. Stephen Heath (London: Fontane Press, 1977), 40n1.
21 David Nowlan, 'Druid Company's Epic at Salthill, Galway', *The Irish Times*, 8 Feb. 1984, 14.

and off for several days as to how their antecedents might have coped with the Famine. They were all living on small farms and the production was very close to the bone for them.[22]

That audience's understanding of the play, then, is rooted in the location of performance, straddling the border between the spectators' consideration of the actual Famine ('how their antecedents might have coped') and Murphy's contention that the play is a comment on contemporary Ireland ('the production was very close to the bone for them'). Chris Morash and Shaun Richards argue that in the 1980s, 'a distinctive or anomalous Irish sense of place begins to implode', and that audiences begin 'moving from a national to a global frame'; Morash and Richards attribute these shifts to changes such as technological advancements, including 'the telecommunications revolution' and the new experience of inward migration, which Ireland would encounter during the next decade's Celtic Tiger.[23] Certainly, this audience reaction can be considered one that reflects a local response to a historical event of national importance; and, after the death of the Celtic Tiger, Ireland again experienced emigration. Thus, it was in a post-Celtic Tiger Ireland, one in which the 'Irish sense of place [had] implode[d]' and that was again experiencing emigration and unemployment, that Druid and Murphy revisited *Famine*.

Druid's *Famine*, 2012

Nearly 30 years later, Druid and Murphy revisited *Famine* as part of their three-part cycle of plays, *DruidMurphy*. In Druid's words, the theatrical event (rounded out with stagings of *Conversations on a Homecoming* and *A Whistle in the Dark*) promised that by '[c]rossing oceans and spanning decades, *DruidMurphy* [...] allows audiences to see who they are— regardless of where they might call home'.[24] After premiering in Galway, *DruidMurphy* toured Ireland and internationally to England and America. Garry Hynes, who directed all three plays, describes the project as 'almost like an archaeological dig. [...] As we move back in time, my goal is to

22 Tom Kenny, 'Weavers of Dreams and Spells', *DruidShakespere* Programme (Galway: Druid Theatre, 2015), 34.

23 Chris Morash and Shaun Richards, *Mapping Irish Theatre: Theories of Space and Place* (Cambridge: Cambridge University Press, 2014), 136.

24 Druid Theatre, 'Press Release: Druid Announces DruidMurphy', 'Plays by Tom Murphy', 25 Nov. 2011: http://archive.druid.ie/websites/2009-2017/news/press-release-druid-announces-druidmurphy (accessed 16 June 2018).

9.3 David Rooney, marketing image for *DruidMurphy*, launched in
November 2011
Image courtesy of Druid and David Rooney: www.davidrooney.com

unveil how they got to where we are'.[25] By conflating audience members
with the plays' characters, Hynes's reveals her goal for the *DruidMurphy*
cycle: to reflect to present-day audiences how historical events, predomi-
nantly the Famine, shaped contemporary Ireland and its people, a view
very much in keeping with Murphy's original creative vision. Hynes's
'archaeological dig' certainly strips back layers of artistic sediment, moving
the audience from the 1970s to the 1960s and then to the 1840s, and an
analysis of some design choices reveals Druid's ability to absorb and react
to current events in the world outside of the theatre, which began when
Druid unveiled the project in November 2011. The press release stated:
'Druid announces details of the biggest theatre project in the company's
history, *DruidMurphy*, a celebration of the writer Tom Murphy through
his epic tales of Irish emigration'.[26] The accompanying marketing image

25 Eric Grode, 'A Dark Irish Voice Revisits His Rage', *The New York Times*, 27 June
2012: www.nytimes.com/2012/07/01/theater/druidmurphy-three-tom-murphy-plays-
at-lincoln-center.html (accessed 16 Jan. 2017).

26 Druid Theatre, 'Press Release: Druid Announces DruidMurphy' (unpaginated).

(Figure 9.3) suggests that the theme of migration—one associated with Ireland both in the past and in the present—is inherent in *DruidMurphy*. There is also, however, a sense of overall ambiguity in the illustration.[27]

Take, for example, the shadow behind the man. Shadows themselves are murky 'figures' of foreboding and gloom. Here, it implies the rootlessness and placelessness felt by emigrants who leave all that is known behind them. The image begins to bridge the temporal gap between Murphy's 1968 play and Ireland in 2012 when we consider the man and the cottage. Although the man's hairstyle and trench coat evoke the early 1960s, the ruined cottage on the shore serves as a reminder not only of John Connor's razed cottage in *Famine* but, for a contemporary audience, of the many unfinished ghost estates that now blight the Irish landscape as a result of the 2008 banking crisis, and, by extension, the 'architects' of those properties: real estate developers who, ironically, emigrated in attempts to avoid litigation. Whether the man is leaving on a boat or contemplating departure on a dock cannot be determined, but the beacon emanating from the lighthouse suggests that his future will be metaphorically brighter in the distance, at a remove from Ireland. The rain in the image provides the clearest tie between the play and the production. It is carried from the image to the walls of the stage, where it is represented by a flat made of tarnished corrugated metal (another nod to the unfinished and decaying houses scattered throughout present-day Ireland).

The audience, then, is figuratively (rain)swept into the theatre and into the world of *DruidMurphy*. Francis O'Connor, Associate Director-Design, reveals that the landscape of the plays, their 'texture' as he calls it, was found after many previous ideas had been explored and rejected. Rusted corrugated metal was chosen because it looks like 'tilled fields'.[28] As the marathon theatrical event reveals one historical period after another, the set is stripped back to its foundations, leading the audience from the 1970s pub in *Conversations* to Michael's 1960s house in *Whistle*, and, finally, to the mid-nineteenth century, when rotted crops filled *Famine*'s 'tilled fields'. The set, though, is not the only scenographic element that asserts the interconnection between the past and present. Some characters wear flat caps and waistcoats, symbols of an earlier time, while others are attired with present-day garb such as a hooded sweatshirt and metal crutches. Rather than a comment on Tom Murphy's Ireland of the1960s, then, Druid's 2012 Brechtian-like production of *Famine* urges the audience

27 David Rooney is an Irish-based artist and illustrator. For more information, see www. davidrooney.com/David_Rooney_Illustration/Home.html (accessed 16 Feb. 2017).
28 Francis O'Connor, Associate Director-Design, *DruidMurphy*, personal interview, 12 May 2015.

to see the play as a critique of present-day Irish society, broadening the playwright's original vision. Such correlations between Murphy's play and Druid's production resonated with some critics like Alexander Gilmour, who found that all the plays in the *DruidMurphy* cycle 'lack the mood of cosy detachment that often accompanies period pieces: they feel urgent and visceral'.[29] Not all critics, however, received the play in that way, and the reviews of *Famine* (and of *DruidMurphy*, generally) contrast with this reading of the production, finding other themes that both reinforce and challenge the goals of the project as they were set out by Druid. Reviewing the critical response in both London and New York highlights the ways in which *Famine* was received in those two places of performance, ultimately accentuating a shift in the perception of the play from its premiere in the 1960s.

Although *DruidMurphy* premiered in May 2012 at the Town Hall Theatre in Galway, Druid strategically garnered more international press for the project by delaying the *official* opening until June, when it arrived in England as part of the London 2012 Festival, the culmination of the Cultural Olympiad. Lasting four years and including events throughout the United Kingdom, the Cultural Olympiad was produced alongside preparations for London's 2012 Olympics and Paralympics. As Druid had emphasized emigration—in both the press release and its accompanying image—as a unifying theme between all three plays, it is through this lens that the play was received in London.

Perhaps unsurprisingly, and similarly to the reception of *Famine* in the 1960s, there is a difference between the reaction of Irish reviewers who travelled to London and the feedback of their English counterparts. The Irish responses to *Famine*, and to *DruidMurphy*, largely resist categorizing the plays as connected by emigration. Rather, the *Irish Independent* finds that they are linked by 'their utter Irishness' while the *Sunday Independent* goes further, noting 'that to describe these plays as themed on emigration is to insult them'.[30] Some English reviewers also eschew emigration and instead focus on England's imperial past. Fifteen years after Tony Blair's formal apology, *The Daily Telegraph* tells readers that the Famine is 'the most shaming chapter of our colonial past', and *WhatsOnStage* observes that the 'triptych' of Murphy plays 'speaks passionately and authentically

29 Alexander Gilmour, 'DruidMurphy, Hampstead Theatre, London', *Financial Times*, 26 June 2012.

30 Sophie Gorman, 'Review: Druidmurphy, Hampstead Theatre, London', *Irish Independent*, 26 June 2012: https://www.independent.ie/entertainment/books/review-druidmurphy-hampstead-theatre-london-26869085.html (accessed 16 Jan. 2017); Emer O'Kelly, 'A Mighty Murphy Marathon', *Sunday Independent*'s 'Living Magazine', 1 July 2012, 25.

about nationhood and colonialism'.[31] The English and Irish responses intersect when considering the response of Alexander Gilmour ('urgent and visceral') and Emer O'Kelly, who observes the limitations of 'the inept and inadequate civic "assistance" offered in a society where the poor (as in other countries, not just Ireland) are regarded as less than fully human'.[32] These remarks bring the critical reception of the play into the present day. However, they do not engage with any specific events—either within Ireland or internationally. One should recall here that the responses to *Famine* in the late 1960s resonated with reviewers in terms of the Vietnam War and Bihar's famine. One of the most pertinent omissions from the critics in 2012 is any mention of Somalia's famine; between October 2010 and April 2012, over a quarter of a million people (half of those, children under the age of five) died from starvation caused by drought, suggesting that although scenographic elements in the *DruidMurphy* version of *Famine* intertwine temporalities they do not evoke similar present-day events for spectators.[33]

American critics, too, avoid comparisons with contemporary world events. The *New York Post*'s Elisabeth Vincentelli comes closest to doing so, equating the play's characters to those found in the popular American television series *The Walking Dead* (based on Robert Kirkman's comic book of the same name). Associating *Famine* with the story of survivors of a zombie apocalypse is, perhaps, a bit of an exaggeration, but there is a certain significance when thinking about the actions of Mother and of John Connor, since '[o]ver time, the characters are changed by the constant exposure to death and some grow willing to do anything to survive'.[34] Even so, Vincentelli does not go so far as to relate it directly to any actual current events. Instead, reviewers of the New York production generally see the play as relating to the historical event 'the Irish Potato Famine'. The types of changes noted in the reception of Druid's 2012 production of Tom

31 Dominic Cavendish, 'Tom Murphy, Hampstead Theatre', *The Daily Telegraph*, 26 June 2012: www.telegraph.co.uk/culture/theatre/theatre-reviews/9356260/Tom-Murphy-Hampstead-Theatre-review.html (accessed 16 Jan. 2017); Michael Coveney, 'Tom Murphy Plays a Blinder', *Whatsonstage.com*: https://www.whatsonstage.com/west-end-theatre/news/tom-murphy-plays-a-blinder_3739.html (accessed 16 Jan. 2017).

32 Gilmour, 'DruidMurphy' and O'Kelly, 'A Mighty Murphy', 25.

33 Francesco Checchi and W. Courtland Robinson, 'Mortality among Populations of Southern and Central Somalis Affected by Severe Food Insecurity and Famine during 2010–2012', United Nations Food and Agricultural Organization's Food Security and Nutrition Analysis Unit for Somalia, 2 May 2013: http://www.ipcinfo.org/fileadmin/user_upload/ipcinfo/docs/Somalia_Mortality_Estimates_Final_Report_1May2013_upload.pdf (accessed 16 Jan. 2016).

34 'AMC Orders Pilots for *The Walking Dead* and *The Killing*' (2010). www.amc.com/shows/the-killing/talk/2010/01/amc-orders-the-killing-pilot (accessed 16 Jan. 2017).

Murphy's *Famine* not only demonstrate a shift in the understanding of the performances between cultures but also underscore how the perception of the play has changed over time.

Conclusion

From 1968 to 1984 to 2012, there is one theme in the play's reception that carries through from one era to another: distancing. This concept relates back to Murphy's incorporation of Bertolt Brecht's Alienation Effect by 'taking the human social incidents to be portrayed and labelling them as something striking, something that calls for explanation [...] The object of this "effect" is to allow the spectator to criticize constructively from a social point of view'.[35] In the late 1960s, Irish critics distanced themselves from the Irish Famine and turned their attention, instead, to international crises, while English critics contextualized the play in terms of their country's history. In 1984, Druid marketed a traditional understanding of *Famine* to potential audience members in opposition to Murphy's contention that the play comments on the contemporary period. Irish commentators in 1984 were not swayed, though, and were primarily distracted by the fact that Druid had produced the play outside its own theatre due to the enormity of the play's set and cast size. Some audience members, however, related the play to their own present-day experiences as small farmers. By 2012, and in the spirit of Murphy's original aim for *Famine*, Druid scenographically highlighted its contemporaneousness as well as the theme of emigration. Critical reception continued to resist such representations of the play, centring instead on such topics as England's culpability in the Famine. These differing perspectives suggest that although the theatre company shapes a production in a specific way for audiences, their responses are unique and unpredictable. Such unpredictability, then, provides a springboard for future analysis of this play and Druid's productions of it.

35 Bertolt Brecht, *Brecht on Theatre: The Development of an Aesthetic*, trans. John Willett (London: Methuen, 1964), 125.

10
Overcoming Amnesia?
Memorializing Finland's 'Great Hunger Years'*

Andrew G. Newby
University of Tampere

The 'Great Hunger Years' (*Suuret Nälkävuodet*), which Finland experienced in the 1860s, have been characterized by Cormac Ó Gráda as the 'last great subsistence crisis of the western world'.[1] And yet Ó Gráda has also noted that it has been an 'unduly neglected' catastrophe, a perspective reinforced by Mary Daly's description of the Finns' 'amnesia' regarding this period of their history.[2] As Finland approached the sesquicentenary of the worst of these famine years, 1867–68, commemoration on a national scale remained muted. Finns have no national monument to their Great Famine such as the Irish have in Murrisk, County Mayo; nor is there a Finnish equivalent of Strokestown's National Famine Museum. None of the larger Finnish towns features emotive installations akin to Rowan Gillespie's 'Famine' (1997) in Dublin. This reinforces the idea that the Great Hunger Years, despite the great spike in mortality in 1868, have been contextualized in the national consciousness as part of the economic growing pains of a new nation.[3] On the subnational level, however, there are over 80 monuments to the hungry

* Research and fieldwork for this article has been funded by the Academy of Finland, projects #1264940 and #1257696.

1 Cormac Ó Gráda, *Ireland: A New Economic History* (Oxford: Clarendon Press, 1994), 208; Antti Häkkinen and Henrik Forsberg, 'Finland's Famine Years of the 1860s: A Nineteenth-Century Perspective', in Declan Curran, Lubomyr Luciuk and Andrew G. Newby (eds), *Famines in European Economic History: The Last Great European Famines Reconsidered* (London: Routledge, 2015), 99.

2 Mary E. Daly, 'Historians and the Famine: A Beleaguered Species?', *Irish Historical Studies*, 30 (1997), 596.

3 Vanessa Pupavac, 'Natural Disasters: Trauma, Political Contestation and Potential to Precipitate Social Change', in Erica Resende and Dovile Budryte (eds), *Memory and Trauma in International Relations* (Abingdon: Routledge, 2013), 82.

years of the 1860s in Finland, and any 'amnesia' is found in the national master narrative rather than in local communities.[4]

This chapter analyses the development of these monuments and notes the similarities and differences that emerge with Ireland's Great Famine memorials. In the context of a volume on Irish visual and material culture, it demonstrates the 'universality' of aspects of the Irish case, countering some of the particularism that can accompany established national perspectives. It is a response to Ó Gráda's proposal that 'there are obvious parallels and contrasts worth pursuing' in comparative Irish–Finnish famine research, and echoes Liam Kennedy's 'preference, when it comes to contextualising the Irish experience, for a European comparative perspective'.[5]

Constructing a National Narrative

Despite many broad similarities between Finland and Ireland in the nineteenth century—particularly as both existed in close proximity to their imperial powers—the Finns' development of what was effectively a 'Home Rule' administration within the Russian Empire after 1809 was a vital difference.[6] Civic and political leaders in Helsinki (Finland's new capital after 1812) made a conscious effort to develop their autonomy via compliance and accommodation with the Russians. The nationalist Fennoman movement nurtured a Finnish identity that emphasized not only their distinctive language, but also character traits such as self-sufficiency, forbearance and sedulity. An academic elite emerged which embraced scientific ethnology, folklore and history as a means of constructing a national identity. The Finnish Senate launched its own currency, the mark, in 1860. Maintaining the credibility of this new currency in international markets was a priority of J.V. Snellman, the philosopher, journalist and economist who became senator responsible for state finances in 1863. The agricultural economy remained fragile, years of dearth were a common phenomenon, and micro- and macro-level economic self-sufficiency was a key component of senate policy during the crisis years of the 1860s. Reflecting on widespread harvest failure in 1862, the Fennoman *Suometar* newspaper had proclaimed that working together through adversity would

4 Andrew G. Newby and Timo Myllyntaus, '"The Terrible Visitation": Famine in Finland and Ireland, 1845 to 1868', in Curran, Luciuk and Newby, *Famines in European Economic History*, 145–63.

5 Ó Gráda, *Ireland: A New Economic History*, 208; Liam Kennedy, *Colonialism, Religion and Nationalism in Ireland* (Belfast: Institute of Irish Studies, 1996), xv.

6 Bill Kissane, 'Nineteenth-Century Nationalism in Finland and Ireland: A Comparative Analysis', *Nationalism and Ethnic Politics*, 6 (2000), 25–42.

ensure that the 'children of the fatherland' would be bound with 'an iron grip'.[7] Far from expecting or seeking assistance from Russia, the Helsinki administration attempted to manage the famine independently, through negotiating overseas loans, managing voluntary donations from home and abroad and instigating public works schemes such as canal and railway building.

The climate—particularly harvest-destroying early frost—was perceived as the Finns' perpetual bogeyman, and it was frost, rather than the Russians, that would be framed as the cause of the Great Hunger Years. Indeed, as a means of rationalizing the death and disease that ravaged the country, Fennomans constructed a narrative that shifted the blame onto nature (and therefore God), meaning that the 1860s had been a Divine challenge to a young nation, and that it should be seen as an opportunity to bind the people together. *Uusi Suometar* made an early effort to claim the narrative of the famine years. An editorial in 1871 claimed that:

> The hard suffering that our citizens endured at the end of the last decade is quite fresh in the memory [...] the sacrifices which both the government and private individuals made to alleviate the distress were exceptionally large [...] these sacrifices are fit to be viewed as a tribute to the spirit that Finland's people showed in the hard fight for their existence.[8]

The theme was continued by Zachris Topelius in *Boken om vårt land* (*The Book of Our Land*) (1875), arguably the 'most influential book published in the Finnish language'.[9] When a challenge emerged to the established narrative, such as K.A. Tavaststjerna's *Hårda tider* (*Hard Times*) (1891), it was quickly refuted.[10] Tavaststjerna's novel implied that the administration had neglected the Finnish people in 1868, and that an entirely predictable early frost should not have precipitated such a demographic catastrophe. The book caused something of an outcry and provoked the prominent Fennoman

7 *Suometar*, 19 Sept. 1862.

8 *Uusi Suometar*, 25 Sept. 1871.

9 Pertti Anttonen, 'Oral Traditions and the Making of the Finnish Nation', in Timothy Baycroft and David Hopkin (eds), *Folklore and Nationalism in Europe during the Long Nineteenth Century* (Leiden: Brill, 2012), 338. Topelius's book was published in 1875 in its original Swedish as *Boken om vårt land*, and appeared in Finnish a year later, translated as *Maamme Kirja*. Derek Fewster, *Visions of Past Glory: Nationalism and the Construction of Early Finnish History* (Helsinki: Finnish Literature Society, 2006), 140. See, for example, chapter 49, 'En Frostnatt', in Zacharias [Zachris] Topelius, *Boken om vårt land* (Helsingfors: Edlund, 1875).

10 Karl August Tavaststjerna, *Hårda tider: berrätelse från Finlands sista nödår* (Helsingfors: Söderström, 1891).

Agaton Meurman to publish *Hungeråren på 1860-talet* (*The Hunger Years of the 1860s*) (1892).[11] Meurman accused Tavaststjerna of irresponsibility and reaffirmed a famine narrative that highlighted the people's stoicism, and the benefits that accrued from the experience of shared suffering. Meurman's arguments provided the template for articles and books on the 1860s until late into the twentieth century, although the 'triumph' of the Fennoman narrative should not perhaps be seen as inevitable.[12]

The semi-centennial famine reminiscences that appeared in 1917–18 generally presented familiar tropes such as chaotic migration and emergency bread.[13] The Finnish Historical Society (SHS) made a particular effort to gather these recollections, and even provided a questionnaire for parishes around the country as a template.[14] Among the 23 specific areas of interest were: memories of snow and frost in the winter of 1867; the extent of harvest failure among various crops; the emergence of new civil society organizations; the extent to which people remained in or fled from their parishes, and, indeed, how many outsiders came to the area; external signs of hunger in the people; and the subsequent development of the parish. As full national independence was achieved in December 1917, the famine years of a half-century earlier might simply have been imagined as a vital building-block for the emergent state. Civil war erupted, however, along the same fault-lines as in Russia—between the socialist Red Guard and the anti-Bolshevik White Guards. A socialist interpretation of the famine—laying blame squarely with Snellman and his bourgeois adminis- tration—was put forward by Edvard Gylling, a Social Democratic MP and member of the revolutionary Finnish government.[15] With the Whites' rapid triumph, this version of events did not gain widespread acceptance. Indeed, it is striking that a (long-planned) public lecture arranged by the SHS for the 50th anniversary took place on 8 May 1918, a few days after the Reds' final military defeat and a week before Marshall Mannerheim's victory parade in Helsinki.[16] Although the SHS made a further call for memoirs in 1919,[17] the idea persisted of a short-lived crisis that helped to create national

11 Agaton Meurman, *Hungeråren på 1860-talet* (Helsingfors: Folkupplysnings-sällskapet, 1892).
12 Tuomas Jussila, 'Nälkävirret: 1860-luvun nälkävuosien historiakuva Pietari Päivärinnan, Juho Reijosen ja Teuvo Pakkalan teoksissa', MA thesis, University of Tampere (2013), 30–31: http://urn.fi/urn:nbn:fi:uta-1-23362 (accessed 10 Feb. 2014).
13 Amongst many contributions, see, for example, Yrjö Juuti (*Ylioppilaslehti*, 11 Mar. 1917), O.A.F. Mustonen (*Uusi Suometar*, 10 June 1917), Alma Skog (*Nutid*, 1 Nov. 1917).
14 *Uusi Suometar*, 2 Feb., 3 Apr. 1917; *Kotiseutu*, 1 Aug. 1917.
15 Edvard Gylling 'Nälkävuodet 1867–68: Puolivuosisataismuisto' ['The Hunger Years 1867–68: A Semicentennial Recollection'], *Työväen Kalenteri XI* (1918), 110, 118, 120.
16 *Uusi Suometar*, 3 Apr. 1917; *Helsingin Sanomat*, 5 May 1918.
17 *Uusi Suomi*, 7 Mar. 1919, and many provincial and local newspapers.

unity[18] and bring agricultural–economic modernity to Finland. Moreover, its commemoration would now tend to be overshadowed in perpetuity by the momentous events that occurred 50 years later.

The Finnish 'Great Hunger Years' and Visual Culture

It is important to note the influence that artistic representations of the 1860s may have had on the subsequent memorialization of the famine years. Regarding the Great Irish Famine, Emily Mark-FitzGerald has argued that 'nineteenth-century visualizations have indeed proven a fertile (if repetitive) inspiration for post-1990s commemorative projects'.[19] One reason that this has not been the case in Finland is a basic lack of contemporary visual material relating to the crisis of the 1860s. Photography came to Finland in the 1840s and 1850s, and some photographs exist, for example, of Alexander II's visit to Helsinki in 1863.[20] Nevertheless, carrying the necessary equipment into the Finnish countryside, at a time when poor internal communications was one of the exacerbating factors of the famine, was not practical.[21] As with the Irish case, where later eviction photographs were (and are) sometimes passed off as representative of the Famine period, so too are later photos of Finns cutting trees to make 'bark-bread' occasionally used to illustrate texts on the Great Hunger Years.[22] An image of a food queue at Tampere in April 1868, however, is a rare, almost unique, photograph of a contemporary famine-related event.[23]

Another important source for the iconography of the Irish Famine, illustrated newspapers, had not yet appeared on the Finnish market by 1868. The satirical Swedish-language *Majken* was introduced in 1871, followed by the Finnish-language newspapers *Suomen Kuvalehti* (1873)

18 *Turun Sanomat*, 6 Dec. 1919.
19 Emily Mark-FitzGerald, *Commemorating the Irish Famine: Memory and the Monument* (Liverpool: Liverpool University Press, 2013), 13.
20 Various examples can be seen on the website of Helsinki City Museum. For example, 'Keisari Aleksanteri II:n vierailu Helsingissä 28–30.7.1863': https://www.finna.fi/ Record/hkm.HKMS000005:00000u8l (accessed 23 June 2018).
21 Even by 1903, when the New York *Christian Herald* engaged in a special mission to highlight renewed famine in Finland, initial illustrations were stock images. As the journey progressed, however, some original photographs were used. See *Christian Herald*, 7 Jan. 1903–20 May 1903.
22 Emily Mark-FitzGerald, 'Photography and the Visual Legacy of Famine', in Oona Frawley (ed.), *Memory Ireland*, vol. 3, *The Famine and the Troubles* (Syracuse, NY: Syracuse University Press, 2014), 121–22.
23 Museovirasto Historian kuva-arkisto, Dia 4572. See also *Suomen Wirallinen Lehti*, 9 Apr. 1868.

and *Kyläkirjaston Kuvalehti* (1873). There was, therefore, no Finnish equivalent of *The Illustrated London News* to transmit shocking images to a metropolitan readership, and no Finnish 'Bridget O'Donnel' on which sculptors could, in the future, base 'naturalistic' artworks commemorating the years of hunger. Moreover, despite international press coverage of the crisis, there seem to have been no attempts by illustrated newspapers abroad to depict the suffering Finns. *The Illustrated London News* noted the famine in Finland but did not obtain or commission any pictures.[24] More notable in this regard is the series of articles entitled 'Skizzer Fran Finland' ('Sketches from Finland'), which were published in the Copenhagen newspaper *Illustreret Tidende* in 1868.[25] The articles and sketches were contributed by the young Danish philologist, Wilhelm Thomsen (1842–1927), who was in Finland as a part of his linguistic studies. The articles do not focus on the terrible conditions of the Finnish people as much as present a standard tourist impression of Finland at the time (again, similar in some cases to Irish Famine depictions where scenic vistas could contrast jarringly with the misery in the foreground). And yet Thomsen was an energetic Fennophile: after returning to Denmark he collected funds specifically for the starving people in some of the Finnish municipalities that he had visited.[26]

The pre-eminence of national romanticism in Finland in the 1860s arguably militated against brutal realism in visual art. Finnish National Romantic art by Robert Ekman (1808–73), notably *Tiggarfamilj vid landsvägen* ('Beggar Family at the Roadside'), has been used to illustrate writing on the famine period. As this work was produced in 1860, however, it speaks more to the endemic poverty in pre-industrial Finland rather than the exceptional circumstances of 1867–68. Moreover, it combines elements of peasant life and scenery with a suffering mother and her three children, eliciting a sympathetic response from the viewer rather than revulsion.[27]

24 *The Illustrated London News*, 21 Mar. 1868, for example, reported that 'those who were employed to carry relief to sufferers [in Finland] have found several villages without a living inhabitant, the corpses of the poor starved creatures lying unburied in the streets and houses'.

25 *Illustreret Tidende*, 19 Jan. 1868 et seqq.

26 Antti Häkkinen and Andrew G. Newby, 'Nälkäkriisi-Suomi kansainvälisen avun kohteena', in Juhani Koponen and Sakari Saaritsa (eds), *Kiiniottoja: kehitysmaa Suomi* (Helsinki: Gaudeamus, forthcoming).

27 Moreover, his 1868 depiction of life in a peasant cottage ('Kreeta Haapasalo playing the Kantele') has no indication of a famine raging outside. Hjalmar Munsterhjelm's 1870 work *Nälkävuosilta* ('From the Famine Year') similarly depicts a destitute mother and her children on a snowy roadside. Munsterhjelm's depiction is privately owned and therefore less ubiquitous as an illustration but is nonetheless used by two important works: Antti Häkkinen, Vappu Ikonen, Kari Pitkänen and Hannu Soikkanen (eds),

10.1 Johan E. Kortman (artist), R. Lappalainen (engraver), wood engraving, published in E.G. Palmén, 'Seitsemän merkkiwuotta Suomen historiasta', *Kansanvalistus-seuran Kalenteri 1898* (Helsinki, 1898), 96
Courtesy of National Library of Finland

Retrospective articles about the 1867–68 famine borrowed the trope of 'whole families driven from their northern homes by famine and despair, wandering from place to place, half-dead with cold, in search of food and work', which had been a feature of contemporary reports.[28] Louis Sparre (1863–1964), later best known as a pioneer of Jugend furniture but very much part of the Finnish National Romantic scene in the 1890s, contributed several sketches to famine-related stories.[29] Johan E. Kortman (1858–1923), another prominent National Romantic artist, produced a depiction of 'shadowlike, ghostly people staggering around the country' (Figure 10.1) for an 1898 historical article that dealt ostensibly with the 1690s famine years in Finland but which was likely to make contemporaries consider the

 Kun halla nälän tuskan toi (Porvoo: WSOY, 1991); cover and Seppo Zetterberg (ed.), *Suomen historian pikku jättiläinen* (rev. edn, Helsinki: WSOY, 2003), 495.
28 *Leeds Mercury*, 28 Dec. 1867.
29 Including the cover of Tavaststjerna's, *Hårda tider* (see n10), and three sketches for Juho Reijonen's 'Nälkävuonna' ('During the Year of Hunger'), which was published in *Nuori Suomi*, 3 (1893). Sparre's illustrations were a strong selling point in the advertisements for the journal. See, for example, *Päivälehti*, 16 Dec. 1893.

The following Finnish text appears alongside the illustration:

Mutta
syömään, ei
dettä vuotec
Koske
lärillä paljor
talon pellot
lehmää. Mu
leltui vilja j
leipää, ja 8
silleen.
Kun
isäntä kerra
männahka o
viskasi vain
— Sɔ
Kaisa
— M
Silloin
nälkäiselle ɩ
Vaimc
kasi ne ove
— Si
syöny

koko

kuude

lihan

sitten

10.2 Illustrations by Helmi Biese for Hilda Käkikoski's 1902 Christmas story for children, set during the 1860s famine years.
Source: Hilda Käkikoski, 'Se Suuri Nälkävuonna', *Joulutervehdys*, 1 Dec. 1902
Courtesy of National Library of Finland

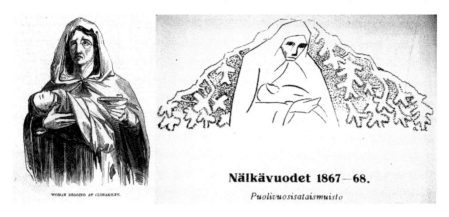

Nälkävuodet 1867–68.

WOMAN BEGGING AT CLONAKILTY. *Puolivuosisataismuisto*

10.3 (left) James Mahony, 'Woman Begging at Clonakilty', *The Illustrated London News*, 13 Feb. 1847; (right) illustration featured in Edvard Gylling's 'Nälkävuodet 1867–68: Puolivuosisataismuisto' ['The Hunger Years 1867–68: A Semicentennial Recollection'], *Työväen Kalenteri XI* (1918)

more recent crises of 1867–68 and, indeed, 1892–93, as Hannu Soikkanen has observed.[30] Only one modern memorial (Mäntsälä) (Figure 10.6) has employed this type of imagery, and there is not a single instance in Finland of the stark human forms expressed in, for example, Rowan Gillespie's Irish Famine memorials in Dublin and Toronto. The prominent feminist and conservative nationalist Hilda Käkikoski's 'The Great Year of Hunger' (1902) was a Christmas-time morality tale aimed at children, decorated with sad but palatable imagery by Helmi Biese (Figure 10.2).[31] Edvard Gylling's 1918 socialist polemic featured a stark illustration of a mother and child, a universal trope in famine imagery that is strongly reminiscent of James Mahony's 'Woman Begging at Clonakilty' (1847), and, given their strong visual correspondence, may possibly have taken direct inspiration from Mahony's engraving (Figure 10.3).[32] This particular image speaks strongly

30 Hannu Soikkanen, '"Miekalla, Nälällä ja Rutolla": Kriisit Historiassa', in Antti Häkkinen, Vappu Ikonen, Kari Pitkänen and Hannu Soikkanen, *Kun halla nälän tuskan toi* (Porvoo: WSOY, 1991), 15. Along with Sparre and Kortman, the same argument might be made for other 1890s works by prominent Finnish artists. These include Venny Soldan-Brofeldt's 'Nälkävuoden Kuva' (1892), Väinö Blomstedt's 'Nälkävuoden Näkijä' (1893), Hugo Simberg's 'Halla' (1895) and Robert Stigell's undated sculpture, 'Nälänhätä', *Uusi Kuvalehti*, April 1892; *Päivälehti*, 19 Nov. 1892; 26 May 1893. I am grateful to Leena Selin, Finnish National Gallery, for details on Stigell's work.

31 Hilda Käkikoski, 'Se Suuri Nälkävuonna', *Joulutervehdys*, 1 Dec. 1902, 24–25.

32 Gylling 'Nälkävuodet 1867–68', 110; *The Illustrated London News*, 13 Feb. 1847.

to Margaret Kelleher's theory of the 'feminization of famine' but also offers a visual connection to later Finnish famine memorials, particularly those created in the 1960s.[33]

1860s Famine Memorials in Finland: Chronology and Distribution

The following discussion of memorials to the Great Hunger Years in Finland adheres to the parameters established by Emily Mark-FitzGerald in her analysis of recent Irish memorials.[34] Thus, a 'Famine monument has been defined as a three-dimensional form set in public space', and other existing historical sites, 'famine roads' or the remains of poor-houses, are not included unless they are also accompanied by a memorial or more extensive commemorative intervention.

As can be seen from Figure 10.4, the geographical spread of memorials and sites of memory relating to Finland's 'Great Hunger Years' relates closely to the areas that were worst affected. There are significant concentrations in *Pohjanmaa* (Ostrobothnia), in *Vaara-Suomi* (the eastern regions of Karelia, Savo and Kajaani),[35] and around the Riihimäki-St Petersburg railway (which formed a large-scale public works project during the famine years). It should also be noted that the northernmost memorial, in Pudasjärvi, is almost 700 km (435 miles) from Helsinki (by way of comparison, the distance from Cork to Derry is about 450 km (280 miles)), but lies barely halfway up the country. The northern half of Finland, much of which is a part of what contemporaries referred to as Lapland or Laponia, was less affected, and, as Sámi historian Veli Pekka Lehtola noted recently, 'The Great famine in the 1860s was in the south of Finland [...] the people who were suffering from the Great famine came to the north, up the coast and other areas to escape it'.[36] In a significant contrast to Ireland, there are no memorials in the capital city, nor indeed in any of the other seven largest towns. Lahti, which was the eighth most populous town in Finland in 2016, is the biggest municipality with a memorial.[37] This distribution reflects the extent to

33 Margaret Kelleher, *The Feminization of Famine: Expressions of the Inexpressible* (Durham, NC: Duke University Press, 1997), 22–23.

34 See Emily Mark-FitzGerald, 'Irish Famine Memorials': https://irishfaminememorials. com/user-guide/ (accessed 15 Oct. 2016).

35 Kajaani is known colloquially as 'Nälkämaa', 'Hunger Land'.

36 See Sandra Bogdanova, 'Bark Food: The Continuity and Change of Scots Pine Inner Bark for Food by Sámi People in Northern Fennoscandia', unpublished MPhil thesis (University of Tromsø, 2016), 10: http://munin.uit.no/bitstream/handle/10037/9295/ thesis.pdf?sequence=3&isAllowed=y (accessed 1 Nov. 2016).

37 Espoo (Tuomikirkko), Helsinki (Tähtitornimäki), Tampere (Pyynikki) have 'sites of memory' through public works schemes and the graves of identifiable individuals.

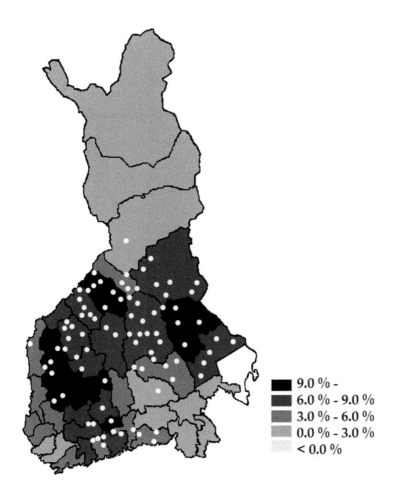

10.4 Map of 1860s Famine Memorials in Finland (represented by dots) and 1868
Deanery-Level Mortality Statistics; created by Andrew G. Newby (2017)
Map courtesy of Miikka Voutilainen

which the crisis, as in Ireland, was 'an intensely local experience, not one
which occurred at a remove from daily life',[38] but also that it has not been
considered of sufficient national 'value' to prompt monuments in important
metropolitan spaces.

38 Emily Mark-FitzGerald, 'The Irish Famine and Commemorative Culture', in
Christian Noack, Lindsay Janssen and Vincent Comerford (eds), *Holodomor and
Gorta Mór: Histories, Memories and Representations of Famine in Ukraine and Ireland*
(London: Anthem Press, 2012), 149.

The First Wave of Famine Memorials in Finland

Memorials to the Great Hunger Years are found in a variety of sites, which might be categorized as follows: (i) marker stones contemporary to the famine, generally erected at public works sites; (ii) later memorials situated by mass-graves near public works projects; (iii) later memorials placed in church graveyards to honour those buried in unmarked mass graves; (iv) other sites, including folk museums or farms.[39] The contemporary 1860s memorials are often rudimentary stones, featuring a crude engraving of a particular year. They tend to be located in the vicinity of relief works schemes, which generally suffered from high mortality rates through the spread of lethal diseases.[40]

Apart from stones left by contemporaries, the Great Hunger Years were left without visual commemoration until 1936, when a monument was established in the eastern industrial town of Varkaus.[41] This memorial, a striking truncated square pyramid, stands in the vicinity of a mass grave for those who perished in the construction of the Taipale Canal.[42] A text recalls 281 nameless victims from 51 parishes who were buried in the mass grave. As would become common, a New Testament quotation is included, in this case from the book of Jeremiah: 'You are my refuge in the day of disaster'.[43] Soon

39 Marianna Niukkanen, *Historiallisen ajan kiinteät muinaisjäännökset: tunnistaminen ja suojelu* (Helsinki: Museovirasto, 2009), 79–80. A more comprehensive account of the location and form of individual memorials can be found in Andrew G. Newby, 'Finland's "Great Hunger Years" Memorials: A Sesquicentennial Report', in Andrew G. Newby (ed.), *'The Enormous Failure of Nature': Famine and Society in Nineteenth-Century Europe* (Helsinki: Collegium, 2017), 173–214. Fieldwork since the publication of this interim report in early 2017 has recorded sites at: Haapavesi, Hamina (Salmi), Hamina (Lankila), Kangaslampi, Kortesjärvi, Kuhmoinen, Parkano, Pyhäjärvi, Rautavaara, Ruovesi, Savonranta, and Suodenniemi. Cataloguing and photographing of sites is ongoing and can be followed via Instagram (@finnishfaminememorials).

40 These stones seem to follow an earlier custom (see, for example, a memorial to the 1835 crisis year which was discovered in Juntulankylä, near Juuka: *Vaarojen Sanomat*, 5 Nov. 1969). Stones related to 1867–69 can be found at Pylvänälä-Joutsentie (near Kangasniemi), Perho, Parkano, Hamina (Salmi), Kuhmoinen and Koria, possibly in their original places. A mass-grave for railway workers at Hausjärvi (Oitti) dates from 1868. Stones at Hikiä, and Liperi were relocated and supplemented by more modern stones in 1988 and 2002 respectively, and the memorial stone at Taivalmaa—commemorating Tokerotie, the long road built by relief labourers in southern Ostrobothnia—was titivated and given an interpretive board in time for the centenary in 1967. The memorial to 'Juurakko Gustaf' at an isolated spot in Kauhaneva-Pohjankangas National Park, for example, simply records that he died of hunger at that spot in April 1868.

41 *Länsi-Savo*, 3 Dec. 1935; 17 Sept. 1936. A monument also seems to have been planned for Lieksa at this time. See *Viena-Aunus*, 1 June 1935; *Puutarha ja Koti*, 6–7, 1937.

42 *Tapio*, 16 Nov. 1867; 7 Dec. 1867; *Rakennustaito*, 13 May 1938.

43 Jer. 17:17.

afterwards another memorial (in the form of a large Christian cross) was inaugurated in the eastern town of Sotkamo, commemorating the 'Hunger and Disease Years' of 1867–68.[44]

Following Pierre Nora's concept of *lieux de mémoire*,[45] Alexander Etkind has argued that 'mourning sites are incomplete if they do not crystallise in monuments'.[46] It was after the 1940s that memories of the Great Hunger Years increasingly coalesced into monuments in Finland. In a recent interview with *Kaleva* newspaper, Ilona Pajari, a historian at the University of Jyväskylä, claimed that 'interest in monuments and other cultural aspects of mortality is kind of a continuation of the nation-builders' worldview, that is, yearning for a connection with the past and a sense of belonging'.[47] Pajari identified the Second World War as a 'clear watershed' moment in the relationship between Finns and 'death culture': 'We have also been affected by the events of 1918, and perhaps also by the famine years of the 1860s. We wanted to bury the dead with dignity in churchyards, not in any old forest, such as happened to the executed reds. These events created a kind of trauma'.[48] Despite the high mortality caused by the 1860s famine, subsequent traumas have featured far more prominently in the national 'collective memory' and in academic memory studies in Finland, notably a bloody Civil War (1918), and the Winter and Continuation Wars against the Soviet Union (1939–40, 1941–44).[49] Pajari's argument—and of course the mass unmarked graves of the 1860s can be used to support the point being made about the civil war executions—is given further strength by the chronology of Finnish famine memorialization.

Between 1945 and the famine centenary in the 1960s, several more memorials were erected. Alajärvi (1951) in Southern Ostrobothnia is typical in many respects: a simple stone engraved with a text and a biblical

44 *Kainuun Sanomat*, 20 Aug. 1938; 28 Aug. 1938.
45 Pierre Nora, 'Between Memory and History: Les *lieux de mémoire*', *Representations*, 26 (1989), 7–24.
46 Alexander Etkind, 'Post-Stalinist Russia: Memory and Mourning', in Siobhan Kattago (ed.), *Ashgate Research Companion to Memory Studies* (Farnham: Ashgate, 2015), 259.
47 Pia Kaitasuo, 'Hiljaisen Kansan Parissa', *Kaleva*, 19 Sept. 2015.
48 Kaitasuo, 'Hiljaisen Kansan Parissa'.
49 Tuomas Tepora and Aapo Roselius (eds), *The Finnish Civil War 1918: History, Memory, Legacy* (Leiden: Brill, 2014); Hana Worthen and Simo Muir, 'Introduction: Contesting the Silences of History', in Simo Muir and Hana Worthen (eds), *Finland's Holocaust: Silences of History* (Basingstoke: Palgrave Macmillan, 2012), 1–30; Ville Kivimäki, 'Between Defeat and Victory: Finnish Memory Culture of the Second World War', *Scandinavian Journal of History*, 37.4 (2012), 482–504. On memorials, see Sampo Ahto, *Muistoja talvisodasta: Suomen talvisodan 1939–1940 muistomerkkejä* (Helsinki: Sotasokeat, 1983); Antero Tuomisto, *Sotiemme muistomerkit* (Helsinki: Suomen Matkailuliitto, 1990); Riitta Kormano, *Sotamuistomerkki Suomessa: voiton ja tappion modaalista sovittelua* (Turku: Turun Yliopisto, 2014).

quotation, placed in the local churchyard, on a plot remembered in folk tradition as a famine-era mass grave, and maintained by the Lutheran parish.[50] More evidence of an increasing public consciousness around famine commemoration, and of the idea that 'memorial politics crystallise in sites of memory',[51] can be found in the memorial to the builders of the Riihimäki–St Petersburg railway, in Lahti (1953). In 1950, the Lahti Society[52] petitioned the town authorities to ensure that the 'so-called "Hunger Years Graveyard", which has persistently been left completely untended', should be protected and equipped with the appropriate symbols of a cemetery.[53] In support of their argument, the Lahti Society provided a historical account of the famine years in the town, noted that popular memory still recalled these harsh times and stressed that the mortality had been so great that the local churchyard could not accommodate the workers' corpses. As a result, the railway authorities reserved land on a nearby ridge for the purpose. Although the site was revered for decades, the current generation had forgotten its significance and it had become a 'playground for the children and dogs' of local inhabitants. The existence of the railway had contributed greatly to the development of the town, the society argued, and so those who gave their lives in creating it should be afforded due recognition.[54] The petition succeeded, a considerable amount of money was raised locally, and when the Railway Board transferred the cemetery to the care of the church in 1953, a monument was established.[55]

50 Heikki Junnila, *Alajärven Historia: erämaasta kaupungiksi* (Alajärvi: Alajärven kaupunki, 1999), 145. The 1950s also saw memorials established in Koiraharju, Veteli (1954), Kiuruvesi (1955) and in the old graveyard in Hämeenlinna (1958). Reports of the Hämeenlinna memorial made specific mention of the 90th anniversary of 1868, an indication of the developing importance of anniversaries. *Keskipohjanmaa*, 4 May 1954; *Suomen Kuvalehti*, 15 Nov. 1958.

51 Andrej Kotljarchuck, 'The Memory of the Roma Holocaust in Ukraine: Mass Graves, Memory Work and the Politics of Commemoration', in Tea Sindbæk Andersen and Barbara Törnquist-Plewa (eds), *Disputed Memory: Emotions and Memory Politics in Central, Eastern and South-Eastern Europe* (Berlin: De Gruyter, 2016), 152.

52 In Finnish, *Lahti-Seura ry.*

53 *Etelä Suomen Sanomat*, 24 Mar. 1950.

54 *Etelä Suomen Sanomat*, 24 Mar. 1950.

55 *Etelä Suomen Sanomat*, 21 Dec. 1950; 12 Sept. 1980. Although the memorial stone is dated 1953, the inauguration ceremony seems to have taken place in the summer of 1954. *Etelä Suomen Sanomat*, 26 June 1954. The memorial's symbolic use of railway track (to fence the mass grave) is repeated in the monumental cross at the Kärkölä railway workers' memorial (1967). The memorial at Hannonsalmi (Kivijärvi, 1985) is made from the remains of a stone bridge that was built as relief work in 1868.

Finnish Famine Memorials and the 1960s Centenary

It has been argued that in Ireland 'the centenary of the Famine in the mid-1940s did little to reverse muted interest in its public commemoration'.[56] This longstanding apathy was partly attributable to 'the State's unease with this tragic event and its memorialisation'.[57] In Finland, the centenary of the Great Hunger Years prompted neither state-approved remembrance nor concerted academic interest. One obvious factor that tends to marginalize famine commemoration on a national stage in Finland is that its independence as a nation (1917), and a civil war that caused nearly 40,000 deaths (1918), followed exactly 50 years later. These events, one celebratory and the other traumatic, take precedence in the commemorative hierarchy. On a local level, however, matters were quite different during the 1960s and, indeed, famine memorials were more prevalent in Finland by the end of the 1960s than they had been in Ireland in the 1940s.[58]

Around a dozen new memorials were inaugurated in Finland during the period 1962–68. The Lehtimäki memorial (1962) features a relief of a mother and child. In Kitee (1963), the memorial depicts a mother with two children, one of whom is carrying a small sack of meal, while the memorial in Nurmes was innovative in that it was a named piece of art, a relief by Veikko Jalava entitled 'Maaemon syli' ('In the Lap of Mother Earth').[59] Jalava's second commemorative sculpture, at Heinävesi (1967), also features a grieving human figure, and recalls the 'suffering inhabitants of our region' during the 'Great Hunger Years of 1866–1868'.[60] The parish of Lavia unveiled a memorial (1967) that depicts a mother bending protectively over her child.[61] Other centenary installations were not so ornate, although another recurrent image emerged in the memorials at Lohtaja (1964), Eno[62] (1967) and Lieksa (1968), that of (sometimes broken) stems of

56 Mark-FitzGerald, *Commemorating the Irish Famine*, 60.
57 John Crowley, 'Sites of Memory', in John Crowley, William J. Smyth and Mike Murphy (eds), *Atlas of the Great Irish Famine* (Cork: Cork University Press, 2012), 620.
58 Individual communities, particularly those associated with the railway builders, held centenary events, schoolchildren were invited to make emergency bread, as their ancestors had done, and newspapers commissioned historical articles. See *Maaseudun Tulevaisuus*, 13 Apr., 15 Apr., 20 Apr. 1967; 8 Feb. 1968.
59 Yrjö Juustila, *Maaemon syli: 1860-luvun nälkävuosien nurmekselaisten uhrien muistolle* (Nurmes: Nälkävuosien muistomerkkitoimikunta, 1965), 6–7.
60 Heimo Martikainen (ed.), *Heinäveden historia, 2, Heinäveden historia kunnallisuudistuksesta (1865) nykypäiviin* (Heinävesi: Heinäveden kunta, 1989), 89.
61 *Maaseudun Tulevaisuus*, 18 Feb. 1967.
62 *Etelä Suomen Sanomat*, 5 June 1967.

cereal.[63] The rye stems are also depicted on the engraved stone memorial at Paltaniemi (1968), along with another trope, 'ojentavat kädet' ('outstretched hands'), which reappears in Rantsila and Haapajärvi.

Post-Centenary Famine Memorials

In the half-century that has passed since the centenary, approximately 30 new memorials to the Great Finnish Famine have been inaugurated. These have tended to follow the themes outlined above: commemorations of mass-graves, particularly in the proximity of relief centres; and churchyards as a focal point for the collective memory of a parish or municipality.

Some of the later famine memorials are striking works of art, specially commissioned (generally using a sculptor from the region) and carefully planned, using symbols, stories and tropes of the 1860s for inspiration. Two such memorials are situated in relatively close proximity, not far from Finland's current south-eastern border with Russia, and although they were unveiled two decades apart they were designed and sculpted by the same prolific artist, Erkki Eronen. Eronen's piece 'Tyhjentynyt Kappa' ('The Emptied Basket') (1974) stands in the churchyard at Kiihtelysvaara (Figure 10.5).[64] A later piece of Eronen's is located 40 kilometres away from Kiihtelysvaara, in Tohmajärvi churchyard, commanding a prominent position overlooking the lake.[65] Completed in 1994, 'Tuhoutuneet Tähkät' ('Destroyed Ears')[66] is supplemented by an inscription claiming that every third resident of Tohmajärvi died in the period 1865–68. The memorials at Mäntsälä (1984) and Jämsä (1987) also form distinctive artworks.[67] The relief at Mäntsälä (Figure 10.6) features clamouring famine refugees, one of the familiar tropes of the Finnish famine, and is visually reminiscent of the much larger Irish memorial in Philadelphia. The wandering hordes were depicted frequently in later articles, and the victims' tortured expressions recall Kortman's illustration from 1898 (Figure 10.1).[68] The most recent memorials have been inaugurated in Vehmersalmi (2010), Kärsämäki

63 The memorials at Kortesjärvi, Veteli and Pudasjärvi also feature this motif.
64 *Kiihtelys-Pyhäselkä Lehti*, 28 Sept. 1974. I have translated 'kappa' here as 'basket', although it is a technical term referring to a container—and by extension weight—of produce, typically potatoes.
65 *Karjalainen*, 23 Dec. 1991.
66 That is, ears of cereal.
67 *Etelä Suomen Sanomat*, 7 November 1983; 23 July 1984; 21 Sept. 1987.
68 See, for example, Olavi Hurmerinta's (1928–2015) depiction of a file of Finnish famine refugees in *Maaseudun Tulevaisuus*, 16 Mar. 1950.

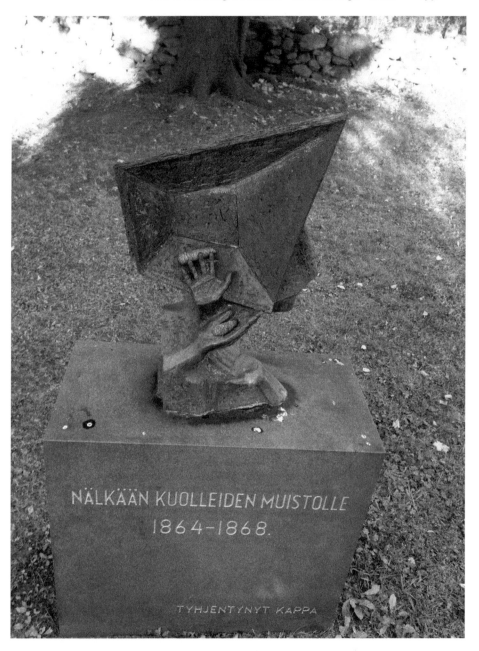

10.5 Famine Memorial at Kiihtelysvaara, North Karelia ('Tyhjentynyt Kappa',
Erkki Eronen, 1974)
Photograph by Andrew G. Newby

10.6 Detail from the famine memorial in Mäntsälä, Uusimaa (Heikki Varja, 1984)
Photograph by Andrew G. Newby

(2012), Kortesjärvi (2017), Ruovesi (2018) and Suodenniemi (2018). A 1950s memorial at Koiraharju (Varpaisjärvi) was also re-consecrated and supplemented by a new stone in 2012.[69]

Famine Memorials in Ireland and Finland

Away from the divergent national narratives, there are various common-alities between Ireland and Finland in the participation of local community committees, producing memorials for a local (rather than external, tourist) audience, which are located on or near previously unmarked mass burial sites, designed to 'honour the "unknown dead"', such as seen in Ireland in Tralee, Carraroe and Sligo.[70] There are some similarities in concept

69 Newby, 'Finland's "Great Hunger Years" Memorials', 184–210.
70 Margaret Kelleher, 'Hunger and History: Monuments to the Great Famine', *Textual Practice*, 16.2 (2002), 257; Mark-FitzGerald, *Commemorating the Irish Famine*, 70.

and form between individual memorials in both countries: for example, the use of a millstone at Tuamgraney, County Clare is repeated in at least four memorials in Finland (Evijärvi, Haapavesi, Ilmajoki and Sonkajärvi), and thus extant objects dating from the period with a connection to food, hunger and relief are refashioned as part of a new monument. There are also some overlaps of symbols: mothers and children, contributing to the discourse begun by Margaret Kelleher on the 'feminization of famine';[71] the representation of food;[72] and a notable preference for religious inscription and references to suffering rather than political statements or constructions (this is also true for most pre-1990s Irish famine memorials).[73] The most common verse is an obvious choice, from Matthew 6:11: 'Give us this day our daily bread'.[74] Other examples include Revelation 7:16 ('Never again will they hunger');[75] John 4:38 ('I sent you to reap what you have not worked for');[76] and Jeremiah 17:17 ('[Lord,] You are my refuge on the day of disaster').[77] Even one of the 'secular' inscriptions (at Sievi, 1966) quotes Runeberg's canonical *Saarijärven Paavo* (1830), the story of a peasant farmer who, despite battling summer frosts, remained diligent and maintained a strong faith in God and better times ahead: 'although the Lord tests us, He does not abandon us'. The focus on the Bible is perhaps not surprising, for not only are many of the memorials situated in the vicinity of mass graves in Lutheran churchyards, but Finnish national identity stressed stoicism and self-reliance—two virtues promoted by the Fennomans and the Lutheran clergy.[78]

71 Kelleher, *The Feminization of Famine*; Kathryn Edgeton-Tarpley, *Tears from Iron: Cultural Responses to Famine in Nineteenth Century China* (Berkeley: University of California Press, 2008), 189, 192–201; Emma Hutchison, *Affective Communities in World Politics: Collective Emotions after Trauma* (Cambridge: Cambridge University Press, 2016), 195.

72 The 'failed' foodstuff is a recurrent symbol in famine monuments, and the Finnish rye brings to mind the wheat depicted on Ukrainian memorials (particularly the large public installation in Washington, DC). Ukraine's National Museum 'Memorial to Holodomor Victims' hosts a memorial named 'Bitter Memory of Childhood', a statue of a girl clutching ears of wheat, featured on the cover of Christian Noack, Lindsay Janssen and Vincent Comerford (eds), *Holodomor and Gorta Mór: Histories, Memories and Representations of Famine in Ukraine and Ireland* (London: Anthem Press, 2012). In the Irish case, potatoes are occasionally represented, but perhaps less than might be expected owing to the crop's derogatory, rather than poetic, associations.

73 Varpaisjärvi: Exod. 3:5; Ullava: 2 Cor. 12:9; Toholampi: John 4:38.

74 This is used on the memorials in, for example, Alajärvi, Evijärvi, Halsua, Iisalmi, Kauhajoki Cathedral, Lapinlahti, Lehtimäki, Lohtaja, Nivala, Nurmo, Piipola, Pudasjärvi, Soini and Sonkajärvi.

75 Lentiira, Pielavesi.

76 Toholampi.

77 Varkaus.

78 Häkkinen and Forsberg, 'Finland's Famine Years of the 1860s', 106.

There are also significant differences. While many Irish monuments seek to demonstrate the 'exemplarity' of the Irish Famine, and make explicit links between famine, oppression and colonialism elsewhere in the world, such symbolism is entirely absent in Finland.[79] Moreover, there are no memorials to the Finnish famine located outside of Finland itself, which is striking in a comparative context, and highlights two important contrasts. First, that there was no strong link between famine and emigration in 1860s Finland. Although there was a great deal of internal displacement, emigration took place largely within the Russian Empire and was perceived as a much more general socio-economic phenomenon. Transatlantic emigration only took place on a large scale two decades after the worst of the famine years.[80] Second, the devolved relationship with the imperial power ensured that there was no political imperative in implying political or economic mismanagement by the St Petersburg authorities. Even during the 1890s and early 1900s, when the relationship between Finland and Russia was at a low ebb and Finnish nationalists actively promoted the idea of 'imperial oppression', the famine was never incorporated into a narrative of grievance. This contrasts markedly with the Irish experience, where the Famine has held a central place in Irish nationalist traditions since the nineteenth century, and its politicization and construction as British oppression (and more controversially genocide) was a constant referent in 1990s famine commemorations in the diaspora.

Famine Memorials and the Politics of Culpability

Cormac Ó Gráda's assertion 'that the impact of the Irish Famine was unequal and divisive' can be applied equally to Finland—geographically and socially—but this interpretation clashes against a historiography emphasizing shared national suffering, and has only seeped gradually into academic discourse.[81] The strength of local remembrance, however, is one

79 Kelleher, 'Hunger and History', 259. See the comments of Mikko Mela of Mäntsälä, during the mid-1980s Ethiopian Famine, which bemoaned that despite the inauguration of many famine memorials in Finland in 'recent years' little attention seemed to be paid to the similar catastrophes which still occurred globally. He asked whether this indicated hypocrisy or smugness, and whether Finns could 'afford to forget our starving brothers in far-away Africa': *Etelä Suomen Sanomat*, 17 Jan. 1985.

80 Andrew G. Newby, '"Neither Do These Tenants or Their Children Emigrate": Famine and Transatlantic Emigration from Finland in the Nineteenth Century', *Atlantic Studies: Global Currents*, 11.3 (2014), 383–402.

81 Antti Häkkinen, 'Suomen 1860-luvun nälkäkatastrofi—syitä ja seurauksia', *Duodecim*, 128.23 (2012), 2425–30; Miikka Voutilainen, 'Feeding the Famine: Social Vulnerability

indication of a tension between 'provincial' and 'metropolitan' narratives, or of a subtle reaction against the persistent elite narrative.[82] There is a strong resonance here with Guy Beiner's argument that the 1798 bicentenary commemorations in Ireland betrayed a significant disengagement between 'metropolitan'-centred academic history and his work on social histories of remembrance, which is focused on provincial folk culture, orality and other forms of material culture, yielding a very different narrative of the impact and legacy of 1798.[83] Beiner's analysis of folk history resonates strongly in the case of the Finnish famine.

Despite its limitations and internal agendas, the social memory expressed in folk history fulfils a unique role. It facilitates the telling of alternative versions of history, which challenge the ways the past has been presented, packaged, and marketed by the political and cultural elites that aspire to dictate the politics of commemoration.[84]

The potential of memorials not only to crystallize folk memories, but also to store, repackage and transmit memory to subsequent generations is exhibited in Aki Ollikainen's historical novel *Nälkävuosi* (2012) (translated as *White Hunger* in 2015). Critically and popularly acclaimed, the novel has arguably done more than any recent academic history to remind Finns of this episode in their history, as well as present the harrowing events of the 1860s to an international audience. The inspiration for the novel came from a Christmas visit by Ollikainen to Haapajärvi cemetery, where the author noticed the emaciated hands—praying, pleading, grasping for rye—depicted on the local famine memorial.[85]

Although unveiling ceremonies have tended to feature speeches from local worthies which reinforce the traditional stories—of frost, bark-bread and refugees desperately searching for food and work—the memorials as a body present a forceful, if subtle, counterpoint to the established narrative of the famine years. The key observation here is that there is no general agreement on the dates of the famine, and the monuments reflect a diversity of local experiences. Margaret Kelleher has argued that the 'long duration of the Irish famine makes it exceptional in international terms', adding that

and Dislocation during the Finnish Famine of the 1860s', in Curran, Luciuk and Newby, *Famines in European Economic History*, 124–44.

82 Laurence Gouriévidis, *The Dynamics of Heritage: History, Memory and the Highland Clearances* (Farnham: Ashgate, 2010), 3.

83 Guy Beiner, *Remembering the Year of the French: Irish Folk History and Social Memory* (Madison: University of Wisconsin Press, 2007), 8–14.

84 Beiner, *Remembering the Year of the French*, 310.

85 *Kansan Uutiset*, 16 Dec. 2012.

the Finnish case was one of several well-known catastrophes that only lasted for a single year.[86] The Great Irish Famine is given different dates between 1845 and 1851, and indeed the Irish government's 'official' sesquicentenary was limited to 1995–97 (before swiftly moving on to the 200th anniversary of the 1798 rebellion). Although 1868 is usually (if not universally) given as the culmination of the crisis in Finnish famine memorials, the start date is variously remembered as 1862 (Hikiä, Pihlajavesi), 1863 (Lehtimäki), 1864 (Kiihtelysvaara), 1865 (Nilsiä, Tohmajärvi, Ullava, Vehmersalmi), 1866 (around a dozen instances), or simply 'the 1860s' (Haapajärvi, Reisjärvi, Iisalmi, Nilsiä, Nurmo).

These divergent interpretations suggest that the exceptional mortality rate of 1868 was not simply due to unusual climatic conditions but was the result of several years of negligence from the administration in Helsinki, and depleted stores after repeated poor harvests.[87] Where no external administration is to be blamed, there is little political or moral capital to be gained in stressing a prolonged crisis. By focusing on a single year—and there is no denying that the mortality spike in 1868 can justify this focus—the idea of a climatic 'accident' because of an early frost, or Meurman's presentation of a land helpless in the face of God's wrath, seems more tenable. The community memorials portray a Finland that was sliding towards famine and asks questions of the autonomous administration in Helsinki. From an Irish perspective, as I have argued elsewhere, this at least introduces an element of doubt into William J. Smyth's assertion, made in 2012's *Atlas of the Great Irish Famine*, that no Irish government could have ignored the 'cry of want' in the 1840s.[88] A 'home rule' administration in Helsinki could not prevent the catastrophic escalation of a crisis in the 1860s. The Finnish case at least *suggests* a scenario in which a Home Rule government in College Green might have prioritized international economic stability over short-term charitable relief for its people, or indeed that metropolitan attitudes in Dublin could have excoriated the 'laziness' or 'backwardness' of the provinces.[89]

86 Margaret Kelleher, 'The Irish Famine: History and Representation', in Mary McAuliffe, Katherine O'Donnell and Leeann Lane (eds), *Palgrave Advances in Irish History* (Basingstoke: Palgrave Macmillan, 2009), 87.

87 Miikka Voutilainen, *Poverty Inequality and the Finnish 1860s Famine* (Jyväskylä: Jyväskylän Yliopisto, 2016). *Suomen Kuvalehti*, 6 Oct. 1962.

88 William J. Smyth, 'The Longue Durée: Imperial Britain and Colonial Ireland', in John Crowley, William J. Smyth and Mike Murphy (eds), *Atlas of the Great Irish Famine* (Cork: Cork University Press, 2012), 63. Newby and Myllyntaus, 'The Terrible Visitation', 149.

89 Heidi Reese, 'A Lack of Resources, Information and Will: Political Aspects of the Finnish Crisis of 1867–68', in Andrew G. Newby (ed.), *'The Enormous Failure of Nature': Famine and Society in Nineteenth-Century Europe* (Helsinki: Collegium, 2017), 90.

Conclusion

As an element of the visual culture of famine, 1860s memorials in Finland present a comparative context for Ireland, but also contribute to an alternative perspective on Finland's own history. The Great Famine Years play a surprisingly minor role in general histories of Finland and have not spawned an academic 'industry' which even remotely approaches the same level as in Ireland. Any attribution of 'amnesia' to the Finns, however, needs to be contextualized and qualified.

Mary Daly's suggestion that Finns' memories have been adjusted by having home rule has considerable merit, not least because the dominant political force shaped the historical narrative in accordance with their own vision of Finnishness.[90] By highlighting the power of God and nature, such narratives put the government's own slow and inadequate response to the 1860s famine into the background. It was also important for the Fennomans not to implicate Russia, as this would have undermined their key concept of national self-sufficiency. Thus, there has been no politicized debate—and of course no demands for apologies from the former imperial power, as per Irish opposition leader Bertie Ahern's crusade in 1994, which did culminate in a 'message of reconciliation' from Tony Blair on behalf of the British government in 1997.[91] In Ireland, the sesquicentenary of 'Black '47' prompted an 'enormous range of activity' around commemoration, characterized by Cormac Ó Gráda as 'famine fever'.[92]

In Finland, local commemorative culture was in many ways in advance of Ireland, as the centenary of their Great Famine saw the number of memorials increase considerably. In contrast, however, the 150th anniversary in Finland has not prompted any great national reflection or renewed memorialization, not least because commemorative events have been focused on the centenary of Finland's independence (2017) and civil war (2018).[93] As in 1968, any commemorations are likely to occur on a local

90 Daly, 'Historians and the Famine', 596.
91 Mark-FitzGerald, *Commemorating the Irish Famine*, 76–79.
92 Mark-FitzGerald, *Commemorating the Irish Famine*, 69; Cormac Ó Gráda, 'After the Famine Fever', *The Irish Times*, 19 May 2001.
93 Local newspapers around Finland have, sporadically, carried commemorative articles, and limited national media coverage emerged in 2017. For example, Finland's main newspaper of record, *Helsingin Sanomat*, noted in an editorial that '150 years ago, a catastrophe began, that Finland does not remember', and asked 'why are the hunger years just one chapter among many others in the history books': *Helsingin Sanomat*, 16 July 2017. State broadcaster YLE ran an article entitled: '150 years Ago 200,000 Finns Died. Do you Remember The Cause?' See https://yle.fi/uutiset/3-9738085 (accessed 20 July 2017).

level in areas that were particularly badly affected, reinforcing the idea that any amnesia in Finland around the Great Hunger Years is usually wilful, and highly selective.

11

Evictions on the TV Screen: The Visual and Narrative Legacies of the Great Famine in *The Hanging Gale*

Marguérite Corporaal

Radboud University

Current debates on the dynamics of memory have increasingly engaged with the ways in which pasts are reconfigured across time and space. Astrid Erll's contribution to the recently published volume *Transcultural Memory* (2014) exposes the traditional 'container-culture approach' in memory research as 'epistemologically flawed', because it erroneously ties memory to 'clear-cut territories and social formations'. Espousing the 'transcultural turn', Erll expresses her belief in the fluidity and transportability of 'travelling' memory '*across* [...] and also *beyond* cultures'.[1] Similarly, Lucy Bond and Jessica Rapson have recognized that memory is not only transferred across generations, but also '*within* and *between* national, ethnic and religious collectives'.[2]

However, cutting-edge research in memory studies has directed its attention not only to transgenerational and transnational mediations of the past, but also to the transmission of cultural memories across the boundaries of medium, form and genre. Fields such as film and theatre studies have traditionally been concerned with the interaction between various media: for example, through adaptation studies.[3] What is new is that these transmedial interactions have become rhetorically connected to

1 Astrid Erll, 'Travelling Memory', in Rick Crownshaw (ed.), *Transcultural Memory* (London: Routledge, 2014), 20–24.

2 Lucy Bond and Jessica Rapson, 'Introduction', in Lucy Bond and Jessica Rapson (eds), *The Transcultural Turn: Interrogating Memory between and beyond Borders* (Berlin: De Gruyter, 2014), 19.

3 See, for example, Jorgen Bruhn, Anne Gjelsvik and Eirik Frisvold Hanssen (eds), *Adaptation Studies: New Challenges, New Directions* (London: Bloomsbury, 2013); and Dennis Cuthins, Laurence Raw and James M. Welsh (eds), *Redefining Adaptation Studies* (Lanham, MD: Scarecrow Press, 2010).

concepts of memory, to analyse the ways in which these transmissions of cultural memories from one cultural medium to another have affected the past that is being remembered, as well as to examine how memories 'travel' from one cultural medium to another. Thus, Debra Ramsay discusses the memory of the Second World War by a transmedial comparison of film, television series and computer games, suggesting how the transference of these memories from one medium to another may transform them in contents and form.[4] Astrid Erll has recently addressed the relevance of studying the ways in which specific schemata that shape memories circulate across various media of remembrance,[5] comparing how cultural memories of the South African 'District 6' in literature, cinema and on museum websites intersect and influence one another.

Scholarship on Ireland's Great Famine is also gradually shifting its focus to the transmedial transference of Famine legacies: Emily Mark-FitzGerald's *Commemorating the Famine: Memory and the Monument* (2013) comparatively analyses nineteenth-century genre paintings, illustrations from the press and Famine monuments, showing how recent monuments have been influenced by the visual legacies of the nineteenth-century illustrated press.[6] Mary C. Kelly's *Ireland's Great Famine in Irish American History* (2014) also approaches the topic of Famine memory from a transmedial perspective, by drawing analogies between journalistic reports and short fiction written for Irish-American cultural communities, and pointing to mutual influence.[7] Nevertheless, there is still much underexplored ground beyond disciplinary-focused research that concentrates on texts or visual representations or material reconfigurations of the Famine past: as the general introduction to this volume also states, especially in terms of contemporaneous evidence.

This chapter follows up on recent debates in memory as well as Irish Famine studies by examining one of the visual memories of the Great Famine from the mid-1990s, the television drama series *The Hanging Gale* (Figure 11.1). The second half of the 1990s, which marked the sesquicentenary of the bleak years of mass starvation, eviction and emigration, saw the erection of new Famine memorials across the globe, such as the western

4 Debra Ramsay, *American Media and the Memory of World War II* (London and New York: Routledge, 2015).

5 Astrid Erll, 'From "District Six" to District 9 and Back: The Plurimedial Production of Travelling Schemata', in Chiara de Cesari and Ann Rigney (eds), *Transnational Memory: Circulation, Articulation, Scales* (Berlin and New York: De Gruyter 2014), 29–50.

6 Emily Mark-FitzGerald, *Commemorating the Famine: Memory and the Monument* (Liverpool: Liverpool University Press, 2013).

7 Mary C. Kelly, *Ireland's Great Famine in Irish American History: Enshrining a Fateful Memory* (Lanham, MD: Rowman & Littlefield, 2014).

New York Irish Famine Memorial (1995), John Behan's 'Coffin Ship' National Famine memorial in Murrisk, County Mayo (1997) and Rowan Gillespie's Famine Memorial on Dublin's Custom House Quay (1997), as well as a boost in Famine historiography.[8] *The Hanging Gale* thus fits in with what Mark-FitzGerald has aptly called the Famine 'memory boom' at the end of the 1990s.[9]

Written by Allan Cubitt, directed by Diarmuid Lawrence and based on an idea by the thespian brothers Joe and Stephen McGann, who had researched their family history, the television series was broadcast in Ireland by RTÉ from 2 to 23 May 1995 and in the United Kingdom by BBC One from 14 May to 4 June 1995. The four-episode series focuses on the Phelan brothers, a family of tenant farmers consisting of Sean; his wife Maeve and their children; Conor, their old father; Liam, who has become a priest; and Daniel, who has become the village schoolmaster. Their community enters into conflict with the land agent Captain William Townsend, and Daniel, a member of a secret society, becomes involved in an attempt on Townsend's life. Upon learning of Daniel's implication in the attempted assassination, Townsend decides to have the Phelans evicted.

Depicting eviction and agrarian outrage, *The Hanging Gale* is infused with the early visual as well as narrative legacies of the Great Irish Famine. This chapter traces the ways in which the series is indebted to the earliest visual images of evictions and tensions between landlords and tenants (as printed in, for instance, *The Illustrated London News*) as well as to the narrative 'templates', the schemata that organize memory into narrative scripts or plots[10] that one finds in early Famine fiction. These 'templates' include the roles of priests and land agents during evictions or in scenes of agrarian outrage. In tracing these things, the analysis aims to examine the following issue: how do modern visual genres such as the television drama reconfigure Famine memories that have mainly come down to us in the form of journalistic reports, fictional stories and (static) illustrations?

8 Titles published around this time include Peter Gray, *The Irish Famine* (London: Thames & Amp, 1995) and *Famine, Land and Politics: British Government and Irish Society, 1843–50* (Dublin: Irish Academic Press, 1999); Christine Kinealy, *This Great Calamity: The Irish Famine, 1845–52* (Dublin: Gill & Macmillan, 1994) and *A Death-Dealing Famine: The Great Hunger in Ireland* (London: Pluto Press, 1997).

9 Emily Mark-FitzGerald, 'The "Irish Holocaust": Historical Trauma and the Commemoration of the Famine', in Griselda Pollock (ed.), *The Visual Politics of Psychoanalysis in a Post-traumatic World* (London: IB Tauris, 2013), 60.

10 See James V. Wertsch, *Voices of Collective Remembering* (New York: Cambridge University Press, 2002), 9. Oona Frawley makes similar points in 'Towards a Theory of Cultural Memory in an Irish Postcolonial Context', in Oona Frawley (ed.), *Memory Ireland*, vol. 1, *History and Modernity* (Syracuse, NY: Syracuse University Press, 2010), 18–34.

Looking at the representations of sectarian conflict, gender and landscape in *The Hanging Gale* from a comparative perspective, this chapter will demonstrate that the series taps into both visual and narrative cultural Famine legacies, thereby accommodating conflicting vantage points representative of various social communities and laying bare the complex power structures that divided Famine-stricken Donegal. Furthermore, in a year which marked the earlier mentioned boom in Famine commemoration, *The Hanging Gale* appears to express an awareness of the Famine as a cultural memory with transgenerational impact.

Remembering Conflict: *The Hanging Gale* and Its Cultural Legacies

The reason land agent Captain William Townsend is determined to eject old Phelan and his extended family from their ancestral cottage differs from the usual motivations for evictions supervised by agents in early cultural representations. Many of the earliest narratives which recollect the bleak years of starvation suggest that tenants are thrown out of their homes because of rent arrears or the refusal to adopt the religion of their landowner. Thus, in David Power Conyngham's novel *Frank O'Donnell* (1861), the protagonist's family hear from the greedy land agent Mr Ellis, who seeks to convert farm land into more profitable pasture, that they will have to give up their house since their 'lease is out' and 'a year and a half's rent due'.[11] In Mary Anne Sadlier's *New Lights; or Life in Galway* (1853), the main reason the O'Dalys are evicted by their landlord Ousely is their defiance of the proselytizers that Ousely had sent to their home and their resistance to conversion: 'Tell them', paterfamilias Bernard O'Daly says to Scripture-reader Andrew McGilligan, 'that the O'Dalys are of the ould stock, or the ould rock, your choice, an' they can die *for* their faith, as they have lived *in* it, them an' their fathers before them'.[12]

11 David Power Conyngham ('Allen Clington'), *Frank O'Donnell* (Dublin: James Duffy, 1861), 399.

12 Mrs. J. Sadlier, *New Lights; or Life in Galway* (New York: D. and J. Sadlier, 1853), 147–48. The proselytizing movement was notorious for striving to convert Famine victims, as Donal Kerr observes in *The Catholic Church and the Famine* (Blackrock: The Columba Press, 1996), 86. The representation of the Souperist whose mission was to win souls for the Protestant cause among the starving population prevails in Catholic fiction. Examples include Richard Baptist O'Brien's *Ailey Moore* (New York: E. Dunigan, 1856) and Emily Bowles's *Irish Diamonds* (London: Thomas Richardson and Son, 1864). For a further discussion of proselytism in Sadlier's novel, see Marguérite Corporaal, 'Memories of the Great Famine and Ethnic identity in Novels by Victorian Irish Women Writers', *English Studies*, 90 (2009), 1–15.

The initially benevolent Townsend does not press rents; nor does he show indifference to the suffering of the starving. When Mary serves him dinner at the table, he states that the famine-stricken community is more entitled to it: 'food should be served to each person from the outside, from the land'. However, this mood of empathy changes into a thirst for revenge a few minutes later, when Mary finds a death warrant signed by the Ribbonmen on the doormat and shows it to her employer. Though it seems unfair that he directs his ire at the entire family, Townsend appears to have more understandable reasons for clearing the Phelans off his land when he learns of their brother Daniel's involvement in the assault on his life. Turning indifferent to the plight of the tenantry, Townsend claims, 'I think they should be made to feel the power of the law'.[13]

What ensues in this scene, set in Townsend's home and prior to the family's eviction, is a digression on Townsend's past frustration with English authorities. A crucial scene is one in which Mary inadvertently picks up a framed sketch showing a younger Townsend in uniform as an officer in India. Upon seeing the image of the imperial man he once was, Townsend fulminates against the way in which the London government let him down upon his return from British India by not securing him a better position. Frustrated by the authorities, his engrained sense of past powerlessness is fuelled by the threatening letter, while the secret societies who seek to exterminate the landholding classes regardless of their character intensify existing tensions. *The Hanging Gale* thereby exposes the complexities that underlie societal tensions during the Famine era.

The fact that all parties involved are determined to exert their authority becomes clear from the use of mirroring scenes and camera work in the scenes that precede the dramatic eviction at the end of episode 3. During the scene in which Townsend receives the threat from the Ribbonmen, the camera shows Mary passing the letter to him, registers the agent's emotion, and then zooms in on the text, and in particular on the words 'No mercy'. In an almost identical scene, Maeve, who is clearly distraught by the letter she has been perusing, hands the epistle to her husband Sean, and the camera subsequently focuses on the phrase 'Notice to Quit'. In this manner, the conflict between the classes is visualized as a rhetorical battle as well.

These tensions that divide the Donegal community culminate in the last part of episode 3, which depicts the eviction of the Phelans. The long eviction scene appears to reflect upon the power struggles that keep famine-stricken Ireland bound in conflict. Language plays a central role here again.

13 Allan Cubitt and Diarmuid Lawrence, *The Hanging Gale*, television drama in 4 (52-minute) episodes (Little Bird Productions, broadcast by RTÉ and BBC, 1995), episode 3.

The man who has been appointed by Townsend to read out the eviction order is shown to speak at the same time as the inhabitants' brother, Father Liam Phelan, who utters a prayer: 'From the malicious fiend defend me'.[14] The camera swerves in medium close-up from the face of Liam to that of the officer as they utter their lines simultaneously, reinforcing this notion of power conflict and social division. Significantly, the officer's words are heard for the first time when the camera is positioned in the cottage's interior, thus rendering the events from the perspective of the family who have barricaded the door and windows. As Kaja Silverman wrote, such a 'disembodied voice' expresses 'omniscience' and 'discursive power';[15] the fact that the audience initially becomes aware of the speaker as a mere voice from outside underscores the vulnerability of the tenant family in the face of the law.

The development of the dynamic eviction scene likewise suggests a contest over power between factions. Intriguingly, very early paintings of Famine evictions often represent the moments after ejection, when a family mourns their loss of home, rather than the ejection itself. *Eviction Scene* (*c*.1850) by Daniel MacDonald represents a rather static tableau of evicted tenants who seem to have been ejected without too many skirmishes, portraying a cottage that is rather intact.[16] The soldiers who stand at the entrance of the house, together with a man who looks like a land agent, appear to be in control of the situation, while to the left an elderly man and a woman bemoan their loss. Frederick Goodall's *An Irish Eviction* (1850) and Erskine Nicol's *An Ejected Family* (1853) likewise do not represent struggle, but a family in despair after they have been dispossessed of their home.[17]

The engraving 'The Ejectment' (Figure 11.1), which was published in *The Illustrated London News* on 16 December 1848, comes closer to expressing the physical violence that the eviction scene in *The Hanging Gale* stages. Accompanied by a text which states that the 'agonies endured' by the Irish 'in this day of their unparalleled affliction' are almost un-representable, 'more poignant than the imagination could conceive, or the pencil of a Rembrandt picture', the engraving evokes an image of deep suffering: an elderly man is brutally thrust out of his cottage and a younger one in vain appears to supplicate a stern man on a horse—most likely the agent who lifts

14 *The Hanging Gale*, episode 3.

15 Kaja Silverman, *The Acoustic Mirror: The Female Voice in Psychoanalysis and Cinema* (Bloomington: Indiana University Press, 1988), 164.

16 Daniel MacDonald, 'Eviction Scene', *c*.1850, oil on canvas, Crawford Art Gallery, Cork, 2633-P: http://www.crawfordartgallery.ie/pages/paintings/Soul_Beggars_26.html.

17 Frederick Goodall, *An Irish Eviction* (1850), oil on canvas, New Walk Museum and Art Gallery, Leicester: https://artuk.org/discover/artworks/an-irish-eviction-81257#; Erskine Nicol, *An Ejected Family* (1853), oil on canvas, National Gallery of Ireland: https://viewsofthefamine.wordpress.com/miscellaneous/an-ejected-family/.

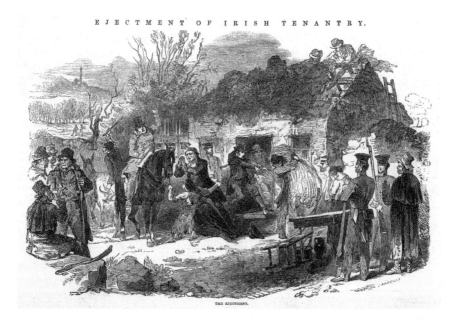

EJECTMENT OF IRISH TENANTRY.

11.1 'Ejection of the Irish Tenantry', wood engraving, published in
The Illustrated London News, 16 December 1848
Image courtesy of Ireland's Great Hunger Museum, Quinnipiac University,
Hamden, Connecticut

a moral finger—for mercy.[18] *The Hanging Gale* likewise depicts violence, as
the cottage door is beaten in, the house is set on fire, and Connor and Sean
are dragged out.

In fact, it can be argued that *The Hanging Gale*, in its represen-
tation of eviction, incorporates the discourses, narrative schemes and
visual repertoires of earlier representations of eviction in multiple media:
newspaper reports, fiction, illustration and photography, related to both the
Great Famine as well as subsequent agricultural crises (during the 1870s and
1880s, for example) that involved eviction. While these memorializations
of evictions impacted one another synchronically, they also constitute a
diachronic repertoire of Famine memory. The way in which the Phelans
wait behind the barricaded door of their cabin, ready to defend themselves if
the police forces invade, is reminiscent of illustrations from the press, such
as 'A Farming Family Defending their Home', published in the *Pictorial
Times* on 2 January 1847, as well as representations of evictions from the

18 'Evictions of Peasantry in Ireland', *The Illustrated London News*, 16 Dec. 1848.
Courtesy of Ireland's Great Hunger Museum, Quinnipiac, Connecticut.

1880s, such as Henry Jones Thaddeus's painting *An Irish Eviction, Co. Galway* (1889).[19] Recent scholarship by L. Perry Curtis, Gail Baylis and Emily Mark-FitzGerald has convincingly demonstrated the ways in which representations of post-Famine evictions are imbued with the discourses and iconographies surrounding the Great Famine, thereby re-enacting familiar mnemonic registers.[20]

The eviction scene in *The Hanging Gale* resonates with such later representations of eviction which in turn derive from Famine memory, such as Aloysius O'Kelly's 'An Eviction in the West of Ireland', published in *The Illustrated London News* on 19 March 1881, which, like the eviction scene in the television drama series, portrays conflict by visually lining up the police forces and the village community on two different sides of the cottage. In *The Hanging Gale*, the preceding scene, in which a group of officers are commanded by Captain Townsend to aim and fire at Father Liam and his congregation who, after praying, place themselves in front of the cottage to prevent an attack, is moreover strongly reminiscent of representations of evictions in prose fiction. For example, in the earlier-cited *Frank O'Donnell*, riots between angry villagers and armed police break out after the O'Donnells have been ejected: 'The people were intensely excited. Some stones were flung at Mr. Ellis; the soldiers and police had collected around him with their guns loaded and bayonets screwed'.[21] In *New Lights*, the angry farmers hold up spades, while '[t]he police themselves were evidently alarmed, and drew close together with bayonets pointed, waiting for the attack'.[22]

As a television drama, *The Hanging Gale* intensifies the idea of power struggle that lies at the heart of cultural memories of Famine evictions with its camera work. The fact that Captain Townsend, who symbolically sits high on his horse, is filmed from low angles, adds to the authority he tries to exert. At the same time, the camera alternately moves to Father Liam, giving medium close-ups of his face as he defiantly gazes back at the soldiers. The vertical movement that the soldiers who kneel and raise their bayonets express contrasts with the horizontal line that the priest and his flock visually form as they position themselves in front of the door, and

19 This painting (oil on canvas, private collection) is discussed extensively in Emily Mark-FitzGerald, 'The Persistence of Vision: Picturing Eviction in the Nineteenth Century', in Brendan Rooney (ed.), *Creating History: Stories of Ireland in Art* (Dublin: National Gallery of Ireland/Irish Academic Press, 2016), 202–24.

20 See Mark-FitzGerald, 'The Persistence of Vision'; Gail Baylis, 'The Eviction Photograph as Shifting Trace', in Oona Frawley (ed.), *Memory Ireland*, vol. 2, *Diaspora and Memory Practices* (Syracuse, NY: Syracuse University Press, 2012), 171–84; and L. Perry Curtis, *Notice to Quit: The Great Famine Evictions* (Cork: Cork University Press, 2015).

21 Conyngham, *Frank O'Donnell*, 428.

22 Sadlier, *New Lights*, 253.

as Father Liam stretches his arms to protect his parishioners. The visual clash between the verticality, associated with the land agent and armed forces, and the horizontality by which the peasantry and the Catholic priest are identified, is dissolved as one soldier stands up and drops his gun, exclaiming 'No! I will not fire at my own countrymen'. Thus the series exposes the complexities of divided loyalties during the Famine.

In the rather gruesome scene which occurs immediately after the eviction, showing how Liam re-enters the burning cabin to look for their father, a vertical movement is reintroduced. Through a reaction shot which features Liam's shocked face, the camera offers a medium long shot of a pair of dangling feet, and gradually moves upwards to reveal the still face of old Phelan, who has hanged himself, probably because he could not bear to leave his childhood home. The defeat of the peasantry by the landed class that this scene expresses through the aged man's suicide is thus emphasized by the vertical movement of the camera that had previously expressed the power of those charged with carrying out the eviction.

Not only in his capacity as a son, but also as a priest, Liam plays a central role in this eviction scene. In its representation of Father Liam, *The Hanging Gale* clearly taps into earlier visual as well as narrative repertoires of the Great Famine and class as well as religious conflict. Father Liam is represented as the person who tries to avoid an escalation of conflict: when he hears about the death warrant that Townsend has received, he tells the villagers in a loud voice: 'I'm a man and I feel as you do—but this is wrong'.[23] The scene takes place outside the church with the graveyard in the background, a site which symbolizes the omnipresence of death during the Famine. The medium to extreme close-ups of Father Liam, shot from low angles, underline the authority he holds in the community, an effect emphasized by the high-angled shots of the listening villagers.

This image of the priest as authority figure who attempts to keep the peace can also be found in the lithograph 'The Eviction; A Scene from Life in Ireland' (1871) by William Henry Powell: at the centre, a priest seeks to admonish an agitated crowd to silence.[24] In Sadlier's novel, Father O'Driscoll successfully disperses the violent crowd, saying, 'I command you to fall back ... and to shed no blood! In the name of God, do what I bid you!'[25] Similarly, in *Frank O'Donnell*, the priest throws himself between the rioting farmers, asking them to stop shedding 'each other's blood', especially

23 *The Hanging Gale*, episode 3.
24 William Henry Powell, 'The Eviction; A Scene from Life in Ireland' (New York: J.T. Foley, 1871), lithograph: Library of Congress. Available from https://www.loc.gov/resource/pga.01258/.
25 Sadlier, *New Lights*, 259.

in the presence of the body of the deceased Mrs O'Donnell, who did not survive the eviction.[26] Furthermore, just like this Father O'Donnell who, outside the cottage, administers the sacrament to the dying Mrs O'Donnell, Father Liam kneels down to bless the corpse of his father.

While *The Hanging Gale* appears to be inspired by earlier cultural legacies of eviction from fiction, painting and newspaper illustration in its depiction of the Catholic clergy, this is also the case for its representation of women. In her pivotal study, *The Feminization of Famine* (1996), Margaret Kelleher points to the gendered representation of starvation, in that images of Famine suffering often focus on women.[27] *The Hanging Gale* certainly seems to be inspired by this cultural repertoire as, for example, in a scene which shows Maeve as she tries to suckle her infant in vain. Traditionally, representations of evictions are also feminized in that they frequently foreground the vulnerability of women. For instance, the engraving 'The Ejectment' shows how a woman and a young child that holds onto her try to capture the reins of the agent's horse, but he seems indifferent to their misery and almost ready to trample upon them.[28] In 'The Present State of Ireland' (*Pictorial Times*, 2 January 1847) (Figure 11.2), the woman and her children stand apart from the men who have barricaded the door. The novel *Frank O'Donnell* highlights the cruelty of Mr Ellis, who dismisses Mrs O'Donnell's physical weakness as '[a]ll a sham', asking the officers to 'pull her out', so she may 'come to in the air'.[29] The heart-rending death scene of the poor woman, whom Frank had previously wrapped in his arms and carried out, accentuates the remorselessness of the landed class. Thus, an image of feminine fragility serves to evoke pity for the plight of the tenantry.

The Hanging Gale partially plays with this issue of female vulnerability, mainly through the figure of Mary, who works as Townsend's servant and is brutally attacked by the villagers, who throw stones at her: she is ostracized because she is working for the Captain and runs back to Townsend's estate in a state of distress. The scenes following the Phelans' receipt of the notice to quit also resonate with how Irish women often figured in portrayals of eviction. For example, in Powell's 'The Eviction', it is the women who appear to achieve reconciliation and to urge peacefulness. To the left of the print, a man is raising a pitchfork, but the woman standing next to him appears to implore him to hold off. With a child by her side, the woman is apparently a mother concerned for the welfare of her offspring.[30] Maeve

26 Conyngham, *Frank O'Donnell*, 428–29.
27 Margaret Kelleher, *The Feminization of Famine* (Cork: Cork University Press, 1996).
28 'Evictions of Peasantry in Ireland', *The Illustrated London News*.
29 Conyngham, *Frank O'Donnell*, 425.
30 Powell, 'The Eviction; A Scene from Life in Ireland'.

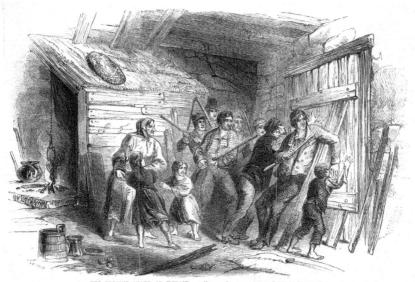

THE PRESENT STATE OF IRELAND — A Nightly Occurrence (see our Leading Article, page 39.).

11.2 'The Present State of Ireland: A Nightly Occurrence', wood engraving, published in *Pictorial Times*, 14 January 1847
Image courtesy of Ireland's Great Hunger Museum, Quinnipiac University, Hamden, Connecticut

plays a similar role in that she repeatedly expresses her anxiety about her fate and that of her children when Sean, Connor and their father chop wood to create barricades for the windows and door from within. She tells the men, 'You're not going to barricade the door. Leave me and the children in'. When they seem to ignore her, she says, 'You don't think of us, do you', and threatens to go with her infants 'anywhere from this'. The fact that she is holding a wailing babe in her arms all the while suggests the negative impact of social frictions and strife on family life.

Eventually, Maeve decides to stay by her husband's side, but her vulnerability as a woman and mother is stressed throughout: before and after the skirmishes Liam demands that he should '[a]t least get Maeve and the children out'.[31] On the other hand, when the house is forced open, Maeve displays equal strength and, like the men, fights back. In this respect, Maeve's more active role in offering resistance seems to hark back to representations of evictions of later decades rather than those concerning the Great Famine. For example, Aloysius O'Kelly's engraving, 'The Irish

31 *The Hanging Gale*, episode 3.

Land League, Agitation, Attack on a Process Server', published in the *Graphic* on 11 December 1880, shows a woman leading an angry mob that is pursuing a land agent attempting to deliver a notice of ejectment. Furthermore, photographs of the Bodyke evictions of 1887 portray women like the widow Margaret McNamara and her daughters who barricade their house against the eviction party.[32]

Framing Evictions: The Role of Place

Narrative and visual representations of the Famine often make use of the pathetic fallacy, expressing the 'great likeness between man and nature in terms of aspects and sympathies of feeling'.[33] This 'great likeness' often takes on the form of the landscape or weather conditions mirroring the sadness and suffering of the people. Thus, in Emily Fox's Irish-American Famine novel *Rose O'Connor* (1880), when Rose's mother and little brother die and the general condition of the famine-stricken Irish people deteriorates, this is reflected in the mood of the season: '[s]ummer passed away, autumn had moaned a sad farewell, and winter shiveringly introduced itself at the doors of many homes, where the inmates were ill prepared for its coming'.[34] Similarly, the O'Dalys in *New Lights* are 'turned out on the world on a cowld winther's day',[35] and in *Frank O'Donnell* it is a cold 'day in February; the snow was heavy upon the ground, and a thick sleet drifted fiercely with the wind', so that the 'poor old priest, his hair floating in the breeze, and covered with sleet and snow' gives his blessings to the dying Mrs O'Donnell.[36] Thus the deprivation of the ejected tenantry is reinforced by the harsh weather conditions. In a similar vein, William Henry Powell's 'The Eviction' depicts a bleak, grey sky that mirrors the threatening atmosphere of violence.[37]

The pathetic fallacy is also used cinematographically in *The Hanging Gale* at the beginning of episode four. While episode three ends with Liam's prayer over the corpse of his father while the flames that emanate

32 National Library of Ireland, photographs, 'Lawrence Collection' (glass plate negatives from 1870 to 1914), Eblana 2662. See also www.clarelibrary.ie/eolas/coclare/history/bodyke_evictions/evictions.htm (accessed 11 Feb. 2017). I would like to thank Emily Mark-FitzGerald for this useful suggestion.

33 Josephine Miles, *Pathetic Fallacy in the Nineteenth Century: A Study of a Changing Relation Between Object and Emotion* (Berkeley: University of California Press, 1942), 188.

34 Emily Fox ('Toler King'), *Rose O'Connor; A Story of the Day* (Chicago: Chicago Legal News Company, 1880), 83.

35 Sadlier, *New Lights*, 254.

36 Conyngham, *Frank O'Donnell*, 424, 427.

37 Powell, 'The Eviction; A Scene from Life in Ireland'.

from the cottage fill the air, episode four begins by showing how Maeve and Liam pile up a funeral monument for their dead father. After they have completed it, they huddle closely together in prayer as the gathered clouds break. Liam exclaims, 'Let it rain', and the water pours over their faces.[38] Thus the universe literally mourns with the bereaved family, and the setting, which so far in the series has been fraught with images of deprivation and strife, turns into a place of commemoration. The landscape had previously functioned as a site of hardship, as in a scene in which the villagers are tottering over the rocky hills to obtain work on the Famine road, or as a space of sectarian strife, such as in the scene in which the Ribbonmen attack Townsend as he rides through the desolate land. Now it becomes a place for a shared grief rather than strife. Interestingly, the blackened cottage forms a suture—a link between episodes 3 and 4— thereby symbolizing the centrality of eviction to the memory of the Great Famine. As an icon of struggle over land that literally travels from one into the next episode, the cottage in the television drama series suggests the transportability of Famine memory across time. The fact that the opening scene of episode four features an act of commemoration on behalf of the mourning family turns the ejected cottage and its land into what Pierre Nora calls '*lieux de mémoire*'.[39] This evocation of the cottage and its lands as sites of memory is interesting in light of the time in which the drama series was produced and broadcast, marking the sesquicentenary of the Famine, and the given that *The Hanging Gale* brings together older visual and narrative legacies, thereby functioning as a medium of remembrance.

At the same time, the image of the ruined cottage is an interesting travelling mnemonic image, for ruins are spectral sites, which, as Dylan Trigg argues, evoke a past presence that is at the same time notably absent, representing 'an altered place' that 'retains the shadow of its old self'.[40] As such, ruins constitute sites that continue to haunt their beholders with the trauma of loss, and may express the ravages of imperialism. However, as Stuart McLean and Kevin Whelan have both observed, ruins may conversely be viewed as sites that enable a retrieval of memories of former days, in the face of colonial powers that seek to root out the indigenous population's pasts. Ruins can foreclose oblivion, and they can 'invoke an otherwise vanished past'[41] that constitutes a form of 'counter-memory' of

38 *The Hanging Gale*, episode 4.
39 Pierre Nora, 'Between Memory and History: *Les lieux de mémoire*', *Representations*, 26 (1989), 9.
40 Dylan Trigg, *The Aesthetics of Decay: Nothingness, Nostalgia and the Absence of Reason* (New York: Peter Lang, 2009), 131.
41 Stuart McLean, *The Event and Its Terrors: Ireland, Famine, Modernity* (Stanford, CA: Stanford University Press, 2004), 149.

socially marginalized groups, 'which answers back to history'.[42] In this light, the ruined cottage in *The Hanging Gale* may express both defeat as well as the potential for future regeneration. The rain may also be interpreted as expressing this revitalization of a land, its cultures and its past, and thus the series appears to convey a prospective memory: it evokes a bleak past that is framed by present knowledge—during the Celtic Tiger—about more prosperous times that are to follow.

One of the central concerns of this book, as outlined in the introduction, is the transmedial memory of the Famine in visual and material cultures. What conclusions can be drawn about transmedial memory on the basis of our analysis of *The Hanging Gale*? In its creation of a 'prosthetic' (that is, mediated and indirect) memory of the Famine years 150 years later, *The Hanging Gale* repeats rhetoric, visual images and narrative templates concerning eviction from both the Famine and, more anachronistically, the post-Famine era.[43] In so doing, it taps into cultural repertoires about eviction from various media: art, photography, fiction. The transmission of Famine memory across generations that the television drama series effects therefore seems to be inextricably bound up with transmedial memory. The various media offer sources that help the series to reconstruct a Famine past from which it is divided by various generations. The interaction between various media in representing and remembering the Famine is not a phenomenon of modern times, but already occurred during the Famine years, and can therefore be analysed both synchronically and diachronically. What makes modern television drama on the Famine particularly compelling to investigate is its reliance on and combination of visual as well as narrative Famine legacies, in ways that expose the dynamics between image and rhetoric, composition and plot. *The Hanging Gale* does not necessarily transform the iconic and narrative repertoires of the Famine from which it borrows, but the series appears to address the issue of commemoration: for example, by presenting a scene that involves building a grave monument and by depicting a site of memory that is figuratively transferred from one episode into another, thereby suggesting processes of transmission. Although the television drama does not consciously comment on issues of memory, it plays with related concepts of commemoration and transference—and at a time when the Famine memory boom was reaching new heights.

42 Kevin Whelan, 'Reading the Ruins: The Presence of Absence in the Irish Landscape', in Howard B. Clarke and Anngret Simms (eds), *Surveying Ireland's Past: Multidisciplinary Essays in Honour of Anngret Simms* (Dublin: Geography Publications, 2004), 349.

43 Alison Landsberg, *Prosthetic Memory: The Transformation of American Remembrance in the Age of Mass Culture* (New York: Columbia University Press, 2004), 3.

12

Gone to Amerikay: Famine Postmemory, the Irish Diaspora and the Graphic Novel

Dawn Miranda Sherratt-Bado

Independent Scholar

Irish and Irish-American memory studies are rapidly expanding fields of enquiry. A part of that expansion involves important research in the area of Famine postmemory, which is explored here through the graphic novel *Gone to Amerikay*. The book was written by Derek McCulloch, illustrated by Colleen Doran, and published in 2012 by Vertigo, an imprint of DC Comics. In *Gone to Amerikay*, the graphic novel form provides a visual and intertextual space in which to explore the long history of Irish emigration to America and its attendant postmemory of forced migration. The novel originated as a literary adaptation of the song 'Thousands are Sailing' (1988) by The Pogues, which addresses the legacy of Famine emigration. In keeping with the aims of this volume, I will explore the ways in which *Gone to Amerikay* performs what Emily Mark-FitzGerald terms the 'transmedial transmission of Famine repertoires'.[1] This graphic novel transmediates the Pogues' ballad, responding to its expression of Famine postmemory and reworking it via text and images. The result is a pop cultural translation of postmemory into a new narrative structure. The postmemories of the Famine and of Irish emigration to America are the most salient historical legacies in the book, and I investigate the book's spectralized narratological treatment of these themes through the figure of the revenant, an interrupting figure from the past who intrudes upon the present both as a *reminder* and as an *expression* of trauma. Correspondingly, a ghost story interjects within the transatlantic and transgenerational narratives of *Gone to Amerikay*, thereby indicating a fractured and unresolved history. This

1 Marguérite Corporaal, Oona Frawley and Emily Mark-FitzGerald (eds), *The Great Irish Famine: Visual and Material Culture* (Liverpool: Liverpool University Press, 2018), 5.

history is represented through three interrelated narrative threads within the novel that take place in New York City during 1870, 1960 and 2010. The text jumps back and forth in time repeatedly; however, its storylines are connected and subtended by that of an Irish emigrant named Fintan O'Dwyer, who dies on a ship bound for America in what seems to be a conscious echo of Famine-era coffin ships.

There are some historical inaccuracies within the novel pertaining to the period of 1870 and its relation to that of the Famine (which occurred between 1845 and 1852). *Gone to Amerikay* blurs the chronology and iconography of the Famine and of Irish emigration to America and elides different phases of historical experience. For example, by 1870, Irish emigrants would probably have come to America on board steamships, not the wooden coffin ships of the 1840s Irish Famine migration. The extension of 'Famine' constructions onto all forms of Irish migration experience within the text is perhaps due in part to its dialogue with other popular cultural forms. The novel seems to portray popular representations of Famine migration as emblematic of all forms of Irish migration. This is certainly a mode of Irish cultural memory, but it is a problematic one; for it demonstrates the popular inclination to collapse emigration narratives into a 'Famine' narrative.[2] This chapter explores the complex and sometimes problematic interplay of text and spectral image within the graphic novel and its capacity to explore the spatial and temporal displacement of Famine postmemory, allowing us insight into the postgenerations of the Irish-American diaspora.

Postmemory and Graphic Narrative

Marianne Hirsch theorizes the potential for the graphic novel form to provide 'an adequate representational structure' for postmemorial artistic expression.[3] Hirsch defines postmemory as a concept which 'describes the relationship that the "generation after" bears to the personal, collective, and cultural trauma of those who came before—to experiences they "remember" only by means of the stories, images, and behaviors among which they grew up'.[4] This notion of postmemory can be expanded to include not only the condition of the 'generation after' but also the transgenerational ripple effects of massive historical trauma, thereby addressing multiple postgen-

2 See Reginald Byron, *Irish America* (Oxford: Clarendon Press, 1999).

3 Marianne Hirsch, *Family Frames: Photography, Narrative, and Postmemory* (Cambridge, MA: Harvard University Press, 1997), 13.

4 Marianne Hirsch, *The Generation of Postmemory: Literature and Visual Culture after the Holocaust* (New York: Columbia University Press, 2012), 5.

erations. The most notable example of the graphic novel as postmemorial art form is American cartoonist Art Spiegelman's *Maus*, serialized in *Raw* magazine from 1980 to 1991. It combines multiple narrative modes, utilizing 'the conventions of anthropomorphic cartooning' and 'a detailed and scrupulously naturalistic account of his parents' experiences of the Holocaust', in addition to a ghost story.[5] Spiegelman's book is also haunted by a revenant, that of his 'Ghost-Brother' Richieu, who was killed at Auschwitz before Art was born. In *Maus*, Richieu takes the form of 'a large blurry photograph', a silent, yet insistent, absent presence which Spiegelman describes as 'a kind of reproach'.[6] In *Gone to Amerikay*, the Irish emigrant Fintan's ghost functions in a similarly reproachful way to the character of Richieu, as both spectral figures tacitly address the ethics of secondary witnessing in postmemorial art. Fintan lived through the period of the Famine as a child, and the novel alludes to this traumatic experience through spectral traces and narrative tropes.

Like *Gone to Amerikay*, *Maus*—the first graphic novel to win a Pulitzer Prize (1992)—is also set in New York City and features a frame narrative. It is, on the one hand, an experimental memoir based on Spiegelman's interviews with his father Vladek about his experiences as a Polish Jew and as a Holocaust survivor. The text shifts back and forth between New York City during the 1970s and Second World War-era Poland, however, and does not remain with the frame narrative alone. Hirsch argues that Spiegelman's work is one of postmemory—a term that she coined, in fact, after reading *Maus*. Hirsch applies the theory of postmemory exclusively to the events of the Holocaust, but points out that 'it is a discussion increasingly taking place in similar terms, regarding other massive historical catastrophes', which 'are often inflected by the Holocaust as touchstone, or increasingly, by the contestation of its exceptional status'.[7] Accordingly, in their writings, contemporary Irish Studies scholars adapt Hirsch's theory of postmemory for the context of transgenerational trauma amongst the Irish and the Irish diaspora, particularly in relation to the Famine.

Famine iconography constellates within the contemporary popular imagination and features visualizations such as the starving body, the empty cottage, the coffin ship and the depopulated landscape. These images, which originated in newspaper illustrations during the Famine period, as well as later misappropriations of post-Famine photographs that depict evictions

5 Joseph Witek, 'Comics Modes: Caricature and Illustration in the Crumb Family's Dirty Laundry', in Matthew J. Smith and Randy Duncan (eds), *Critical Approaches to Comics: Theories and Methods* (London: Routledge, 2014), 28.

6 Art Spiegelman, *The Complete Maus* (London: Penguin Books, 2003), 175.

7 Hirsch, *The Generation of Postmemory*, 2.

and the suffering of the poor in Ireland, shape the ways in which we now visualize the Famine. Contemporary visual knowledge of the Famine and its impacts often conflates or confuses these images. Photography was new to Ireland in the 1840s and, as Mark-FitzGerald observes, 'the pictorial conventions of early photography proved unable to accommodate direct representation of the Famine and its effects'.[8] Consequently, she remarks that our contemporary frustration with 'Victorian photography's failure to picture the Famine' is linked to the notion of 'the receding image at the very moment of potential apprehension'.[9] Contemporary visual art practice redeploys iconographic Famine images in ways that question and subvert traditional (post)memorial representation, problematizing notions of indexicality. As David Lloyd argues, 'the Famine reappears as a kind of displaced memory that haunts the afterlife of Irish culture, not directly but in images and tropes that form its traces'.[10] Mark-FitzGerald underscores 'the prevalence of lens- and time-based media (photography, video, film, installation)' in recent visual art as a means to explore the Famine in 'the search for empathic identification in spite of this aporia'.[11]

In contrast to these new media art forms, the graphic novel uses a print-based, pop cultural medium to present a visual realm that addresses the aporias of Famine knowledge. Several of these have appeared in recent years: *Ireland: A Graphic History* (1995), a didactic text written by Morgan Llewelyn and illustrated by Michael Scott, includes a nine-page chapter on the Famine.[12] An English-language graphic novel about the Famine, *The Bad Times: An Drochshaol*, written by Christine Kinealy and illustrated by John Walsh, was published in 2015 and it is set to be translated into Irish.[13] However, unlike the aforementioned texts, *Gone to Amerikay* does not name the Famine directly, but rather engages with it through narrative circumlocution. *Gone to Amerikay*'s approach to this subject is unconventional and oblique due to its use of 'hauntology',[14] which makes strange its visual and narratological representation of the Famine.

8 Emily Mark-FitzGerald, 'Photography and the Visual Legacy of Famine', in Oona Frawley (ed.), *Memory Ireland*, vol. 3, *The Famine and the Troubles* (Syracuse, NY: Syracuse University Press, 2014), 126.

9 Mark-FitzGerald, 'Photography and the Visual Legacy of Famine', 132, 126.

10 David Lloyd, *The Irish Times: Temporalities of Modernity* (Dublin: Field Day, 2008), 6.

11 Mark-FitzGerald, 'Photography and the Visual Legacy of the Famine', 132.

12 See Morgan Llewelyn and Michael Scott, *Ireland: A Graphic History* (Shaftesbury: Element Books, 1995).

13 Christine Kinealy, *The Bad Times: An Drochshaol*, illustrated by John Walsh (Ann Arbor, MI: XanEdu Publishing, 2015).

14 See Jacques Derrida, *Specters of Marx: The State of the Debt, The Work of Mourning, and the New International*, trans. Peggy Kamuf (New York: Routledge, 1994), 5.

Postmemorial Intertextuality

The title *Gone to Amerikay* is taken from a popular theme in Irish folk ballads about emigration to America. Music is an important intertextual thread throughout the novel, which responds to the song 'Thousands are Sailing' (1988) performed by the London-based Irish post-punk band The Pogues, and written by member Phil Chevron, who was born in Dublin. The ballad explores the long history of Irish emigration to New York City and its false promise of prosperity:

Thousands are sailing
Across the western ocean
To a land of opportunity
That some of them will never see
Fortune prevailing
Across the western ocean.[15]

'Thousands are Sailing' is a work of postmemorial art which functions simultaneously as a pre-text and an intertext for *Gone to Amerikay*, for its themes reappear as motifs within the book. As Marguérite Corporaal *et al.* assert, 'The memories carried by works of literature interact with other modes of recollection and may therefore change'.[16] *Gone to Amerikay* exhibits this interaction between literature and other modes of recollection through the strategic devices of intertextuality and frame narrative. In addition to the prevalence of song via its inclusion of Irish folk and post-punk music, the novel also incorporates actual historical events and interweaves transgenerational stories of Irish immigrants in America in order to portray the evolving relationship between the Old Country and the New World.

The constitutive spaces of the novel exist within its dialectical tension of presence and absence. The book begins in 1870 in lower Manhattan's notorious Five Points slum, so named because it was the location of a five-point intersection. It was also a cultural crossroads—a tightly enclosed

Derrida defines hauntology as a discourse that is neither ontological nor epistemological, since the figure of the ghost 'is' insofar as 'one does not know if precisely it *is*, if it exists, if it responds to a name and corresponds to an essence'. He argues, 'One does not know: not out of ignorance, but because this non-object, this non-present present, this being-there of an absent or departed one no longer belongs to knowledge. At least no longer to that which one thinks one knows by the name of knowledge'.

15 'Thousands Are Sailing': www.pogues.com/Releases/Lyrics/LPs/IfIShould/Thousands.html (accessed 10 Jan. 2017).

16 Marguérite Corporaal, Christopher Cusack and Lindsay Janssen (eds), *Recollecting Hunger* (Dublin: Irish Academic Press, 2012), 6.

district that housed Irish-American, African-American and other immigrant communities during the nineteenth century. Furthermore, Five Points was the site of gang warfare between Irish-American and nativist ethnopolitical factions. The Five Points no longer stands and Little Water Street, one of the streets that formed the intersection, has vanished from the map. The Five Points is therefore a space that exists only at the intersection of history and memory, and in the text, it is associated with the trauma of forced migration.

As the majority of trauma theorists maintain, traumatic memory resists narrativization because it 'alters the linearity of historical, narrativized time'.[17] Traumatic memory is an incomplete memory since it is obscured from full cognition.[18] Consequently, just as trauma alters time, so too does it alter space. Postmemorial art spatializes traumatic memory in fragments, blank spaces, or repetitive patterns. Thus, in a way, the Five Points is another revenant in the text, which potentially draws on the '*dinnsenchas*' tradition of layered place-lore resurfacing or being retained.[19] *Dinnsenchas* is a class of onomastic text in early Irish literature which recounts the origins of place names and traditions concerning events and figures associated with the place in question. Therefore, it is possible to read *Gone to Amerikay* as a text that reworks the *dinnsenchas* tradition in order to explore the ways in which place-lore re-emerges or is preserved within postmemorial art.

The layering of place-lore is also evident in Figure 12.1, the triptych of New York City that appears at the opening of *Gone to Amerikay*, which features the changing skyline and modes of immigrant transportation within three distinct but interconnected time periods: 1870, 1960 and 2010. The three plotlines within the graphic novel explore variations on the theme of the Irish emigrant 'gone to Amerikay' in search of the American dream. The first tells the tale of Ciara O'Dwyer and her daughter Maire, who take part in the mass exodus from Ireland to America in the latter half of the nineteenth century. The second story is that of an Irish folk musician named Johnny McCormack, who hopes to break onto the Broadway stage in the 1960s. The third storyline—not discussed here for reasons of space—portrays Lewis Healy, a billionaire music fan from contemporary Dublin who retraces Johnny's journey to America. As the triptych

17 Jenny Edkins, *Trauma and the Memory of Politics* (Cambridge: Cambridge University Press, 2003), 40.
18 See Cathy Caruth, *Unclaimed Experience: Trauma, Narrative, and History* (Baltimore, MD: Johns Hopkins University Press, 1996).
19 In Old and Middle Irish, *dinnsenchas* (also *dindsenchas*, *dindshenchas*, *dinnsheanchas*) refers to the tradition or lore of places. The related modern Irish word *dinnseanchas* refers to topography.

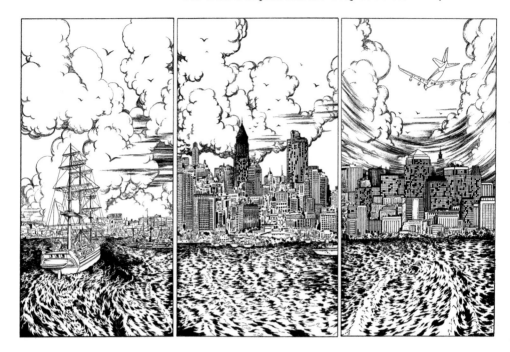

12.1 Colleen Doran, 'Triptych of New York City', published in Derek
McCulloch, *Gone to Amerikay*, with illustrations by Colleen Doran and José
Villarrubia (New York: Vertigo/DC Comics, 2012)
Reproduced with permission of the illustrators

illustrates, the book's three narrative trajectories overlap and occasionally
intersect. Here they are linked by their shared experience of liminality,
which is spatialized via iconographic images of Irish emigration. Corporaal
et al. point out that 'a central topos in Famine literature depicting transat-
lantic emigration is the coffin ship'.[20] The novel examines additional topoi
or, more precisely, chronotopes: as well as the coffin ship, the triptych
also features the gateway of New York Harbour and the aeroplane on its
transatlantic flight from Ireland to America. These are liminal chronotopes
because they are points of transit rather than arrival. These are also the
time-spaces of 1870, 1960 and 2010, part of the spectrum of the lived
experience of Irish emigration to America.

 This notion of lived experience is captured in the speech bubbles in
each section of the triptych, which feature nervous exchanges between the

20 Corporaal, Cusack and Janssen, *Recollecting Hunger*, 21. However, as I explain in
the introduction, the novel's depiction of a wooden coffin ship in 1870 is historically
inaccurate since by that time they were replaced by steamships.

incoming Irish: it is as though we are overhearing their conversations. In the first panel, set in 1870, a passenger asks Ciara O'Dwyer, 'Have you people here?' 'A cousin, aye. And my husband is following', she responds.[21] In the second panel, set in 1960, some of the passengers tease Johnny McCormack with comments such as, 'Well off yez go then and break your leg, as they say', and 'Don't forget where you came from, Johnny. Blow us a kiss from the Broadway stage.'[22] Undaunted, he replies, 'I'll blow you two farts, the lot of yez.'[23] 'Aye, he'll never forget', they exclaim.[24] In the third panel, set in 2010, Lewis Healy says to his friend, 'I'll remember this next time you want something, Sophie.'[25] She answers, 'All in good time. I'll show you the whole city, over 140 years.'[26] *Gone to Amerikay* also shows us the city over 140 years, as the shifting Manhattan skyline in the triptych indicates. However, the novel does not reveal 'the whole city'—rather, it highlights particularized, individual lived experiences of New York.

The lived experiences of these successive generations of Irish immigrants are also haunted by what Lloyd terms 'ghosts of the *unlived* and unworked-through past'.[27] Their narratives are inflected by the subtext of Famine migration, which sets the tone of the book. For example, the song 'Thousands are Sailing', which inspired the novel, opens with the lines:

> The island it is silent now
> But the ghosts still haunt the waves
> And the torch lights up a famished man
> who fortune could not save.[28]

The location of the 'island' which 'is silent now' in the first line is rendered deliberately ambiguous, but three possible referents initially come to mind: Ellis Island, which closed in 1954 and is no longer in use as an immigration facility;[29] the island of Ireland, which was perceived to be culturally 'silent'

21 Derek McCulloch, *Gone to Amerikay*, with illustrations by Colleen Doran and José Villarrubia (New York: Vertigo/DC Comics, 2012) (unpaginated).

22 McCulloch, *Gone to Amerikay*.

23 McCulloch, *Gone to Amerikay*.

24 McCulloch, *Gone to Amerikay*.

25 McCulloch, *Gone to Amerikay*.

26 McCulloch, *Gone to Amerikay*.

27 David Lloyd, 'The Indigent Sublime: Specters of Irish Hunger', in Oona Frawley (ed.), *Memory Ireland*, vol. 3, *The Famine and the Troubles* (Syracuse, NY: Syracuse University Press, 2014), 3; emphasis mine.

28 'Thousands Are Sailing'.

29 It is important to note that Ellis Island was not in use during the Famine: it did not open until 1892. Castle Garden was the immigration station during the Famine years. This mistake is very common, however, and Ellis Island dominates popular memory

on the topic of the Famine for several generations; and the isle of Manhattan, whose ever-changing cityscape has erased spaces such as the Five Points, thereby occluding contemporary memory of its early Irish-American inhabitants. Most likely the track references all three of these islands, and it is this semantic slippage that characterizes the imagery within the song and within the novel. There is also a fourth island that must be considered here: Britain. Since several members of The Pogues are London Irishmen and their song is an intertext for the book, Britain circulates within both texts as an unspoken location that also witnessed successive generations of Irish immigration. In addition, the lines seem to reference the torch held by the Statue of Liberty, which was dedicated in 1886. It is located on Liberty Island, which is very close to Ellis Island.[30] These island spaces are connected by the Atlantic, which is also the site of an absence, as it is the final resting place for many Irish emigrants who perished on board the coffin ships and whose bodies were thrown into the sea.

Fintan

Ciara O'Dwyer's narrative is set in 1870, 18 years after the end of the Famine in 1852, when she and her daughter Maire sail to America, leaving her husband Fintan behind. She and Fintan are members of the generation who survived the Famine during their childhood. Fintan, who intends to join them in America later, is a member of the Irish Republican Brotherhood (IRB). He stays in Ireland to look after his uncle and comrade Wallace, who is arrested and wrongly accused of murdering a British soldier. Once his business in Ireland is complete Fintan boards a ship bound for New York, but he dies before reaching American shores when he is murdered on board by a political rival. His fate echoes a verse from 'Thousands are Sailing':

Ah no, says he, 'twas not to be
On a coffin ship I came here
And I never even got so far
That they could change my name.[31]

even though it is not historically true for the Famine period (or indeed the period of the graphic novel).

30 Furthermore, the phenomenon of quarantine islands looms large in the Canadian consciousness, especially Grosse Île (which is a mass grave). Other islands in North America with Irish Famine mass graves include Partridge Island in New Brunswick and Deer Island in Massachusetts.

31 'Thousands Are Sailing'.

After awaiting Fintan's arrival for an extended period, Ciara eventually comprehends that her husband will not come, and therefore she must devise a plan to ensure her survival. A political opponent murders Fintan for his association with his uncle Wallace and with the IRB. This complicates Fintan's role within the novel, for it overtly politicizes his death and portrays him as an insurrectionary figure who dies for his participation in the Irish Republican Brotherhood. His willingness to die for his cause and his transfiguration as a revenant thus imbue Fintan with redemptive potential; however, it is only visible in flashes within the novel. These coruscations are traces of an alternative futurity, which the text intimates and gradually moves towards via its fitful, nonlinear trajectory.

The Indigent Sublime

As Oona Frawley observes, trauma disrupts identitarian narratives, for it 'disturbs that coherence of self, defies narrative expectations, and does not follow convention' and therefore 'creates aporia, repetitions, gaps, silence'.[32] This 'resistance to symbolization' is evident in *Gone to Amerikay* (Figure 12.2), which examines how the 'ghosts still haunt the waves' of the Atlantic, whose reflective surface also represents the screen of creative memory.[33] Lloyd terms this phenomenon of 'the unrepresentable in representation' the 'indigent sublime'. He remarks upon:

> the much-theorized unrepresentability of the traumatic event, being registered as a shock suffered by observers who do not themselves undergo the perils of starvation. Haunting is the afterlife of that shock and it emerges [...] in the collective and individual memory of those who live on in Ireland after the Famine—ghosts of the unlived and unworked-through past appear in oblique and unexpected ways in the material practices of a culture that is marked in largely unacknowledged ways by catastrophe.[34]

Whilst theories that Irish literature and historiography were silent on the topic of the Famine have been thoroughly disproved, the trope of silence persists nonetheless in popular culture.[35] I would argue that represen-

32 Oona Frawley, 'Introduction; Cruxes in Irish Cultural Memory: The Famine and the Troubles', in Frawley, *Memory Ireland*, vol. 3, 5.
33 Frawley, 'Introduction; Cruxes in Irish Cultural Memory, 6.
34 Lloyd, 'The Indigent Sublime', 23.
35 James S. Donnelly's and Peter Gray's respective work on Famine historiography (and political rhetoric) traces the very clear presence of the Famine in the immediate

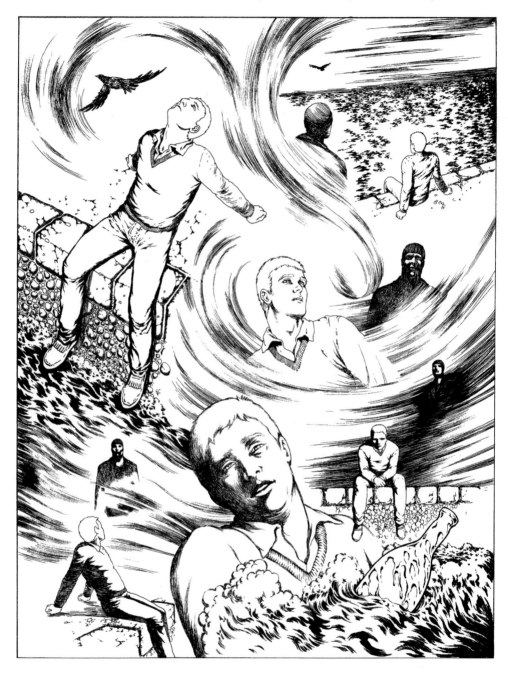

12.2 Colleen Doran, 'Johnny Encounters Fintan at the Waterfront', published in
Derek McCulloch, *Gone to Amerikay*, with illustrations by Colleen Doran with
José Villarrubia (New York: Vertigo/DC Comics, 2012)
Reproduced with permission of the illustrators

tations of Famine postmemory utilize this trope as a means to explore the silencing effect of trauma. Corporaal *et al.* maintain that 'unresolved trauma resists integration into narrative' and, consequently, in much of Famine literature, 'hunger is pushed to the margins of the narrative, as what Christopher Morash calls "a series of tangents": loose images in the text that are not fully integrated, and placed at a safe distance from the reader'.[36] Similarly, for most of *Gone to Amerikay*, Fintan's ghost is 'placed at a safe distance from the reader', as a 'loose image' which appears in snippets of Ciara's speech and in the words of his letter. However, towards the very end of the novel, Fintan's spectre breaks through these narrative strictures and into view for Johnny and for the reader. Nevertheless, the novel only provides a partial view of Fintan's countenance, and his facial features remain blurred. Fintan is a figuration of traumatic memory, which is ungraspable; therefore, he cannot be rendered fully. Although the novel only allows a glimpse of Fintan's face, his apparition exhibits a superabundance that threatens to overtake the entire text. The revenant is a paradoxically supersaturating absent presence—a phenomenon that Lloyd describes as 'the excess of lack'.[37] The eruption of Fintan's ghost into other time periods and across the novel's pages can be seen to signify the intrusion of repressed Famine (post)memory into the lived experiences of the Irish-American postgenerations.

Fintan's appearance as a spectre in the novel (Figure 12.3) evokes contemporaneous, ghastly descriptions of Famine victims as resembling the 'living dead'. Corporaal argues that the spectre is 'a major transcultural mnemonic image which carries and performs the memory of the Famine in Irish and Irish diaspora fiction'.[38] In *Gone to Amerikay*, Fintan's spectre returns in the 1960s—over a century after the Famine—to haunt Johnny, an Irish folk singer and arriviste in New York City. In a disturbing passage towards the end of the novel, Johnny encounters Fintan, who not only speaks to him, but in fact *enters into* Johnny's body and mind. Johnny explains to his landlady Mrs Lefkowitz, 'I don't know how to say it [...] he *dissolved*, turned into smoke, mist, and I was breathing him. He was [...] well, he was all *in* me. In my head ... I was *saturated* with him.'[39] Johnny continues:

 aftermath and into the twentieth century. The Famine also persists in Irish folklore. See James S. Donnelly, *The Great Irish Potato Famine* ([2001] Stroud: The History Press, 2008); Peter Gray, *The Irish Famine, 1845–1852* (Cork: Mercier Press, 1995).

36 Chris Morash, cited in Corporaal, Cusack and Janssen, *Recollecting Hunger*, 8.
37 Lloyd, 'The Indigent Sublime', 29.
38 Corporaal, cited in Liedeke Plate and Anneke Smelik, 'Introduction', in Liedeke Plate and Anneke Smelik (eds), *Performing Memory in Art and Popular Culture* (New York: Routledge, 2013), 10.
39 McCulloch, *Gone to Amerikay* (unpaginated).

12.3 Colleen Doran, 'Fintan Confronts Johnny', published in Derek McCulloch, *Gone to Amerikay*, with illustrations by Colleen Doran and José Villarrubia (New York: Vertigo/DC Comics, 2012)
Reproduced with permission of the illustrators

12.4 Colleen Doran, 'Johnny Ingests Fintan's Ghost', published in Derek
McCulloch, *Gone to Amerikay*, with illustrations by Colleen Doran and José
Villarrubia (New York: Vertigo/DC Comics, 2012)
Reproduced with permission of the illustrators

I have his whole life in me head. It's fading, but it's there. I felt what it's like to die. Like it's me own memory. The pain. Falling, falling down ... That's when I got sick. Sick through and through, for weeks. Couldn't keep food down, couldn't think a straight thought.

Mrs Lefkowitz: 'You were infected.'

Johnny: 'A bad case of dead man.'

Mrs Lefkowitz: 'That's the best ghost story I've heard in a long, long time.'

Johnny: 'I'd be happy not to know it.'[40]

The most striking element of Johnny's encounter with the revenant is that he actually *ingests* Fintan's ghost: this depiction of a 1960s Irish immigrant *ingesting* not only a Famine survivor's spirit, but also his memories, is significant in terms of its representation of the movement from memory to postmemory. This scene is a polyvalent exploration of the postmemory of hunger via the embodied gesture of Johnny's *ingestion* of a *Famine* survivor's ghost. After this occurrence, Johnny is unable to eat, 'to keep food down' or to 'think a straight thought' for a prolonged period. The symptoms that he describes mirror the physical suffering of the Famine victim. Therefore, Johnny experiences Famine postmemory on not only a psychological level, but also on a corporeal level. Moreover, the fact that he ingests Finan's *memories* and recounts them afterwards evokes issues of silence surrounding the Famine. The Famine victim does not speak in traditional Famine narratives but is always already *spoken for* by the controlling gaze of the narrator. In *Gone to Amerikay*, the Famine victim is also subject to the mediating eye/I of the illustrator and of the reader (Figure 12.4).

Spectral Signifier

Johnny first encounters Fintan's spectre by the waterfront that overlooks New York Harbour and opens out to the Atlantic. Fintan reveals immediately that he is one of the countless 'Irishmen sleeping under the waves'.[41] Distracted, Johnny ignores this comment and proceeds to have a conversation with Fintan, who remarks, 'I write songs too.'[42] Johnny marvels, 'How d'you know I write songs?'[43] Fintan responds, 'Here's one I wrote',

40 McCulloch, *Gone to Amerikay*.
41 McCulloch, *Gone to Amerikay*.
42 McCulloch, *Gone to Amerikay*.
43 McCulloch, *Gone to Amerikay*.

and he begins to sing 'Ciara's Song'.[44] Johnny sputters, 'How do you know my—There's [...] smoke.'[45] 'Sure, it's more of a mist', Fintan replies.[46] His already indistinct facial features transform into that of a wraith, and he begins to diffuse gradually into a suffocating grey vapour. He invites Johnny to: 'Have a smell. It's not death. It's everything before and after.'[47] This image of Fintan's diffusion into a vaporous substance evokes the noxious, sweet smell produced by the potato blight's soft rot which hung in the air above the potato drills in Ireland. It also evokes the 'miasma' of cholera, which was widely believed to be a carrier of the disease in the nineteenth century.[48] Fintan wants to tell Johnny about 'everything before and after death'—his death. For Fintan, it is urgent that he impart the unwitnessed story of his experience of the Famine, which, ironically, he survives, only to be murdered on board the ship by a political rival.

'Leave me alone!' Johnny exclaims, but, sensing that there is no escape, he asks, 'What do you want?'[49] Fintan replies, 'I'll tell you a story. I'll sing you a song. You must learn it all.'[50] Frightened, Johnny crumples on the ground and screams for help, begging Fintan to 'Stop'.[51] Johnny is afraid of Fintan's ghost story and he does not want to know it. Nevertheless, Fintan insists that Johnny must learn about the experiences that he faced. His spirit is an uncontrollable force that overpowers Johnny and enters into his very *being*. As Emilie Pine argues, in traumatic narratives, 'the ghost represents the unbiddable, irrepressible, and uncontainable nature of memory'.[52] Correspondingly, this scene demonstrates the ways in which traumatic memory transmits and transmutes into postmemory—through ghostly traces. However, it is important to note that the author seems to collapse historical periods here and conflates the traumatic (post)memory of the Famine with that of emigration. Fintan's spectre, which exists as a figuration of traumatic memory, takes on a miasmic form in order to penetrate Johnny's consciousness. Similarly, Lloyd notes 'the ghosts that rise like vapors through the disjointed frame of the present'.[53] In the case of the graphic novel, 'the disjointed frame of the present' is the delimiting panel through which Fintan's ghost seeps. Panels are the basic structural unit of a

44 McCulloch, *Gone to Amerikay*.
45 McCulloch, *Gone to Amerikay*.
46 McCulloch, *Gone to Amerikay*.
47 McCulloch, *Gone to Amerikay*.
48 There are numerous contemporaneous illustrations which depict clouds of choleric miasma.
49 McCulloch, *Gone to Amerikay*.
50 McCulloch, *Gone to Amerikay*.
51 McCulloch, *Gone to Amerikay*.
52 Emilie Pine, *The Politics of Irish Memory* (Basingstoke: Palgrave Macmillan, 2011), 16.
53 Lloyd, 'The Indigent Sublime', 18.

graphic novel—boxes that are sometimes, but not always, surrounded by a border or an outline. However, the panels disappear from the sections that depict Johnny's encounter with Fintan. Instead, these scenes are illustrated using splash pages—panel-less spreads which take up entire pages in order to highlight a particular event. In *Gone to Amerikay*, sublimated Famine memory disrupts the narrative framework and threatens to saturate its pages (Figure 12.5).

Transmission

While describing this encounter to his landlady Mrs Lefkowitz, Johnny discovers that she is in fact Maire's daughter and the granddaughter of Ciara and Fintan O'Dwyer. She tells Johnny that her mother Maire is in a nursing home in Queens, an outer borough of New York City. Johnny goes to visit Maire and discloses that Fintan's ghost asked him to deliver a message to her. He recounts his strange meeting with the revenant and plays a song for her. He tells Maire:

> Yes, 'Ciara's Song.' That's what he called it. I never believed those old stories, you know. The ghosts and the *bean-sidhe* and such. But I met him. I met a dead man. And he put these thoughts in me head. These memories. I couldn't think why he did this to me. But now I know. He wanted me to talk to you. Fintan. Your father. He wanted you to know.[54]

Confused, Maire responds, 'He [...] went to India.'[55] 'No. He never did', Johnny replies.[56] He recounts Fintan's death en route to America, stating: 'We fell down, down, down. His last thought was of your hand in his. Your small, warm, dear hand.'[57] Significantly, Johnny uses the pronoun 'we' when recalling Fintan's death, suggesting that, for Johnny, postmemory remains an embodied sensory experience and not simply a psychological one. Fintan not only puts his 'thoughts' and 'memories' in Johnny's 'head', he also imprints them onto his *body*.

Gone to Amerikay reimagines the past of Irish immigration to America in order to reimagine its future. As Corporaal *et al.* argue, '"The past is continuously modified and redescribed even as it continues to shape the

54 McCulloch, *Gone to Amerikay.*
55 McCulloch, *Gone to Amerikay.*
56 McCulloch, *Gone to Amerikay.*
57 McCulloch, *Gone to Amerikay.*

12.5 Colleen Doran, 'Johnny Gives Maire a Message from Fintan', published
in Derek McCulloch, *Gone to Amerikay*, with illustrations by Colleen Doran and
José Villarrubia (New York: Vertigo/DC Comics, 2012)
Reproduced with permission of the illustrators

future," and is therefore marked by transgenerational developments, often depending on [...] postmemory'.[58] Correspondingly, Lloyd observes:

> This means [...] tracking two kinds of ghostly revenant, one of which is the phantom of 'future possibility', of other possible horizons of human sociality that might have emerged [...] This is the ghost of hopes that are the afterlife of lost imaginary futures. The other haunting is the more familiar ghost that rises from destruction itself and that seeks redress for the injustice of its negation.[59]

Lloyd's theory of redress is filtered through Benjaminian thought; for, as Walter Benjamin contends, 'the past carries with it a secret index by which it is referred to redemption'.[60] If we apply Lloyd's formula to *Gone to Amerikay*, it is possible to argue that Fintan's ghost is a split signifier. On the one hand, Fintan could represent the first type of revenant, the 'phantom of future possibility', since as a Famine survivor he had the chance to make a new start in Ireland after the country slowly began to recover. Instead, he chose to emigrate, believing that America offered a better way of life. On the other hand, however, he also represents the second type of revenant, 'the more familiar ghost that rises from destruction itself and that seeks redress for the injustice of its negation'.[61] Fintan represents the ghost of the Famine survivor and emigrant, as well as that of the Irish republican rebel.

In a cruel twist, Fintan is killed by the destructive forces of political violence rather than by the Famine. He is enmeshed in the violence of revolutionary Ireland and it follows him on the ship to America, ultimately leading to his demise when he is murdered on board by a political rival. His misfortune echoes a verse from the song:

> Thousands are sailing
> Across the western ocean
> Where the hand of opportunity
> Draws tickets in a lottery.[62]

58 Corporaal, Cusack and Janssen, *Recollecting Hunger*, 6, quoting Mieke Bal, Leo Spitzer and Jonathan Crewe (eds), *Acts of Memory: Cultural Recall in the Present* (Hanover, NH: University Press of New England, 1999), vii.
59 Lloyd, 'The Indigent Sublime', 22.
60 Walter Benjamin, 'On the Concept of History', in Howard Eiland and Michael W. Jennings (eds), *Selected Writings*, vol. 4, *1938–1940* (Cambridge, MA: Belknap Press, 2003), 390.
61 Lloyd, 'The Indigent Sublime', 22.
62 'Thousands Are Sailing'.

Fintan is killed unjustly by Tim O'Shea, who (wrongly) suspects Fintan of wanting revenge for the imprisonment and subsequent death of his uncle Wallace. Tim meets Ciara in the Five Points and lies to her, telling her that he saw Fintan at home in Ireland and that Fintan said he was leaving for India instead of America. Tim tells Ciara that Fintan could not bear his uncle Wallace's death, and he decided to join the Connaught Rangers on their deployment to India because 'he wanted the chance to forget'.[63] Consequently, Ciara never learns the truth about her husband's fate. Unsure whether she is widowed or abandoned, Ciara tells her daughter Maire that her father went to India in the service of the British Empire. Fintan's life story remains untold for nearly a century, and his redemptive potential lies in the fact that he seeks out Johnny and transmits his reminiscences to him. Through the work of postmemory, Johnny becomes a secondary witness to Fintan's traumatic experiences. When Johnny relays this account to Maire, it redeems Fintan in the eyes of his daughter, and his spirit is finally at rest.

Conclusion

The graphic novel provides a narratological mode that is exceptionally well-suited to the visual expression of postmemory, owing to its episodic structure and multiperspectival gaze. Postmemorial graphic novels such as *Maus* and *Gone to Amerikay* demonstrate that 'recollection is a continuous process of change'.[64] (Post)memory is multiply mediated in *Gone to Amerikay* via its intertextual and frame narrative structural devices. In personal correspondence, the novel's author Derek McCulloch linked his Scottish-Canadian ancestry and illustrator Colleen Doran's Irish-American heritage to The Pogues' London Irish inheritance, and he described *Gone to Amerikay* as 'a postcolonial secondhand mishmash of pop-culturally processed Irish postmemory'.[65] Here the postmemorial is processed and transmitted via the postcolonial and post-punk. This plethora of 'posts' attests to 'the troubled relationship between medium, memory and knowing' in contemporary visualizations of the Famine.[66] As Colin Graham asserts, 'when we think about Ireland and its visual representations, we are quickly shown through every example a fractured

63 The Connaught Rangers were an Irish infantry regiment of the British Army engaged across a large swathe of Empire. However, they were active between 1881 and 1922; thus, this is another historical inaccuracy in the novel.

64 Corporaal, Cusack and Janssen, *Recollecting Hunger*, 5.

65 Personal correspondence, 31 Dec. 2016.

66 Mark-FitzGerald, 'Photography and the Visual Legacy of the Irish Famine', 137.

epistemology'.[67] Famine (post)memory constitutes a fractured ontology; thus, it follows that the field of Famine Studies is 'a fractured epistemology'. *Gone to Amerikay* reflects this fragmentation through its blurring of generic and historical boundaries, as well as its refusal to narrate Fintan O'Dwyer's lived experience. Fintan exists outside of narrated time because he is dead before the novel begins, but also because his traumatic experience as a survivor of the Famine is unknowable and therefore unrepresentable. Accordingly, Fintan does not enter any of the three main narratives in a straightforward way—rather, he appears obliquely, imagistically interposing within the novel via flashbacks or phantasmal eruptions. The emigrant Fintan never *arrives* fully in the text or in America, just as traumatic memory never arrives fully within consciousness.

This graphic novel is a pop cultural form that engages with the Famine in a way that Victorian photography and its particular mode of indexicality could not. *Gone to Amerikay* engages with the 'secret index'[68] of the past through its use of hauntology, for it spectralizes 'the receding image at the very moment of potential apprehension'.[69] As Benjamin argues, 'The true image of the past flits by. The past can be seized only as an image that flashes up at the moment of its recognizability'.[70] When Fintan's ghost blasts apart the panels of the book, flashing up into view before Johnny and before the reader, this spectre threatens to explode itself and the entire novel. Benjamin maintains that '[t]he epic moment will always be blown apart in the process of construction',[71] and the moment when the revenant confronts us is the moment we realize that Fintan's experience exists beyond traditional narrative frameworks.[72] Famine memory is popularly conceived to be beyond narration: accordingly, the book does not attempt to narrativize the traumatic experience of the Famine by following an irreversible teleology. Rather, the novel utilizes a recombinatory logic which destabilizes temporal and visual frameworks by intercutting and rearranging them. This pastiche method advances the redemptive potential that is inherent within the fractures of (visual) Famine knowledge. Postmemorial art is a privileged medium of remembrance and yet it is also, paradoxically, an aporial art.

67 Colin Graham, Foreword, in Eóin Flannery and Michael Griffin (eds), *Ireland in Focus: Film, Photography, and Popular Culture* (Syracuse, NY: Syracuse University Press, 2009), xii.

68 Benjamin, 'On the Concept of History', 390.

69 Mark-FitzGerald, 'Photography and the Visual Legacy of the Irish Famine', 126.

70 Benjamin, 'On the Concept of History', 390.

71 Walter Benjamin, 'Paralipomena to "On the Concept of History"', in Howard Eiland and Michael W. Jennings (eds), *Selected Writings*, vol. 4, *1938–1940* (Cambridge, MA: Belknap Press, 2003), 406.

72 See, for instance, Joseph O'Connor's *The Star of the Sea* (London: Vintage, 2003) as a useful frame of comparison.

Gone to Amerikay acknowledges this paradox by remembering the Famine and its legacy from points of disjuncture, through which new empathetic possibilities emerge.

Bibliography

Abrams, Brett L., *Hollywood Bohemians: Transgressive Sexuality and the Selling of the Movieland Dream* (Jefferson, NC: McFarland, 2008).

Agamben, Giorgio, *Profanations*, trans. Jeff Fort (New York: Zone Books, 2007).

—— *The Kingdom and the Glory: For a Theological Genealogy of Economy and Government*, trans. Lorenzo Chiesa (Palo Alto, CA: Stanford University Press, 2011).

—— *Opus Dei: An Archaeology of Duty*, trans. Adam Kotsko (Palo Alto, CA: Stanford University Press, 2013).

Ahto, Sampo, *Muistoja talvisodasta: Suomen talvisodan 1939–1940 muistomerkkejä* (Helsinki: Sotasokeat, 1983).

Alexander, Lynn M., *Women, Work, and Representation: Needlewomen in Victorian Art and Literature* (Athens: Ohio University Press, 2003).

Anbinder, Tyler, 'Lord Palmerston and the Irish Famine Emigration', *Historical Journal*, 44.2 (2001), 441–69.

Anderson, Ross, *Abbott Handerson Thayer* (Syracuse, NY: Emerson Museum, 1982).

Andrews, Helen, 'John Doyle', q.v. James Maguire and James Quinn (eds), *Dictionary of Irish Biography* (Dublin: Royal Irish Academy, 2009).

Anttonen, Pertti, 'Oral Traditions and the Making of the Finnish Nation', in Timothy Baycroft and David Hopkin (eds), *Folklore and Nationalism in Europe during the Long Nineteenth Century* (Leiden: Brill, 2012), 325–50.

Arts Council of Great Britain, *Gustave Courbet: 1819–1877* (London: Arts Council of Great Britain, 1978).

Ashworth, John Hervey, *Saxon in Ireland: Or, the Rambles of an Englishman in Search of a Settlement in the West of Ireland* (London: John Murray, 1851).

Bal, Mieke, Leo Spitzer and Jonathan Crewe (eds), *Acts of Memory: Cultural Recall in the Present* (Hanover, NH: University Press of New England, 1999).

Banim, John, *The Anglo-Irish of the Nineteenth Century: A Novel*, 3 vols (London: Henry Colburn, 1828).

Barber, Fionna, *Art in Ireland since 1910* (London: Reaktion Books, 2013).

Barrow, John, *A Tour round Ireland, Through the Sea-Coast Counties, in the Autumn of 1835* (London: John Murray, 1836).

Barthes, Roland, *Critical Essays*, trans. Richard Howard (Evanston, IL: Northwestern University Press, 1972).

—— *Image Music Text*, trans. Stephen Heath (London: Fontane Press, 1977).

Baylis, Gail, 'The Eviction Photograph as Shifting Trace', in Oona Frawley (ed.), *Memory Ireland*, vol. 2, *Diaspora and Memory Practices* (Syracuse, NY: Syracuse University Press, 2012), 171–84.

Beiner, Guy, *Remembering the Year of the French: Irish Folk History and Social Memory* (Madison: University of Wisconsin Press, 2007).

Benjamin, Walter, 'On the Concept of History', in Howard Eiland and Michael W. Jennings (eds), *Selected Writings*, vol. 4, *1938–1940* (Cambridge, MA: Belknap Press, 2003), 389–400.

—— 'Paralipomena to "On the Concept of History"', in Howard Eiland and Michael W. Jennings (eds), *Selected Writings*, vol. 4, *1938–1940* (Cambridge, MA: Belknap Press, 2003), 401–11.

Bexar, Gunilla, 'John Mitchel's *The Last Conquest of Ireland (Perhaps)* and Liam O'Flaherty's *Famine*: A Question of Tone', *Critical Quarterly*, 5.1 (2007), 73–90.

Black, Gregory D., *Hollywood Censored: Morality Codes, Catholics, and the Movies* (Cambridge: Cambridge University Press, 1994).

Bogdanova, Sandra, 'Bark Food: The Continuity and Change of Scots Pine Inner Bark for Food by Sámi People in Northern Fennnoscandia', unpublished MPhil thesis (University of Tromsø, 2016): https://munin.uit.no/handle/10037/9295.

Bond, Lucy, and Jessica Rapson (eds), *The Transcultural Turn: Interrogating Memory between and beyond Borders* (Berlin: De Gruyter, 2014).

Bourke, Angela, 'The Baby and the Bathwater: Cultural Loss in Nineteenth-Century Ireland', in Tadhg Foley and Seán Ryder (eds), *Ideology and Ireland in the Nineteenth Century* (Dublin: Four Courts Press, 1998), 79–92.

—— *Voices Underfoot: Memory, Forgetting, and Oral Verbal Art* (Hamden, CT: Quinnipiac University Press, 2016).

Bourke, Angela, and Niamh O'Sullivan, 'A Fairy Legend, a Friendship, a Painting: Thomas Crofton Croker, James McDaniel, and Daniel Macdonald's *Sídhe Gaoithe/The Fairy Blast*', *Éire-Ireland*, 51.2–3 (2016), 7–22.

Bourke, Richard, and Ian McBride (eds), *The Princeton History of Modern Ireland* (Princeton, NJ and Oxford: Princeton University Press, 2016).

Bowles, Emily, *Irish Diamonds* (London: Thomas Richardson and Son, 1864).

Brecht, Bertolt, *Brecht on Theatre: The Development of an Aesthetic*, trans. John Willett (London: Methuen, 1964).

Brew, Margaret, *The Chronicles of Castle Cloyne* (London: Chapman and Hall, 1885).

Brock, George, *et al.*, *George Bellows* (Washington, DC: National Gallery of Art, 2012).

Broeker, Galen, *Rural Disorder and Police Reform in Ireland, 1812–36* (London: Routledge & Kegan Paul, 1970).

'Brother James', *Eva O'Beirne; or, The Little Lace Maker* (Dublin: James Duffy, 1856).

Bruemmer, René, 'Irish Famine Exhibit Celebrates Courage of Montreal's Grey Nuns', *Montreal Gazette*, 11 Apr. 2016: http://montrealgazette.com/news/local-news/irish-famine-exhibit-celebrates-courage-of-montreals-grey-nuns.

Bruhn, Jorgen, Anne Gjelsvik and Eirik Frisvold Hanssen (eds), *Adaptation Studies: New Challenges, New Directions* (London: Bloomsbury, 2013).

Butler, James, *The Most Rev. Dr. James Butler's Catechism: Revised, Enlarged, Approved, and Recommended by the Four R.C. Archbishops of Ireland as a General Catechism for the Kingdom* (Dublin: The Catholic Book Society, 1836).

Butler, Nesta, 'Daniel MacDonald', in Nicola Figgis (ed.), *Art and Architecture of Ireland*, vol. 2, *Painting 1600–1900* (Dublin and New Haven, CT: Royal Irish Academy and Yale University Press, 2014), 353–54.

Byron, Reginald, *Irish America* (Oxford: Clarendon Press, 1999).

Carleton, William, *Traits and Stories of the Irish Peasantry* (Dublin: William Curry, June & Co., 1830).

—— 'Battle of the Factions', in *Traits and Stories of the Irish Peasantry* (Dublin: W.F. Wakeman, 1834), vol. 2, 267–39.

—— *The Black Prophet* (Dublin: Simms & McIntyre, 1847).

Carlyle, Thomas, *Reminiscences of My Irish Journey in 1849* (London: Sampson Low, Marston, Searle, & Rivington, 1882).

Carpenter, Andrew (gen. ed.), *Art and Architecture of Ireland*, vol. 2, *Painting 1600–1900*; vol. 3, *Sculpture 1600–2000;* vol. 5, *Twentieth Century* (Dublin, New Haven, CT and London: Royal Irish Academy and Yale University Press, 2014).

Carroll, Michael P., 'Rethinking Popular Catholicism in Pre-Famine Ireland', *Journal for the Scientific Study of Religion*, 34.3 (1995), 354–65.

Caruth, Cathy, *Unclaimed Experience: Trauma, Narrative, and History* (Baltimore, MD: Johns Hopkins University Press, 1996).

Casey, Christine, *Amharc Oidhreacht Éireann/Folk Tradition in Irish Art, an Exhibition of Paintings from the Collection of the Department of Irish Folklore* (Dublin: UCD Press, 1993).

—— *The Buildings of Ireland: Dublin. The City within the Grand and Royal Canals and the Circular Road* (London: Penguin, 2005).

—— 'Painting Irish Folk Life: The Picture Collection', in Críostóir Mac Cárthaigh, Séamas Ó Catháin, Ríonach uí Ógáin and Seosamh Watson (eds), *Treasures of the National Folklore Collection/ Seoda as Cnuasach*

Bhéaloideas Éireann (Dublin: Comhairle Bhéaloideas Éireann, 2010), 98–99.

Casteras, Susan P., '"Weary Stitches": Illustrations and Painting for Thomas Hood's "Song of the Shirt" and Other Poems', in Beth Harris (ed.), *Famine and Fashion: Needlewomen in the Nineteenth Century* (Aldershot: Ashgate, 2005), 13–39.

Castles, Heather, 'Hybrid Stitched Textile Art: Contemporary Interpretations of Mid-Nineteenth-Century Irish Crochet Lace Making', unpublished PhD thesis (University of Ulster, 2011).

Cavendish, Dominic, 'Tom Murphy, Hampstead Theatre', *The Daily Telegraph*, 26 June 2012: www.telegraph.co.uk/culture/theatre/theatre-reviews/9356260/Tom-Murphy-Hampstead-Theatre-review.html.

The Census of Ireland for the Year 1851, Part VI: General Report (Dublin: Her Majesty's Stationery Office, 1856).

Charbonneau, André, and André Sévigny, *1847 Grosse Île: A Record of Daily Events* (Ottawa: Canadian Heritage, Parks Canada, 1997).

Chaudhuri, Una, *Staging Place: The Geography of Modern Drama* (Ann Arbor: University of Michigan Press, 1997).

Checchi, Francesco, and W. Courtland Robinson, 'Mortality among Populations of Southern and Central Somalis Affected by Severe Food Insecurity and Famine during 2010–2012', United Nations Food and Agricultural Organization's Food Security and Nutrition Analysis Unit for Somalia (2 May 2013): http://www.ipcinfo.org/fileadmin/user_upload/ipcinfo/docs/Somalia_Mortality_Estimates_Final_Report_1May2013_upload.pdf.

Clark, Samuel, and James S. Donnelly, Jr. (eds), *Irish Peasants: Violence and Political Unrest, 1780–1914* (Manchester: Manchester University Press, 1983).

Cleary, Joe, 'Amongst Empires: A Short History of Ireland and Empire Studies in International Context', *Éire-Ireland*, 42.1–2 (2007), 11–57.

—— 'Irish American Modernisms', in Joe Cleary (ed.), *The Cambridge Companion to Irish Modernism* (Cambridge: Cambridge University Press, 2014), 174–92.

Cleary, Joe, and Claire Connolly (eds), *The Cambridge Companion to Modern Irish Culture* (Cambridge: Cambridge University Press, 2005).

Clonbullogue I.C.A., *The Life, the Times, the People: Clonbullogue, Bracknagh and Walsh Island* (Tullamore: 'The Committee', 1993).

A Complete Catholic Registry, Directory, and Almanack (Dublin: Battersby, 1847).

'Concern about Trump's Position on Emigration, Climate Change: Vigil Held at Famine Memorial in Ballytivnan in Sligo' (radio broadcast). Ocean FM News, 23 Jan. 2017: www.oceanfm.ie/2017/01/23/concern-about-trumps-position-on-emigration-climate-change/?cn-reloaded=1.

Connolly, S.J., *Priests and People in Pre-Famine Ireland, 1780–1845* (Dublin: Four Courts, 1982).

Conyngham, David Power ('Allen Clington'), *Frank O'Donnell* (Dublin: James Duffy, 1861).

Corish, P.J., 'The Catholic Community in the 19th Century', *Archivium Hibernium*, 38 (1983), 26–33.

Corporaal, Marguérite, 'Memories of the Great Famine and Ethnic Identity in Novels by Victorian Irish Women Writers', *English Studies*, 90 (2009), 1–15.

—— *Relocated Memories of the Great Famine in Irish and Diaspora Fiction, 1847–1870* (Syracuse, NY: Syracuse University Press, 2017).

Corporaal, Marguérite, and Christopher Cusack, 'Rites of Passage: The Coffin Ship as a Site of Immigrants' Identity Formation in Irish and Irish American Fiction, 1855–85', *Atlantic Studies*, 8.3 (2011), 343–59.

Corporaal, Marguérite, Christopher Cusack and Lindsay Janssen (eds), *Recollecting Hunger* (Dublin: Irish Academic Press, 2012).

Corporaal, Marguérite, Christopher Cusack, Lindsay Janssen and Ruud van den Beuken (eds), *Global Legacies of the Great Irish Famine: Transnational and Interdisciplinary Perspectives* (Oxford: Peter Lang, 2014).

Corporaal, Marguérite, and Jason King (eds), *Irish Global Migration and Memory: Transatlantic Perspectives of Ireland's Famine Exodus* (London: Routledge, 2017).

Costello, Peter, 'Liam O'Flaherty', *Dictionary of Irish Biography*: http://dib. cambridge.org.

Coveney, Michael, 'Tom Murphy Plays a Blinder', *Whatsonstage.com*: https:// www.whatsonstage.com/west-end-theatre/news/tom-murphy-plays-a-blinder_3739.html.

Croker, Thomas Crofton, *Fairy Legends and Traditions of the South of Ireland* (London: John Murray, 1825).

—— *Researches in the South of Ireland 1812–22, Illustrative of the Scenery, Architectural Remains, and the Manners and Superstitions of the Peasantry* (Dublin: Irish Academic Press, 1981).

Crowley, John, 'Sites of Memory', in John Crowley, William J. Smyth and Mike Murphy (eds), *Atlas of the Great Irish Famine* (Cork: Cork University Press, 2012), 614–20.

Crowley, John, William J. Smyth and Mike Murphy (eds), *Atlas of the Great Irish Famine* (Cork: Cork University Press, 2012).

Cubitt, Allan, and Diarmuid Lawrence, *The Hanging Gale*, television drama in 4 (52-minute) episodes (Little Bird Productions, broadcast by RTÉ and BBC, 1995).

Cullen, Fintan, *Visual Politics: The Representation of Ireland 1750–1930* (Cork: Cork University Press, 1997).

—— 'From Mythical Abstractions to Modern Realities: Depicting the Irish Émigrée', in Fintan Cullen and R.F. Foster (eds), *'Conquering England': Ireland in Victorian London* (London: National Portrait Gallery, 2005), 54–65.

—— *Ireland on Show: Art, Union, and Nationhood* (Farnham: Ashgate, 2012).

—— 'Visual Parody and Political Commentary: John Doyle and Daniel

O'Connell', in Ciaran O'Neill (ed.), *Irish Elites in the Nineteenth Century* (Dublin: Four Courts Press, 2013), 233–47.

—— 'Robert Peel, John Doyle and Visual Parody', in R.A. Gaunt (ed.), *Peel in Caricature: The 'Political Sketches' of John Doyle ('H.B.')* (Bristol: The Peel Society, 2014), xxxiii–xxxvii.

Cullen, Fintan, and Roy Foster (eds), *'Conquering England': Ireland in Victorian London* (London: National Portrait Gallery, 2005).

Cullen, Mary, 'Anna Maria Haslam', in Mary Cullen and Maria Luddy (eds), *Women, Power and Consciousness in 19th-Century Ireland: Eight Biographical Studies* (Dublin: Attic Press, 1995), 161–96.

Curtis, L. Perry, *Apes and Angels: The Irishman in Victorian Caricature* (Washington, DC and London: Smithsonian Institution Press, 1997).

—— *Notice to Quit: The Great Famine Evictions* (Cork: Cork University Press, 2015).

Cuthins, Dennis, Laurence Raw and James M. Welsh (eds), *Redefining Adaptation Studies* (Lanham, MD: Scarecrow Press, 2010).

Daly, Mary E., 'Historians and the Famine: A Beleaguered. Species?', *Irish Historical Studies*, 30 (1997), 591–601.

Darrah, William C., *The World of Stereographs* (Gettysburg, PA: W.C. Darrah, 1977).

Deane, Seamus (ed.), *The Field Day Anthology of Irish Writing* (Derry: Field Day, 1991).

Delaney, Enda, and Donald M. MacRaild, 'Irish Migration, Networks, and Ethnic Identities since 1750: An Introduction', *Immigrants and Minorities*, 23.2–3 (2005), 127–42.

—— (eds), *Irish Migration, Networks and Ethnic Identities since 1750* (London and New York: Routledge, 2007).

Delay, Cara, '"The Gates were Shut": Catholics, Chapels and Power in Late Nineteenth Century Ireland', *New Hibernia Review*, 14.1 (2010), 14–35.

Delson, Susan, *Dudley Murphy: Hollywood Wildcard* (Minneapolis: University of Minnesota Press, 2006).

Derrida, Jacques, *Specters of Marx: The State of the Debt, The Work of Mourning, and the New International*, trans. Peggy Kamuf (New York: Routledge, 1994).

Des Rochers, Jacques, '*Le Typhus*, History of a Painting', in Patricia Simpson and Louise Pothier (eds), *Notre-Dame-de-Bon-Secours: A Chapel and Its Neighbourhood* (Montreal: Fides, 2001), 92–93.

Devotions to the Sacred. Heart of Jesus, and a Charming Little Devotion to the Holy Virgin, etc. (Dublin: James Duffy, 1851).

Diano, Francesca, *Fairy Legends* (Cork: Collins Press, 1998).

Dickens, Charles, *Martin Chuzzlewit*, ed. Margaret Cardwell (Oxford: Clarendon Press, 1982).

Diner, Hasia R., *Erin's Daughters in America: Irish Immigrant Women in*

the Nineteenth Century (Baltimore, MD and London: Johns Hopkins University Press, 1983).

Donnelly, James S., *The Great Irish Potato Famine* ([2001] Stroud: The History Press, 2008).

Dorian, Hugh, *The Outer Edge of Ulster: A Memoir of Social Life in Nineteenth-Century Donegal*, ed. David Dickson and Breandán Mac Suibhne (Dublin: The Lilliput Press, 2001).

Doyle Dreidger, Sheila, *An Irish Heart: How a Small Irish Community Shaped Canada* (Toronto: HarperCollins, 2010).

Druid Theatre, 'Press Release: Druid Announces DruidMurphy', 'Plays by Tom Murphy', 25 Nov. 2011. http://archive.druid.ie/websites/2009-2017/news/press-release-druid-announces-druidmurphy.

Dunne, Tom, 'The Dark Side of the Irish Landscape: Depictions of the Rural Poor, 1760–1850', in Peter Murray (ed.), *Whipping the Herring: Survival and Celebration in Nineteenth-Century Irish Art* (Cork: Cork University Press, 2006), 47–59.

Eagleton, Terry, *Heathcliff and the Great Hunger: Studies in Irish Culture* (London: Verso, 1995).

—— 'Cork and the Carnivalesque', in *Crazy John and the Bishop and Other Essays on Irish Culture* (Cork: Cork University Press, 1998), 158–211.

Edgeton-Tarpley, Kathryn, *Tears from Iron: Cultural Responses to Famine in Nineteenth-Century China* (Berkeley: University of California Press, 2008).

Edgeworth, Maria, 'Letter to Central Relief Committee (1847)', in Angela Bourke, *et al.* (eds), *The Field Day Anthology of Irish Writing: Irish Women's Writing and Traditions* (Cork: Cork University Press, 2002), vol. 5, 698–99.

Edkins, Jenny, *Trauma and the Memory of Politics* (Cambridge: Cambridge University Press, 2003).

Engen, Rodney, *Richard Doyle* (Stroud: Catalpa Press, 1983).

Erll, Astrid, 'From "District Six" to District 9 and Back: The Plurimedial Production of Travelling Schemata', in Chiara de Cesari and Ann Rigney (eds), *Transnational Memory: Circulation, Articulation, Scales* (Berlin and New York: De Gruyter, 2014), 29–50.

—— 'Travelling Memory', in Rick Crownshaw (ed.), *Transcultural Memory* (London: Routledge, 2014), 20–24.

Erll, Astrid, and Ann Rigney (eds), *Mediation, Remediation, and the Dynamics of Cultural Memory* (New York and Berlin: De Gruyter, 2009).

Etkind, Alexander, 'Post-Stalinist Russia: Memory and Mourning', in Siobhan Kattago (ed.), *Ashgate Research Companion to Memory Studies* (Farnham: Ashgate: 2015), 251–64.

Evans, Bryce, *Ireland during the Second World War: Farewell to Plato's Cave* (Manchester: Manchester University Press, 2014).

'Evictions of Peasantry in Ireland', *The Illustrated London News*, 16 Dec. 1848.

Eyman, Scott, *Print the Legend: The Life and Times of John Ford* (New York: Simon & Schuster, 2015).

Faber, Frederick William, *All for Jesus: or, the Easy Ways of Divine Love* (London: Richardson and Son, 1854).

Fagg, John, 'Near Vermeer: Edmund C. Tarbell's and John Sloan's Dutch Pictures', *Modernist Cultures*, 11 (2016), 86–117.

Fairbrother, Trevor J., *The Bostonians: Painters of an Elegant Age, 1870–1930* (Boston, MA: Museum of Fine Arts, 1986).

—— 'Edmund C. Tarbell's Paintings of Interiors', *Antiques*, 131, Jan. 1987, 224–35.

'Famine and Fashion!', *Punch*, 4 Nov. 1843, 203.

Faughnan, Leslie, 'Play about the Famine', *The Irish Times*, 25 June 1968, 8.

Faunce, Sarah, and Linda Nochlin (eds), *Courbet Reconsidered* (New Haven, CT and London: Brooklyn Museum and Yale University Press, 1989).

Fegan, Melissa, *Literature and the Great Irish Famine 1845–1919* (Oxford: Clarendon Press, 2002).

—— 'The Moral Economy of the Irish Hotel from the Union to the Famine', in Susanne Schmid and Monika Elbert (eds), *Anglo-American Travelers and the Hotel Experience in Nineteenth Century Literature: Nation, Hospitality, Travel Writing* (London: Routledge, 2017).

Ferrie, Adam, *Letter to the Rt. Hon. Earl Grey, One of Her Majesty's Most Honorable Privy Council and Secretary of State for Colonial Affairs; Embracing a Statement of Facts in Relation to Emigration to Canada during the Summer of 1847* (Montreal: Printed at the Office of 'the Pilot', 1847).

Fewster, Derek, *Visions of Past Glory: Nationalism and the Construction of Early Finnish History* (Helsinki: Finnish Literature Society, 2006).

FitzGerald, Brian, *Correspondence of Emily, Duchess of Leinster (1731–1814)*, 3 vols (Dublin: Stationery Office, 1949).

FitzGerald, Garret, Gillian O'Brien, Cormac Ó Gráda, Michael Murphy and James Kelly, *Irish Primary Education in the Early Nineteenth Century* (Dublin: Royal Irish Academy, 2013).

Fitzgerald, Patrick, and Brian Lambkin, *Migration in Irish History, 1607–2007* (Basingstoke and New York: Palgrave Macmillan, 2008).

Fitzpatrick, William John, *The Life, Times, and Correspondence of the Right Rev. Dr. Doyle, Bishop of Kildare and Leighlin* (Boston, MA: P. Donahue, 1862).

Flanagan, Thomas, 'The Irish in John Ford's Films', in Michael Coffey and Terry Golway (eds), *The Irish in America* (New York: Hyperion, 1997), 191–95.

Fletcher, Pamela, '"To Wipe a Manly Tear": The Aesthetics of Emotion in Victorian Narrative Painting', *Victorian Studies*, 51.3 (2009), 457–69.

Foster, Roy F., *Modern Ireland 1600–1972* (London: Allen Lane, 1988).

—— '"An Irish Power in London": Making It in the Victorian Metropolis', in Fintan Cullen and Roy F. Foster (eds), *'Conquering England': Ireland in Victorian London* (London: National Portrait Gallery, 2005), 12–24.

Foucault, Michel, *Discipline and Punish: The Birth of the Prison*, trans. A. Sheridan (New York: Vintage Books, 1995).

Fox, Emily ('Toler King'), *Rose O'Connor; A Story of the Day* (Chicago, IL: Chicago Legal News Company, 1880).

Frawley, Oona, 'Towards a Theory of Cultural Memory in an Irish Postcolonial Context', in Oona Frawley (ed.), *Memory Ireland*, vol. 1, *History and Modernity* (Syracuse, NY: Syracuse University Press, 2010), 18–34.

—— 'Introduction; Cruxes in Irish Cultural Memory: The Famine and the Troubles', in Oona Frawley (ed.), *Memory Ireland*, vol. 3, *The Famine and the Troubles* (Syracuse, NY: Syracuse University Press, 2014), 1–14.

Gallagher, Tag, *John Ford: The Man and his Films* (Berkeley: University of California Press, 1984).

'General State of Kilrush', *Illustrated London News*, 15 Dec. 1849, 394.

George, Dorothy, *English Political Caricature 1793–1832: A Study of Opinion and Propaganda* (Oxford: Clarendon Press, 1959).

Gibbons, Luke, 'Between Captain Rock and a Hard Place: Art and Agrarian Insurgency', in Tadhg Foley and Sean Ryder (eds), *Ideology and Ireland in the Nineteenth Century* (Dublin: Four Courts, 1998), 23–43.

—— *The Quiet Man* (Cork: Cork University Press, 2002).

Gilmour, Alexander, 'DruidMurphy, Hampstead Theatre, London', *Financial Times*, 26 June 2012.

Gilroy, Paul, 'Diaspora and the Detours of Identity', in Kathryn Woodward (ed.), *Identity and Difference* (London: Sage Publications and The Open University Press, 1997), 299–346.

Godson, Lisa, 'Charting the Material Culture of the Devotional Revolution: The Advertising Register of the *Irish Catholic Directory*, 1838–98', in *Proceedings of the Royal Irish Academy* (Dublin: Royal Irish Academy, 2016), 265–94.

Godson, Lisa, and Joanna Brück (eds), *Making 1916: Material and Visual Culture of the Easter Rising* (Liverpool: Liverpool University Press, 2015).

Gorman, Sophie, 'Review: Druidmurphy, Hampstead Theatre, London', *Irish Independent*, 26 June 2012: https://www.independent.ie/entertainment/books/review-druidmurphy-hampstead-theatre-london-26869085.html.

Gottfried, Martin, *Arthur Miller: A Life* (London: de Capo, 2003).

Gouriévidis, Laurence, *The Dynamics of Heritage: History, Memory and the Highland Clearances* (Farnham: Ashgate, 2010).

Graham, Colin, 'Foreword', in Eóin Flannery and Michael Griffin (eds), *Ireland in Focus: Film, Photography, and Popular Culture* (Syracuse, NY: Syracuse University Press, 2009).

Grant, James, 'The Great Famine and the Poor Law in Ulster: The Rate-in-Aid Issue of 1849', *Irish Historical Studies*, 27.105 (1990), 30–47.

Gray, Clive, *The Politics of Museums* (Basingstoke: Palgrave Macmillan, 2015).

Gray, Peter, '*Punch* and the Great Famine', *History Ireland*, 1.2 (1993), 26–33.

—— *The Irish Famine, 1845–1852* (London: Thames and Hudson, 1995).

—— *Famine, Land and Politics: British Government and Irish Society 1843–50* (Dublin: Irish Academic Press, 1999).

—— '"Hints and Hits": Irish Caricature and the Trial of Daniel O'Connell, 1843–4', *History Ireland*, 12.4 (2004), 45–51.

—— *The Making of the Irish Poor Law, 1815–43* (Manchester: Manchester University Press, 2009).

—— 'The Great Famine in Irish and British Historiographies, *c.*1860–1914', in Marguérite Corporaal, Christopher Cusack, Lindsay Janssen and Ruud van den Beuken (eds), *Global Legacies of the Great Irish Famine: Transnational and Interdisciplinary Perspectives* (Oxford: Peter Lang, 2014), 39–60.

'The Great Exhibition: Pencillings by a Lady', *Lady's Newspaper*, 7 June 1851, 319.

Gregory, Ian N., and Niall A. Cunningham, '"The Judgement of God on an Indolent and Unself-Reliant People"? The Impact of the Great Irish Famine on Ireland's Religious Demography', *Journal of Historical Geography*, 51 (2016), 76–87.

Grimes, Brendan, 'Funding a Roman Catholic Church in Nineteenth-Century Ireland', *Architectural History*, 52 (2009), 147–68.

Grode, Eric, 'A Dark Irish Voice Revisits His Rage', *The New York Times*, 27 June 2012: www.nytimes.com/2012/07/01/theater/druidmurphy-three-tom-murphy-plays-at-lincoln-center.html.

Haas, Katherine, 'The Fabric of Religion: Vestments and Devotional Catholicism in Nineteenth-Century America', *Material Religion*, 3.2 (2007), 290–17.

Häkkinen, Antti, 'Suomen 1860-luvun nälkäkatastrofi: syitä ja seurauksia', *Duodecim*, 128.23 (2012), 2425–30.

Häkkinen, Antti, and Andrew G. Newby, 'Nälkäkriisi-Suomi kansainvälisen avun kohteena', in Juhani Koponen and Sakari Saaritsa (eds), *Kiinniottoja: kehitysmaa Suomi* (Helsinki: Gaudeamus, forthcoming).

Häkkinen, Antii, and Henrik Forsberg, 'Finland's Famine Years of the 1860s: A Nineteenth-Century Perspective', in Declan Curran, Lubomyr Luciuk and Andrew G. Newby (eds), *Famines in European Economic History: The Last Great European Famines Reconsidered* (London: Routledge, 2015), 99–123.

Hall, S.C., *Recollections of a Long Life from 1815–1883* (London: Bentley, 1883).

Hall, Mr and Mrs S.C. Hall, *Ireland: Its Scenery, Character, &c.*, 3 vols (London: How and Parsons, 1841–43).

—— *Handbooks for Ireland*, 4 vols (vol. 1, *Dublin and Wicklow*; vol. 2, *The North and Giant's Causeway*; vol. 3, *The South and Killarney*; vol. 4, *The West and Connemara*) (London: Virtue, Hall & Virtue; Dublin: James M'Glashan, 1853).

Harris, Beth (ed.), *Famine and Fashion: Needlewomen in the Nineteenth Century* (Aldershot: Ashgate, 2005).

Hayes, Richard, and Christopher Morash (eds), *Fearful Realities: New Perspectives on the Famine* (Dublin: Irish Academic Press, 1996).

Head, Francis B., *A Fortnight in Ireland* (London: John Murray, 1852).

Heinz, Kosok, 'Thomas Crofton Croker, the Brothers Grimm and the German Image of Ireland', in Claire O'Reilly and Veronica O'Regan (eds), *Ireland and the Irish in Germany: Reception and Perception* (Baden-Baden: Nomos Verlag, 2014), 85–103.

Hills, Patricia, 'John Sloan's Images of Working-Class Women: A Case Study of the Roles and Interrelationships of Politics, Personality, and Patrons in the Development of Sloan's Art, 1905–16', in Marianne Doezema and Elizabeth Milroy (eds), *Reading American Art* (New Haven, CT and London: Yale University Press, 1998), 311–49.

Hirsch, Marianne, *Family Frames: Photography, Narrative, and Postmemory* (Cambridge, MA: Harvard University Press, 1997).

—— *The Generation of Postmemory: Literature and Visual Culture after the Holocaust* (New York: Columbia University Press, 2012).

Hoare, Mary Anne, 'The Knitted Collar', in *Shamrock Leaves; or, Tales and Sketches of Ireland* (Dublin: James M'Glashan; London: Partridge & Oakey, 1851), 58–67.

Hodge, James, *Construction of the Great Victoria Bridge in Canada* (London: John Weale, 1860).

Hood, Thomas, 'The Song of the Shirt', *Punch*, 16 Dec. 1843, 260.

Hooper, Glenn, *Travel Writing and Ireland, 1760–1860: Culture, History, Politics* (Basingstoke: Palgrave Macmillan, 2005).

Hoppen, K. Theodore, *Ireland since 1800: Conflict and Conformity* (London: Longman, 1989).

Horner, Dan, '"The Public Has a Right to Be Protected from a Deadly Scourge": Debating Quarantine, Migration, and Liberal Governance during the 1847 Typhus Outbreak in Montreal', *Journal of the Canadian Historical Association*, 23.1 (2012), 65–100.

Hotten-Somers, Dianne M., 'Relinquishing and Reclaiming Independence: Irish Domestic Servants, American Middle-Class Mistresses, and Assimilation, 1850–1920', in Kevin Kenny (ed.), *New Directions in Irish–American History* (Madison: University of Wisconsin Press, 2003), 227–42.

Hubbard, R.H., *Antoine Plamondon and Théophile Hamel: Two Painters of Quebec* (Ottawa: National Gallery of Canada, 1970).

Hutchison, Emma, *Affective Communities in World Politics: Collective Emotions after Trauma* (Cambridge: Cambridge University Press, 2016).

Hynes, Eugene, *Knock: The Virgin's Apparition in Nineteenth Century Ireland* (Cork: Cork University Press, 2008).

Ignatiev, Noel, *How the Irish Became White* (New York and London: Routledge, 1995).

Inglis, Tom, *Moral Monopoly: The Rise and Fall of the Catholic Church in Ireland* (Dublin: UCD Press, 1998).

The Irish Tourist's Illustrated Handbook for Visitors to Ireland (London: Office of the National Illustrated Library; Dublin: James M'Glashan, 1852).

Jones, William Bence, *The Life's Work in Ireland of a Landlord Who Tried to Do His Duty* (London: Macmillan and Co., 1880).

Junnila, Heikki, *Alajärven Historia: erämaasta kaupungiksi* (Alajärvi: Alajärven kaupunki, 1999).

Jussila, Tuomas, 'Nälkävirret: 1860-luvun nälkävuosien historiakuva Pietari Päivärinnan, Juho Reijosen ja Teuvo Pakkalan teoksissa', unpublished MA thesis (University of Tampere, 2013): http://urn.fi/urn:nbn:fi:uta-1-23362.

Juustila, Yrjö, *Maaemon syli: 1860-luvun nälkävuosien nurmekselaisten uhrien muistolle* (Nurmes: Nälkävuosien muistomerkkitoimikunta, 1965).

Kaitasuo, Pia, 'Hiljaisen Kansan Parissa', *Kaleva*, 19 Sept. 2015.

Keenan, Desmond J., *The Catholic Church in Nineteenth-Century Ireland: A Sociological Study* (Dublin: Gill & Macmillan, 1983).

Kelleher, Margaret, *The Feminization of Famine: Expressions of the Inexpressible?* (Durham, NC: Duke University Press, 1997).

—— 'Hunger and History: Monuments to the Great Famine', *Textual Practice*, 16.2 (2002), 249–76.

—— 'The Irish Famine: History and Representation', in Mary McAuliffe, Katherine O'Donnell and Leeann Lane (eds), *Palgrave Advances in Irish History* (Basingstoke: Palgrave Macmillan, 2009), 84–99.

Kelly, A.A. (ed.), *The Letters of Liam O'Flaherty* (Dublin: Wolfhound Press, 1996).

Kelly, Mary C., *Ireland's Great Famine in Irish American History: Enshrining a Fateful Memory* (Lanham, MD: Rowman & Littlefield, 2014).

Kennedy, Liam, *Colonialism, Religion and Nationalism in Ireland* (Belfast: Institute of Irish Studies, 1996).

Kennedy, Thomas, 'Church Building', in *A History of Irish Catholicism*, vol. 5, *The Church Since Emancipation* (Dublin: Gill & Macmillan, 1970), 1–8.

Kenny, Kevin, *The American Irish: A History* (Harlow: Longman, 2000).

—— 'Diaspora and Comparison: The Global Irish as a Case Study', *Journal of American History*, 90.1 (2003), 134–62.

—— (ed.), *Ireland and the British Empire* (Oxford: Oxford University Press, 2004).

Kenny, Tom, 'Weavers of Dreams and Spells', *DruidShakespere* programme (Galway: Druid Theatre, 2015), 34.

Kerr, Donal A., *Peel, Priests and Politics: Sir Robert Peel's Administration and the Roman Catholic Church in Ireland, 1841–1846* (Oxford: Clarendon Press, 1982).

—— *The Catholic Church and the Famine* (Blackrock: The Columba Press, 1996).

Kinealy, Christine, *This Great Calamity: The Irish Famine 1845–52* (Dublin: Gill & Macmillan, 1994).

—— *A Death Dealing Famine: The Great Hunger in Ireland* (London: Pluto Press, 1997).

—— *The Bad Times: An Drochshaol*, illustrated by John Walsh (Ann Arbor, MI: XanEdu Publishing, 2015).

Kinealy, Christine, Jason King and Ciarán Reilly (eds), *Women and the Great Hunger* (Cork: Cork University Press, 2017).

King, Jason, 'Remembering Famine Orphans: The Transmission of Famine Memory between Ireland and Quebec', in Christian Noack, Lindsay Janssen and Vincent Comerford (eds), *Holodomor in Ukraine and Great Famine in Ireland: Histories, Representations and Memories* (London: Anthem Press, 2012), 115–43.

—— 'The Remembrance of Irish Famine Migrants in the Fever Sheds of Montreal', in Marguérite Corporaal, Christopher Cusack, Lindsay Janssen and Ruud van den Beuken (eds), *Global Legacies of the Great Irish Famine: Transnational and Interdisciplinary Perspectives* (Oxford: Peter Lang, 2014), 249–54.

—— (ed.), 'Irish Famine Archive': http://faminearchive.nuigalway.ie.

—— (ed.), 'Grey Nuns Famine Annal', *Ancien Journal*, 1 (1847): http://famine archive.nuigalway.ie/docs/grey-nuns/GreyNunsFamineAnnalAncien JournalVolumeI.1847.pdf.

King, Jason, and Christine Kinealy, 'Saving the Famine Irish: The Grey Nuns and the Great Hunger': https://www.qu.edu/on-campus/institutes-centers/ irelands-great-hunger-institute/grey-nuns-and-the-great-hunger.html.

Kinmonth, Claudia, *Irish Rural Interiors in Art* (New Haven, CT and London: Yale University Press, 2006).

Kissane, Bill, 'Nineteenth Century Nationalism in Finland and Ireland: A Comparative Analysis', *Nationalism and Ethnic Politics*, 6 (2000), 25–42.

Kivimäki, Ville, 'Between Defeat and Victory: Finnish Memory Culture of the Second World War', *Scandinavian Journal of History*, 37.4 (2012), 482–504.

Kormano, Riitta, *Sotamuistomerkki Suomessa: voiton ja tappion modaalista sovittelua* (Turku: Turun Yliopisto, 2014).

Kotljarchuck, Andrej, 'The Memory of the Roma Holocaust in Ukraine: Mass Graves, Memory Work and the Politics of Commemoration', in Tea Sindbæk Andersen and Barbara Törnquist-Plewa (eds), *Disputed Memory: Emotions and Memory Politics in Central, Eastern and South-Eastern Europe* (Berlin: De Gruyter, 2016), 149–74.

Kramer Leader, Bernice, *The Boston Lady as a Work of Art: Paintings by the Boston School at the Turn of the Century* (Ann Arbor, MI and London: University Microfilms International, 1980).

Laffan, William, and Christopher Monkhouse (eds), *Ireland: Crossroads of Art and Design, 1690–1840* (Chicago, IL: Art Institute of Chicago/Yale University Press, 2015).

Landsberg, Alison, *Prosthetic Memory: The Transformation of American Remembrance in the Age of Mass Culture* (New York: Columbia University Press, 2004).

Larkin, Emmet, 'The Devotional Revolution in Ireland, 1850–75', *American Historical Review*, 77.3 (1972), 625–52.

—— 'Introduction', in Emmet Larkin and Herman Freudenberger (trans and eds), *A Redemptorist Missionary in Ireland, 1851–1854: Memoirs by Joseph Prost* (Cork: Cork University Press, 1998).

Lawless, Catherine, 'Devotion and Representation in Nineteenth-Century Ireland', in Ciara Breathnach and Catherine Lawless (eds), *Visual, Material and Print Culture in Nineteenth-Century Ireland* (Dublin: Four Courts Press, 2010), 85–97.

Leadbeater, Mary, *Cottage Dialogues among the Irish Peasantry* (London: J. Johnson and Co., 1811).

Lee, J.J., and Marion R. Casey (eds), *Making the Irish American: History and Heritage of the Irish in the United States* (New York and London: New York University Press, 2006).

Leech, John, 'Pin Money/Needle Money', *Punch*, 23 Dec. 1849.

Leerssen, Joep, *Hidden Ireland, Public Sphere* (Dublin: Arlen House, 2002).

—— *National Thought in Europe: A Cultural History* (Amsterdam: Amsterdam University Press, 2006).

Lennon, Colm (ed.), *Confraternities and Sodalities in Ireland: Charity, Devotion and Sociability* (Dublin: The Columba Press, 2012).

Lentin, Ronit, 'Playwright Returns from His Exile', *Irish Press*, 26 Sept. 1983, 9.

Levy, Bill, *John Ford: A Bio-Bibliography* (Westport, CT: Greenwood, 1998).

Lindsey, Ben, *Irish Lace: Its Origin and History* (Dublin: Hodges, Figgis, and Co., 1886).

'Literature: Brother James's Tales', *Freeman's Journal*, 12 July 1856, 3.

Llewelyn, Morgan, and Michael Scott, *Ireland: A Graphic History* (Shaftesbury: Element Books, 1995).

Lloyd, David, *The Irish Times: Temporalities of Modernity* (Dublin: Field Day, 2008).

—— 'The Indigent Sublime: Specters of Irish Hunger', in Oona Frawley (ed.), *Memory Ireland*, vol. 3, *The Famine and the Troubles* (Syracuse, NY: Syracuse University Press, 2014), 17–58.

Lloyd, M.A., *Susanna Meredith: A Record of a Vigorous Life* (London: Hodder & Stoughton, 1903).

Loeber, Rolf, and Magda Loeber, *A Guide to Irish Fiction* (Dublin: Four Courts Press, 2006).

Longfield, Ada K., *Catalogue to the Collection of Lace* (Dublin: Stationery Office, 1937).

Luddy, Maria, *Women and Philanthropy in Nineteenth-Century Ireland* (Cambridge: Cambridge University Press, 1995).

Lynch-Brennan, Margaret, *The Irish Bridget: Irish Immigrant Women in Domestic Service in America, 1840–1930* (Syracuse, NY: Syracuse University Press, 2009).

Lysaght, Patricia, 'Perspectives on Women during the Great Irish Famine from the Oral Tradition', *Béaloideas*, 64–65 (1996–97), 63–130.

McBride, Joseph, *Searching for John Ford: A Life* (London: Faber & Faber, 2003).

McCarthy, B.G., 'Thomas Crofton Croker 1798–1854', *Studies*, 32 (1943), 539–56.

McCord, James N., 'The Image in England: The Cartoons of HB', in Maurice O'Connell (ed.), *Daniel O'Connell: Political Pioneer* (Dublin: Institute of Public Administration, 1991), 57–71.

McCulloch, Derek, *Gone to Amerikay*, with illustrations by Colleen Doran and José Villarrubia (New York: Vertigo/DC Comics, 2012).

McDannell, Colleen, *Material Christianity: Religion and Popular Culture in America* (New Haven, CT: Yale University Press, 1995).

MacDonagh, Oliver, *A Pattern of Government Growth, 1800–1860: The Passenger Acts and Their Enforcement* (London: MacGibbon and Gee, 1961).

McGrath, Thomas G., 'The Tridentine Evolution of Modern Irish Catholicism, 1563–1962: A Re-Examination of the "Devotional Revolution" Thesis', *Recusant History*, 20.4 (1991), 512–23.

McHugh, Elizabeth Anne, 'Irish Famine Immigration and Dust Bowl Migration: A Comparative Study', unpublished MA thesis (Humboldt State University, 2005).

McHugh, Michael, 'Europe "Should Learn the Lessons of the Irish Famine" in Current Refugee Crisis: New Memorial Unveiled at National Famine Commemoration at Glasnevin Cemetery', *Irish Independent*, 11 Sept. 2016.

McLean, Stuart, *The Event and Its Terrors: Ireland, Famine, Modernity* (Stanford, CA: Stanford University Press, 2004).

McLean, Thomas, *An Illustrative Key to the Political sketches of H.B., from No. 1 to No. 600* (London: McLean, 1841).

McNamer, Sarah, *Affective Meditation and the Invention of Medieval Compassion* (Philadelphia: University of Pennsylvania Press, 2010).

Mac Philib, Séamas, 'Ius Primae Noctis and the Sexual Image of Irish Landlords in Folk Tradition and in Contemporary Account', *Béaloideas*, 56 (1988), 97–140.

Maguire, John Francis, *The Industrial Movement in Ireland, as Illustrated by the National Exhibition of 1852* (Cork: John O'Brien; London: Simpkin, Marshall and Co., 1853).

Mahony, James, 'Mullins's Hut, at Scull', *The Illustrated London News*, 10 Feb. 1847, 116.

Malkki, Liisa, 'Speechless Emissaries: Refugees, Humanitarianism, and Dehistoricization', *Cultural Anthropology*, 11.3 (1996), 377–402.

'Manufacture Movement', *Nation*, 29 Mar. 1851, 2.

Mark-FitzGerald, Emily, 'The Irish Famine and Commemorative Culture', in Christian Noack, Lindsay Janssen and Vincent Comerford (eds), *Holodomor and Gorta Mór: Histories, Memories and Representations of Famine in Ukraine and Ireland* (London: Anthem Press, 2012), 145–64.

—— *Commemorating the Irish Famine: Memory and the Monument* (Liverpool: Liverpool University Press, 2013).

—— 'The "Irish Holocaust": Historical Trauma and the Commemoration of the Famine', in Griselda Pollock (ed.), *The Visual Politics of Psychoanalysis in a Post-traumatic World* (London: IB Tauris, 2013), 60–78.

—— 'Photography and the Visual Legacy of Famine', in Oona Frawley (ed.), *Memory Ireland*, vol. 3, *The Famine and the Troubles* (Syracuse, NY: Syracuse University Press, 2014), 121–37.

—— 'Irish Famine Memorials': https://irishfaminememorials.com/user-guide/.

—— 'The Persistence of Vision: Picturing Eviction in the Nineteenth Century', in Brendan Rooney (ed.), *Creating History: Stories of Ireland in Art* (Dublin: National Gallery of Ireland/Irish Academic Press, 2016), 202–24.

Marshall, Catherine, 'Diaspora and the Visual Arts', in Catherine Marshall and Peter Murray (eds), *Art and Architecture of Ireland*, vol. 5, *Twentieth Century* (Dublin and New Haven, CT: Royal Irish Academy and Yale University Press, 2014), 134–40.

—— *Monuments and Memorials of the Great Famine* (Hamden, CT: Quinnipiac University Press, 2014).

Martikainen, Heimo (ed.), *Heinäveden historia*, 2, *Heinäveden historia kunnallisuudistuksesta (1865) nykypäiviin* (Heinävesi: Heinäveden kunta, 1989).

Martineau, Harriet, *Letters from Ireland* (London: John Chapman, 1852).

Marx, Karl, *Capital: A Critique of Political Economy*, trans. Ben Fowkes (Harmondsworth: Penguin Classics, 1990).

Maschio, Geraldine, 'Ethnic Humor and the Demise of the Russell Brothers', *Journal of Popular Culture*, 26.1 (1992), 81–92.

Mathur, Saloni, 'Introduction', *The Migrant's Time: Rethinking Art History and Diaspora* (New Haven, CT and London: Yale University Press, 2011), i–ix.

Maume, Patrick (ed.), *The Repealer Repulsed! A Correct Narrative of the Rise and Progress of the Repeal Invasion of Ulster: Dr Cooke's Challenge and Mr O'Connell's Declinature, Tactics and Flight* (Dublin: UCD Press, 2003).

Meadows, Kenny, 'Death and the Drawing Room, or the Young Dressmakers of England', *The Illuminated Magazine*, 1 (May–Oct. 1843), 97.

Meloy, Elizabeth, 'Touring Connemara: Learning to Read a Landscape of Ruins, 1850–1860', *New Hibernia Review*, 13 (2009), 21–23.

Meredith, Susanna, *The Lacemakers: Sketches of Irish Character, with Some Account of the Effort to Establish Lacemaking in Ireland* (London: Jackson, Walford, and Hodder, 1865).

Meurman, Agaton, *Hungeråren på 1860-talet* (Helsingfors: Folkupplysnings-sällskapet, 1892).

Miles, Josephine, *Pathetic Fallacy in the Nineteenth Century: A Study of a Changing Relation between Object and Emotion* (Berkeley: University of California Press, 1942).

Miller, David W., 'Irish Catholicism and the Great Famine', *Journal of Social History*, 9 (1975), 81–98.

—— 'Mass Attendance in Ireland in 1834', in Stewart J. Brown and David W. Miller (eds), *Power and Piety in Ireland, 1760–1960: Essays in Honour of Emmet Larkin* (Belfast and Notre Dame, IN: Queen's University of Belfast/ University of Notre Dame Press, 2000), 158–79.

Miller, Kerby A., 'Emigrants and Exiles: Irish Cultures and Irish Emigration to North America, 1790–1922', *Irish Historical Studies*, 22.86 (1980), 97–125.

—— *Emigrants and Exiles: Ireland and the Exodus to North America* (Oxford: Oxford University Press, 1985).

Moore, Thomas, Memoirs *of* Captain Rock, *the* Celebrated Irish Chieftain, *with* Some Account *of* his Ancestors. Written *by* Himself (London: Longman, Hurst, Rees, Brown Orme and Green, 1824).

Morash, Chris, and Shaun Richards, *Mapping Irish Theatre: Theories of Space and Place* (Cambridge: Cambridge University Press, 2014).

Morgan, David, *The Sacred Heart of Jesus: The Visual Evolution of a Devotion* (Amsterdam: Amsterdam University Press, 2008).

—— 'The Look of Sympathy: Religion, Visual Culture, and the Social Life of Feeling', *Material Religion*, 5.2 (2009), 132–54.

Morgan, Jack, 'Thoreau's "The Shipwreck" (1855): Famine Narratives and the Female Embodiment of Catastrophe', *New Hibernia Review*, 8.3 (2004), 47–57.

Moser, Joseph Paul, *Irish Masculinity on Screen: The Pugilists and Peacemakers of John Ford, Jim Sheridan and Paul Greengrass* (London: McFarland, 2013).

Murphy, James H., 'The Role of Vincentian Parish Missions in the "Irish Counter- Reformation" of the Mid-Nineteenth Century', *Irish Historical Studies*, 24.94 (1984), 152–71.

—— 'Fashioning the Famine Queen', in Peter Gray (ed.), *Victoria's Ireland? Irishness and Britishness, 1837–1901* (Dublin: Four Courts Press, 2004), 15–26.

Murphy, Margaret, 'Croker, Thomas Crofton', *Dictionary of Irish Biography*: http://dib.cambridge.org.

Murphy, Maureen, 'Bridget and Biddy: Images of the Irish Servant Girl in *Puck* Cartoons, 1880–1890', in Charles Fanning (ed.), *New Perspectives on the Irish Diaspora* (Carbondale and Edwardsville: Southern Illinois University Press, 2000), 152–75.

—— 'From Scapegrace to Grásta: Popular Attitudes and Stereotypes in Irish American Drama', in John P. Harrington (ed.), *Irish Theater in America: Essays on Irish Theatrical Diaspora* (Syracuse, NY: Syracuse University Press, 2009), 19–37.

Murphy, Tom, *Famine* (Dublin: Gallery Press, 1977).

—— *Plays: 1*, rev. edn (London: Methuen, 1997).

Myles, Jonathan, *Medusa: The Shipwreck, The Scandal, The Masterpiece* (London: Pimlico, 2008), 169–77.

Nakamura, Tetsuko, 'Interrelated Travel Discourses on Connemara and Joyce Country in the 1830s', *Journal of Irish Studies*, 25 (2010), 18–27.

—— 'Daniel Maclise's Representations of Irishness: His Drawings in John Barrow's *Tour round Ireland* (1836)', *Odysseus*, 17 (2013), 41–57.

Neave, Digby, *Four Days in Connemara* (London: Richard Bentley, 1852).

Newby, Andrew G., '"Neither Do These Tenants or Their Children Emigrate": Famine and Transatlantic Emigration from Finland in the Nineteenth Century', *Atlantic Studies: Global Currents*, 11.3 (2014), 383–402.

—— *Éire na Rúise: An fhionlainn agus Éire ar thóir na saoirse* (Dublin: Coiscéim, 2016).

—— 'Sites of Memory: An Interim Report on Finnish Famine Memorials', in Andrew G. Newby (ed.), *'The Enormous Failure of Nature': Famine and Society in Nineteenth-Century Europe* (Helsinki: Collegium, 2017).

Newby, Andrew G., and Timo Myllyntaus, '"The Terrible Visitation": Famine in Finland and Ireland, 1845 to 1868', in Declan Curran, Lubomyr Luciuk and Andrew G. Newby (eds), *Famines in European Economic History: The Last Great European Famines Reconsidered* (London: Routledge, 2015), 145–63.

Ní Dhomhnaill, Nuala, *The Astrakhan Cloak*, trans. Paul Muldoon (Loughcrew: Gallery, 1992).

Nicholson, Asenath, *Lights and Shades of Ireland* (London: Charles Gilpin, 1850).

—— *Annals of the Famine in Ireland* (1851), ed. Maureen Murphy (Dublin: Lilliput Press, 1998).

Niukkanen, Marianna, *Historiallisen ajan kiinteät muinaisjäännökset: tunnistaminen ja suojelu* (Helsinki: Museovirasto, 2009).

Noack, Christian, Lindsay Janssen and Vincent Comerford (eds), *Holodomor and Gorta Mór: Histories, Memories and Representations of Famine in Ukraine and Ireland* (London: Anthem Press, 2012).

Nochlin, Linda, 'Courbet and the Representation of "Misère": A Dream of Justice', in Klaus Herding and Max Hollein (eds), *Courbet: A Dream of Modern Art* (Ostfildern: Hatje Cantz Verlag, 2010), 76–83.

Nolan, Emer, 'Irish Melodies and Discordant Politics: Thomas Moore's Memoirs of Captain Rock (1824)', *Field Day Review*, 2 (2006), 41–54.

Nora, Pierre, 'Between Memory and History: *Les lieux de mémoire*', *Representations*, 26 (1989), 7–24.

Norton, Desmond, 'Lord Palmerston and the Irish Famine Emigration: A Rejoinder', *Historical Journal*, 46.1 (2003), 155–65.

—— *Landlords, Tenants, Famine: The Business of an Irish Land Agency in the 1840s* (Dublin: UCD Press, 2006).

Nowlan, David, 'Druid Company's Epic at Salthill, Galway', *The Irish Times*, 8 Feb. 1984, 14.

O'Brien, Richard Baptist, *Ailey Moore* (New York: E. Dunigan, 1856).

Ó Ciosáin, Niall, *Print and Popular Culture in Ireland, 1750–1850* (Basingstoke: Palgrave Macmillan, 1997).

—— 'Approaching a Folklore Archive: The Irish Folklore Commission and the Memory of the Great Famine', *Folklore* (Aug. 2000), 222–32.

O'Connor, Anne V., 'Anne Jellicoe', in Mary Cullen and Maria Luddy (eds), *Women, Power and Consciousness in 19th-Century Ireland: Eight Biographical Studies* (Dublin: Attic Press, 1995), 125–60.

O'Connor, Joseph, *The Star of the Sea* (London: Vintage, 2003).

O'Donnell, Patrick D., *The Irish Faction Fighters of the 19th Century* (Dublin: Anvil Books, 1975).

O'Driscoll, Katherine, 'Reform, Instruction and Practice: The Impact of the Catholic Revival on the Laity in the Dublin Diocese, 1793–1853', unpublished PhD thesis (National University of Ireland Galway, 2016).

O'Flaherty, Liam, *Famine* (London: Gollancz, 1949).

Ó Gráda, Cormac, *Ireland: A New Economic History* (Oxford: Clarendon Press, 1994).

—— 'After the Famine Fever', *The Irish Times*, 19 May 2001.

O'Kelly, Emer, 'A Mighty Murphy Marathon', *Sunday Independent*'s 'Living Magazine', 1 July 2012, 25.

O'Leary, Elizabeth, *At Beck and Call: The Representation of Domestic Servants in Nineteenth-Century American Painting* (Washington, DC and London: Smithsonian Institution Press, 1996).

Ó Murchadha, Ciarán, *Figures in a Famine Landscape* (London: Bloomsbury Academic, 2016).

O'Neill, Eugene, *Long Day's Journey into Night* (London: Jonathan Cape, 1966).

O'Rourke, Kevin, 'The Fighting Irish: Faction Fighting as Leisure in the Writings of William Carleton', in Leeann Lane and William Murphy (eds), *Leisure and the Irish in the Nineteenth Century* (Liverpool: Liverpool University Press, 2015), 130–46.

O'Ryan, Edmund, and Julia O'Ryan, *In re Garland: A Tale of a Transition Time* (London: Thomas Richardson and Son, 1870).

O'Shea, James, *Priests, Politics and Society in Tipperary 1850–1891* (Dublin: Wolfhound, 1983).

Ó Súilleabháin, Seán, *Handbook of Irish Folklore* (Dublin: Educational Company of Ireland Limited, 1942).

O'Sullivan, Niamh, *Aloysius O'Kelly: Art, Nation, Empire* (Dublin: Field Day Publications, 2010).

—— '"All native, all our own, and all a fact": John Mulvany and the Irish-American Dream', *Field Day Review*, 11 (2011), 138–49.

—— *The Tombs of a Departed Race: Illustrations of Ireland's Great Hunger* (Hamden, CT: Quinnipiac University Press, 2014).

—— *In the Lion's Den: Daniel Macdonald, Ireland and Empire* (Hamden, CT: Quinnipiac University Press, 2016).

O'Toole, Fintan, *A History of Ireland in 100 Objects* (Dublin: Royal Irish Academy, 2013).

Ó Tuathaigh, Gearóid, *I mBéal an Bháis: The Great Famine and the Language*

Shift in Nineteenth-Century Ireland (Hamden, CT: Quinnipiac University Press, 2015).

'Obituary of Liam O'Flaherty', *The Irish Times*, 3 Sept. 1973.

Official Catalogue of the Great Industrial Exhibition (Dublin: John Falconer, 1853).

Olick, Jeffrey K., Vered Vinitzky-Seroussi and Daniel Levy, 'Introduction', in Jeffrey K. Olick, Vered Vinitzky-Seroussi and Daniel Levy (eds), *The Collective Memory Reader* (Oxford: Oxford University Press, 2011), 3–62.

Otway, Caesar, *A Tour in Connaught: Comprising Sketches of Clonmacnoise, Joyce Country, and Achill* (Dublin: William Curry, 1839).

—— *Sketches in Erris and Tyrawly* (Dublin: William Curry, 1841; repr. Dublin: Thomas Connolly, 1850).

Pine, Emilie, *The Politics of Irish Memory* (Basingstoke: Palgrave Macmillan, 2011).

Plate, Liedeke, and Anneke Smelik (eds), *Performing Memory in Art and Popular Culture* (New York: Routledge, 2013).

Prost, Joseph, *A Redemptorist Missionary in Ireland, 1851–1854: Memoirs by Joseph Prost*, trans. and ed. Emmet Larkin and Herman Freudenberger (Cork: Cork University Press, 1998).

Prunty, Jacinta, 'Margaret Louisa Aylward', in Mary Cullen and Maria Luddy (eds), *Women, Power and Consciousness in 19th-Century Ireland: Eight Biographical Studies* (Dublin: Attic Press, 1995), 55–58.

Pugliese, Joseph, 'Crisis Heterotopias and Border Zones of the Dead', *Continuum*, 23.5 (2009), 663–79.

Pupavac, Vanessa, 'Natural Disasters: Trauma, Political Contestation and Potential to Precipitate Social Change', in Erica Resende and Dovile Budryt (eds), *Memory and Trauma in International Relations* (Abingdon: Routledge, 2013), 74–91.

Quick, Michael, Jane Myers and Marianne Doezema, *The Paintings of George Bellows* (New York: Harry N. Abrams, Inc., 1992).

Rafferty, Oliver P., 'The Ultramontane Spirituality of Paul Cullen', in Dáire Keogh and Albert McDonnell (eds), *Cardinal Paul Cullen and His World* (Dublin: Four Courts Press, 2011), 61–77.

Ramsay, Debra, *American Media and the Memory of World War II* (London and New York: Routledge, 2015).

Reese, H. 'A Lack of Information, Resources and Will: Political Aspects of the Finnish Crisis of 1867–68', in Andrew G. Newby (ed.), *The Enormous Failure of Nature: Famine and Society in Nineteenth-Century Europe* (Helsinki: CollEgium, 2017), 83–102.

Reilly, Ciarán, *John Plunket Joly and the Great Famine in King's County* (Dublin: Four Courts Press, 2012).

—— *The Irish Land Agent, 1830–60: The Case of King's County* (Dublin: Four Courts Press, 2014).

—— *Strokestown and the Great Irish Famine* (Dublin: Four Courts Press, 2014).

Report from Her Majesty's Commissioners of Inquiry into the State of the Law and Practice in Respect to the Occupation of Land in Ireland (Dublin: A. Thom, 1845).

Report of the Commissioners Appointed to Take the Census of Ireland, for the Year 1841 (Dublin: Her Majesty's Stationery Office, 1843).

Rockett, Kevin, Luke Gibbons and John Hill, *Cinema in Ireland* (London: Croom Helm, 1987).

Rooney, Brendan (ed.), *Creating History: Stories of Ireland in Art* (Dublin: National Gallery of Ireland/Irish Academic Press, 2016).

Rothberg, Michael, *Multidirectional Memory: Remembering the Holocaust in the Age of Decolonization* (Stanford, CA: Stanford University Press, 2009).

Rowan, Alistair, 'Irish Victorian Churches: Denominational Distinctions', in Raymond Gillespie and Brian Kennedy (eds), *Ireland: Art into History* (Dublin: Townhouse, 1994), 207–30.

Rutherford, Jonathan (ed.), *Identity: Community, Culture, Difference* (London: Lawrence & Wishart, 1990).

Sadlier, Mrs. J., *New Lights; or Life in Galway* (New York: D. and J. Sadlier, 1853).

St John, Ambrose (trans.), *The Raccolta: or, Collection of Indulgenced Prayers and Good Works to Which the Sovereign Pontiffs Have Attached Holy Indulgences*, 6th edn (London: Burns and Oates, 1910).

Sauter, Willmar, 'Reflections on *Miss Julie*, 1992: Sensualism and Memory', in Willmar Sauter (ed.), *The Theatrical Event: Dynamics of Performance and Perception* (Iowa City: University of Iowa Press, 2000), 158–64.

Schulte, Augustin Joseph, 'Altar Vessels', q.v. *The Catholic Encyclopedia*, vol. 1 (New York: Robert Appleton, 1907): www.newadvent.org/cathen/01357e.htm.

Schultz, April, 'The Black Mammy and the Irish Bridget: Domestic Service and the Representation of Race, 1830–1930', *Éire-Ireland*, 48 (2013), 176–212.

Shaughnessy, Edward L., 'O'Neill's African and Irish-Americans: Stereotypes or "Faithful Realism"?', in Michael Manheim (ed.), *The Cambridge Companion to Eugene O'Neill* (Cambridge: Cambridge University Press, 2006), 148–63.

Sheehan, Patrick, *My New Curate* (Dublin: Talbot Press, 1900).

Sherratt-Bado, Dawn Miranda, *Decoloniality and Gender in Jamaica Kincaid and Gisèle Pineau: Connective Caribbean Readings* (Basingstoke: Palgrave Macmillan, 2018).

Silverman, Kaja, *The Acoustic Mirror: The Female Voice in Psychoanalysis and Cinema* (Bloomington: Indiana University Press, 1988).

Sinden, Donald, *A Touch of the Memoirs* (London: Hodder & Stoughton, 1982).

Sinnema, Peter W., *Dynamics of the Pictured Page: Representing the Nation in the Illustrated London News* (Aldershot: Ashgate, 1998).

Sloan, Robert, *William Smith O'Brien and the Young Ireland Rebellion of 1848* (Dublin: Four Courts Press, 2000), 148–56.

Smith, Alison, David Blaney Brown and Carol Jacobi (eds), *Artist and Empire: Facing Britain's Imperial Past* (London: Tate Publishing, 2015).

Smith, Joseph Denham, *Connemara: Past and Present* (Dublin: John Robertson, 1853).

Smyth, William J., 'The Longue Durée: Imperial Britain and Colonial Ireland', in John Crowley, William J. Smyth and Mike Murphy (eds), *Atlas of the Great Irish Famine* (Cork: Cork University Press, 2012), 40–63.

Soikkanen, Hannu, '"Miekalla, Nälällä ja Rutolla": Kriisit Historiassa', in Antti Häkkinen, Vappu Ikonen, Kari Pitkänen and Hannu Soikkanen (eds), *Kun halla nälän tuskan toi* (Porvoo: WSOY, 1991), 11–35.

'The Song of the Famine', *Dublin University Magazine*, 30.175 (July 1847), 102–04.

Sontag, Susan, *Regarding the Pain of Others* (New York: Picador, Farrar, Straus and Giroux, 2003).

Spanos, William V., *Exiles in the City: Hannah Arendt and Edward W. Said in Counterpoint* (Columbus: The Ohio State University Press, 2012).

Spiegelman, Art, *The Complete Maus* (London: Penguin Books, 2003).

Tavaststjerna, Karl August, *Hårda Tider: berrätelse från Finlands sista nödår* (Helsingfors: Söderström, 1891).

Taves, Ann, *The Household of Faith: Roman Catholic Devotions in Mid-Nineteenth Century America* (South Bend, IN: University of Notre Dame Press, 1986).

Tenniel, John, 'The Haunted Lady, Or "The Ghost" in the Looking-Glass', *Punch*, 4 July 1863, 5.

Tepora, Tuomas, and Aapo Roselius (eds), *The Finnish Civil War 1918: History, Memory, Legacy* (Leiden: Brill, 2014).

Thomas, Julia (ed.), *Reading Images* (Basingstoke and New York: Palgrave Macmillan, 2000).

Toibin, Colm, and Diarmaid Ferriter, *The Irish Famine* (London: Pluto Press, 2004).

[Tonna], Charlotte Elizabeth, *The Wrongs of Woman: in Four Parts*, Part 4, *The Lace-Runners* (London: W.H. Dalton, 1844).

Topelius, Zacharias [Zachris], *Boken om vårt land* (Helsingfors: Edlund, 1875).

The Tourist's Illustrated Hand-Book for Ireland (London: John Cassell for the Railway Companies, Parties to the Irish Tourist Ticket System, 1853).

The Tourist's Illustrated Hand-Book for Ireland (London: W. Smith; Dublin: M'Glashan & Gill, for the Railway Companies, Parties to the Tourist Ticket System, and for the Galway and American Line of Steam Packets, 1859).

Townshend, Charles, 'The Making of Modern Irish Public Culture', *Journal of Modern History*, 61.3 (1989), 534–54.

Trigg, Dylan, *The Aesthetics of Decay: Nothingness, Nostalgia and the Absence of Reason* (New York: Peter Lang, 2009).

'A Triumph at the Peacock', *The Sunday Press*, 24 Mar. 1968.

Trollope, Anthony, *Castle Richmond* (London: Chapman and Hall, 1860).

Troupe, Shelley, 'When Druid Went to Jail: Returned Migrants, Irish Prisoners, and Tom Murphy's Conversations on a Homecoming', *Irish Studies Review*, 22.2 (2014), 224–37.

Tuke, James, *A Visit to Connaught in the Autumn of 1847: A Letter Addressed to the Central Relief Committee of the Society of Friends* (London: Charles Gilpin; York: John L. Linney, 1848).

Tuomisto, Antero, *Sotiemme muistomerkit* (Helsinki: Suomen Matkailuliitto, 1990).

Vézina, Raymond, 'Théophile Hamel', q.v. *Dictionary of Canadian Biography* (Toronto: University of Toronto Press, 1976), vol. 9: www.biographi.ca/en/bio/hamel_theophile_9E.html.

Vogl-Bienek, Ludwig, and Richard Crangle (eds), *Screen Culture and the Social Question, 1880–1914* (New Barnet: John Libbey Publishing, 2014).

Voutilainen, Miikka, 'Feeding the Famine: Social Vulnerability and Dislocation during the Finnish Famine of the 1860s', in Declan Curran, Lubomyr Luciuk and Andrew G. Newby (eds), *Famines in European Economic History: The Last Great European Famines Reconsidered* (London: Routledge, 2015), 124–44.

—— *Poverty, Inequality and the Finnish 1860s Famine* (Jyväskylä: Jyväskylän Yliopisto, 2016).

Waterfield, Giles, and Anne French (with Matthew Craske), *Below Stairs: 400 Years of Servant's Portraits* (London: National Portrait Gallery, 2003).

Watts, A.A. (ed.), *Literary Souvenir; or, Cabinet of Poetry and Romance* (London: Longman, Rees, Orme, Brown and Green, 1832).

Weber, Max, *Economy and Society*, vol. 1, ed. Guenther Roth and Claus Wittich (Berkeley: University of California Press, 1968).

Weinberg, H. Barbara, Doreen Bolger and David Park Curry, *American Impressionism and Realism: The Paintings of Modern Life, 1885–1915* (New York: Metropolitan Museum of Art and Harry N. Abrams, 1994).

Wertsch, James V., *Voices of Collective Remembering* (New York: Cambridge University Press, 2002).

Whelan, Kevin, 'The Catholic Parish, the Catholic Chapel and Village Development in Ireland', *Irish Geography*, 16 (1983), 1–15.

—— 'Pre-and Post-Famine Landscape Change', in Cathal Póirtéir (ed.), *The Great Irish Famine* (Cork and Dublin: Radio Telefís Éireann/Mercier Press, 1995), 19–33.

—— 'Reading the Ruins: The Presence of Absence in the Irish Landscape', in Howard B. Clarke and Anngret Simms (eds), *Surveying Ireland's Past: Multidisciplinary Essays in Honour of Anngret Simms* (Dublin: Geography Publications, 2004), 297–354.

Whelehan, Niall, *Transnational Perspectives in Modern Irish History: Beyond the Island* (London: Routledge, 2015).

'While the Crop Grows, Ireland Starves', *The Puppet Show*, 13 May 1849.

White, Nelson C., *Abbott H. Thayer: Painter and Naturalist* (Hartford: Connecticut Printers, 1951).

Wilde, William, *Irish Popular Superstitions* ([1852] Dublin: Irish Academic Press, 1979).

—— *Census of Ireland Report*, 1851, part 5, vol. 1 (Dublin: 1856).

Williams, William H.A., *Tourism, Landscape, and the Irish Character: British Travel Writers in Pre-Famine Ireland* (Madison: University of Wisconsin Press, 2008).

Wilson, Ann, 'Irish Catholic Fiction of the Early Twentieth Century: The Power of Imagery', *New Hibernia Review*, 18.1 (2014), 30–49.

Wilson, David, *Thomas D'Arcy McGee: Passion, Reason, and Politics: 1825–1857* (Montreal and Kingston: McGill-Queen's University Press, 2008).

Witek, Joseph, 'Comics Modes: Caricature and Illustration in the Crumb Family's Dirty Laundry', in Matthew J. Smith and Randy Duncan (eds), *Critical Approaches to Comics: Theories and Methods* (London: Routledge, 2014), 27–42.

Worthen, Hana, and Simo Muir, 'Introduction: Contesting the Silences of History', in Hana Worthen and Simo Muir (eds), *Finland's Holocaust: Silences of History* (Basingstoke: Palgrave Macmillan, 2012), 1–30.

Young, A.B., 'Royal Court: The Famine', *Financial Times*, 11 Nov. 1969.

Young, Arthur, *A Tour in Ireland, 1776–1779*, vol. 2 (London: Cadell, 1780).

Zurier, Rebecca, *Picturing the City: Urban Vision and the Ashcan School* (Oakland: University of California Press, 2006).

Zurier, Rebecca, Robert W. Snyder and Virginia M. Mecklenburg, *Metropolitan Lives: The Ashcan Artists and their New York* (New York and London: National Museum of American Art, Norton and Co., 1995).

Index